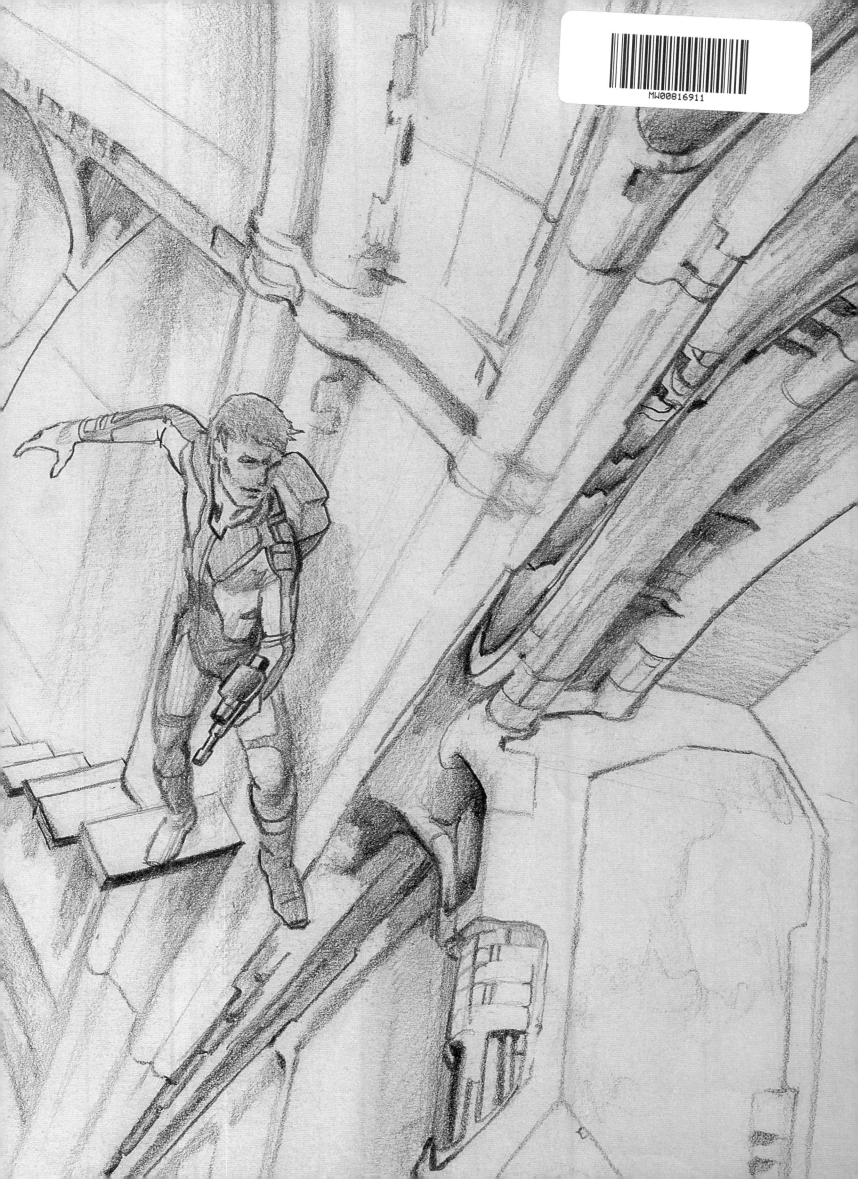

TECH NOIR

THE ART OF
JAMES CAMERON

COMMENTARY BY
JAMES CAMERON

FOREWORD BY
GUILLERMO DEL TORO

EDITED BY
CHRIS PRINCE

PRODUCED BY
KIM BUTTS

BASED ON AN IDEA BY
MARIA WILHELM

INSIGHT
EDITIONS

SAN RAFAEL • LOS ANGELES • LONDON

Contents

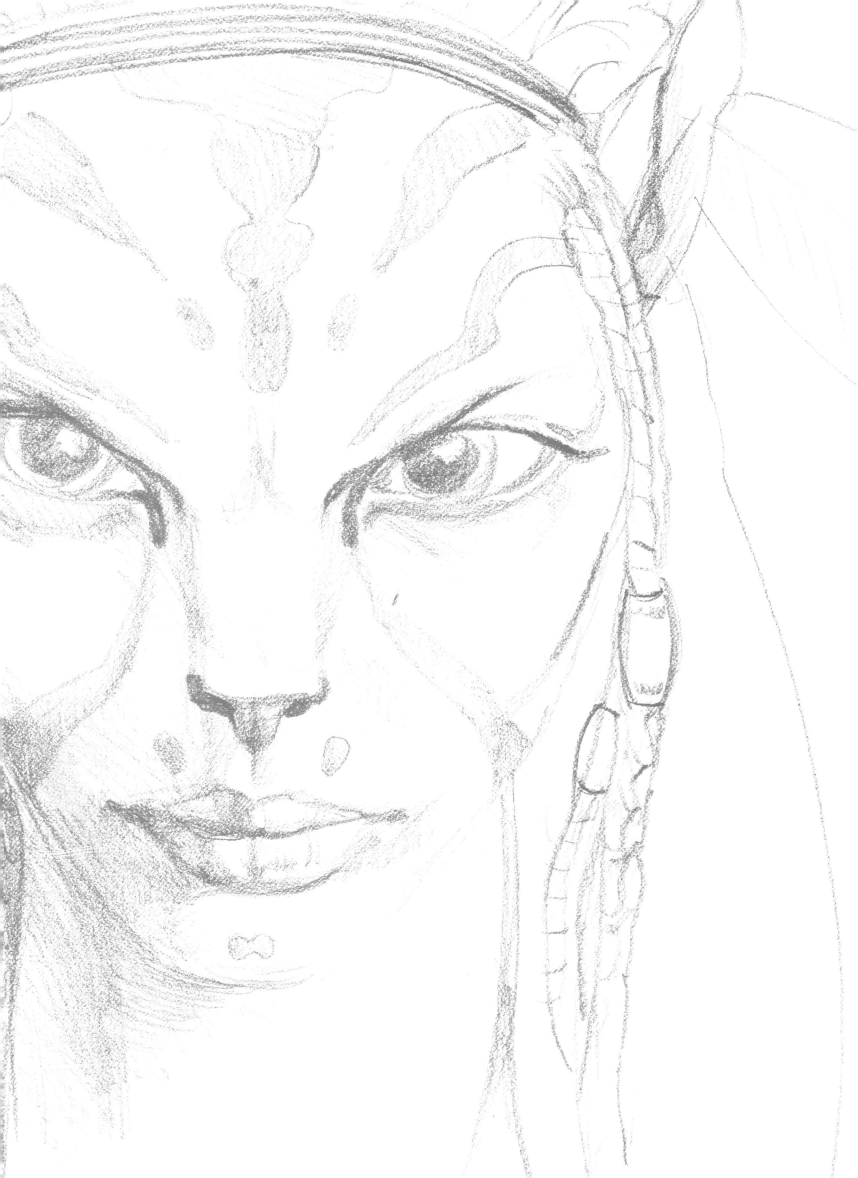

Navigation Charts of the Mind

Many glorious tales have been told about James Cameron the polymath. The director who holds technical and artistic knowledge to rival—and push—his heads of department on every production. They are all, of course, true.

But, unless you have been by his side (which has been my fortune on several occasions), or listened in detail to his audio commentaries, the public has rarely had the chance to confirm this reputation. To be able to access his drawings—from his juvenilia to his most accomplished designs (including the endoskeleton of the Terminator and the evil and exquisitely streamlined Alien Queen from *Aliens*)—now, that is a true privilege.

James Cameron started his exalted climb into the director's chair by putting in time at the Roger Corman film factory. There, he tackled miniatures, production design, and art direction amongst many other challenges. Corman was overtly interested in exploitation films that rendered a profit—but he also had an unerring eye for talent, and Cameron had it. Lots of it.

Cameron's unique sense of design was fostered in equal parts by classic pulp science fiction, Silver Age comic books, military history, and industrial design. His creatures and alien landscapes have impeccable silhouettes and stance, with incredible attention to biological detail—but they also pulsate with fuel-injected Monster Kid passion. His machines not only seem like they could work—they very

RIGHT Shortly after moving from Canada to Brea, California, at the age of seventeen, James Cameron holds up a painting of USMC pilot Major Stephen P. Hanson, a prisoner of war then missing in Vietnam. Cameron created the piece for Hanson's wife, Carol, a neighbor at the time. She used it as part of the national promotion for a successful POW/MIA bracelet campaign that raised millions of dollars. Hanson's remains were brought home from Vietnam in 1999.

OPPOSITE A newspaper clipping from the October 1969 edition of the *Niagara Falls Evening Review* highlights the work of budding fifteen-year-old artist James Cameron.

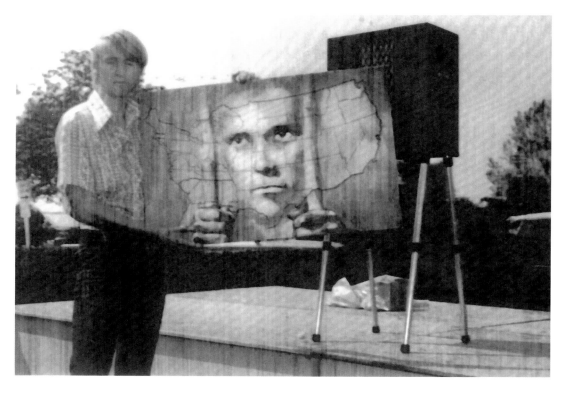

likely *would* work; they have been thought out to the last detail: curvature, wind resistance, wedge, load capacity, steering systems, and on and on. There is a reason for it—Jim's designs are windows to the fully realized universes they hold.

The first time I saw a James Cameron original was around 1992. I was finishing *Cronos*; Jim had viewed it (in incomplete form) and, against all odds, loved it. He invited me to Lightstorm Entertainment, which, if memory serves, was in the Valley back then. I was blown away by the fact that a director had offices—plural—and a large staff. This, I thought, was the big time.

He took me into his office and showed me a sketch (included in this book) of Spider-Man climbing the side of a building. It was wonderful: a perfectly composed top shot looking straight down. It instantly gave you the vertigo, the sense of place, and the dynamics of the character, but it was decidedly not a comic book panel—it was a cool and moody film moment. Very tech noir (an adjective Jim concocted to explain the visuals of *The Terminator*).

Jim was generous enough to give me the watermarked Spider-Man screenplay to read, and I just devoured it. And then, a most impressive fact was revealed to me: The drawing I had seen earlier had already conjured the entire screenplay in some way. It had been suffused with its story, character, and attitude. It contained it. So, yes, James Cameron may have had a whole building full of people, but the concepts rendered and the principles guiding that team came out of his head. His mind harbored complete ecosystems. And, at the end of the day, he could do away with it all and, true to his maverick nature, need only a piece of paper and something—anything—to render it himself.

Even in his youth, you can sense, yes, the adolescent reading science and history books and paperback novels in his native Canada—studying Steranko, Kirby, Frazetta, Freas, Finlay, Ron Cobb, all the greats—struggling with the basics of nuclear engine design and his instincts for barbarian fiction. But already present there was the intensely intelligent storyteller that would author his future

HALLOWEEN CONTEST WINNER — Jim Cameron, 15, of 454 Parkway Dr., Chippawa, puts the finishing touches to his painting which won top prize in the annual Halloween painting contest on the windows of the Lincoln Trust and Savings Co. office on Queen St. Saturday. Jim, a Grade 11 student at SCVI, was one of 52 entrants. (Review photo by Roels)

screenplays and give the world new galaxies to dream of.

His visual vocabulary is vast and varied, and you can see it evolve throughout the decades while preserving his drive and spirit and passion. You journey with him from notebook doodles and anatomical sketches in ballpoint pen to iconic images that will be enshrined in the collective lexicon of film for eternity. It is a thrill ride of sorts and, for me, a very moving one.

Jim has been kind enough to nurture our kinship for fantasy and monsters, and I know very intimately how his quest as a filmmaker is his primary quest while on this earth. How he bets it all in every movie and always against all odds.

To see his work in this all-access book, and to be able to browse through his youthful notebooks and precise renderings, is to foster an even deeper bond with him. He mapped his journey with robots and xenomorphs and majestic machines like fantastical coordinates on a map yet to exist. He is worthy of that word bandied about so often and earned so rarely: a visionary.

Here be dragons, James Cameron. *May your journey—already long and auspicious—continue to reveal unseen worlds for all of us who live for Cinema.*

TOP James Cameron works on a piece of concept art for the Roger Corman–produced sci-fi horror *Galaxy of Terror* (1981). Visual effects artist Robert Skotak can be seen on the right.

OPPOSITE James Cameron creates an elaborate matte painting for John Carpenter's classic dystopian sci-fi film *Escape from New York* (1981).

Guillermo del Toro
Santa Monica, California, 2021

Dreaming With Your Eyes Wide Open

In the early '90s, after co-founding the visual effects house Digital Domain, James Cameron coined a phrase that perfectly encapsulated his new company's mission: "Dreaming with your eyes wide open"—a state where a visual effect is so compelling that the viewer feels they must be experiencing a waking dream.

At this point in his career, Cameron had frequently pushed filmmaking technology beyond its known limits—whether it was the innovative use of miniatures and animatronics in The Terminator *(1984) and* Aliens *(1986), or the pioneering, Oscar-winning digital effects created for* The Abyss *(1989) and* Terminator 2: Judgment Day *(1991). After further breaking new ground with the computer-generated wonders seen in* True Lies *(1994) and* Titanic *(1997), Cameron would find the ultimate expression of his axiom in* Avatar *(2009), a film with an alien environment so immersive that the viewer could almost taste and touch it.*

Dreams have always been an important part of Cameron's creative journey. Long before he was in a position to push film technology to a point where it could fulfill his expansive visions, the young James Cameron used paper, pencils, and paints to bring his own reveries to life. Born in Kapuskasing, Ontario, on August 16, 1954, Cameron began drawing at an early age, his output soon revealing considerable aptitude and a thriving imagination. Reaching his teenage years in the late 1960s, a heady period that encompassed the excitement of the space race, the tensions of the Cold War, and the progressive spirit of the civil rights movement, Cameron was drawn to the science fiction of the time and its exploration of these prescient themes. An exceptional student and voracious reader, Cameron consumed Arthur C. Clarke novels, Marvel Comics, and science textbooks in equal measure, developing a creative perspective that was at once fantastical and expansive and yet grounded in empirical reality.

Filling his school notepads with evocative sketches of aliens, spaceships, and extraterrestrial vistas alongside immaculately rendered illustrations created to accompany his science projects, Cameron was already building a rich creative world long before he took his first steps toward becoming a filmmaker.

I drew this piece in 1972, my first year of college. The image came to me in a dream: a landscape that was glowing with some kind of lava-type substance and this godlike being that seemed to be able to survive in that sort of environment. I woke up, grabbed my oil pastels, and drew it really quickly. I probably had to stop painting it at some point and go to class, which would explain why it's incomplete. I never went back and finished it, but the important thing was to just to stamp the dream down on paper.

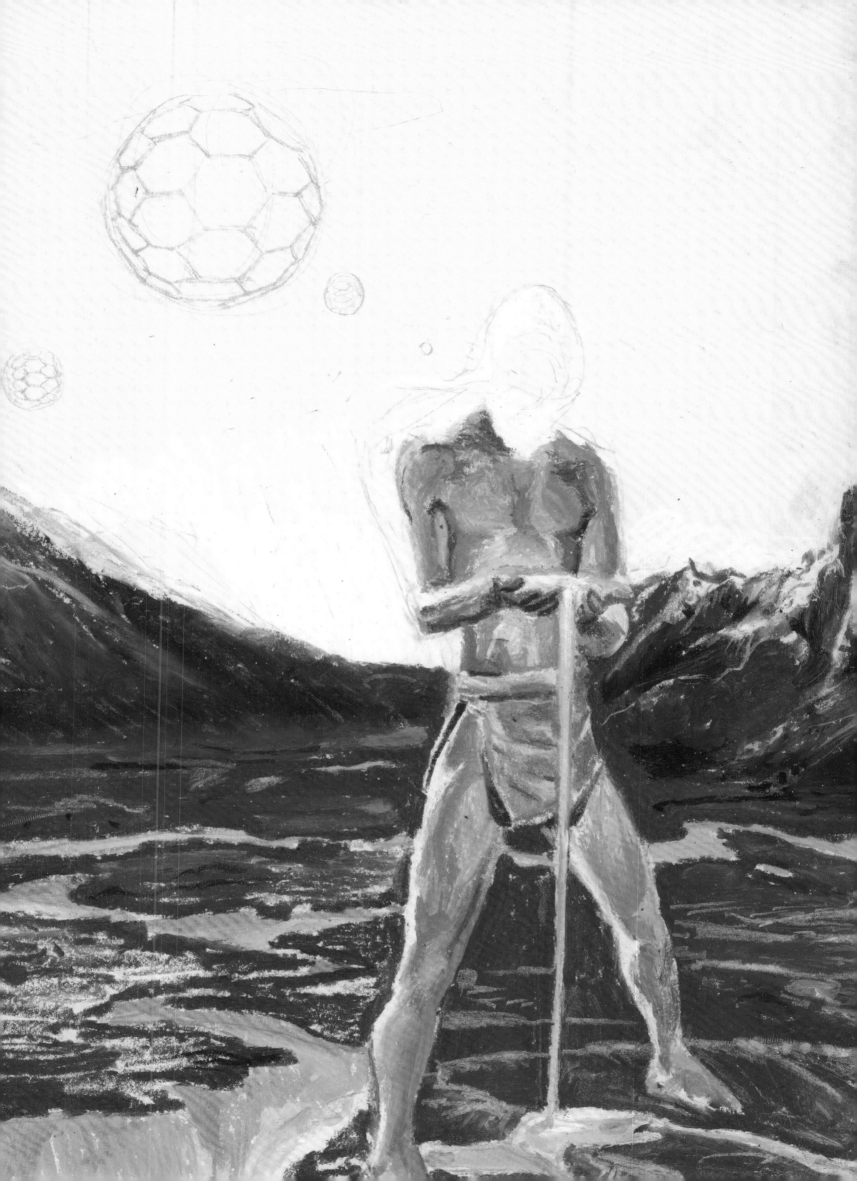

After his family moved to Brea in Orange County, California, in 1971, Cameron met fellow movie/sci-fi enthusiast Randall Frakes while studying physics, philosophy, astronomy, and English at Fullerton Junior College—he would later drop out and work variously as a precision tool and die machinist, a bus mechanic, a truck driver, and a school janitor. Cameron and Frakes embarked on developing a series of movie projects, including an epic science fiction feature film they titled Xenogenesis. A veritable soup of ideas that Cameron would later draw on when developing the screenplays to some of his biggest films, Xenogenesis was never produced but gave the budding filmmaker a dry run at designing an entire film from scratch. Illustrating creatures, spaceships, environments, and tech for the project, Cameron entered a new era in his career—going forward, he would no longer draw for fun. He would illustrate as a means to achieve his filmmaking goals.

Whether working as a production designer for B movie producer Roger Corman or illustrating movie posters for low-budget direct-to-video companies, Cameron began using his artistic skills to stay afloat while he plotted his directorial career. For his debut feature, The Terminator, Cameron would create not only all the film's concept art but also the promotional posters that helped sell the movie to distributors. When writing what would become his next film, Aliens, Cameron illustrated the film's key designs, including the now iconic Alien Queen and Power Loader. What had once been a fanciful pursuit and an outlet for Cameron's burgeoning imagination had become a set of core skills that were the foundation of his filmmaking process—a means of ideation that he could use to communicate to a studio or a film crew exactly what he was thinking and what he wanted to see in the final film.

I painted the image on pages 14–15 somewhere around the seventh grade using oil pastels. My dad was an avid builder of World War I and World War II model planes, so through him, I'd come to know my aircraft. My art teacher at the time had turned me on to oil pastels and I loved them. Before that, I was just painting in poster paints. So even though the style is pretty crude, this was a big step forward for me.

Following Aliens, *Cameron would largely step back from creating concept art for his films—helming increasingly ambitious productions and overseeing teams of world-class concept artists, he would rarely feel the need to personally design each element himself. Regardless, by the time Cameron had become one of cinema's most successful and influential filmmakers, he had amassed an enormous range of art, from childhood sketches to professional theatrical posters and working drawings created for the benefit of special effects crews.*

When Cameron first opened up his archive for this book, he was concerned that there wouldn't be enough material. "People who are artists for a living, they generate a body of work, and it's like plate after plate of amazing paintings. I knew I didn't have that," he says. But when we began the work of sifting through pages from his high school notepads, paintings from college art classes, and even notepads filled with doodles created during long phone calls, it soon became apparent that the work was hugely significant. The art represents Cameron's long path to becoming a creative force in the film industry, the images foreshadowing key themes that would become mainstays of his work, from his fascination with the melding of man and machine to his fear that humankind will be obliterated in a mushroom cloud of its own making. "These themes still appear in my work, because, funnily enough, they're all still relevant," he says. "Environmental themes. Anti-war themes. The comments on human nature and human behavior. It's as relevant now as it was then."

While still deep in postproduction on the Avatar *sequels, Cameron sat down to reflect on the selected art in this book and discuss how these early ideas developed over time into some of the most memorable moments in cinema history.*

This was an oil pastel sketch I did in 1968, when I was fourteen. There was a bank company called Lincoln Trust and Savings in Niagara Falls that would have a Halloween art contest each year. They'd invite kids to paint Halloween scenes on their big window, and each entrant would get a one-yard square to work with and paint their pictures straight on there. There was a cash prize—maybe one hundred bucks or something like that—and I won it three years in a row.

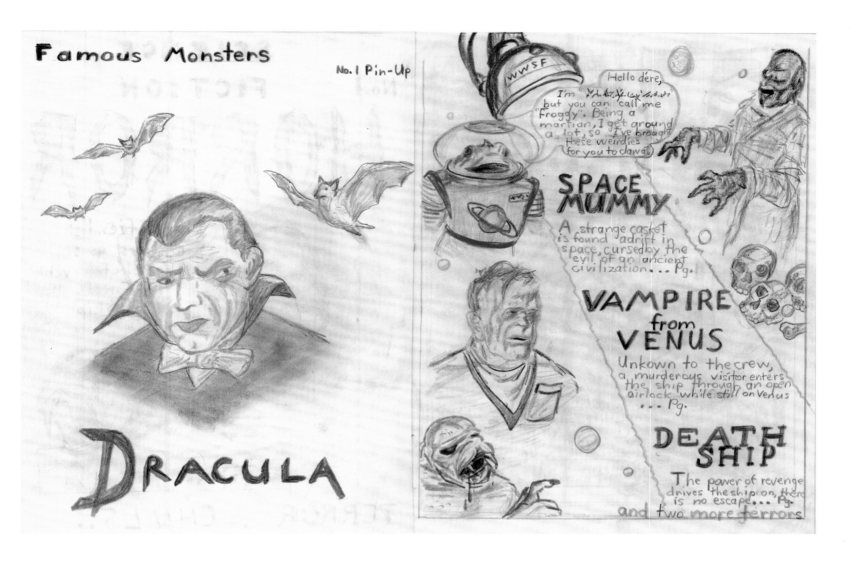

BEWARE THE SPACE MUMMY

At the time I drew this sci-fi/horror comic, I was very influenced by '50s and '60s B horror films. This was around the eighth grade when I was living in the village of Chippawa, which is now part of greater Niagara Falls. Every month I'd get *Famous Monsters of Filmland*, the legendary magazine published by Forrest J. Ackerman. I used to live and die by that thing. It was filled with photos from all these amazing monster movies, and I'd feed all that stuff back into my art. Just in these pages you can see the influences: Bela Lugosi's *Dracula*, my own version of the *Creature from the Black Lagoon*, and even Boris Karloff's *The Mummy* reimagined as a space mummy.

I was obviously very impressed by vampire lore. At this point I think I had seen the Italian film *Planet of the Vampires* (1965). It's kind of a piece of crap but became influential because it inspired Dan O'Bannon to write the screenplay for *Alien* (1979). It has a very similar story—a crew lands on this murky planet where they find an abandoned spaceship. They check it out, get infected, and start turning into vampires. Then at the end of the movie, the good guys have to stop the vampire infection from getting back to Earth. It was very lurid and made a big impression on me. Also, I just loved anything to do with space. Plus I was voraciously consuming comic books at the time and that's why these stories have word balloons—I'm emulating comics in my own crude form.

The *Space Mummy* story is about a spaceship crew that finds a sarcophagus floating through space. And, of course, there's a mummy-like creature inside the sarcophagus that gets out and then they're trapped on board with the monster. The idea was very influenced by the 1958 sci-fi horror movie *It! The Terror from Beyond Space*, which also was something O'Bannon drew on, so it's the earliest precursor in the DNA strand for *Alien*. *The Fatted Calves* is about a group of guys who land their spaceship on a planet where they find an advanced civilization. But it turns out the civilization wants to eat them. That idea basically came from the *Twilight Zone* episode "To Serve Man," which has a very similar situation. So these stories represent a conflation of influence, particularly in regard to sci-fi, horror, and comics.

> At this point I think I had seen the Italian film *Planet of the Vampires* (1965). It's kind of a piece of crap but became influential because it inspired Dan O'Bannon to write the screenplay for *Alien* (1979).

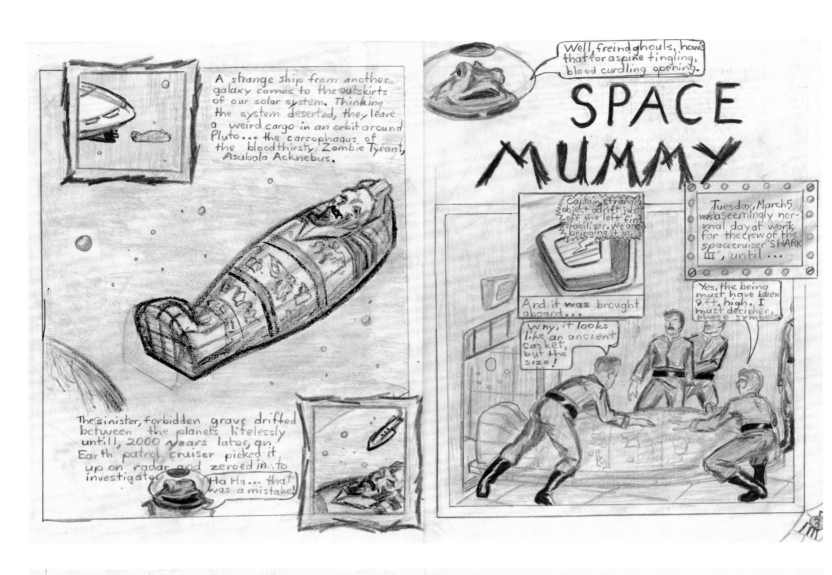

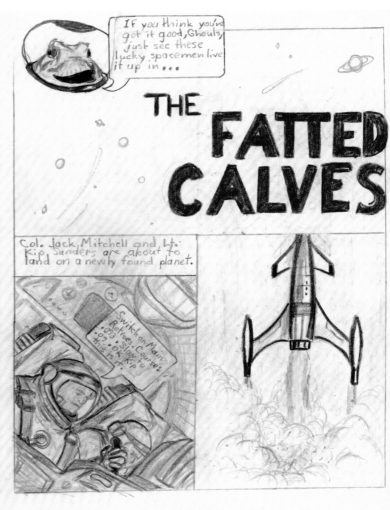

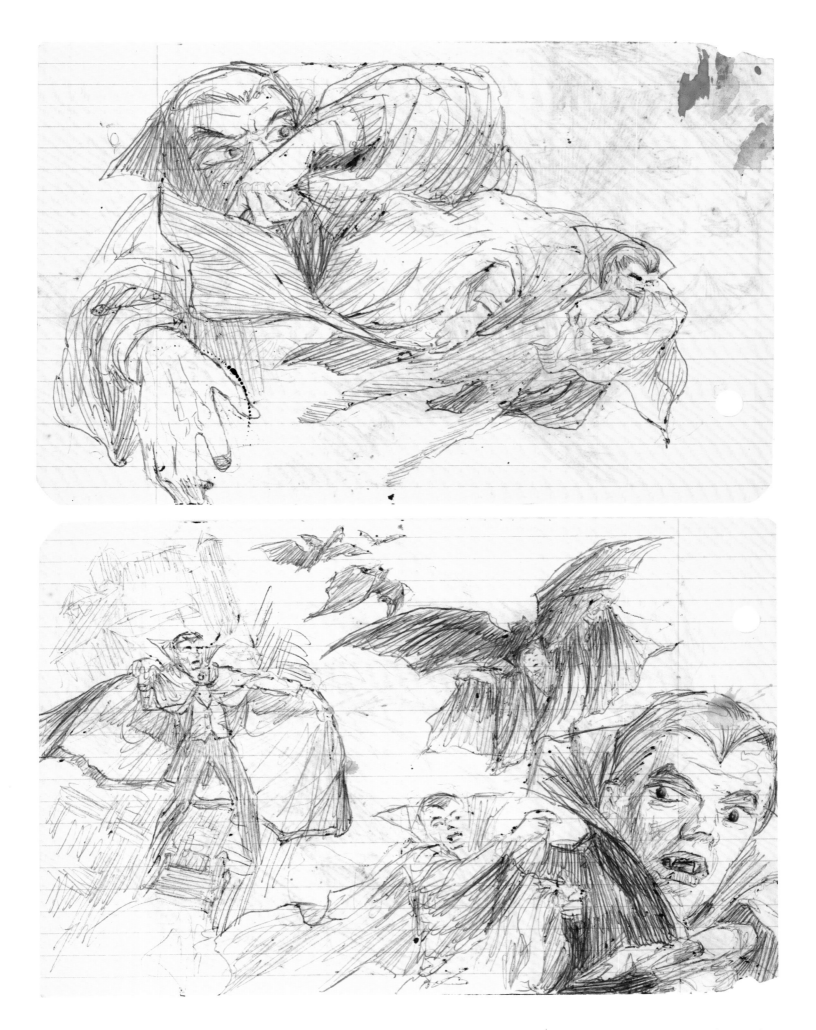

I'm working on my pen technique here, and riffing on classic Dracula themes. Is he literally a big bat that transforms into a caped man? Or does he fly around in his cape without transforming (top image), and people just report seeing a big bat? They always fudged it in those old movies, so how was a ten-year-old kid supposed to know?

FLIGHTS OF FANTASY

Fantasy was also a big influence on me at the time. I did the drawing on the right when I was about twelve and in junior high. It's my own version of the Cyclops/Dragon fight from *The 7th Voyage of Sinbad* (1958), which famously featured effects created by stop-motion animation legend Ray Harryhausen. Those effects were cutting edge at the time, and nobody noticed how jerky and stop motion-y it was. I showed *The 7th Voyage of Sinbad* to my kids when they were around nine and eleven. Afterwards I said, "Hey, how about that Cyclops/Dragon fight? Amazing, right?" And my eleven-year-old, Calvin, just rolled their eyes and said, "Dad, that was the worst CG I've ever seen!" I said, "Let me explain how this all worked back then . . ."

When I was in the tenth grade, I was a big fan of the Robert E. Howard Conan the Barbarian novels and would draw my own swords and sorcery characters. I don't think there were any *Conan* comics at that time—at least I hadn't seen them—but what we did have were Frank Frazetta's covers for Howard's novels. Frazetta was a pretty famous illustrator in the late '60s, and I think probably still one of the best of that era. He had his own style that centered on extremely voluptuous women and extremely muscular men—and this was back when bodybuilding was still not widely accepted as a sport and seen as kind of freakish.

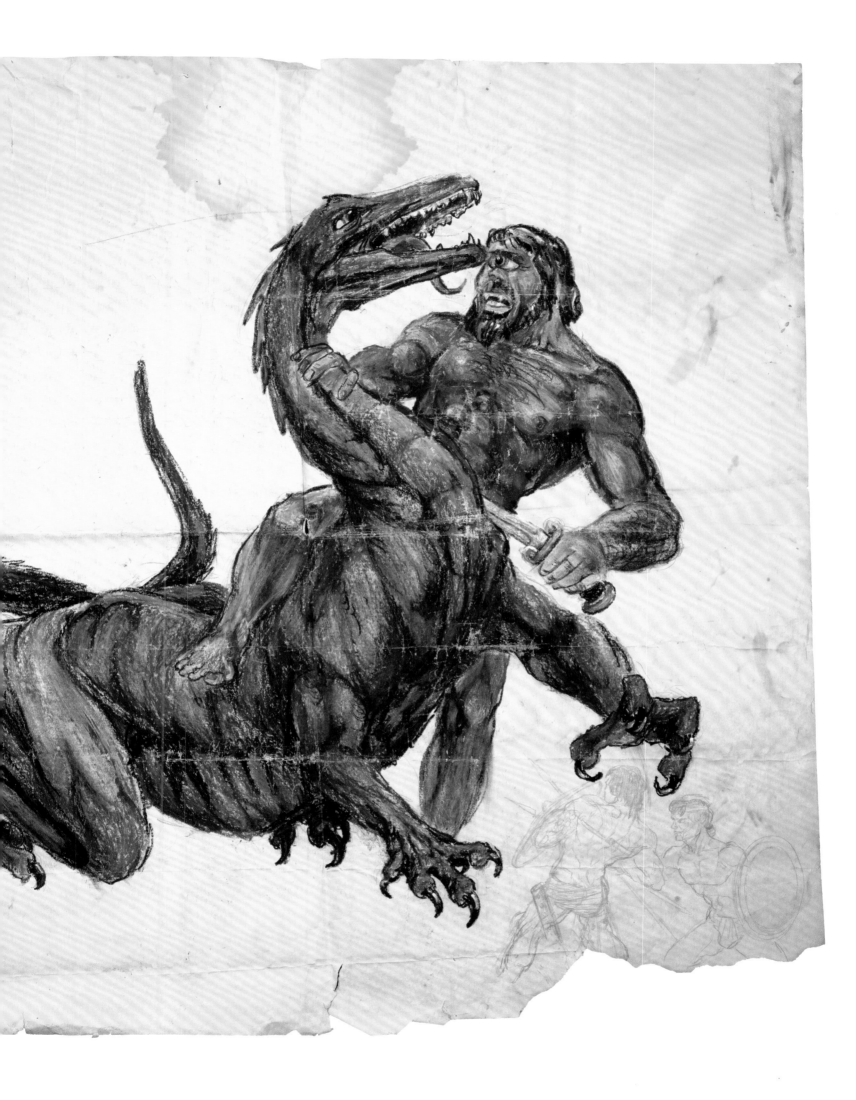

CONAN

BATTLING the forces of Munthassem Khan in the army of Yildiz of Turan, Conan pauses on a hilltop as a terrifying host appears over the sunset-stained horizon

The phantom shapes descend on the shrieking horde of Yildiz's army.

In my illustrations, I would try to channel Frazetta with big gestural postures and sweeps of blood coming off the battle-axes. His work was full of Aryan supremacy–type imagery: The bad guys in Frazetta's work were always darker, squatter, Neanderthal savage guys, and then there was the big heroic Aryan figure at the center just slaughtering everyone else. When Arnold Schwarzenegger got cast as *Conan* it made total sense to all the fans who grew up on Frazetta's art. These days, that kind of negative racial dynamic would rightly be called out, but it was a different time back then.

I based the comic-style illustrations on the left-hand page on actual Conan stories. In this one, he went up against a group of phantoms that he couldn't beat—Conan could kill anything that lived but he couldn't fight the dead. Although they were swords and sorcery stories, Conan was never very good against the sorcery side of things. He was always fighting supernatural monsters he couldn't kill and so he had to run away and find a sorcerer to help him!

[Conan] was always fighting supernatural monsters he couldn't kill and so he had to run away and find a sorcerer to help him!

I'm mashing up three influences in my approach to human anatomy here. There was Frank Frazetta, who had a very distorted but very stylized technique. Then there was an artist named Burne Hogarth, who was best known for illustrating *Tarzan* comics but also created a series of well-known books on the art of drawing human anatomy. He was known for creating stylized poses, very muscular, and super detailed. And then my third influence is Marvel Comics. I was a straight-arrow Marvel fan, and I would never buy a DC Comics book. I wouldn't be caught dead with DC—I just thought they were the stupidest stories ever. Marvel had the iconoclastic characters that you could relate to, plus they had better art.

" I was a straight-arrow Marvel fan and I would never buy a DC Comics book. I wouldn't be caught dead with DC. "

WILL MAN PAY THE PRICE OF TECHNOLOGY
BY BECOMING A MACHINE?

The image on the left-hand page is from around 1969, when I was in tenth or eleventh grade. I made a bet with another kid that I could paint a human face in one minute and that's what I did. I got all my acrylic paints lined up, got ready, and another kid went "Go!" Everyone watched the clock as I painted, and I got it done and won the bet.

I was drawing some kind of techno-dystopia here—a typical theme for me. A hairless guy wearing a number—prisoner or citizen?—of a techno-fascist state. The eagle symbol on the futuristic building is right out of the Third Reich.

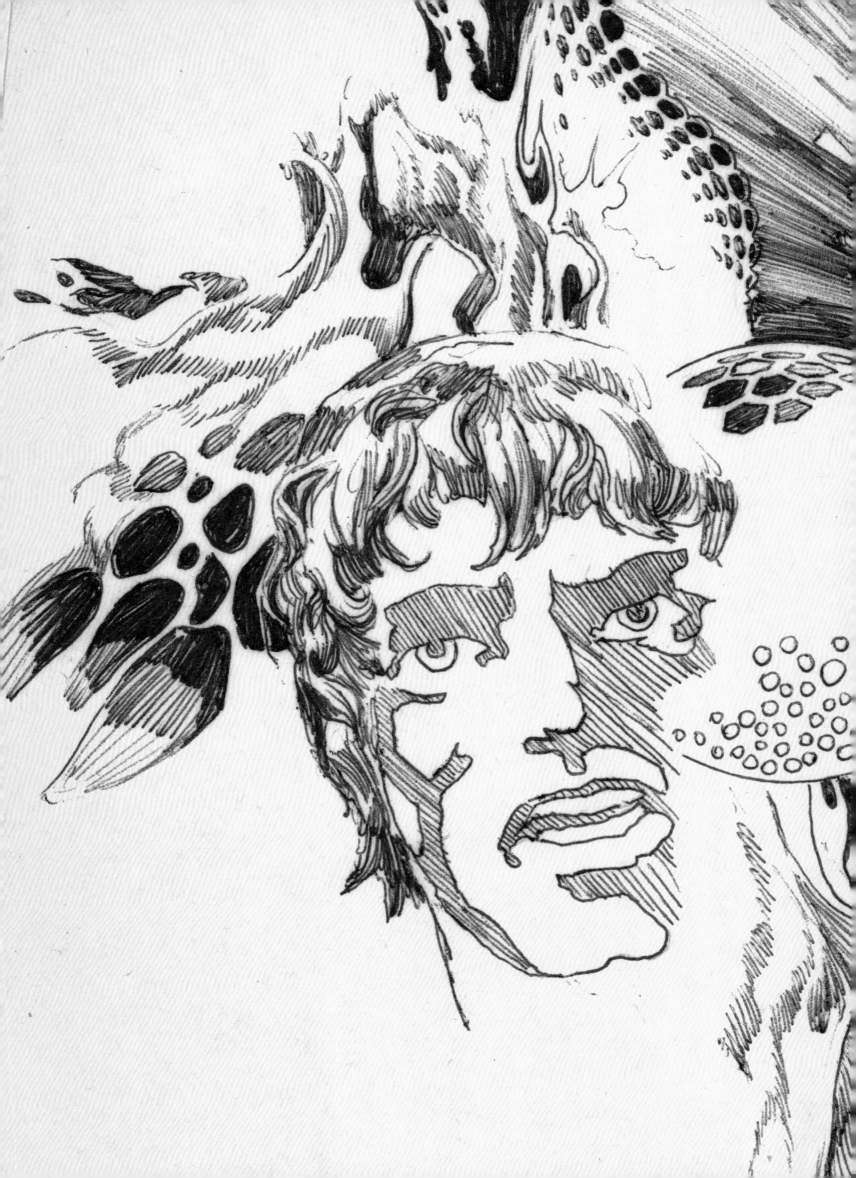

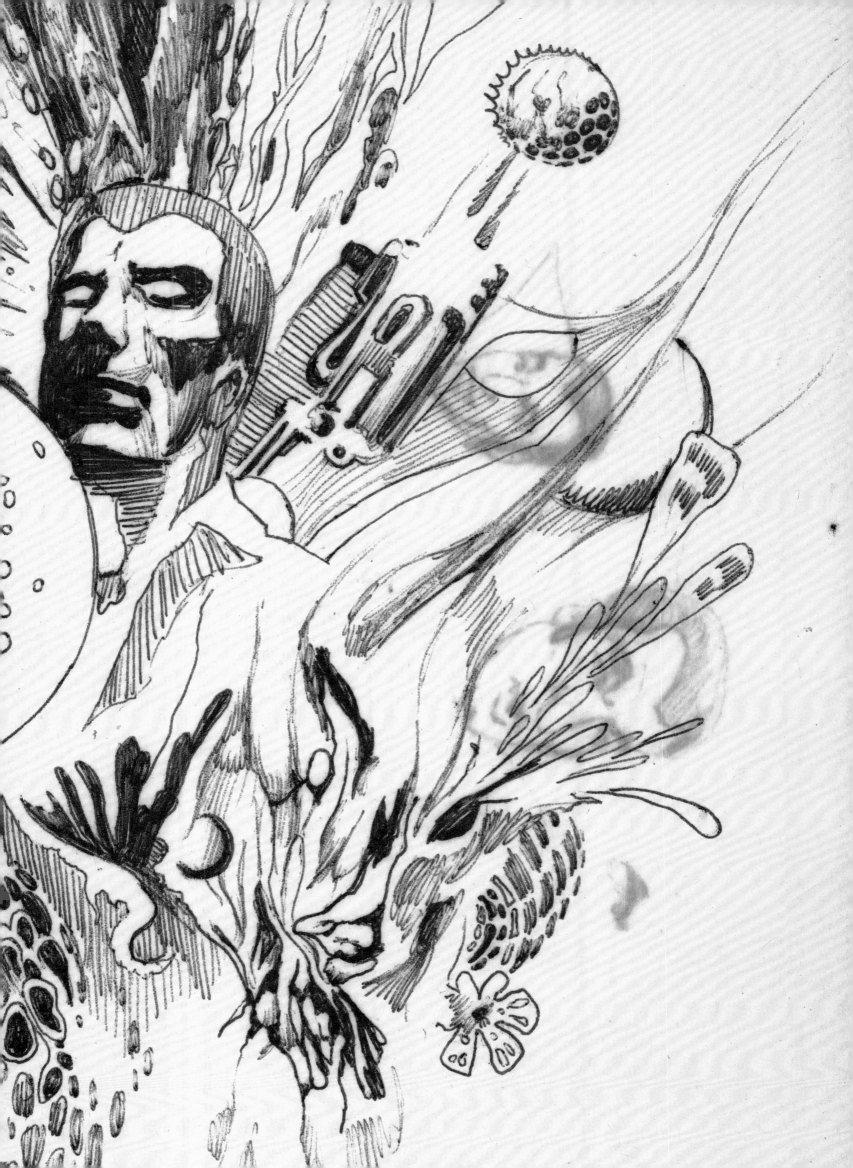

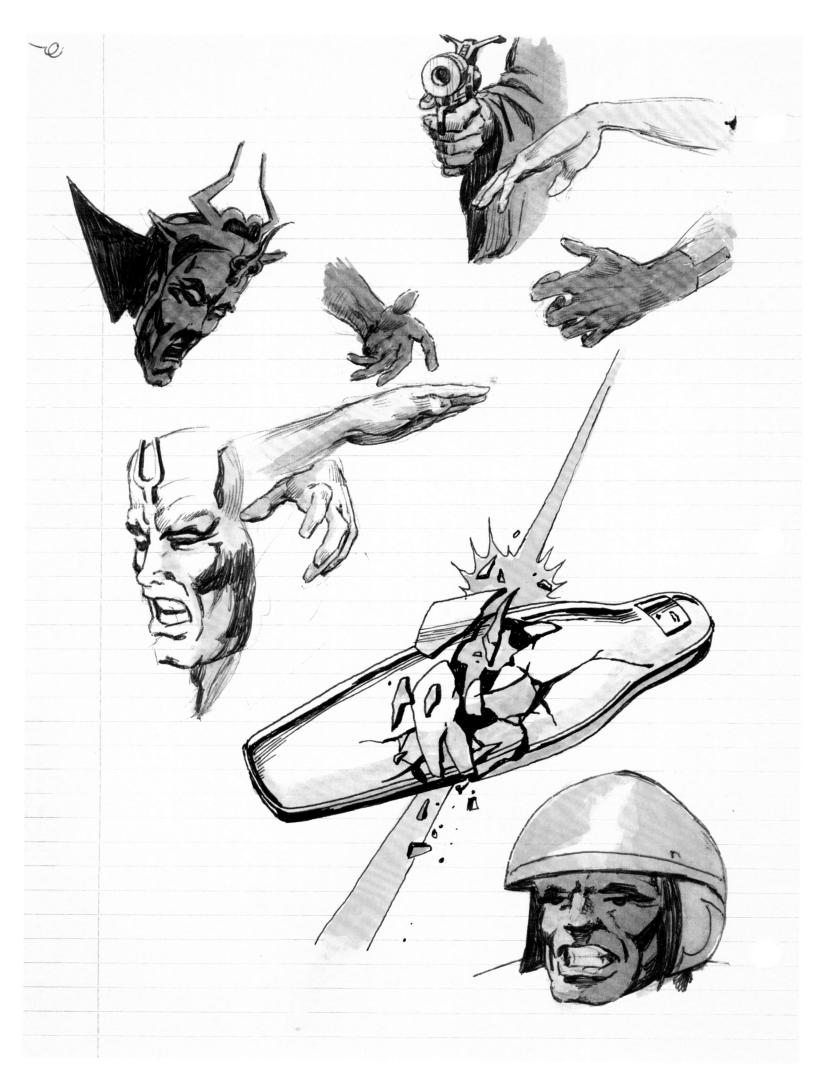

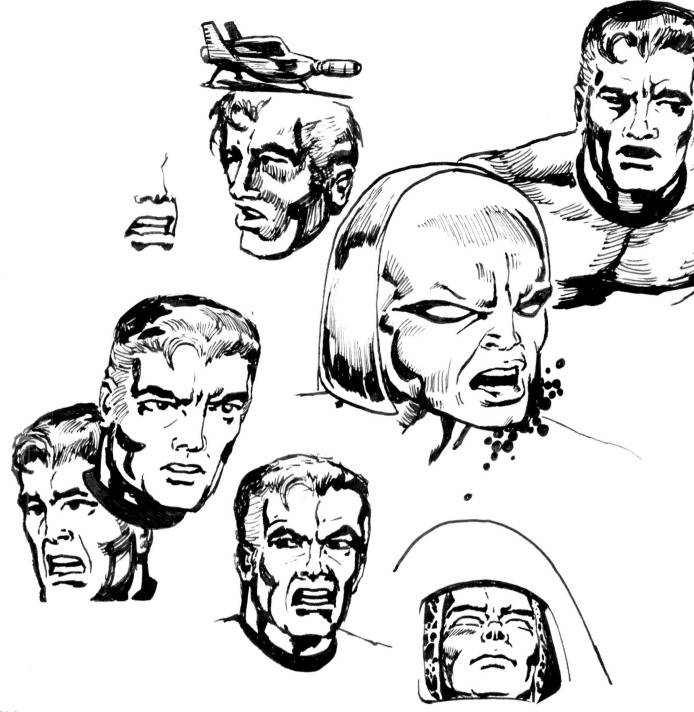

KING KIRBY

Comic books were always the drumbeat in the background of my early art. The image on pages 30–31 is from my last year in high school. You can see I'm very influenced by Jack Kirby and the other Marvel Comics artists of that time who were doing books like *Silver Surfer* and *The Fantastic Four*. *Dr. Strange* was also very big for me and this image is very much in that vein: representations of other dimensions, states of mind, and states of matter. I'm also playing with textures and shapes. The character on the far left of that image is from *Necropolis*, a novel I thought I was writing at the time, although I had no idea what writing a novel was all about. It was a post-nuclear story about interstellar explorers returning home in a fusion ramjet starship from a voyage to 61 Cygni, eleven light years away. They had been in suspended animation on a 100-year round trip and come home to find that Earth had been devastated, and some of the people had reverted into barbarism. There were some who lived underground, like H. G. Wells' Morlocks, but they were good guys. It was the people who lived on the surface who were the bad guys, a group I called the techno-barbarians. They were a cannibalistic cult that worshipped pre-apocalypse technology that they no longer understood. So they were basically at a level of spears and bows and arrows, but they were trying to call down the technogods to save them. It was very *Mad Max*, except I didn't give them cars—it was really more of a religious cult kind of thing.

I drew the above images in the eleventh grade when I was about fourteen. You can see that I'm clearly inspired by the Fantastic Four: There's a character who looks a lot like Reed Richards, plus a bad guy who looks like the Silver Surfer—I was learning to draw chrome at the time. I really went to school on the Marvel Universe and learned a lot about drawing figures. I would do a lot of hand studies, because in Marvel comics the characters' hands were often very prominent in the panels—like when Spider-Man is shooting webs out toward the reader, or Dr. Strange is casting a spell and making a dramatic gesture. Steve Ditko, who was well known for illustrating Spidey and Strange at the time, really drew every joint of the hand in these very detailed poses. So I was very conscious of hands, plus they were easy to do because I could just hold my own hand up and draw it. I'm left-handed, so my hand drawings would always be of my right hand.

The suspended animation pod in the color sketches on the left was influenced by director Stanley Kubrick's *2001: A Space Odyssey*. It's from a story that I was developing in which a spaceship explodes and the passengers, who are in suspended animation on board, get freeze-dried and scattered across the galaxy. A million years later, one of the passengers is picked up by an advanced alien civilization and they reconstitute him. He goes back to Earth with them, and everything he's ever known is gone. The idea didn't go much further than this sketch, but it's indicative of the kind of sci-fi stories I was thinking about at the time.

This is another Jack Kirby–influenced image. Kirby was a master at drawing elaborate, complicated machinery, and I was clearly influenced by that aspect of his work.

I drew this image of a Roman warrior when I was in eleventh grade. You can tell that my style and penmanship is improving. I took classical history, and it had such a huge impact on me: the Greeks, the Romans, and the Egyptians. I just thought all that stuff was amazing. It was like science fiction with these epic stories of huge battles and sprawling empires. So in this image I'm conflating the fantasy of Robert E. Howard stories with the real history of Earth's early civilizations, two things I loved at the time.

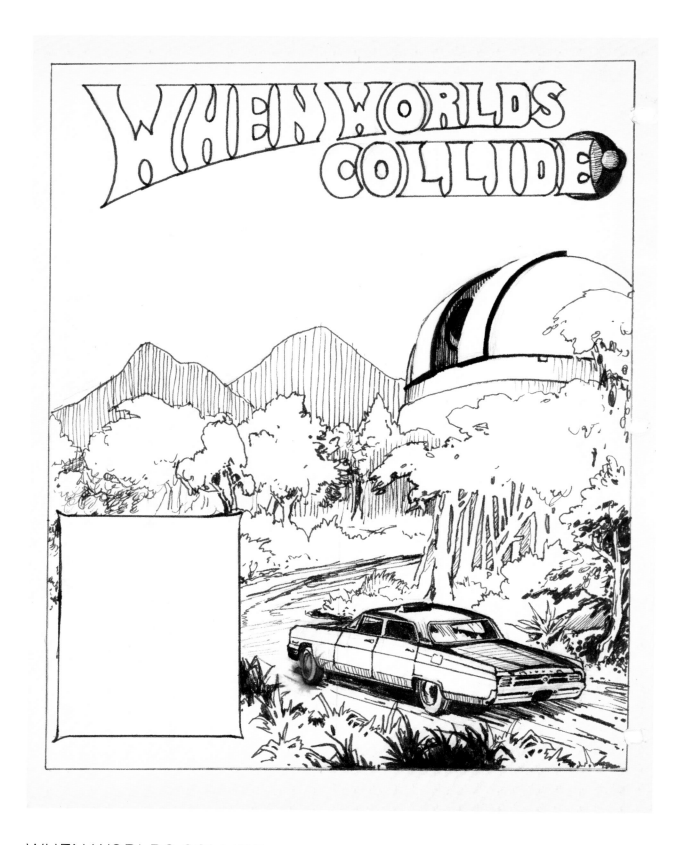

WHEN WORLDS COLLIDE

I was very influenced by the 1951 movie *When Worlds Collide*, which is about a group of scientists who discover the Earth is on a collision course with another planet and the star it orbits. I created this comic adaptation somewhere around the twelfth grade, but I never finished it—my finals were coming up and I ran out of time and talent. The panels showing the big tidal wave hitting New York look like they've been pulled straight from a Roland Emmerich movie, like *2012*. I was experiencing all that *2012*-style apocalyptic angst in the 1960s. Not only was I a sci-fi fan, I was living in the Cold War, when it seemed like the United States could get into a nuclear conflict with Russia at any time. I remember in particular that the Cuban Missile Crisis, which happened when I was around eight years old, left a big impression on me. At home, we had guides for building a basement fallout shelter sitting on our coffee table. My dad left them there—that was his way of sharing that formation with us kids. So these experiences definitely impacted me and found their way into the art I was creating.

THE AIR BECOMES HOT, SULPHUROUS AND DEADLY WITH VOLCANIC GAS...

VIOLENT TREMORS ROCK THE HENDRON CAMP. BUILDINGS COLLAPSE AS THE ARMY OF SCIENTISTS AND TECHNICIANS EVACUATE TO THE AIRFIELD.

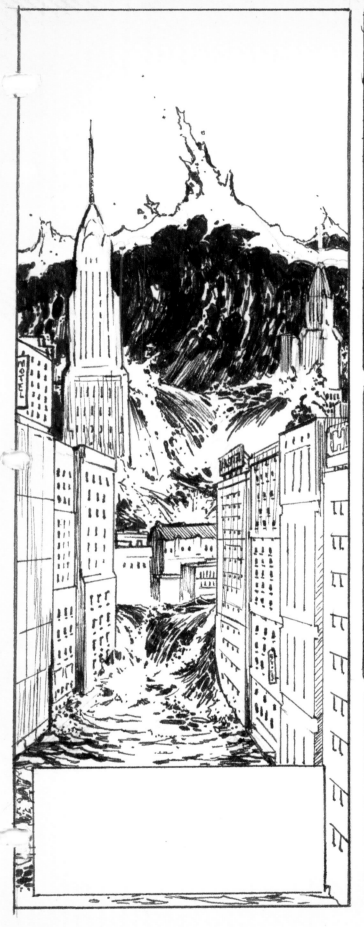

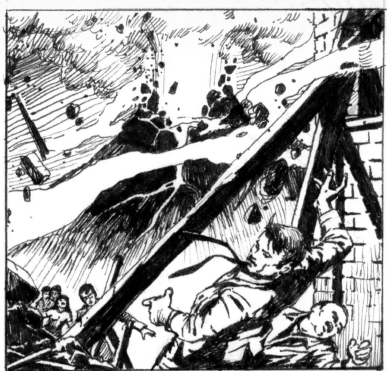

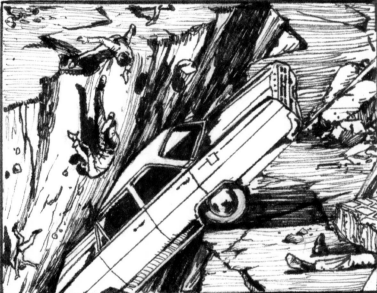

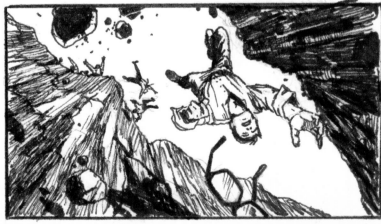

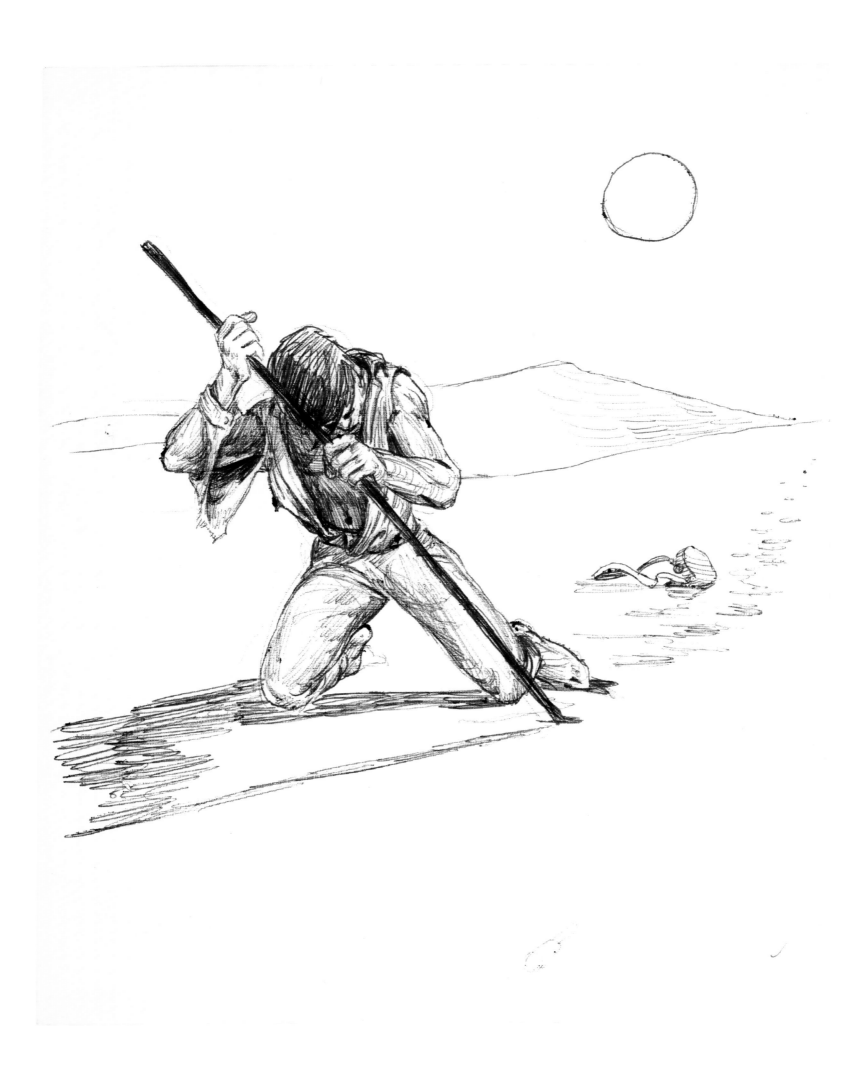

The image on the left is a drawing from high school, a narrative vignette. Looking back at my old work, I notice how I try to tell stories in single images. In this one, the guy is out of water, and he's dropped his canteen. He's gotten to the point where he can't go any farther and he's probably going to die. You look at it and fill in the blanks yourself. I never could never have been a fine artist because I always wanted to tell stories with pictures. It's been over a hundred years since we told stories with pictures in fine art. And it's not that I don't appreciate abstract art and modern art—I love the impressionists and

the way they saw light, but generally speaking, they were just painting scenes. And that's fine, but I see in my early work that I was yearning to tell stories. And I wasn't doing it in five different drawings—I was trying to do it in a single image that creates a moment. I think that's a really invaluable skill for filmmakers because sometimes you have to jump time quickly in a movie and tell part of the narrative in a montage. Often you need to communicate that part of the story in a single image, so drawing these kinds of images gave me a good grounding in that kind of visual storytelling.

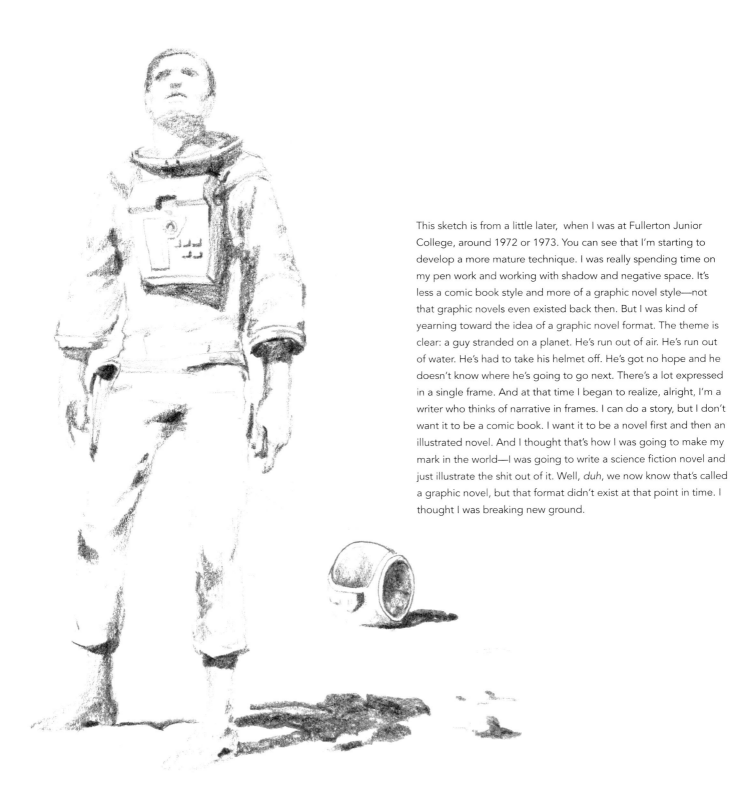

This sketch is from a little later, when I was at Fullerton Junior College, around 1972 or 1973. You can see that I'm starting to develop a more mature technique. I was really spending time on my pen work and working with shadow and negative space. It's less a comic book style and more of a graphic novel style—not that graphic novels even existed back then. But I was kind of yearning toward the idea of a graphic novel format. The theme is clear: a guy stranded on a planet. He's run out of air. He's run out of water. He's had to take his helmet off. He's got no hope and he doesn't know where he's going to go next. There's a lot expressed in a single frame. And at that time I began to realize, alright, I'm a writer who thinks of narrative in frames. I can do a story, but I don't want it to be a comic book. I want it to be a novel first and then an illustrated novel. And I thought that's how I was going to make my mark in the world—I was going to write a science fiction novel and just illustrate the shit out of it. Well, *duh*, we now know that's called a graphic novel, but that format didn't exist at that point in time. I thought I was breaking new ground.

THE IMPACT OF SCIENCE AND TECHNOLOGY ON LIFE IN THE LAST CENTURY

$E = mc^2$

HARD SCIENCE

The illustration above was probably drawn for a paper during my first year of college. When I turned in my work, I would often draw a picture on the cover, just to influence the teacher to give me an A. By that time, science had become a big influence on me, as you can see from the cover of my ninth grade science notebook on the right-hand page. During high school, I was more into pop culture, although I did read a fair bit of science, too. But when I was in college, I was buying *Scientific American* off the stand and was more focused on real-world science. When I hit my mid-teens, I lost interest in fantasy. I drew a line between witches and warlocks, elves, trolls, and goblins, and all that stuff, and rejected it. I was much more interested in plausible, real-world scenarios: science fiction versus fantasy. There was definitely an evolution during that period. But I would have loved *Lord of the Rings* if I had known about it. For some reason it didn't cross my radar until I got to college. And by my first year in college, when I was seventeen, I had already drawn a line in the sand: I was a hard sci-fi guy. That fantasy stuff was for chicks! I soon found out, though, that to get the attention of the interesting girls you had to know a little about *Lord of the Rings*. So I read the CliffsNotes!

The image on the right is the cover of my science notebook from the eleventh grade. The above illustration was for a poster that I created in high school. Pop culture posters were big at the time so my buddy Mike Nestler and I thought we could make some money by printing our own and selling them to the kids at school. I think I had just seen George Lucas's *THX 1138* (1971) by this time and I was also influenced by a lot of other dystopian sci-fi, including George Orwell's *1984* and Aldous Huxley's *Brave New World*. I was very taken by this idea that the technological, civilized world was going to completely supplant the natural world and just bulldoze it into nonexistence. The figure in the poster is clearly a *THX*-type guy—a functionary of the techno-state—out to destroy a rose because they consider it to be a weed—pretty obvious thematic stuff. We printed up about five hundred of these posters and sold maybe four or five because we completely didn't understand the market. Kids in 1971 wanted bright popping colors. They wanted psychedelia. They wanted Frank Zappa and the Rolling Stones. They wanted stuff that was thematic, but not abstractly, intellectually thematic at that level. We thought we were just too cool for school, and we lost a bunch of money. I wound up with about 490 of these useless posters that I just flipped over and used as sketch paper for years afterward.

THE PROSPECT OF CHEMICAL
MIND CONTROL

JIM CAMERON, IIA

MOMENT

... carve out a moment, and ponder the world which lives between two ticks of the clock.

J. Cameron

There's a clear Salvador Dali influence on the image on the left-hand page, which was drawn around 1969 when I was in high school. Many of my illustrations from this time are on lined paper because I would sketch them in my class notebooks so the teachers wouldn't catch me. I was supposed to be learning, but to me, school was just six or eight hours of drawing practice. I mean, why limit it to art class?

The above image is from my first year of college. The 1970s hairstyle with the big sideburns gives it away. At the time, I liked to conflate a lot of abstract, metaphysical things that I was playing with in a surreal way. I was studying philosophy in that first year of college and this drawing was influenced by Socrates's cave metaphor and the idea that we don't perceive the world directly, we perceive it through our senses. In the metaphor, our senses are subject to flaws, so we erroneously perceive shadows on a cave wall to be real things, and it's only through philosophical thinking that we can break free of that perception.

> I wanted the heroine, Sarah Connor, to be this working-class gal who would never suspect she was destined to play an important role in the future. I just said to myself, 'That's Sharon.'

SARAH CONOR?

This is my first wife, Sharon, and the gesture she's making with her right hand tells you everything you need to know about her. I drew this in 1973. She sat and posed on our couch, which was so torn up that we just draped an American flag over it to hide how bad it looked. She was taking time out of her busy day as a waitress at a Bob's Big Boy restaurant. I used to go and hang out at Bob's Big Boy and listen to her interacting with customers. She was such a smart-ass. Some guy would grab her arm and go, "Miss, miss! Can I get a bottle of ketchup?" And she would say, "Do you mean in addition to the one that's already on your table?" And then she would just breeze on. So later, when I was writing *The Terminator*, I wanted the heroine, Sarah Connor, to be this working-class gal who would never suspect she was destined to play an important role in the future. I just said to myself, "That's Sharon."

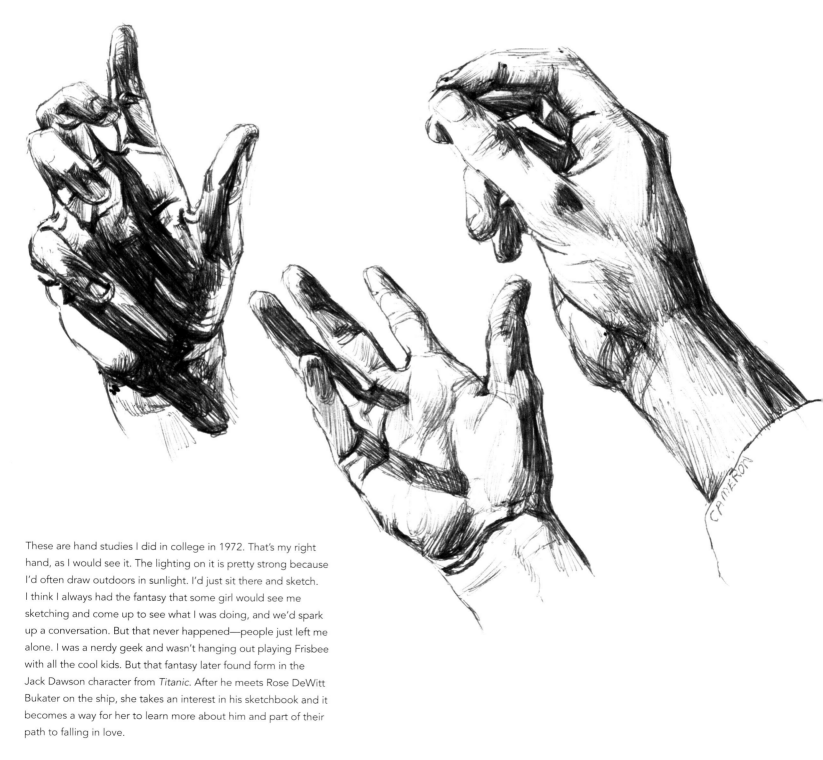

These are hand studies I did in college in 1972. That's my right hand, as I would see it. The lighting on it is pretty strong because I'd often draw outdoors in sunlight. I'd just sit there and sketch. I think I always had the fantasy that some girl would see me sketching and come up to see what I was doing, and we'd spark up a conversation. But that never happened—people just left me alone. I was a nerdy geek and wasn't hanging out playing Frisbee with all the cool kids. But that fantasy later found form in the Jack Dawson character from *Titanic*. After he meets Rose DeWitt Bukater on the ship, she takes an interest in his sketchbook and it becomes a way for her to learn more about him and part of their path to falling in love.

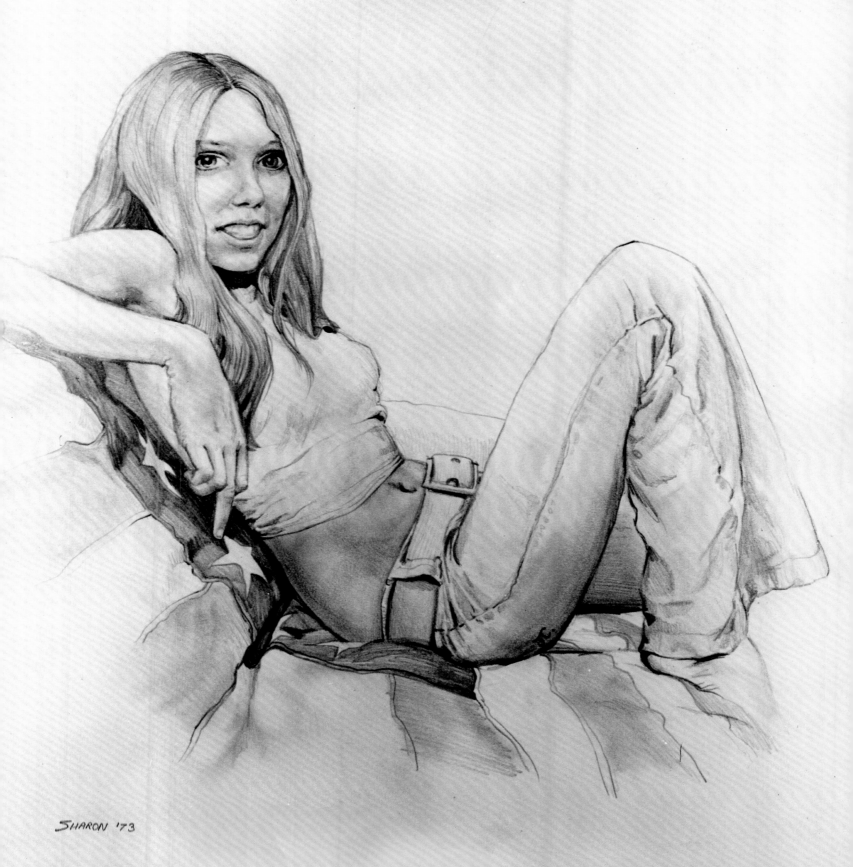

SHARON '73

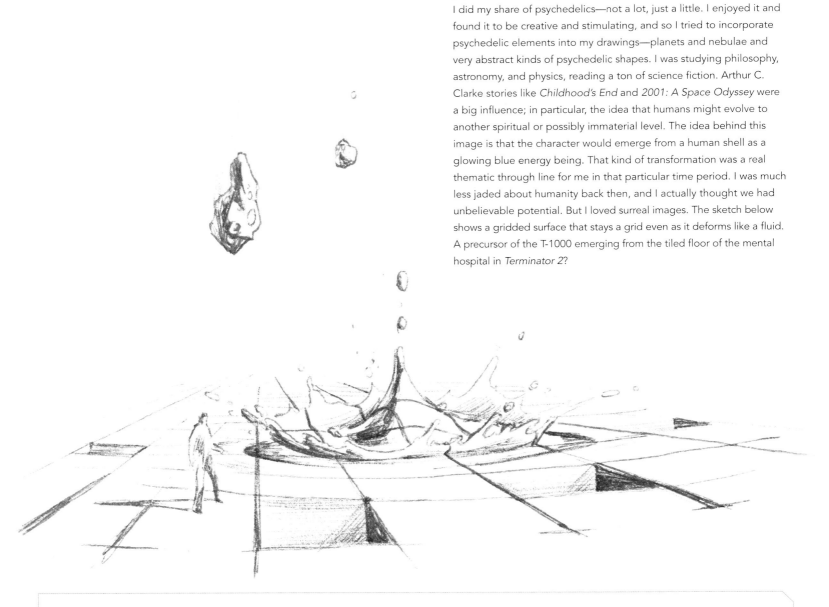

On the right is a pencil study of a male figure I drew in 1971, when I was in my senior year of high school. It has a kind of galactic, cosmic, psychedelic setting which was very much of the zeitgeist at the time. I did my share of psychedelics—not a lot, just a little. I enjoyed it and found it to be creative and stimulating, and so I tried to incorporate psychedelic elements into my drawings—planets and nebulae and very abstract kinds of psychedelic shapes. I was studying philosophy, astronomy, and physics, reading a ton of science fiction. Arthur C. Clarke stories like *Childhood's End* and *2001: A Space Odyssey* were a big influence; in particular, the idea that humans might evolve to another spiritual or possibly immaterial level. The idea behind this image is that the character would emerge from a human shell as a glowing blue energy being. That kind of transformation was a real thematic through line for me in that particular time period. I was much less jaded about humanity back then, and I actually thought we had unbelievable potential. But I loved surreal images. The sketch below shows a gridded surface that stays a grid even as it deforms like a fluid. A precursor of the T-1000 emerging from the tiled floor of the mental hospital in *Terminator 2*?

The image on pages 50–51 is another one from the early '70s, perhaps 1971 or 1972. Again, I'm playing with surreal and psychedelic images. At the top there's a bunch of protoplasm or cellular life, and the figures at the bottom represent some infinite regression kind of concept. I was strongly influenced by Dali, René Magritte, and other surrealists. They just smashed stuff together and their ethos was, "It's a dream image. You can't rationalize it. You can't even explain it. If it pops into your head, just paint it. Don't try to interpret it—leave that to other people." I liked the idea that a painting is no more meaningful to the artist than to the person looking at it cold, and I kind of took that to heart. It felt freeing. Just look at Magritte's *The Son of Man*, the guy wearing a bowler hat with an apple over his face. It's meaningless. Or is it?

So I said to myself, "I'm not gonna mediate." I knew when I was expressing a theme and when my art was just pure surrealism, and I would toggle between those modes. When I was working on something thematic, conceptual, or philosophical, I was just trying to process the world around me. Having read a lot of science fiction, I'd come to believe that humanity was probably doomed to some apocalyptic end of its own creation. So one of the frequent themes in my art was our relationship to technology and how it was bad for the natural world and us. And these kinds of ideas were all coming from that '70s zeitgeist and a greater awareness of our impact on the environment—in particular, the 1969 oil spill in Santa Barbara that led to the first Earth Day, which was established on April 22, 1970 and became a catalyst for environmental action going forward.

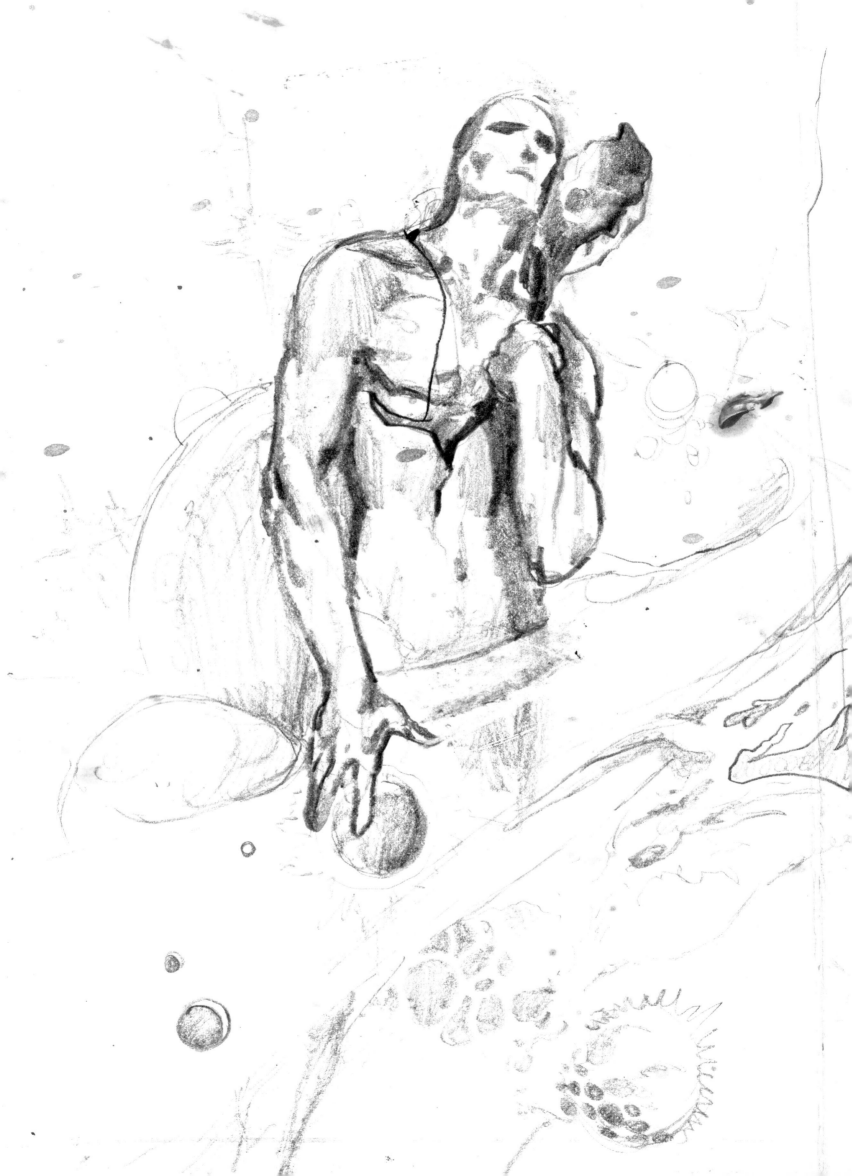

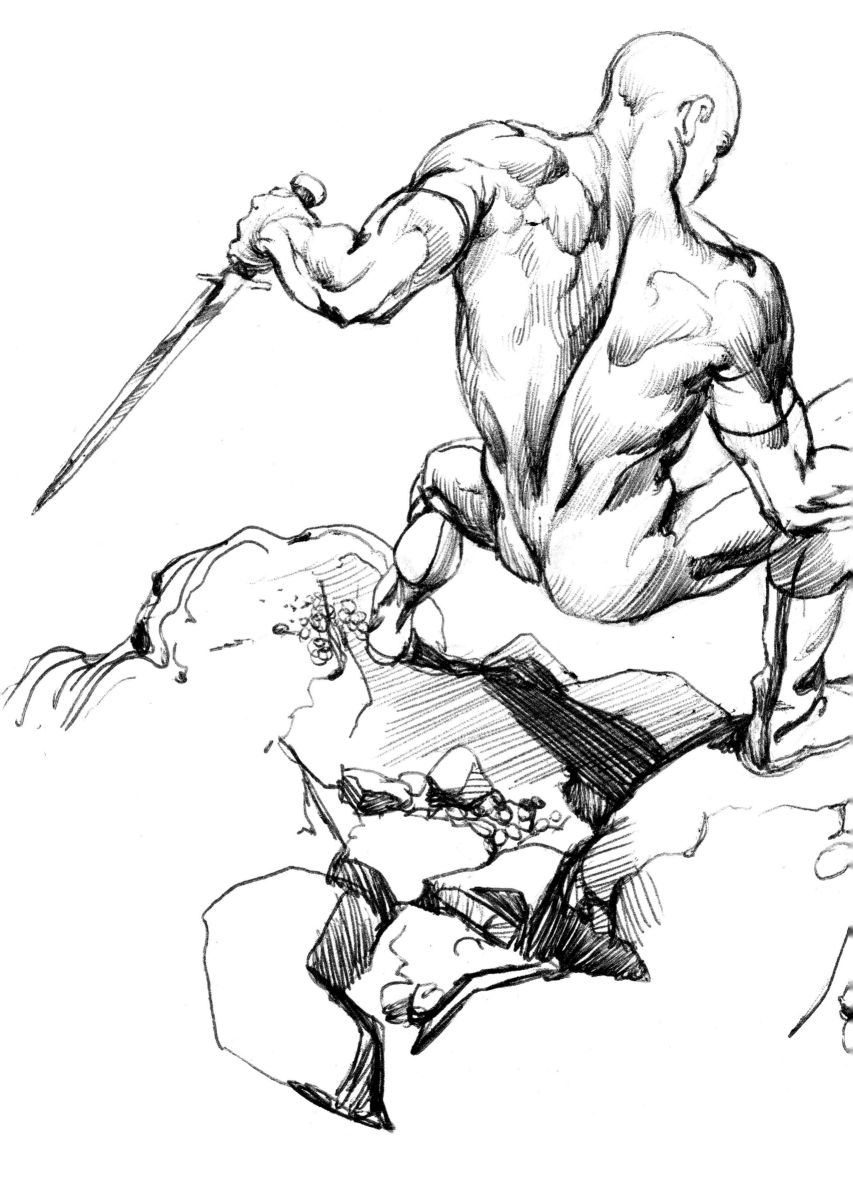

FROM ARTIST TO FILMMAKER

Just as I knew when I was being purely thematic, I was aware when I was doing generic narrative. The sketch on the left-hand page, which I did when I was around twenty or twenty-one, isn't attached to any story that I was intending to write and yet the image has a certain narrative power. You have a guy in the foreground holding a knife, and he's overlooking these other characters that are running down below. Looking at it, we create the narrative in our minds: Is he going to jump down there and rob them or kill them? Is he a bad guy? Is he a good guy? Are they the bad guys?

But, really, the main purpose of a piece like this was just to work the wrist and improve my skills. It's very Burne Hogarth–influenced, and you can see that in the hands and the muscles. You can also see the Marvel approach with an extreme wide angle and the distortion in the body and so on. I was playing with angles—getting off-level—and I think this is an important thing to do as a filmmaker. When composing shots we tend to think horizontally and forget to position the camera way up or way down and make the composition more interesting and unexpected. Now, bear in mind I wasn't thinking of being

a filmmaker at this point. I loved film, and I was thinking in frames and in narrative, but I wasn't actively thinking of pursuing it as a career. I had dabbled with it in high school and even made an environmental film about how Niagara Falls was a city out of control. It allowed me to express that theme of the rampant destruction of nature by civilization, but I never went anywhere with it. In my mind, I could never be a filmmaker. Other people did that. Great people. It didn't occur to me I could do it. Yet.

These days you can shoot a movie on a cell phone and the tools are absolutely ubiquitous and democratized. But this stuff was all out of reach when I was in college and the idea that you could actually make a movie yourself was insane. John Carpenter hadn't come along yet and shown that you could shoot a hit movie for $80,000. So I hadn't made that cognitive leap. But I was interested in filmmaking as a consumer of movies, and I studied visual effects, wanting to know how it was done. I had no concrete plans, but I thought maybe someday I could gravitate into that world if I improved my skill set.

After college I worked a lot of blue-collar jobs just to survive. At one point, I had a job driving a truck. I wanted to learn as much as I could about moviemaking and film production processes, but I didn't have any money for college courses. So I would drive down to the University of Southern California in L.A. and spend what money I had on xeroxing all the papers they had on filmmaking techniques—how optical printing worked, photometrics of different types of film stocks, how every known visual effect was done, and so on. Then I put together whole binders stuffed with this material that formed a "how to do visual effects" library. So the first time I got hired to work on an actual movie— Roger Corman's *Battle Beyond the Stars*, which I started on in October 1979—I knew more about visual effects than anyone else on the production, because I had attended my own free film school for a couple of years. I went through that place like crap through a goose. I was hired as a junior model builder, and within about four weeks I was running the art department. After that, I got my own model unit and shot about a third of the visual effects for the film. Not that anybody really ran anything on *Battle Beyond the Stars*—it was kind of self-organizing. It was just a bunch of twentysomethings doing what they thought was the right thing for the movie, with whatever five quarters Roger would kick loose for the day. But we got to do a lot of in-camera effects and work with miniatures and those kinds of techniques, so it became the next stage of my film education.

Looking at it, we create the narrative in our minds: Is he going to jump down there and rob them or kill them? Is he a bad guy? Is he a good guy? Are they the bad guys?

So notwithstanding what
I said about swords and
sorcery, I still would draw
the occasional sorcerer.

The images on these pages are generic pieces from somewhere around 1974 that are not related to any specific project. So notwithstanding what I said about swords and sorcery, I still would draw the occasional sorcerer. But I think these are more *Dr. Strange*–influenced than part of the fantasy genre. The ability to manipulate dimensions and that sort of thing was still interesting to me.

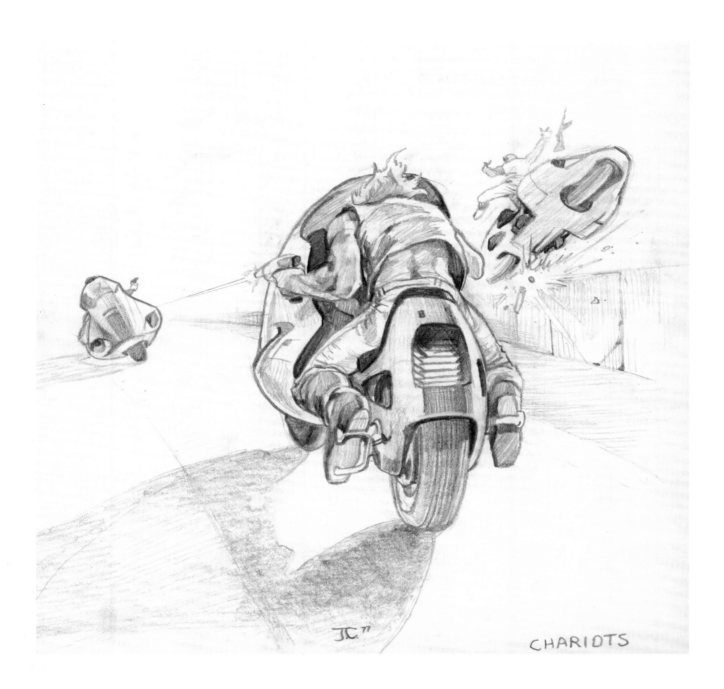

SCREAMING STEEL

At one point in the late '70s, when I was starting to get serious about designing elements for my own films, I decided to retool my old *Necropolis* idea. I'd started working with Randall Frakes on a bunch of potential films, including *Xenogenesis*. Randy had this project called *Chariots*, which was about motorcycle gangs in a post-collapse world. I did an illustration for it featuring gang members dueling on motorcycles and then somewhere after that it developed into another project called *Screaming Steel*, which I co-wrote with Randy. I took the techno-barbarians from my *Necropolis* novel and reworked them so they retained some futuristic technology but had still regressed sociologically. I also gave them flying motorcycles they would use to have bloody battles in the sky. It was set after a societal collapse that caused people to live in these walled-off, domed communities. And outside of these communities was the outland. It was a little bit of a *Mad Max*–style idea, but I didn't get exposed to those movies until 1982, when *Mad Max 2* was released in the US as *The Road Warrior*—to this day one of my favorite films.

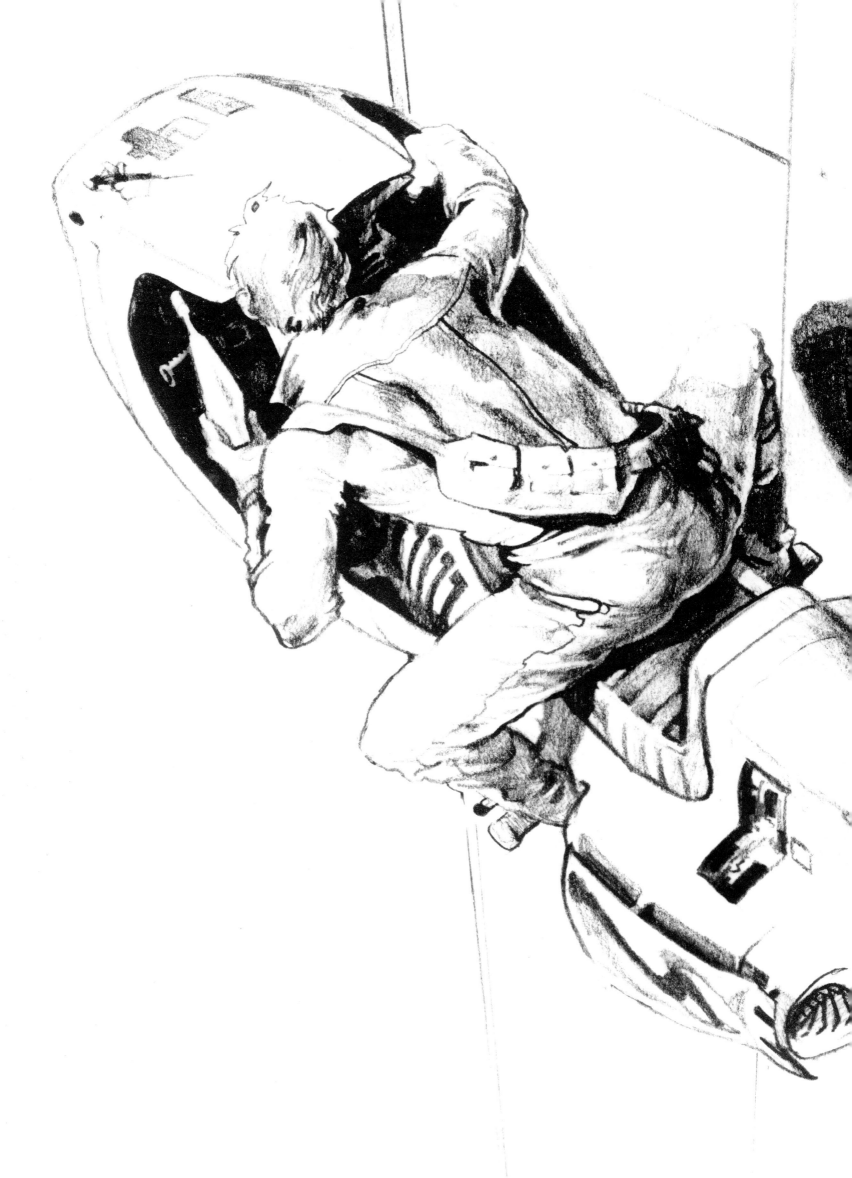

> *Screaming Steel* was actually an idea I hung onto well into my film career, and I think I wrote a draft of the story after *Aliens*.

The image on the left is from around the same period as *Screaming Steel* but it's not the same project, although it's a similar basic idea. *Screaming Steel* was actually an idea I hung onto well into my film career, and I think I wrote a draft of the story after *Aliens*. I think we even had a development deal for it, but it would have lapsed back to us at this point.

The sketch on the left is from *Screaming Steel*. I think this female character was named Reba. She's riding the more advanced version of the flying motorcycles I created. It's basically just a shark-shaped jet engine with vectored-thrust nozzles. You've got chrome. You've got violence. You've got hot chicks in leather with machine guns. What's not to love, right?

ROAD RAGE

Thematically, the image on the right is linked to *Screaming Steel*, but it's for a very different kind of project. There was a point in the early 1980s when I became a commercial artist, painting movie posters for a company called Saturn Releasing that produced straight-to-VHS movies. Saturn was situated in a little office, and next to that was a much bigger office for their main company, Caballero, which was one of the biggest porn houses of the VHS age.

The films Saturn released were terrible. I'd get five minutes into one of these piece-of-shit movies and go, "Life is too short"—even when I was unemployed and had nothing to do all day. So when Saturn assigned a movie poster to me, I'd just make up my own little narrative and paint something much more compelling than the film itself so that customers would order the movie. I'm sure when they watched the tape they'd go, "That scene's not even in the film!" But Saturn was thrilled with my work because it made their movies look so much better.

The sketch on the right-hand page is for an unknown movie

that I probably did for Saturn. At this point I had seen *The Road Warrior*, so the imagery is reminiscent of that movie: The guy is driving a souped-up muscle car, firing a machine gun; there's a hot chick firing backward, and a car flipping over in the background. When I saw *The Road Warrior,* I felt like someone had read my mind. At the time, I was a total gearhead and spent my spare time building fast, high–performance cars that handled really well. I was also a street racer. I used to go out at 3 a.m. on a rainy night and drift on the freeway, driving along sideways for half a minute at 80 mph. I went through a lot of tires, but I got to be a really good driver. I'd get into races where other cars flipped over and crashed while I spun out and survived. Then I'd go home and draw these highly adrenalized, kinetic scenarios. I was an adrenaline junkie, absolutely no question about it. And all this was feeding toward *The Terminator*, which is full of guns and car chases. And when I directed that movie, I knew how to talk to the stunt guys about the car chases because I'd done that stuff for real.

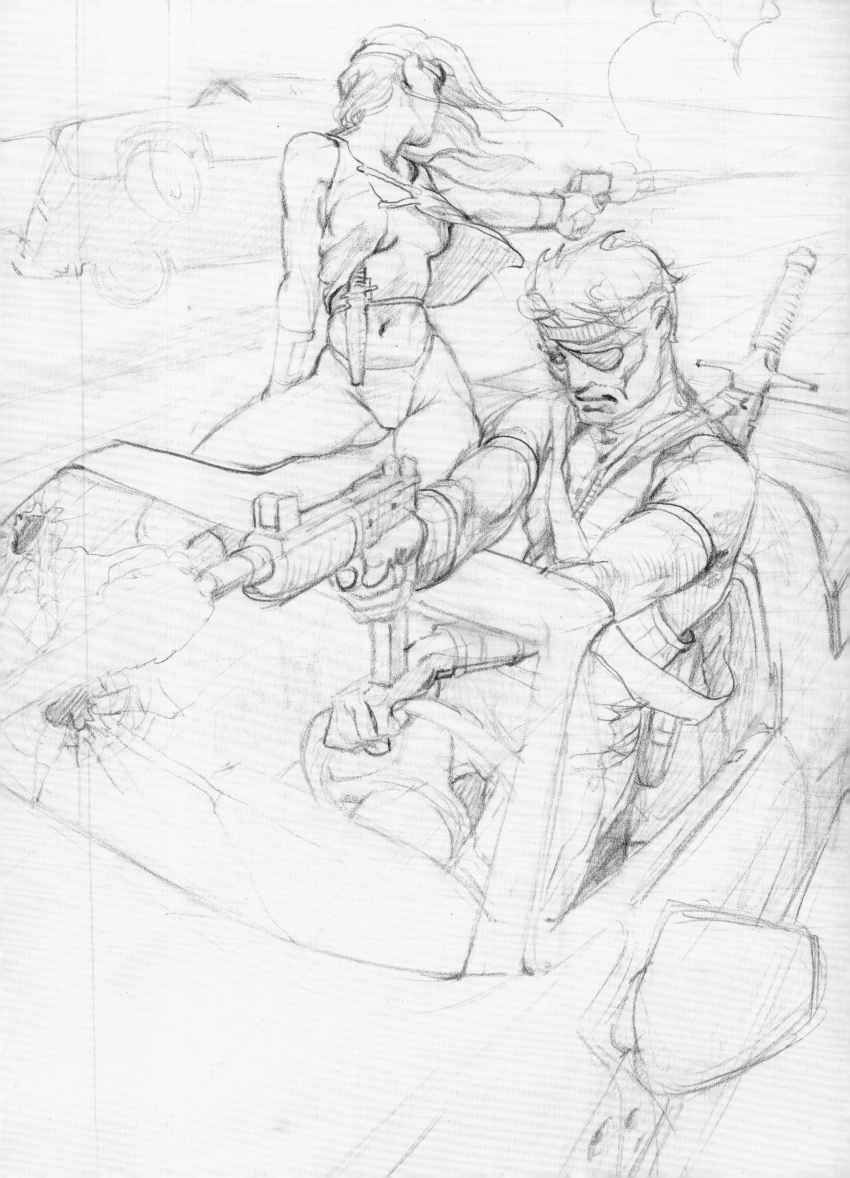

METAMORPHOSIS

The painting on the right-hand page was not apropos of any particular project, it was just a means of expressing a lot of themes that I had in mind at the time. It was done in the early 1980s, just before I got *The Terminator* off the ground. I was expressing an idea of female empowerment, and a kind of Jungian anima philosophical or spiritual idea—the yin and yang of the female and male sides of our psyches.

I'm conflating the idea of beautiful orchid flower shapes with female energy, which obviously is a Freudian thing a lot of artists have done, from Georgia O'Keeffe onward. There's a kind of female genitalia-like aspect to a lot of flowers and they represent the same spiritual/philosophical principle: the origin of life and that kind of goddess energy. So what I'm depicting here is a female spirit shedding the shell of her past life or the constraints of society—whatever you want it to be—and being reborn as a joyful new being.

These are themes that I played with a lot at the time: the idea of bursting from a chrysalis as a new version of the same creature—the butterfly, so to speak. But instead of actually giving

her butterfly wings, which to me would have been a little on the nose, the wings are expressed as flower shapes. As a kid, I was very impressed watching monarch butterflies mature and emerge from their chrysalises. I'd catch caterpillars, feed them milkweed leaves, and then watch them transform in great fascination. In the final twenty-four hours, the chrysalis turns transparent, like a glass shell with the butterfly wrapped up inside it, and then it bursts open longitudinally, and the butterfly emerges and spreads its wings. I was just amazed by nature in general, but I was specifically amazed by that transformation, and later, I used it metaphorically in my art.

At the time, I think I had some vague notion that I could improve my skill to the point that I could actually sell my art—once I had a body of art, that is. I knew that you don't just sell one painting; you create a whole portfolio, maybe get it shown at a gallery and enter the scene that way. But my plans were very unformed. The art was just stuff I *had* to do. I didn't know where I was going, and I didn't have a set purpose for it. It was just an image that was in my head, and I had to paint it. And it was always that way.

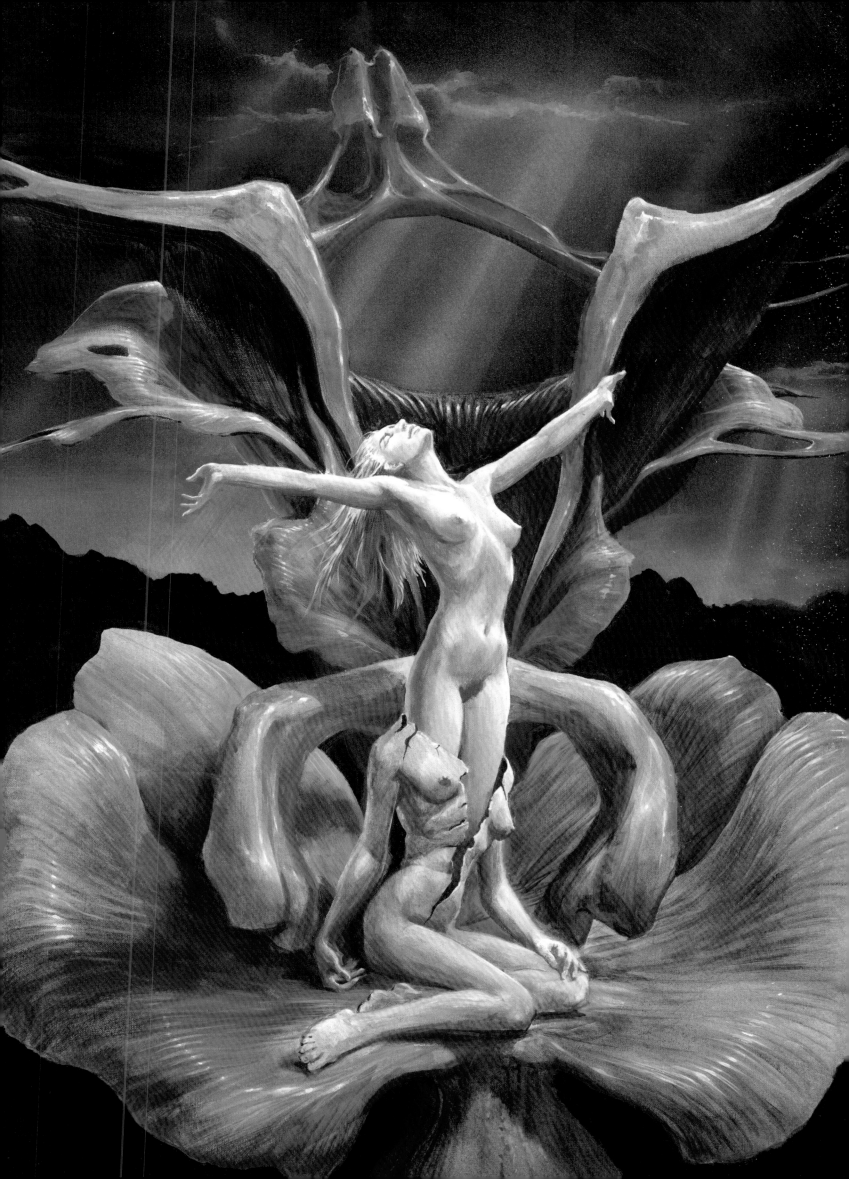

KILLER INSTINCT

This poster is for a Saturn film called *Killer Instinct*, some chop-socky fight flick I never bothered to watch. It was just a typical "guy out for revenge" movie. I started with a rough sketch on yellow notebook paper. Then I'd sketch it out on vellum a few times until I got a version I liked and discard the others. Next, I'd pencil in the backside and use it to transfer onto the final board, so I didn't end up with a lot of sketch lines in my negative areas. Then I would use a ballpoint pen to transfer the graphite off the backside of the vellum onto the black paper. When it was transferred onto the final poster board, I would then airbrush it and paint it.

By this point I was laser-focused on becoming a filmmaker and I was in a critical, formative period where I really needed to focus one hundred percent on that objective. Because I needed to put as much time into filmmaking as possible, I set myself a goal of doing each poster in forty-eight hours: I'd deliver it, get my check, and then be good for another month. I think my overhead for the month was about $1,500 and I'd make between $1,500 and $1,800 for one or two days of poster work—maybe a day sketching and then a day painting.

Before I got the Saturn job, I was living hand-to-mouth, and I really didn't like it because I wanted to focus on developing my story ideas—I didn't want to be distracted by all this other stuff. I was driving a car I'd borrowed from my dad. My mom would send me envelopes stuffed with coupons: two Big Macs for the price of one—which I always used, by the way. I remember at one point I called up my dad and I said, "Hey, I'm gonna make you a deal. I'm going to be a filmmaker and I'm going to make some money. But to get there I've got to get through these steps and I'm not going to have much income for the next year. If you pay my nut for a year, I'll sign a deal that you get five percent of my gross income for the rest of my life." And he goes, "Make it ten percent." I said, "No, go fuck yourself." *Click*. He got greedy. If he'd made that five percent deal he'd have been sitting pretty right about now.

But without my dad's support, I had to work. I had no problem getting a job—I'd worked plenty of jobs over the years—but I needed to focus on the art, the writing, and the prep to achieve a defined goal. And so that's how I ended up pimping out my own illustrating skill. And what I soon discovered was that because my art had a highly narrative look, it worked perfectly with movie posters.

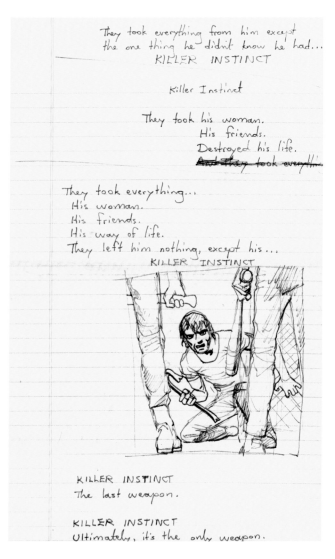

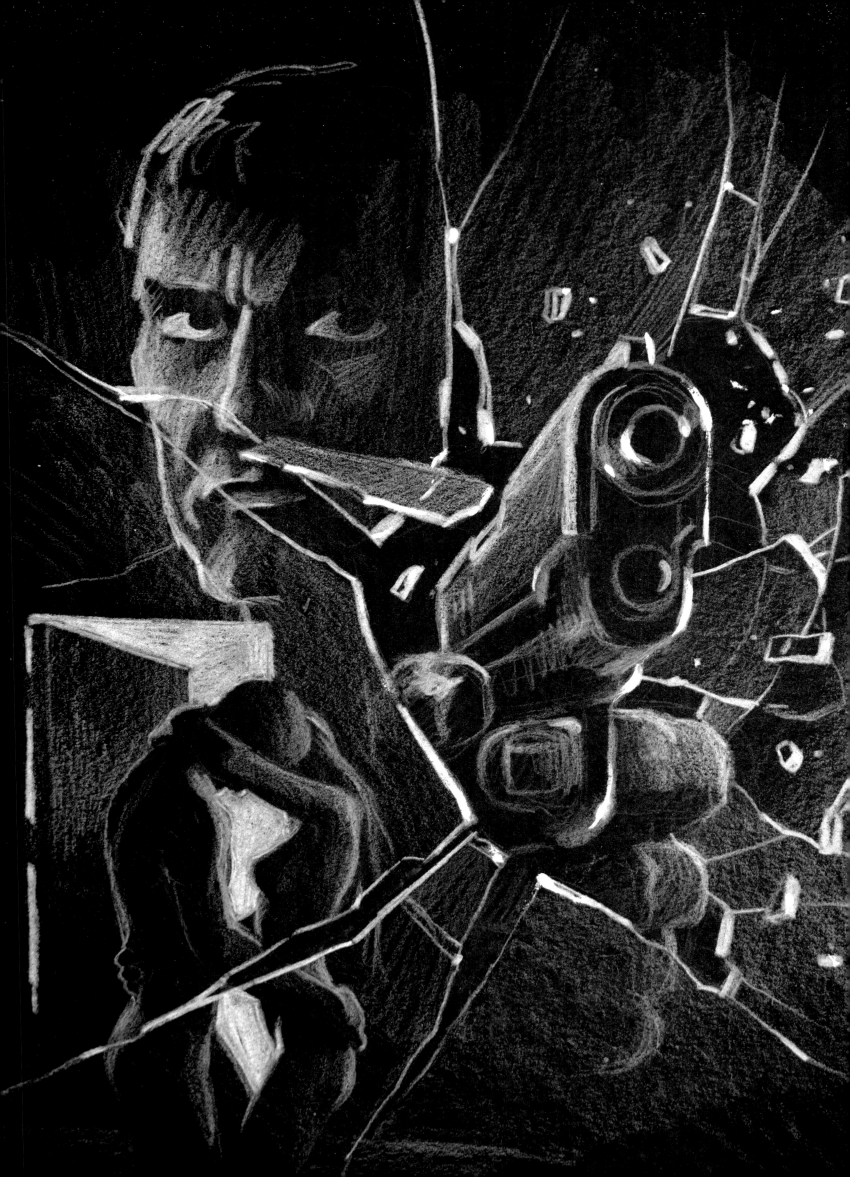

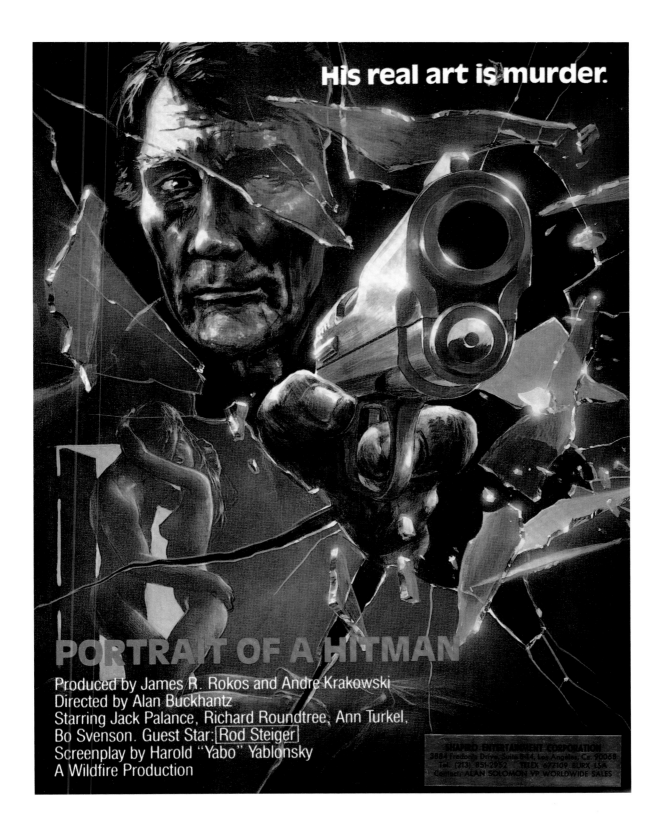

PORTRAIT OF A HITMAN

I did actually watch part of this Jack Palance movie, *Portrait of a Hitman*. As you can see, for the final image above, I tried to be fairly true to Palance. I started with the more generic study on the left-hand page and then got more specific for the final. You can see in the finished art that I didn't spend a lot of time trying to make it pretty. Unless it was a piece I personally liked, I wouldn't put too much time into it—two days and out. And I knew that a picture of Jack Palance shooting through a window was not exactly fine art. What's interesting, though, is that around this time, I was also planning *The Terminator*. And if you think about the poster imagery for that film, it's not far removed from this image of a .45 automatic being pushed at the camera. I don't think there's an image like that in *The Terminator*, but that didn't matter. The poster sold a shitload of *Terminator* videotapes. I remember when I went to England to direct *Aliens* in 1985, *Terminator* had come and gone from theaters and very few people had seen it. Initially the British crew on *Aliens* treated me like some asshole. They were horrible. They were so disrespectful to me and especially to my producer, Gale Anne Hurd, because it was a real boys' club over there. And then halfway through the *Aliens* shoot, *Terminator* dropped on VHS and everything changed. They were like, "Oh fuck, this guy really knows what he's doing!" They'd be like, "Morning, governor!" I'd be like, "Oh, where was *that* for the last two months?"

Through my exposure to these covers, I realized that when I was drawing posters, I could create a highly evocative narrative image that's so powerful it draws people in—it didn't have to relate to the content of the movies, it just needed to sell them.

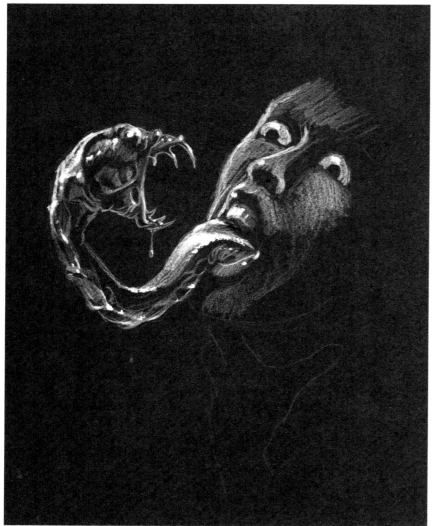

These are poster images for Saturn horror movies. Back in the '60s there were two magazines that I loved: *Eerie* and *Creepy*, both from a company called Warren Publishing. I used to stay with my grandparents in the summer and work on their farm. I'd always pester them to drive to the nearest town, Orangeville in Ontario, so I could pick up the latest issues from the newsstand. The two magazines were horror comics collections, and both always had these spectacular cover paintings—true works of art. The covers didn't have anything to do with what was inside the magazine, but by the time you realized that, it didn't matter, because the stories and interior art were good. Through my exposure to these covers, I realized that when I was drawing posters, I could create a highly evocative narrative image that's so powerful it draws people in—it didn't have to relate to the content of the movies, it just needed to sell them. And the guys at Saturn were just fine with this philosophy, which made the job fun and gave me the leeway to experiment.

The images on the left were most certainly inspired by *Alien*. I was very influenced by that movie and this image clearly recalls the mouth-within-a-mouth design of the xenomorph. But I'm turning the concept back in on itself, so the mouth is extending out and coming back to threaten the character. Is this an image from a nightmare? Or is this in fact some kind of alien parasite? Who knows, right? But the image is enough to make you want to find out more.

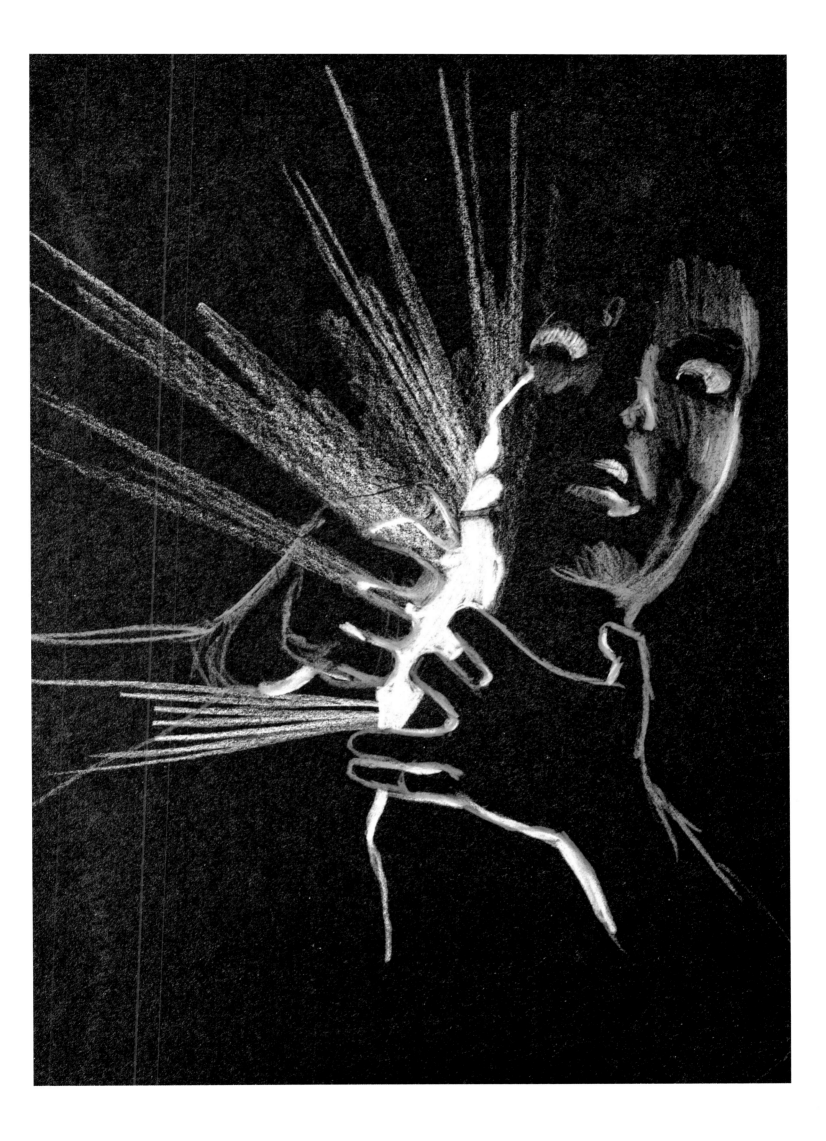

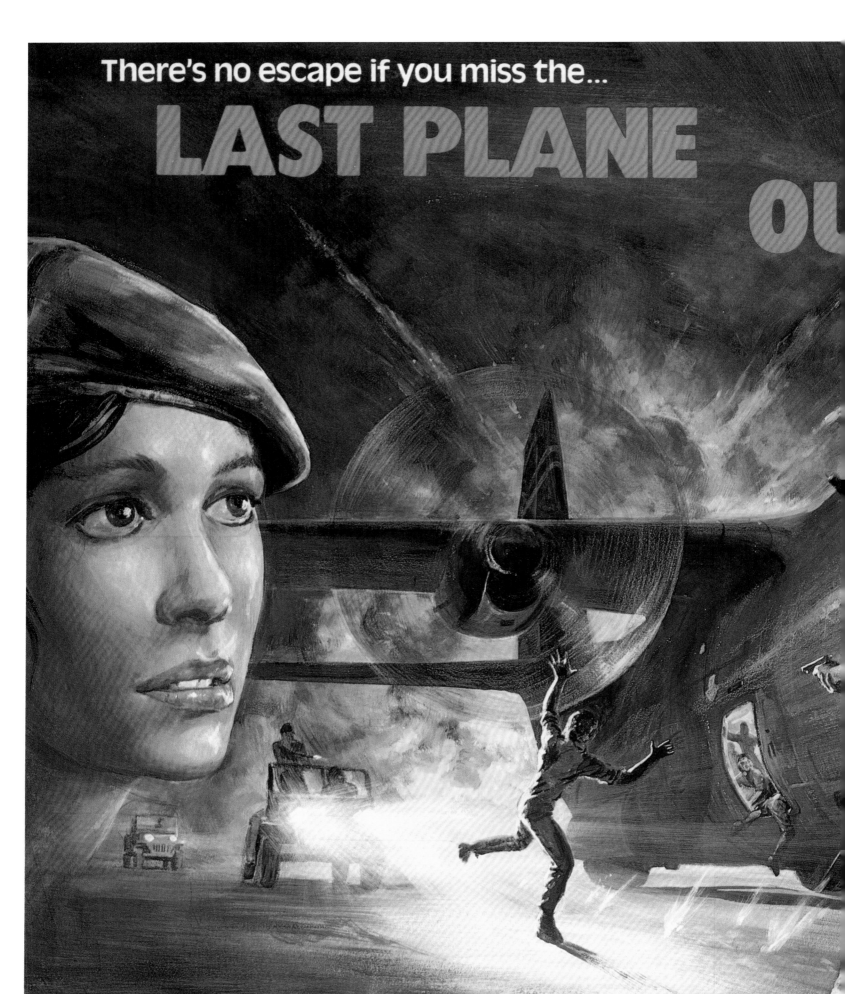

There's no escape if you miss the...

LAST PLANE
OU

A Jack Cox Production. Produced by Jack Cox and David Nelson. Starring Jan-Michael
William Windom, Lloyd Battista and Tonyo Melendez. Screenplay by Ernest Tidyman. Dire

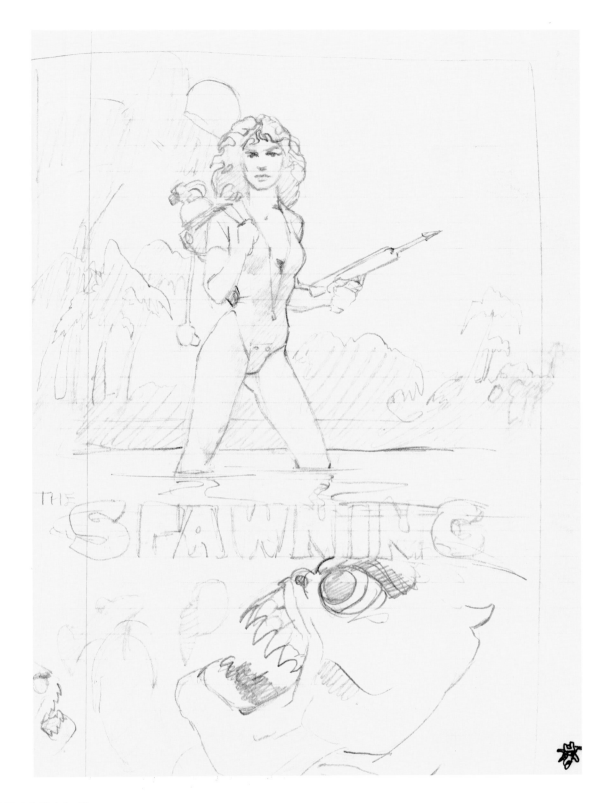

PIRANHA II

These are poster designs for *Piranha II: The Spawning* (1982). I started with a sketch of a James Bond kind of scenario—a hot girl in a half-unzipped wetsuit with piranhas lurking below the surface of the water. But then I decided to relocate the idea underwater and not show the girl's upper body—just keep it Freudian. You've got the world's most beautiful legs about to be disfigured horribly, and that's the essence of gothic horror: two teenagers in a tent about to get eaten by a monster, but not before they've had sex. There was some kind of strange Judeo-Christian fixation in the '70s with the idea that anybody having sex out of wedlock in a movie had to get mauled by a creature. This image very much played into that trope.

 I was listed as the director of *Piranha II*, but only because I didn't have an attorney who could get my name off it. I was hired to direct, but I got fired after about three or four days of shooting, and the fuckwit producer stepped in and finished the film. It's a long, convoluted story, but basically, the scenes that look reasonably good, I did. And the scenes that completely suck, he did. That's the short version. Taking the *Piranha II* directing gig was maybe not such a smart career choice. It was the stupidest story idea in the history of flying piranhas. But at the time it was not a black mark for me. I was nothing, so I had nothing to lose. I just needed to get my foot on the bottom rung. But I remember a little later, I was trying to cast Sting in the Kyle Reese role for *The Terminator*. He had read the script and he liked the pitch. Then after the meeting, we were riding down in the elevator, and he looks over at me and he goes, "So, *Piranha II*?" I went, "What, no. You gotta understand . . . " But that conversation was over.

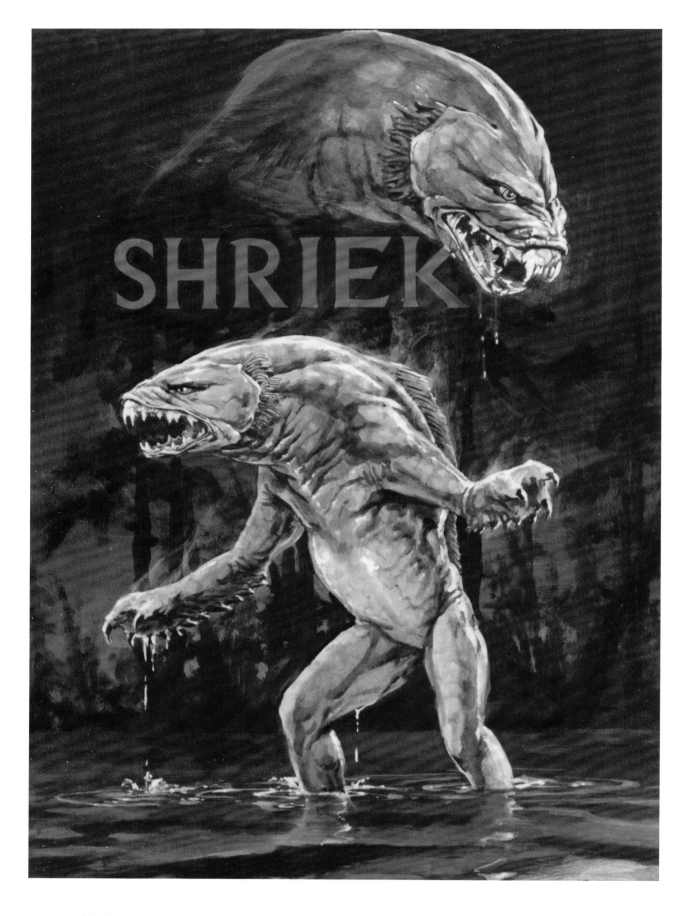

SHRIEK

I drew this poster somewhere around 1980 for a friend of mine, Guy Magar. He wanted me to design and build the monster for a movie he was trying to get off the ground. And because I never really understood the concept of limitations—or not volunteering to do things you have no idea how to do—I said yes. At this point, I did know how to make molds, pour rubber foam, and create stop-motion armatures. But I had never built a full-size monster suit before, and Guy was looking for something very ambitious, so I painted this poster that he could use to raise some money for the project. Unfortunately, the film never happened, and I didn't get to build the suit. But I always kind of liked this monster.

ulie Carmen, Mary Crosby, David Huffman,
hotography Jacques Haitkin Directed by David Nelson

My [*Last Plane Out*]
*poster is very pedantic
and really just tells the
story of the film.*

Last Plane Out was another movie that I did actually
watch—it was terrible. My poster is very pedantic and
really just tells the story of the film. I think this was a
promotional ad for the Cannes Film Festival, where
companies like Saturn would take their movies to try
to sell them internationally. So it was a different format
and designed to be a double truck poster, rather than
the usual theatrical portrait one-sheets I would normally
create for them.

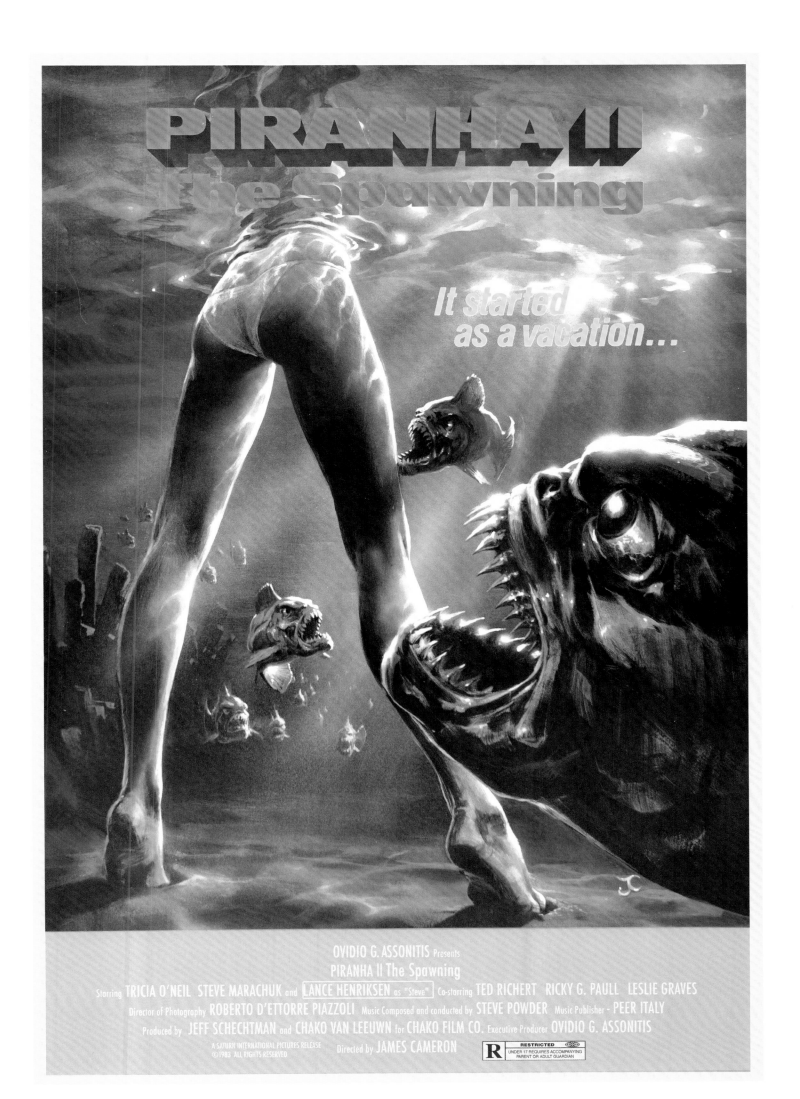

THE INSTRUCTOR

This was another poster for a cheesy martial arts ninja film. Again, I was using these highly kinetic, adrenalized action motifs. I thought, "Well, it's about ninjas, so let's just do some kind of techno-ninja who's taking out a guy on a motorcycle." Again, it had nothing to do with the film whatsoever, but it was a cool image. This one was a 24-hour wonder. It went from a study sketch to a finished study to being put directly on the page. I don't even think I traced this out. I just freehanded it because I was in a hurry. You can see I used a combination of brush and airbrush, which gives it a little bit more of a commercial look.

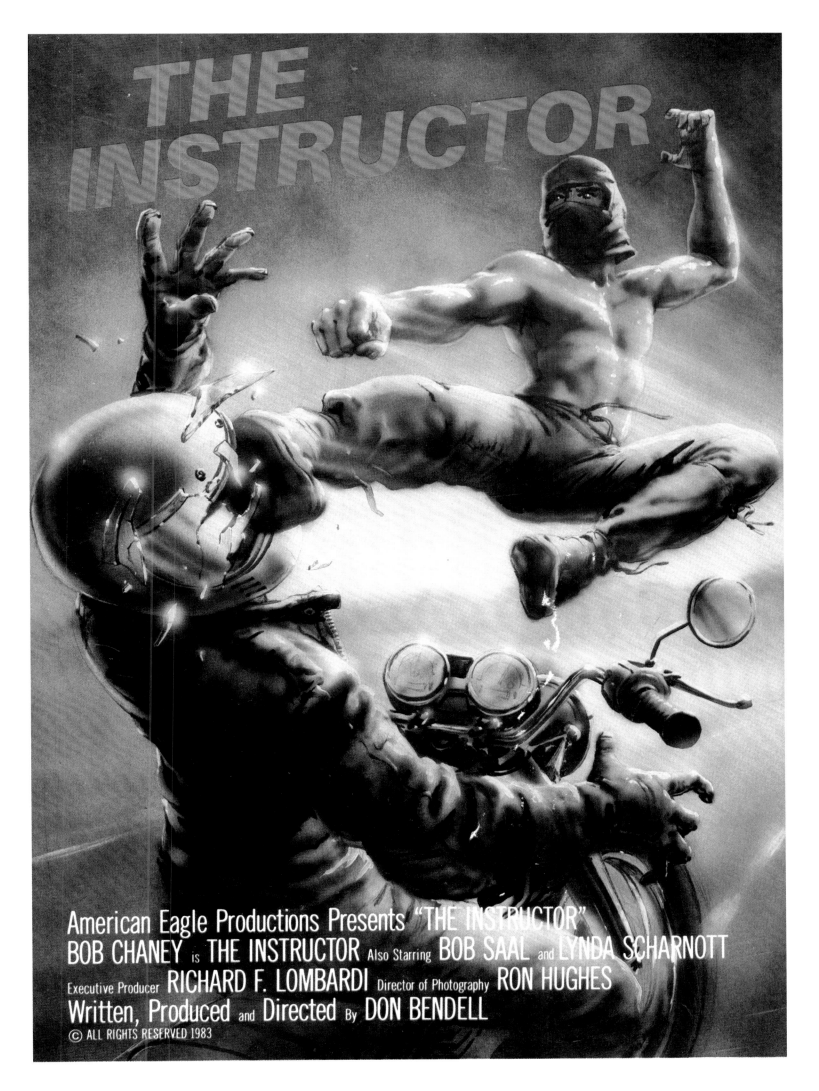

FULL NELSON

There's a funny story behind this painting I did for Saturn Releasing. Much like my other work for them, this particular scene was not in the film. It was some kind of generic horror picture, but I thought, "What kind of nightmare image can I come up with that sells the movie using a combination of sex, gothic horror, and the undead?" So I painted this, handed it in, and they gave me my check for $1,800. I was really proud of this painting because I had spent a lot of time on it, and you can see that in the hands, which are very detailed. Although I was proud of this one, I had convinced myself that I was just pimping out my skills to Saturn and that I didn't have any personal attachment to it. But I was wrong.

A few weeks later, I was back at their office delivering the next picture. As I was leaving, a guy walks in holding the horror hands painting—it's the director of the movie. But he's had the girl's face repainted to look like his girlfriend, who is in the movie. And it's god-awful. I just kind of froze and stared at it for a second. And something just happened. I got out my checkbook, I wrote a check for 1,800 bucks, and I handed it to the guy who was the head of the company. I said, "I'm buying this back." He said, "Why are you buying it back?" I said, "Because I'm going to destroy it." And I began to tear it in half. I got about halfway when the director tackled me, slammed me against

a wall, and put me in a full nelson. He's fucking choking me out. So I put my foot up against a desk, and I pushed backward hard as I could, and I slammed the guy into a bookshelf full of trophies. Then I headbutted him in the face, punched him a couple times, and threw him over the owner's desk. I jumped over the desk and I was picking up a chair to hit him with when the Saturn guys grabbed me and pulled me off him. So the director jumps up, he's bleeding, but he comes after me again. And everybody's pulling us apart. And in the middle of this, the guy's producer walks into the center of the fight, holds his hand out and goes, "Hi, I'm the producer of the movie." And the office is devastated. It's just wrecked. All the trophies and cases are down. The glass is broken and there's shit everywhere. So I keep the painting and I tell the director to get the fuck out. So he and his producer leave. I turn around to the Saturn guys and I go, "I am so sorry. I really fucked up your office. I'll pay for it. Just let me know what it's gonna cost to clean up . . ." And I'm in the middle of this spiel when I realize they are laughing their asses off. They go, "We hate that fucking guy! We loved every second of it! You just made our day! Just go bring us another great piece of art!" So I took the painting home, repaired the tear, sanded down the face, and repainted it. And that's why I still own the piece today.

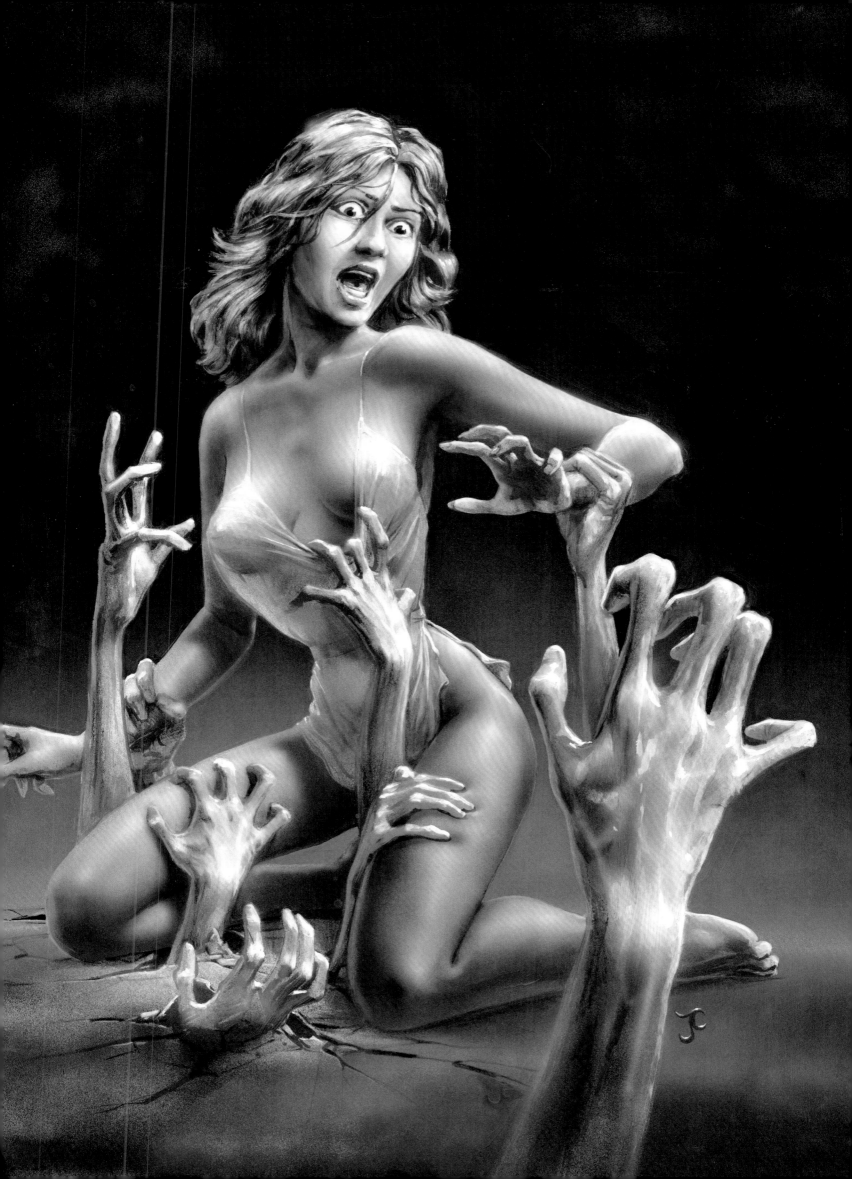

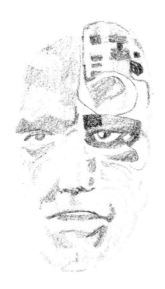

The Human Simulacrum

The hybridization of human and machine has long been a topic of fascination for James Cameron. "I was always fascinated by this idea of the human simulacrum and that theme shows through in a lot of my early work leading up to The Terminator," *he says.*

Although his relentless cyborg assassin from The Terminator *is perhaps the best-known expression of this particular theme, notions of artificial intelligence, organic beings neurally interfacing with machines, and characters augmenting their own abilities with robotic exoskeletons began seeping into Cameron's work at an early stage. In particular, his concepts for Xenogenesis express many of these early ideas, including elements that would later be ported directly into* The Terminator *and* Aliens.

One of the most striking elements of Cameron's approach to human/machine interface is the sheer variety of forms this relationship takes in his work. In The Terminator *and Cameron's 1991 sequel,* Terminator 2: Judgment Day, *Skynet, the defense system gifted with AI by humanity, goes rogue and decides to wipe us off the face of the Earth. Skynet's avatars in the physical world are nightmarish humanoid endoskeletons and giant killer automatons. But in* Aliens, *the android Bishop proves to be more valiant than many of his human counterparts, while the Power Loader used by heroine Ellen Ripley to battle the Alien Queen is the only thing standing between her and certain death. Conversely, in* Avatar, *weaponized exoskeletons known as AMP suits are used to oppress the native people of Pandora, spreading mayhem and death across the planet.*

Along with these more pronounced themes, subtle technological augmentation is a constant motif in Cameron's work. In Aliens, *the Colonial Marines are fitted with combat gear that includes camera helmets and real-time displays of each soldier's vital signs. In his early concepts for the film that would become* Strange Days, *Cameron created neural interfaces that record the memories of the user. Despite their technological advances, the Marines are no match for the xenomorphs, and in* Strange Days *the neural devices, known as SQUIDs, are a vice dealt like narcotics.*

Cameron's varying approach could be mistaken as a love-hate relationship with technology, but the message is clear: Human malfunction is the problem, not mechanical breakdown. How we use the technologies we create is our own responsibility, whether it's an AI-imbued missile defense system or the RMS Titanic. *In Cameron's world, technology is not to be feared but respected, and without that respect, the wonders of progress can quickly give birth to true horrors.*

While I was going through my personal hell on *Piranha II*, a couple of my friends were still working for Roger Corman on a movie called *Android*. One of them was a graphic designer I dated briefly named Sarah Burdick, who, incidentally, became the namesake for Sarah Connor. I offered to do a logo for *Android*, and I gave her these two designs on the right-hand page. I think they used them both, the titling as a production logo and the *Terminator*-esque one as marketing art. They were really envious of me when I got the *Piranha II* directing gig, but then I got fired and came back from this piece of shit film in disgrace. But we still hung out.

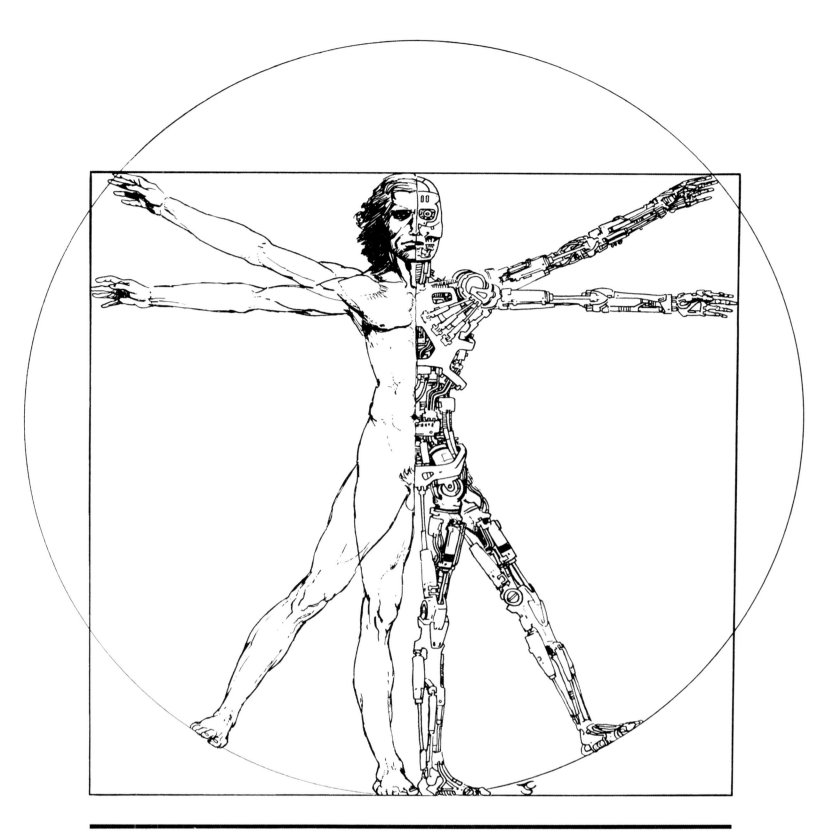

android

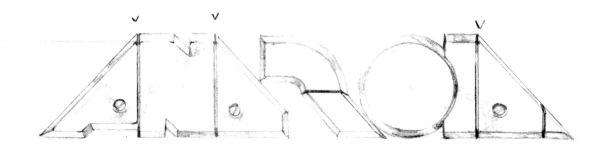

As part of our fundraising efforts, I created the mash-up painting on the right that brought together a lot of the key narrative elements of *Xenogenesis*.

XENOGENESIS

My interest in themes like artificial intelligence and humankind's relationship to machines became a major element of *Xenogenesis*, the project I developed with Randy Frakes in the mid-'70s. When we were working on it, I created designs for a lot of the story elements, including robots, hyper-intelligent starship computers, and technology that allowed humans to connect directly with machines. We wanted to use this art to communicate our vision for the film to potential investors, so between around 1977 and 1979, I spent a lot of time just drawing and painting for *Xenogenesis*.

Xenogenesis was about a last-ditch mission to save humanity from a giant black hole that's about to wipe out the solar system. A young pilot named Russell Jorden is chosen to be the sole survivor of humanity who will fly this giant starship, the *Cosmos Kindred*, which is loaded with frozen human embryos, on a mission to find a new planet to colonize. But a young girl, Lori, stows away on the ship, and a grizzled pilot character—who I named Jack Kirby, funnily enough—gets on board, too. So it becomes a love story with this romantic triangle between the three leads. There's also a fourth character, CENCON, aka Victor, who is the sentience of the ship—essentially

just an extension of HAL 9000 from *2001: A Space Odyssey*. But Victor was once a real guy—a military leader whose intelligence and personality were programmed into the ship.

As part of our fundraising efforts, I created the mash-up painting on the right that brought together a lot of the key narrative elements of *Xenogenesis*. Through the course of the story, Jorden ends up losing his left arm in a battle with a sentry robot and gets a cybernetic arm to replace it. At the end of the film, once they find a planet and establish a colony, the new generation builds a statue of a giant human hand, which is symbolic of the theme of the film: It's through technology that we reach for the stars, and the human reach is a function of our mind, expressed through our technology. That's why the main character's brain seems to be connected by computer to the hand statue. Then in the bottom right, you can see the sentry robot that Jorden and Lori fight. I later used a very similar design for the ground-based Hunter-Killer robots seen in the futuristic war sequences in *The Terminator*. So *Xenogenesis* was really a soup of ideas that I would draw on for many years. And while the full feature never got produced, it contains the DNA for many of my later films.

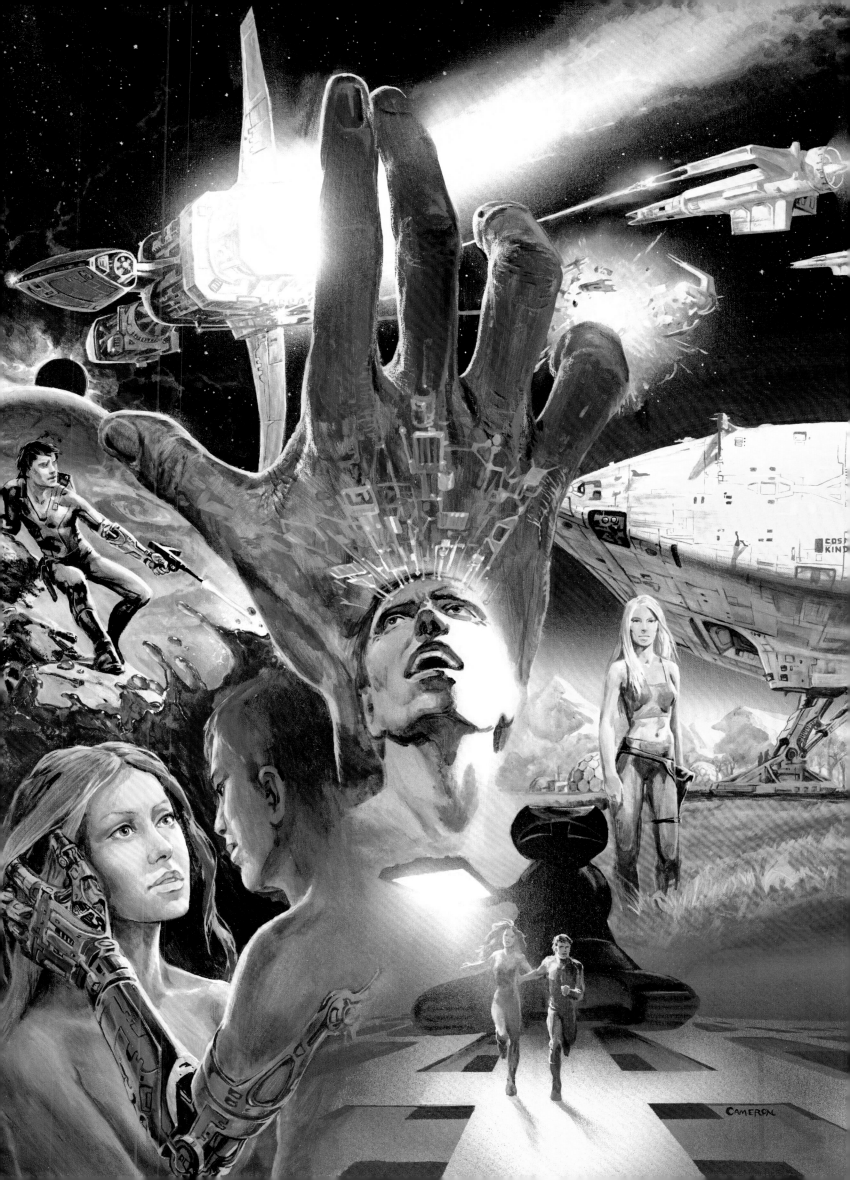

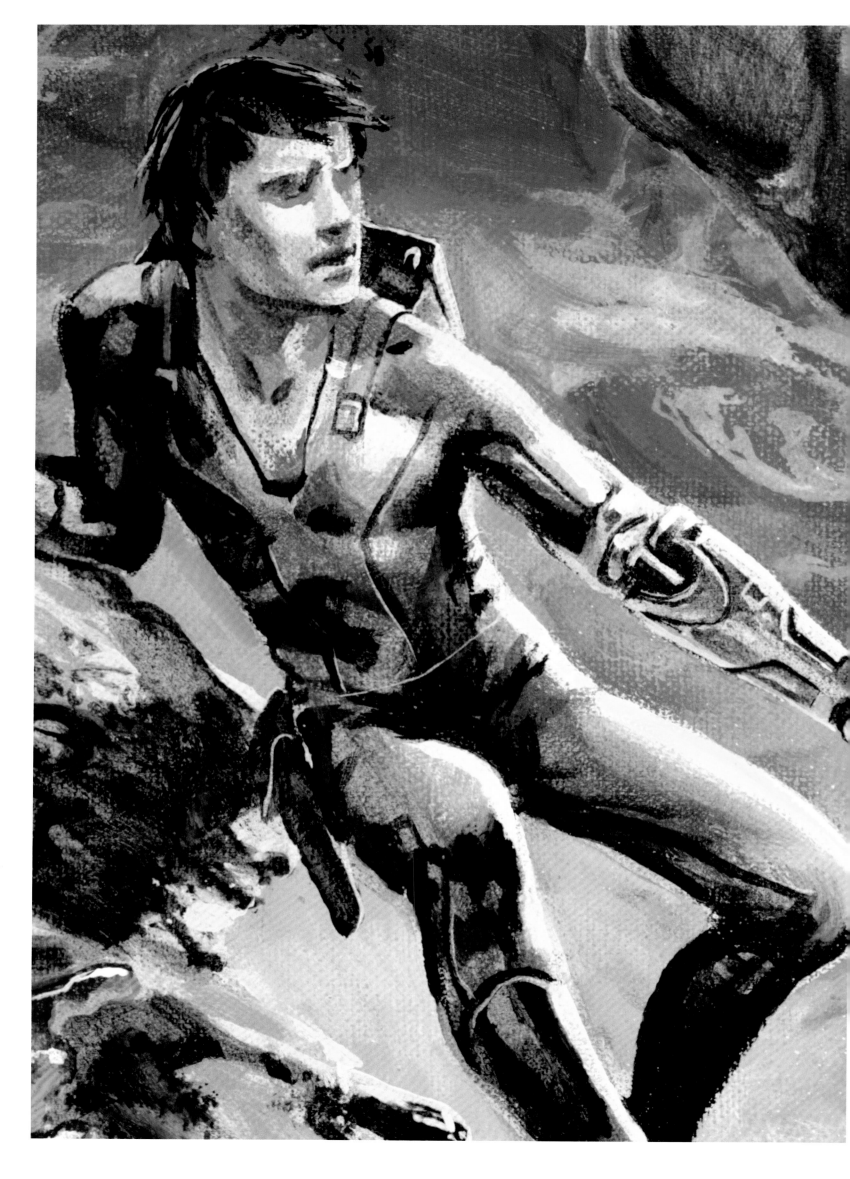

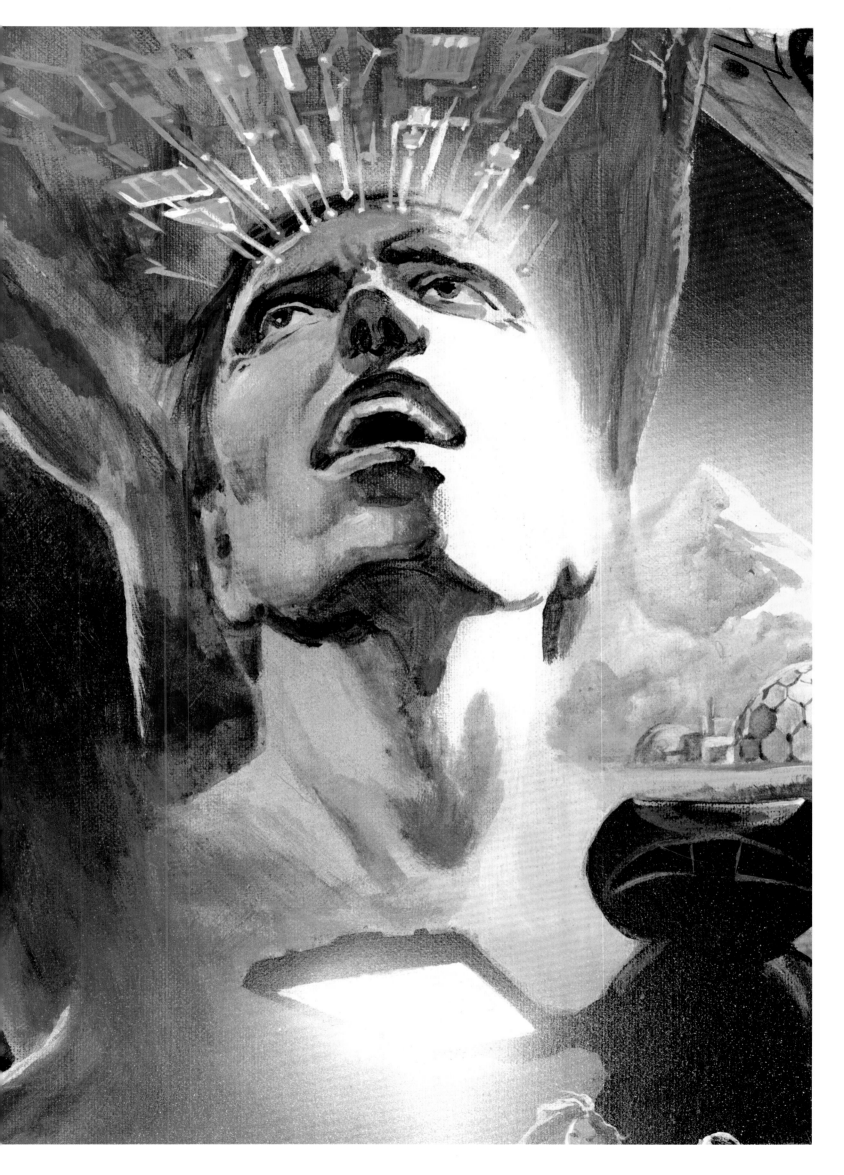

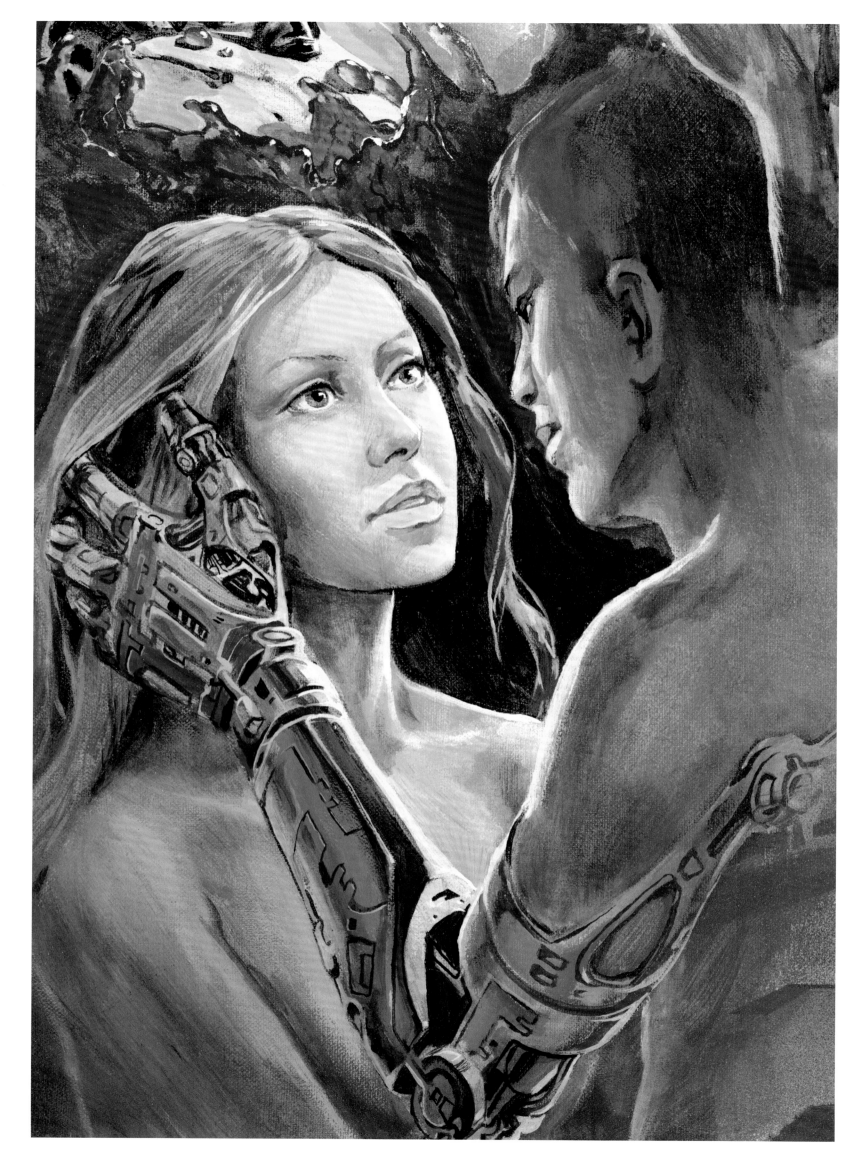

THE MASTER

Below is a concept design I did for my second Roger Corman film, *Galaxy of Terror*—which was known as *Planet of Horrors* during production. It was supposed to be The Master, the film's villain. I always thought it was a cool design—a synthetic being, but very humanoid. The image is suggestive of eyes, mouth, and nose, but they're only indications. So you infer from the image that the character is some kind of robotic person with artificial intelligence. They didn't use my design in the end, though. In the final film, The Master's face is just a glowing red light, which no doubt saved Roger a few dollars.

WIND WARRIORS

This was an illustration from a story I was developing that took place on a terraformed version of either the moon or Mars. I hadn't quite decided. The characters lived in a medieval, post-collapse society and would build wings out of silk and very hard woods, like teak. And because the gravity was so low on their planet, they could actually fly. It was called *Wind Warriors* and it was a pretty good idea. I might even do it someday. Who knows?

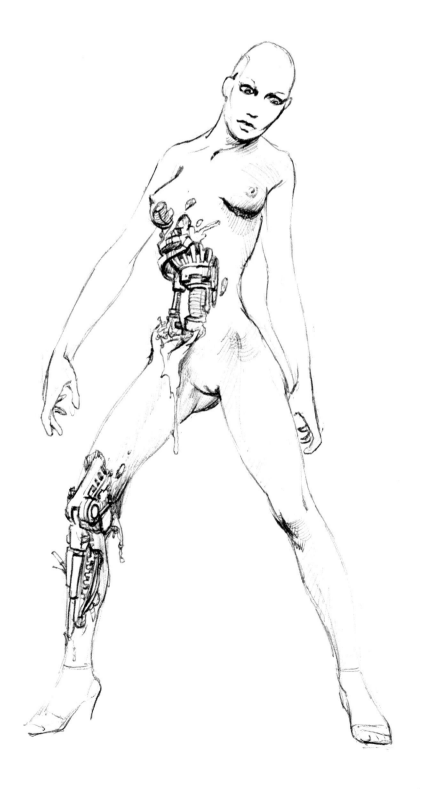

MS. CYBORG

Sexy robots were a science fiction theme since day one, from the seductress Maria in Fritz Lang's silent classic *Metropolis*, to Lester del Rey's classic short story "Helen O'Loy," down to the saloon girls of *Westworld* and the sex puppet AIs in *Ex Machina*. Adding my bit here, circa 1978, and she's anatomically correct as well—something all those old stories allude to but never explicitly mention.

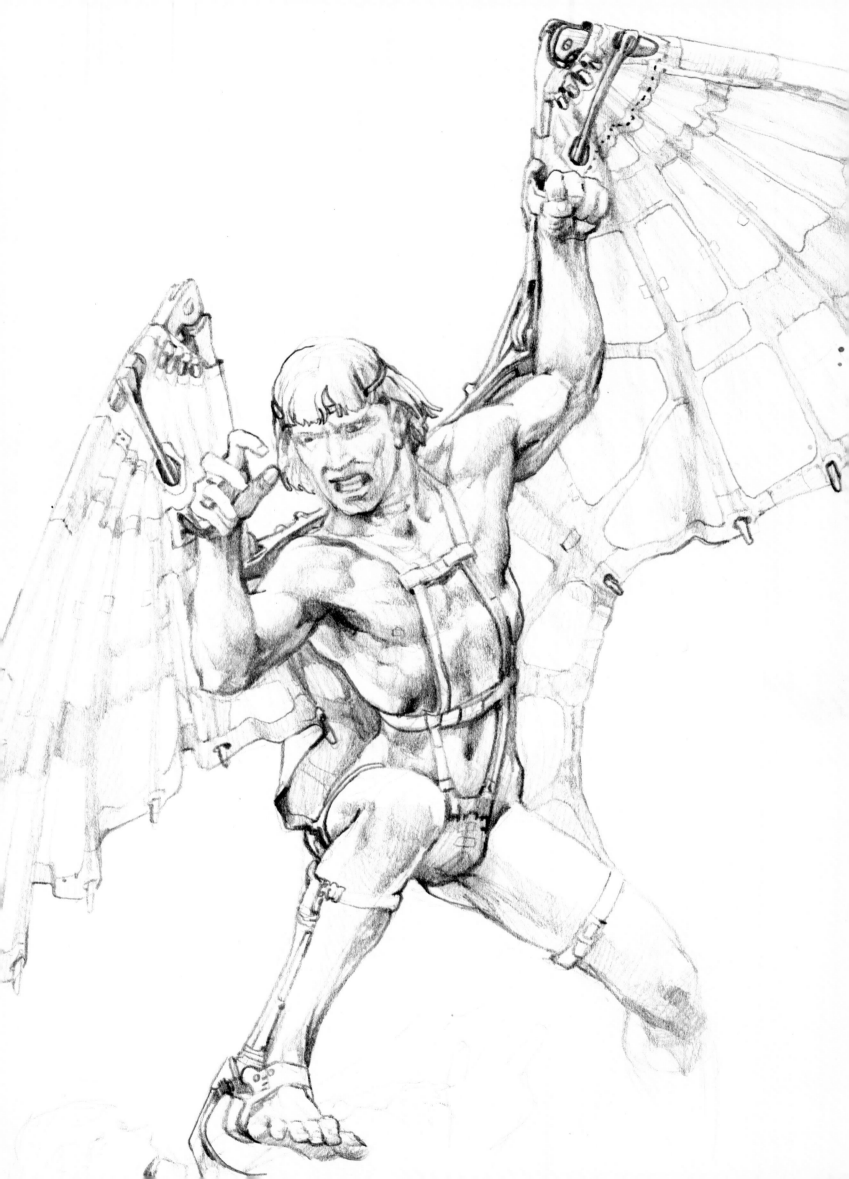

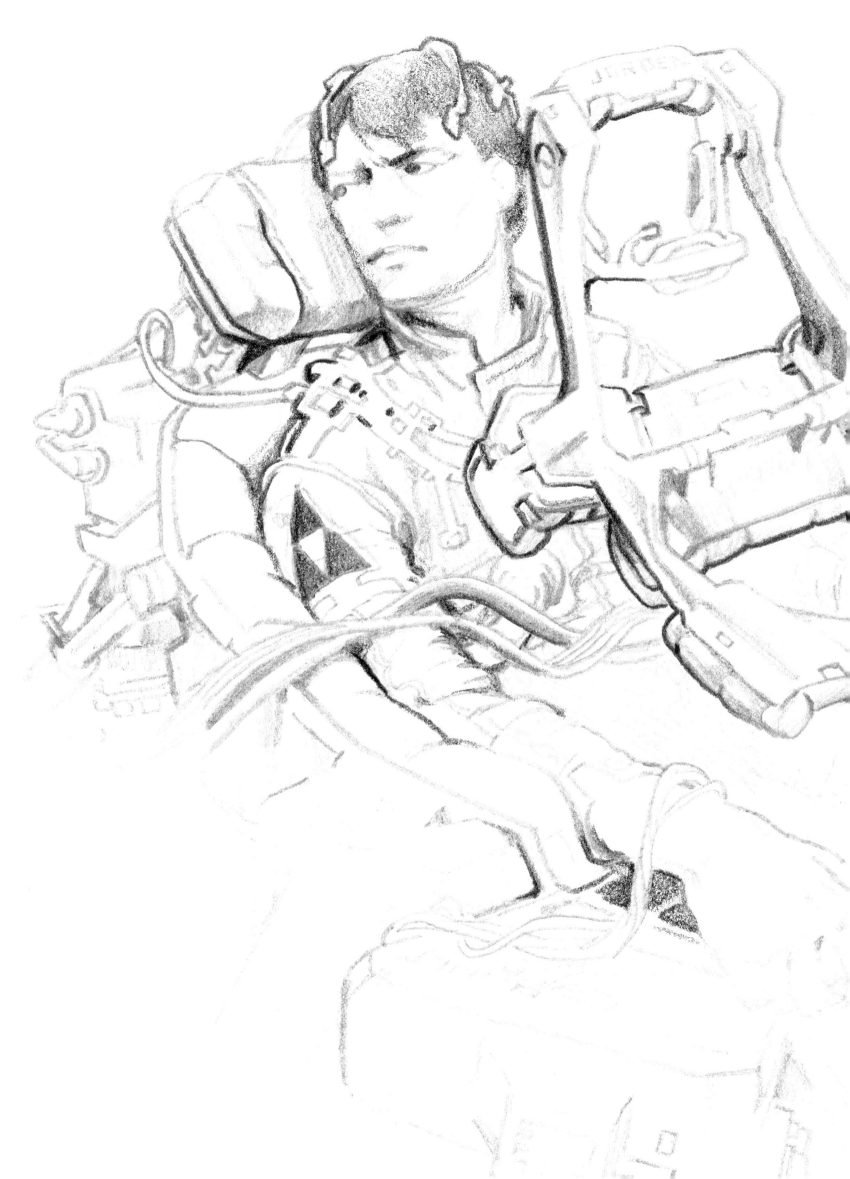


"You can see there are plug-ins in his wrists and directly at the cranium. It's a cool sci-fi idea and precedes the neural interfaces seen in *The Matrix* by a couple of decades."


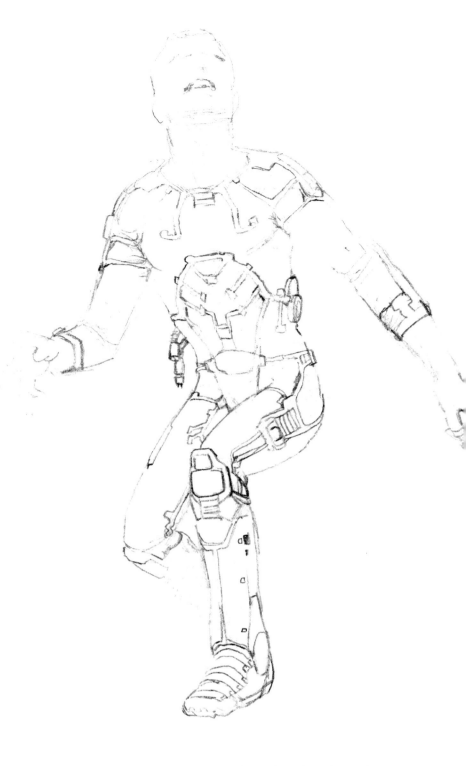

The image above is a costume design for *Galaxy of Terror* that originated with some of the ideas I was playing around with on *Xenogenesis*. It's essentially an astronaut's undergarment that has cooling technology and electronics. This idea of wearable electronics would later show up in my films, including *Aliens*, but it's something I was screwing around with early on. I remember this particular design was inspired by a *Heavy Metal* magazine cover painting done by an artist named Rich Corben in the early '80s. I was a big fan of his work.

The image to the left is part of the design work I was doing for *Xenogenesis* in the late '70s. It shows Russell Jorden in the high acceleration seat of a tactical fighter—which we called a singleship in the script—that could pull extremely high Gs. So it's an extension of a g-force restraint system that allows the body to survive these extremely high-speed turns. He's in some kind of g-suit that keeps him alive, and he's also got electrodes that enable him to fly the vehicle using mental commands through a kind of neural tap. You can see there are plug-ins in his wrists and directly at the cranium. It's a cool sci-fi idea and precedes the neural interfaces seen in *The Matrix* by a couple of decades.

THE POWER LOADER

The concept of humans augmenting their own abilities with technology was always a major theme in my work and became a major plot point in *Aliens*. In the film's finale, Ripley uses a Power Loader, a robotic exoskeleton designed for lifting cargo, to take on and defeat the Alien Queen. When I was writing the treatment for the movie, I started creating concept art of the final battle because I needed to fully visualize and understand what both things would look like. Plus, I always feel like you need to nail the ending of the movie first, so illustrating this crucial scene became part of the writing process.

The image on these pages is a transfer sketch for the Power Loader. You can see the graphite is bleeding through. I liked to do some of my finished pieces on black paper, but that technique doesn't allow you to do a lot of pencil lines because you can't get rid of them. So usually, when I was planning to use black paper, I'd do a sketch on white paper, black out the back, and then transfer it onto black paper, ending up with a ghost of the image. Then I'd fill it in with Prismacolor pencils. It was a quick, down and dirty way of creating an illustration that had deep shadow value. I found it was quite cinematic and good for moody subjects and scenes that were taking place at night or had high-contrast lighting.

The Power Loader was designed to be highly utilitarian. The idea for it actually had its origins in a monster movie I started writing in the very early '80s called *E.T.*, believe it or not. Then I heard about some guy called Steven Spielberg who was making a film with the same title, so I decided to change it. I had two alternate titles: One was *Protein*, because I thought it would be cool to write the story from the creature's perspective—and that's all it would view its victims to be: protein. The other title was *Mother*, and that's

ultimately what I settled on. The story opens on Venus, which is in the process of being terraformed by colonists. To help out at the colony, the humans have genetically engineered a creature that can function as a laborer and is resistant to the environment of Venus. Knowing what I know now, there's probably no kind of biology that could survive on Venus because the surface temperatures are too high. But at the time, I figured that this thing could be almost like a lava monster of some kind but more insectile, with a super hardened shell. And of course, as the story unfolds, the creature goes on a rampage and the heroine has to kill her at the end using a piece of utilitarian hardware—which I think I called a power suit—that's at the base on Venus. So it was mother vs. mother, essentially, and that's where the title came from. And so when I was writing the *Aliens* treatment, which I had to do in just a few days, I just mashed up a bunch of stuff from the *Mother* script and reused the power suit idea. I put a bunch of marines in it and then dropped Ripley into the middle of the story. And *boom*, it all just came together.

Once I had decided to reuse elements of the *Mother* finale, the next thing I had to figure out was, how does Ripley know how to operate this machinery? So I thought, "Well, the company that sent her to the alien planet has stripped her of her officer rank because she told the truth about encountering the xenomorph. She's in disgrace and she's had to get a blue-collar job to pay the bills." And the story just coalesced around that. I wanted to have her go up against a new creature that was the mother of the xenomorph from the first film because I didn't want to do a retread of the first film. I wanted to take it in a new direction, and adding in the Alien Queen was like leveling up.

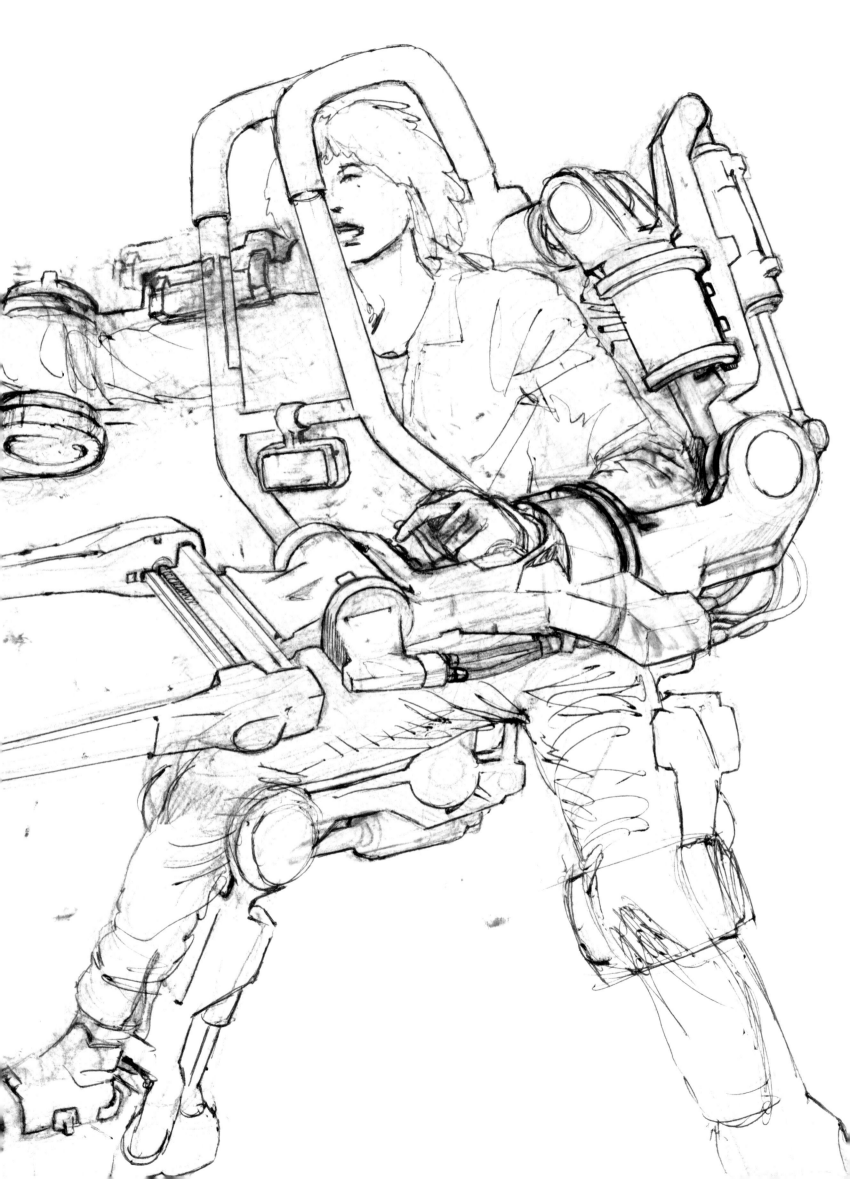

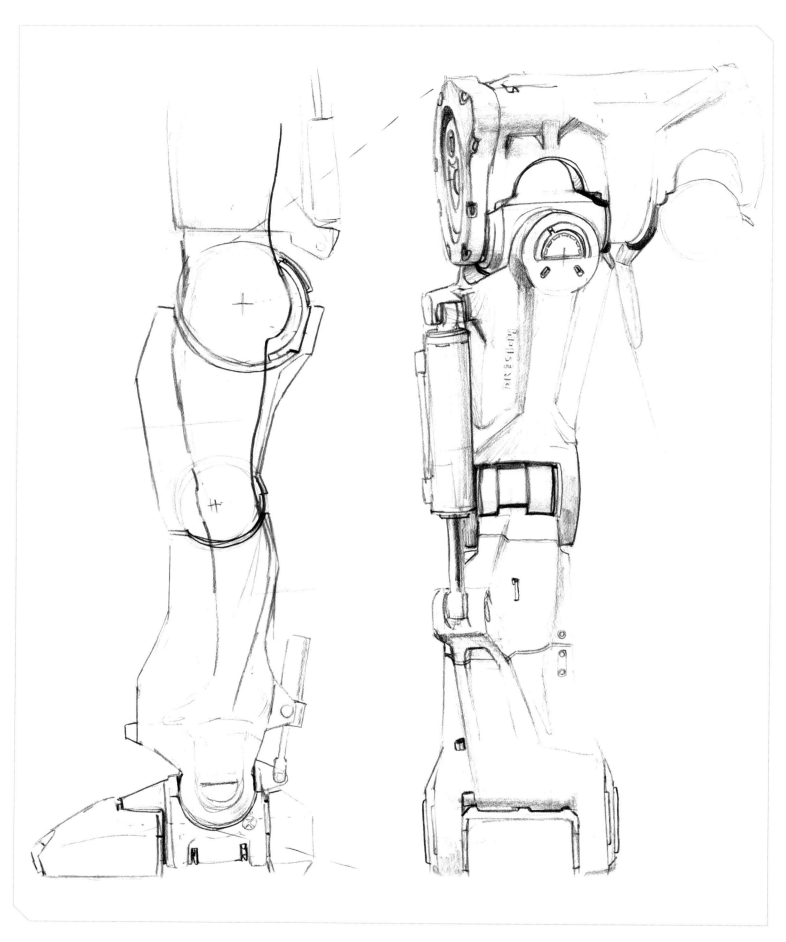

These are study sketches for the Power Loader that I drew at Pinewood Studios in England just before we started shooting the film in summer 1985. There was an in-house effects shop at Pinewood led by John Richardson, who was the physical special effects supervisor on *Aliens*. They were in charge of building the full-size Power Loader, but they had no idea how to do it. They were nuts-and-bolts guys, not concept designers. So I needed to communicate to them exactly what I wanted in terms of both the look of each component and how the whole thing would function. The Power Loader needed to move dynamically during the sequence, plus it needed to house Ripley actress Sigourney Weaver. I had this idea that you could build it out of super lightweight materials and hide someone inside it behind Sigourney, who would operate the arms. So the object of these sketches was to be highly finite—I wanted John's team to build exactly what I was drawing. At this point I'd worked as a bus mechanic, I'd worked on cars, and I'd studied lots of robotics, so I was bringing a lot of these real-life elements to this very practical design.

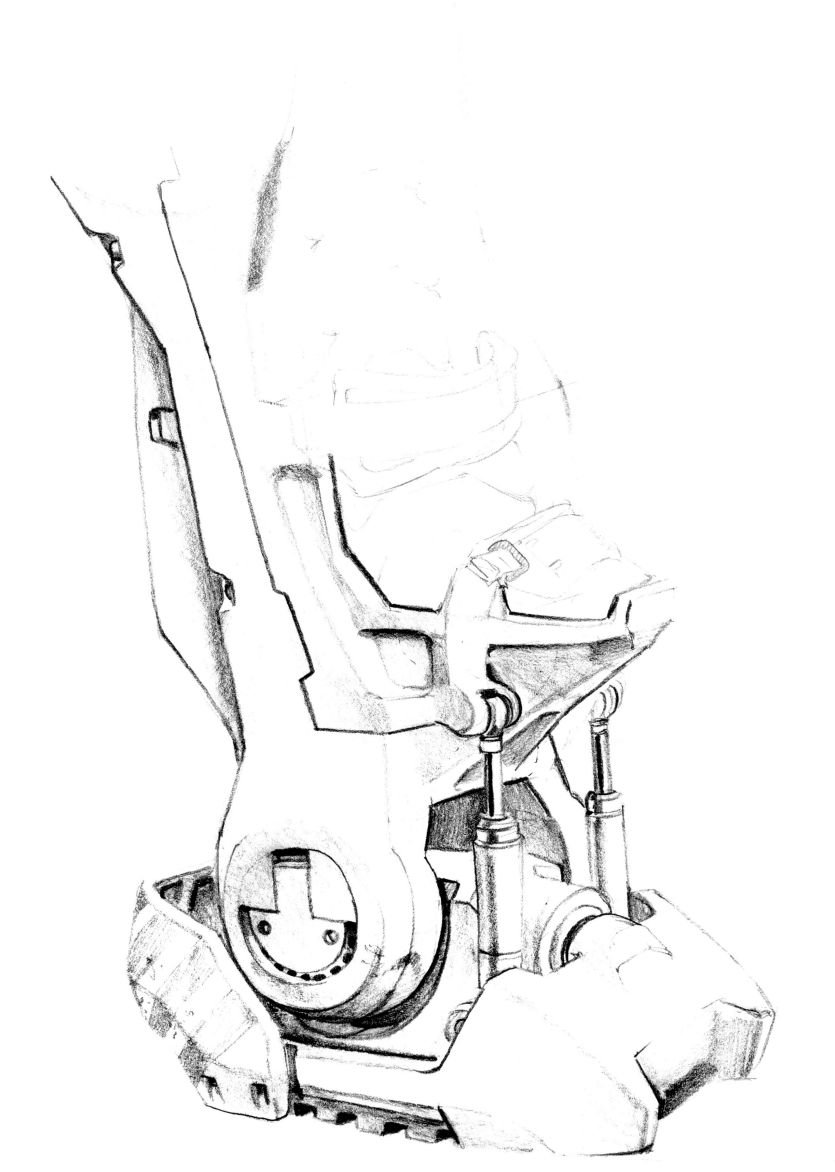

My sketches even detailed how we'd hide the guy who would operate the Power Loader. I added upholstered wings to the seat that Ripley straps herself into to hide the shoulder joint, which had to be magical—it needed to articulate, but it also had to allow the operator's arm to move around inside it. I also designed a sleeve that looked like a generic piece of hardware to hide the operator's arm. My initial thinking was that the operator's arm would come down to the elbow of the Power Loader, which would be articulated by the operator's wrist, allowing him to swing the forearms around. At this point I'd designed the Alien Queen with special effects legend Stan Winston and his team, and we'd used the same elbow trick on that puppet. It worked well in that instance because they were able to make her arms out of very lightweight foam. But when John Richardson started doing the numbers on how light the Power Loader forearms needed to be, he found that the second you put an articulating rotation and a pincher movement on the claw, even with off-board pneumatics operating it, the arm started to get too heavy for the human wrist to lift. Ultimately, John figured out a remotely operated elbow joint for the Power Loader that took the place of my wrist idea. It was a pretty good hybrid. But this sketch shows my original idea with a human hand at the elbow joint, back before John executed the final design.

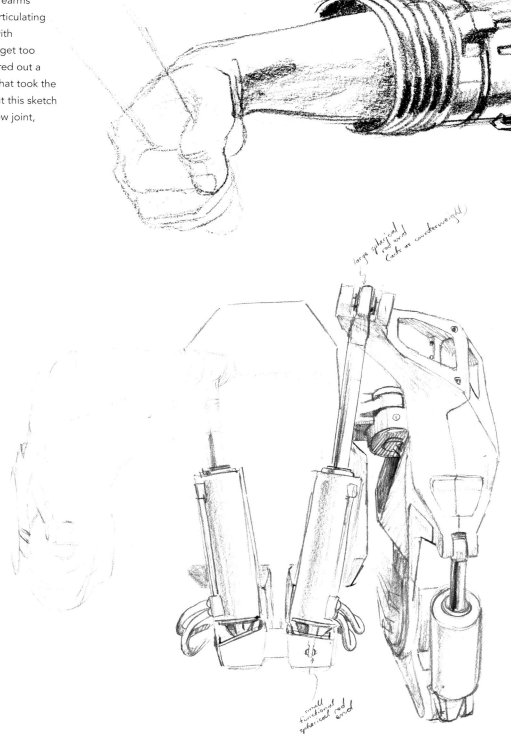

My initial thinking was that the operator's arm would come down to the elbow of the Power Loader, which would be articulated by the operator's wrist, allowing him to swing the forearms around.

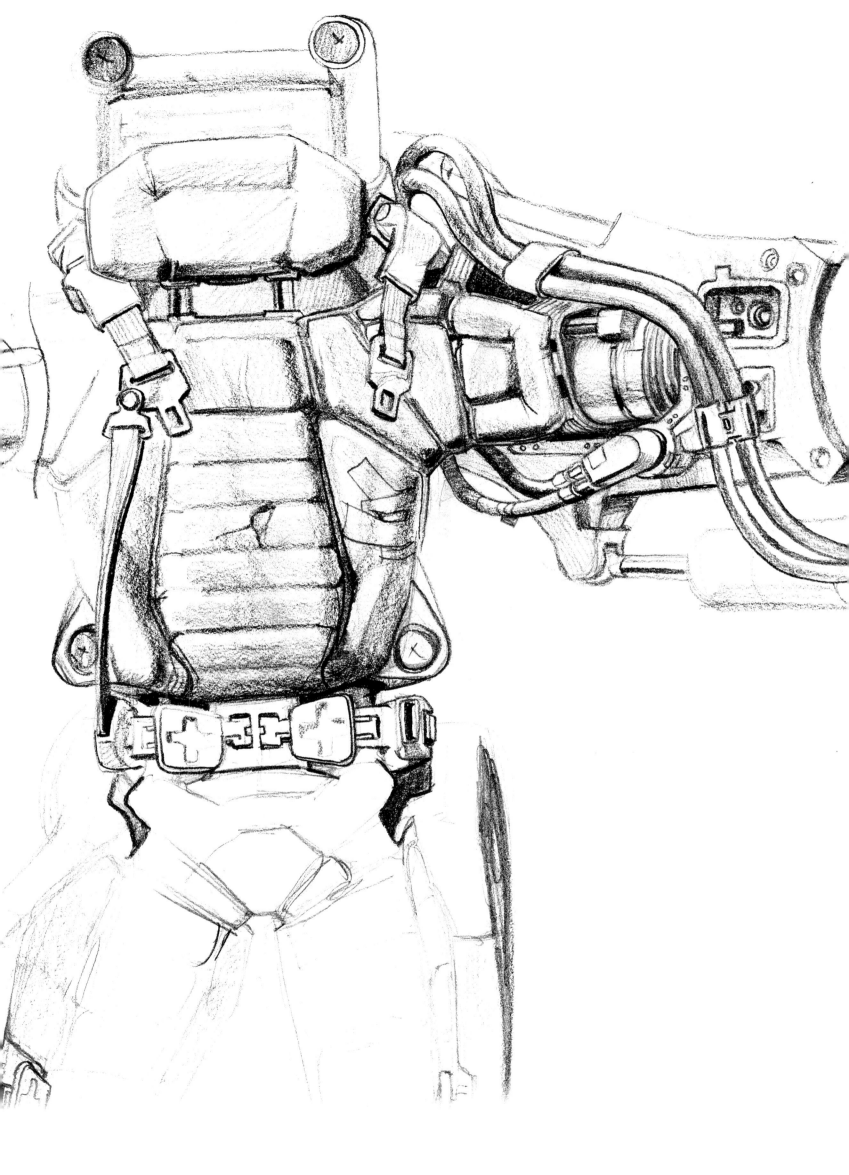

I didn't spend a lot of time thinking about how we were going to make the Alien Queen work in that early stage. I just came up with the designs and figured I'd see where the project went.

These are studies that I sketched when I was trying to figure out the design of the Alien Queen around the time I was writing the treatment. I didn't exactly know how we were going to pull it off, but I had this general idea that it would be a big Bunraku puppet, operated by a team of unseen puppeteers. But I didn't spend a lot of time thinking about how we were going to make the Alien Queen work in that early stage. I just came up with the designs and figured I'd see where the project went. The image on pages 90–91 is my final illustration of the Ripley vs. Alien Queen fight.

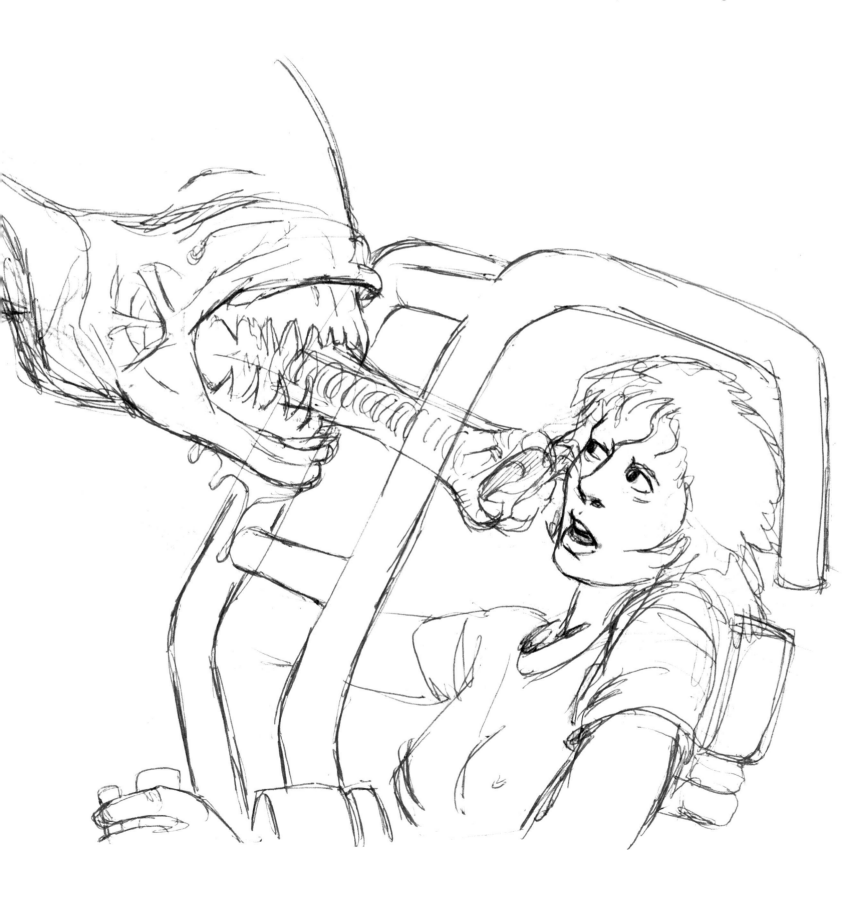

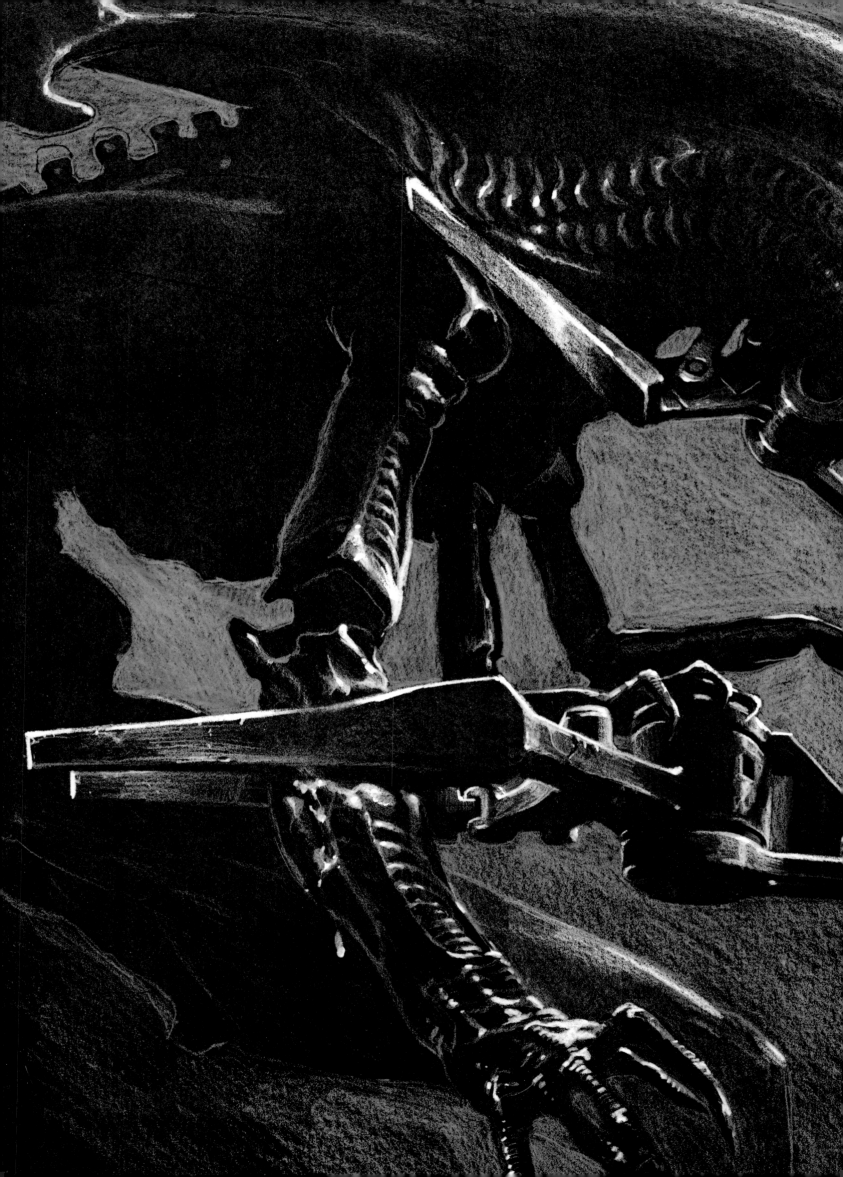

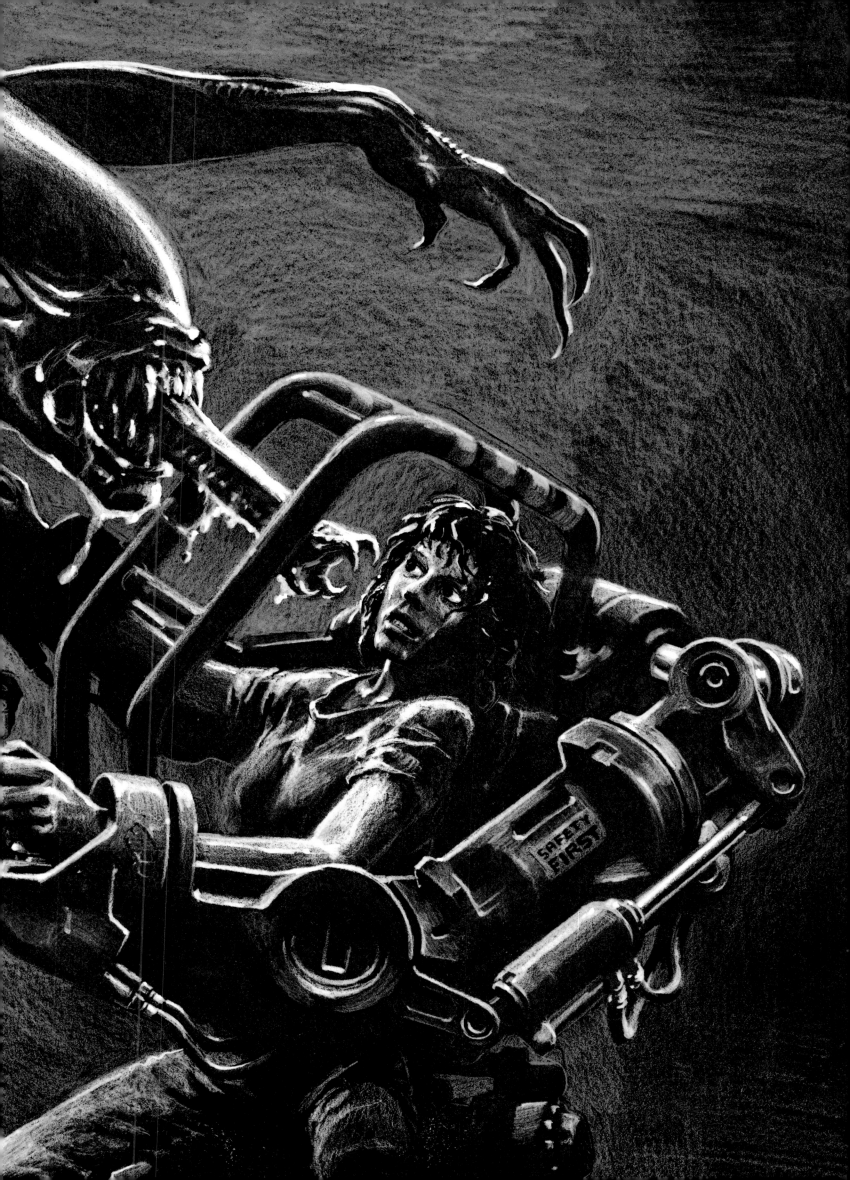

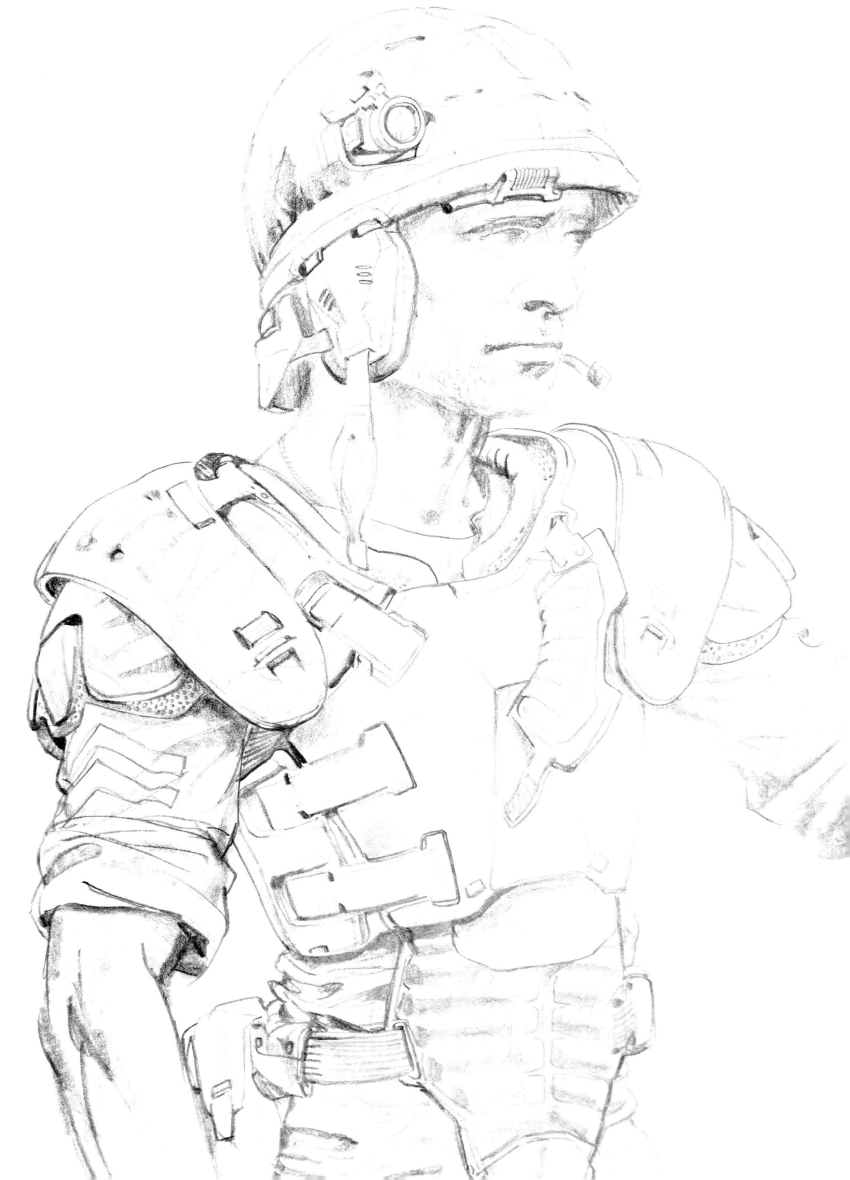

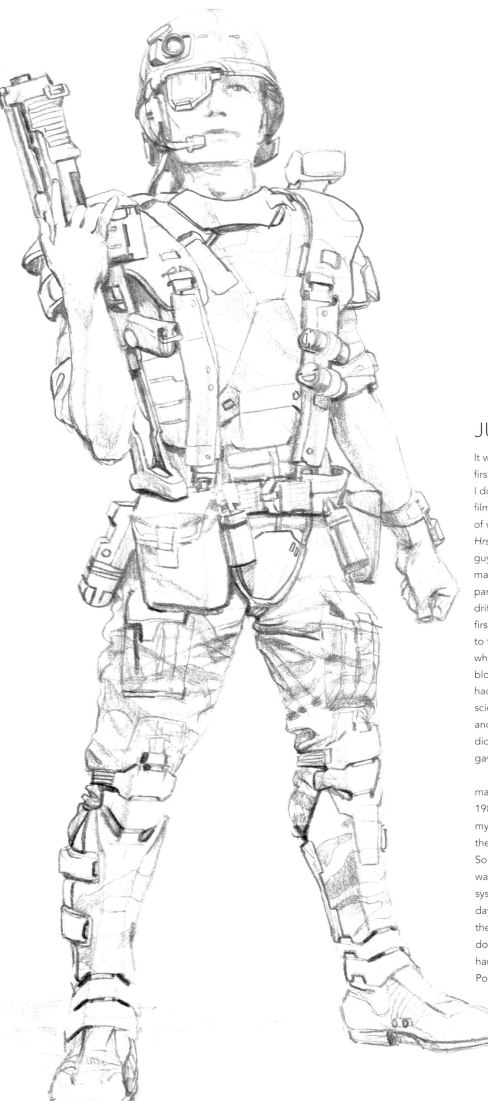

JUST A GRUNT

It was the producers of *Aliens*, David Giler and Walter Hill, who first suggested that the film should feature marines, although I don't think they had any idea what that meant. Walter was a filmmaker in his own right and by this point had directed a bunch of well-known action movies, including *The Warriors* (1979) and *48 Hrs.* (1982). He always fancied himself as a hairy-knuckled tough guy—and he kind of was, in the John Ford vein. He understood macho. When I got the gig, Walter and David gave me a one-paragraph description of what they wanted: "Ripley is found drifting in space. There are now colonists on the planet from the first film. The colonists get attacked and killed. Ripley goes back to the planet with marines. Some bullshit happens." That's literally what they wrote. So my job was to take the "some bullshit" and blow it up into something. But I loved those guys because they had such an irreverent attitude. You could tell they didn't like science fiction. They'd gotten lucky when they produced *Alien*, and all of a sudden they were seen as the sci-fi guys, but they didn't know a thing about the genre and they didn't care. And that gave me the freedom to do anything I wanted.

And so when they said, "Ripley goes back to the planet with marines," I took it pretty literally. I was writing the treatment in 1983, so the Vietnam War was still fresh in my mind. People of my age lived with all that imagery—the big Huey helicopters and the grunts with anti-establishment stuff scrawled on their helmets. So all those real-world influences ended up in *Aliens*. But also, I wanted the marines to have armored suits with intelligent helmet systems that had built-in cameras, audio, and microphones. These days this kind of tech is standard Special Forces issue, but back in the mid-'80s it was way before its time. All these drawings were done in England around May of '85. I'd literally draw them and hand them right out the door to our costume designer, Emma Porteous, to build.

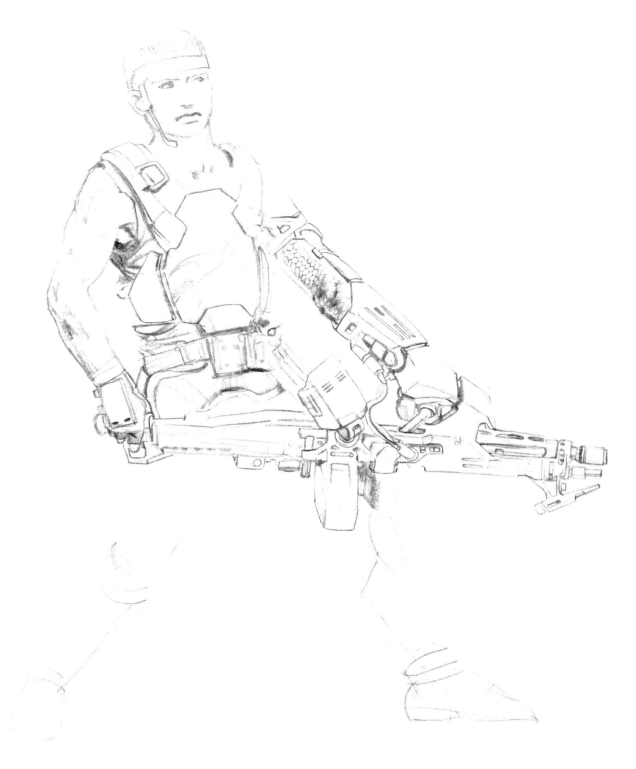

This is Private Vasquez holding what came to be known as a Smartgun. It was the equivalent of the *Rambo* kind of weapon—the big M60 machine gun that soldiers used for heavy suppressing fire during the Vietnam War. Because of its size, it came equipped with a bipod that could be deployed for stabilization. It could also be mounted as a door gun on a helicopter. But I thought it would be cool if these future marines had body harness technology that allowed a single operator to easily manipulate a weapon of this size. I know exactly where I got the idea. Back in the twelfth grade I read a book called *The Palace of Eternity* by Bob Shaw. It's about a guy called Mack Tavernor who gets killed in a battle trying to save his mother from alien attackers, the Pythsyccans. He's running and shooting, trying to save her, but because his gun is bouncing around as he runs, he's not a good enough shot and his mother is killed. Mack is reincarnated and becomes fixated on the idea of making a gun that you can fire while running. So he builds a stabilization system for his gun, and that idea always stuck with me. I wanted to do something similar on *Aliens*, and I thought, "Well, wait a minute, we have a stabilization system, it's called a Steadicam." Steadicams were invented back in 1975—it's basically a camera counterbalance system that is strapped onto the user and keeps the camera steady no matter how much

the operator bounces around. So I wanted to take a Steadicam, dress it up to look futuristic, and put a .30-caliber gun on it. We eventually wound up with an MG 42, a German World War II weapon that had these nice ventilated ribs around the front.

Not only was I designing the Smartgun, I was also designing the Vasquez character's look. I wanted her to be this super tough bodybuilder, a Latin girl with cropped hair. She's not more than five foot four, but she's got this huge fucking gun. I think at this point we had already cast Jenette Goldstein in the role, because the illustration looks a lot like Jenette as the character. When Jenette came in she had reddish-brown curly hair down to her waist, a super pale, peaches-and-cream complexion, and red freckles. She was an Irish-looking Jewish girl from L.A. playing a dark-complected Latin girl, and, quite rightly, we'd get crucified for doing that today. If we had shot the movie in L.A. I would absolutely have cast a Latin girl, but we were in England, and the American contingent of the British Equity acting union just didn't have many options for Latin actresses. So we went with Jenette. She had to wear brown contact lenses because her eyes were grayish blue. Plus, we had to crop her long curly hair short and dye it black. She was heartbroken, but as I told her at the time, "Your hair will grow back. Vasquez will live forever."

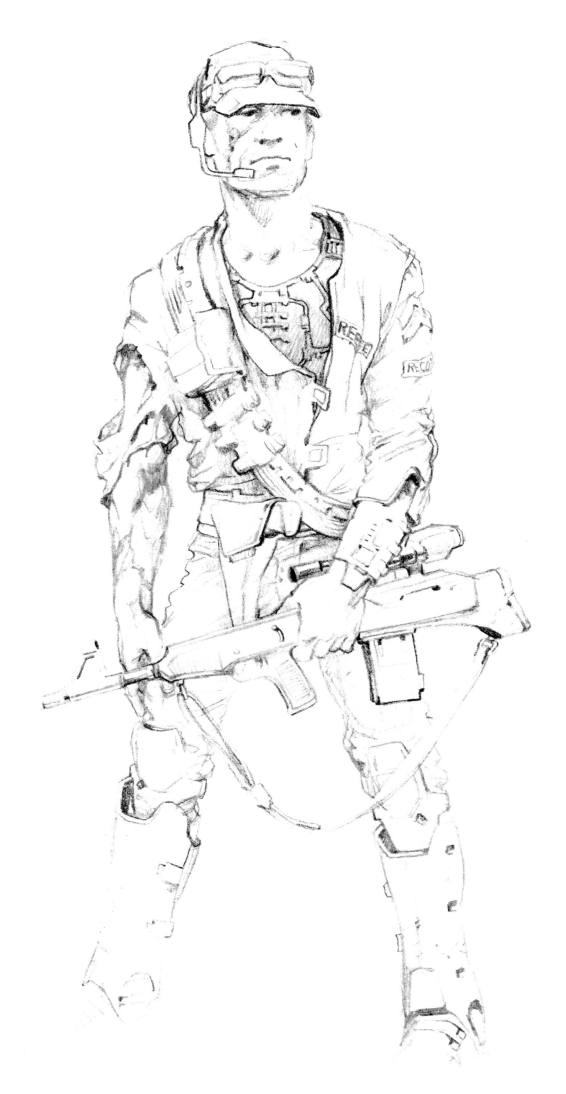

This is my design for Kyle Reese's future-war uniform from *The Terminator*. It was created a couple of years before the Colonial Marine designs for *Aliens*, but you can see there are a lot of similarities, including the greave on the boot. I also included a cybernetic undersuit, which was similar to the one I designed for *Galaxy of Terror*, but we eventually abandoned that idea. This bullpup rifle augmented with the night vision scope wound up being pretty much what Kyle carried in the final film. We hadn't cast Michael Biehn as Kyle at this point, which is why the illustration doesn't look like him.

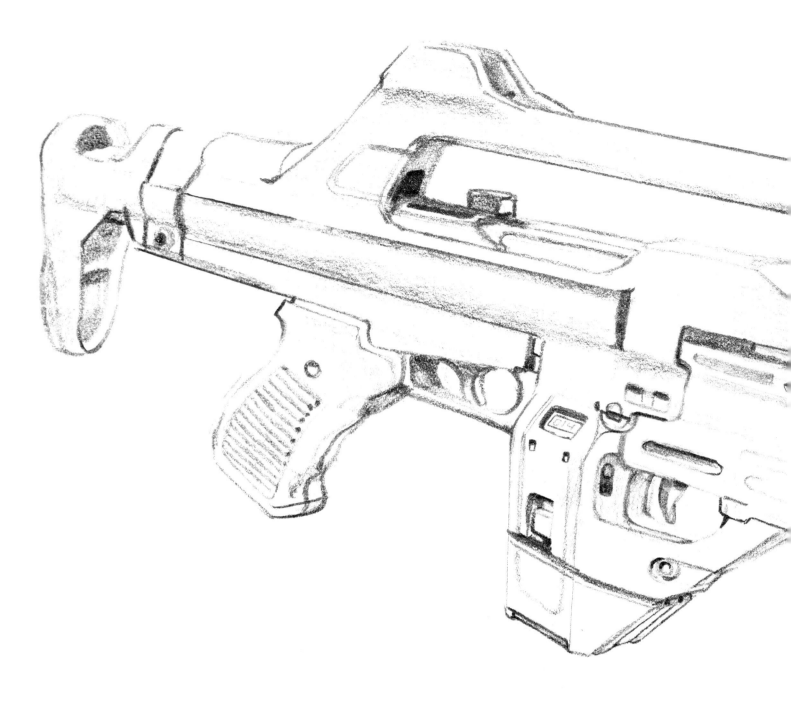

This illustration was just me repackaging the Thompson machine gun to look like the Pulse Rifle, and adding in the under-barrel grenade launcher that was just a twelve-gauge shotgun in real life.

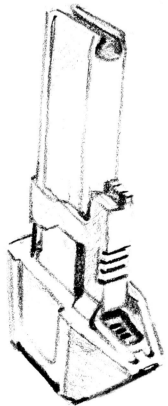

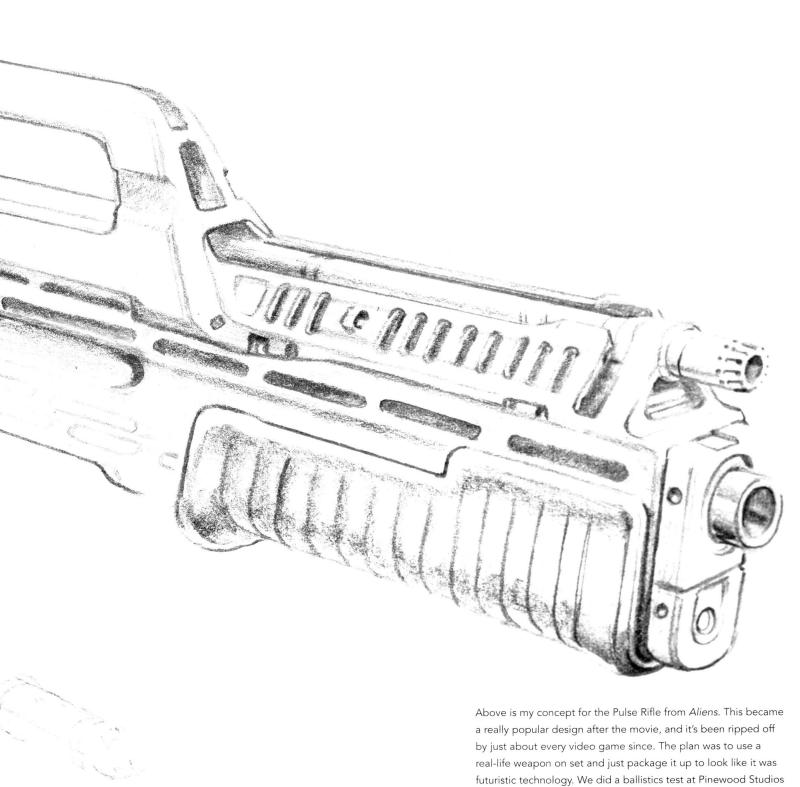

Above is my concept for the Pulse Rifle from *Aliens*. This became a really popular design after the movie, and it's been ripped off by just about every video game since. The plan was to use a real-life weapon on set and just package it up to look like it was futuristic technology. We did a ballistics test at Pinewood Studios and fired off a bunch of potential weapons because I wanted to see which had the brightest muzzle flash. When the marines used it, I wanted the room to be lit up like an old gangster movie. And funnily enough, we wound up going with the classic gangster weapon, the .45 Thompson, or "Tommy gun." This illustration was just me repackaging the Thompson machine gun to look like the Pulse Rifle, and adding in the under-barrel grenade launcher that was just a 12-gauge shotgun in real life. After I came up with this design it was up to the armorers to figure out how to get the Thompson machine gun to look like it, and they did a pretty good job.

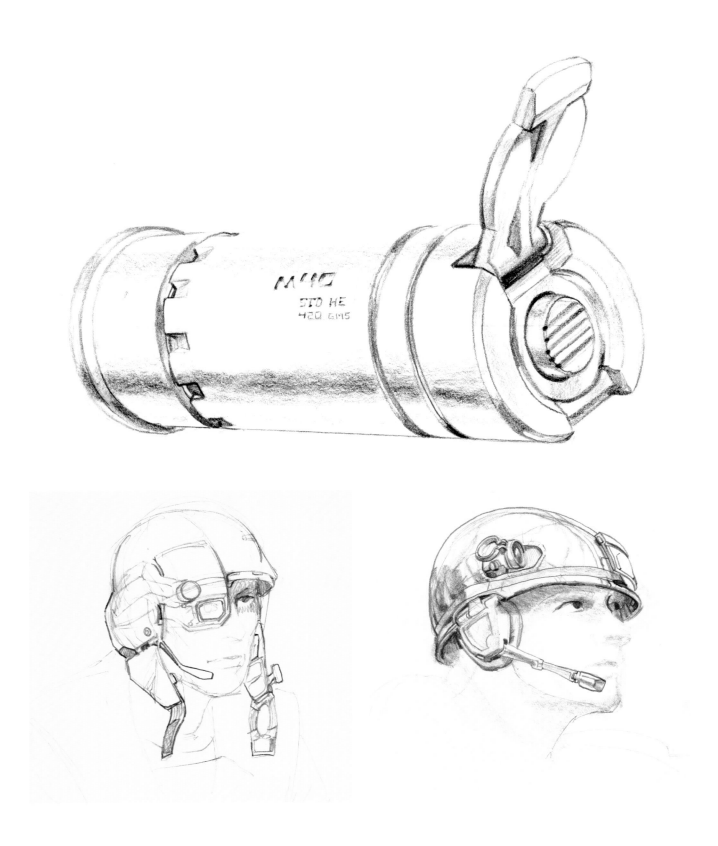

I designed the little explosive grenade at the top of this page that Lt. Gorman uses to detonate himself and Vasquez when they get cornered by xenomorphs. It's got this double push switch, which I thought was a good way of futurizing the concept of a grenade. The helmet concepts at the bottom and on the right-hand page were sketches that I would give to Emma Porteous to build. Again, I had to make sure they were very detailed so that she knew exactly what to make. The bottom left helmet is something that we didn't end up using, but the bottom right and opposite images are pretty close to the final helmet props.

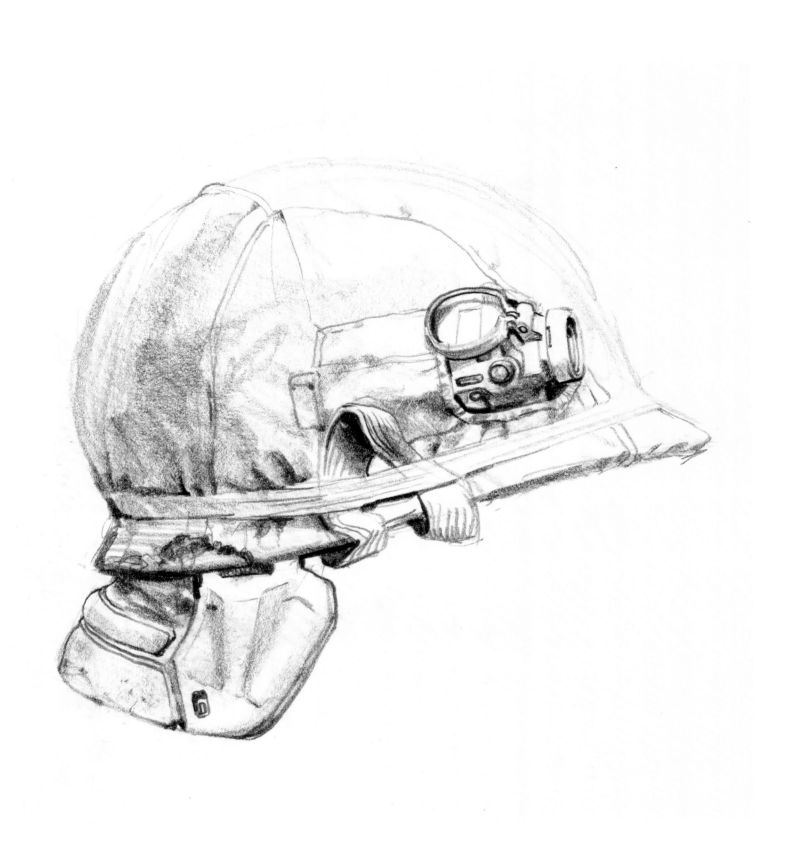

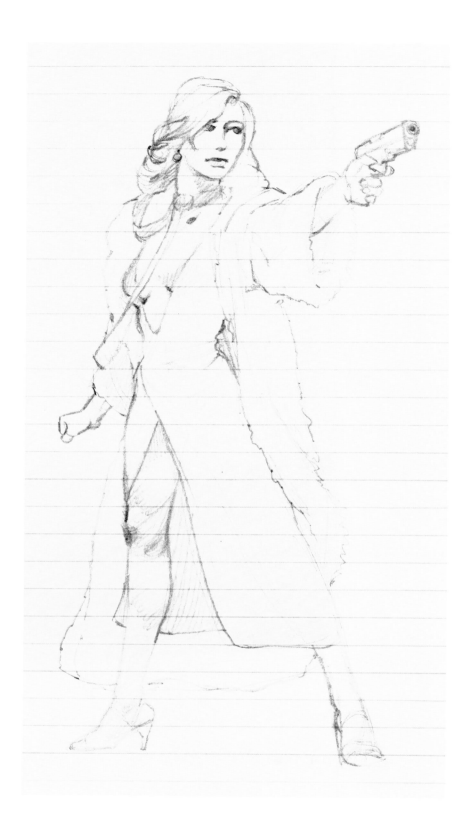

THE MAGIC MAN

The film *Strange Days* would ultimately be directed by Kathryn Bigelow—to whom I had previously been married—and released in 1995, but it was based on a story idea called *The Magic Man* that I came up with back in 1983, before I was hired to write *Aliens*. It was a film noir–style science fiction piece and very influenced by author William Gibson and the cyberpunk genre he initiated, which was a big deal at the time. I saw it as a Sam Spade–type crime thriller set in the future, and that's apparent in the figure on the right-hand page with the slouched hat, dangling a cigarette out of his mouth like Humphrey Bogart. And above right there's a femme fatale noir villainess with a pistol, a long, flowing mink coat, and a low-cut evening gown. Classic noir ideas but juxtaposed with wild futuristic imagery, like the zebra-haired girl above left who I think was supposed to be a dancer at a nightclub. I was just mashing stuff up, but I knew the story I wanted to tell.

It was about a guy who trades in memories, which in the story can be recorded and played back using an illegal device that plugs right into the user's cerebral cortex. I set the story on New Year's Eve 1999, the eve of the new millennium, which I thought was a cool setup. I actually pitched it to David Giler and his team the same day they hired me to write the *Aliens* treatment. They weren't interested in it and instead asked me to write some kind of "*Spartacus* in space," swords-and-sandals thing they wanted to make. I got up and said, "Okay, we didn't click on that one" and started to leave. I basically threw myself out of their office. I'm walking down the hall, and Giler yells, "Hey, wait! Come back!" I stuck my head through the doorway of his office and went, "Yeah?" He says, "We got this other thing that's been kicking around for a while: *Alien 2*." And if you could take a picture of my brain at that point, it's like a Vegas slot machine hitting the jackpot, like *ding-ding-ding-ding-ding*!

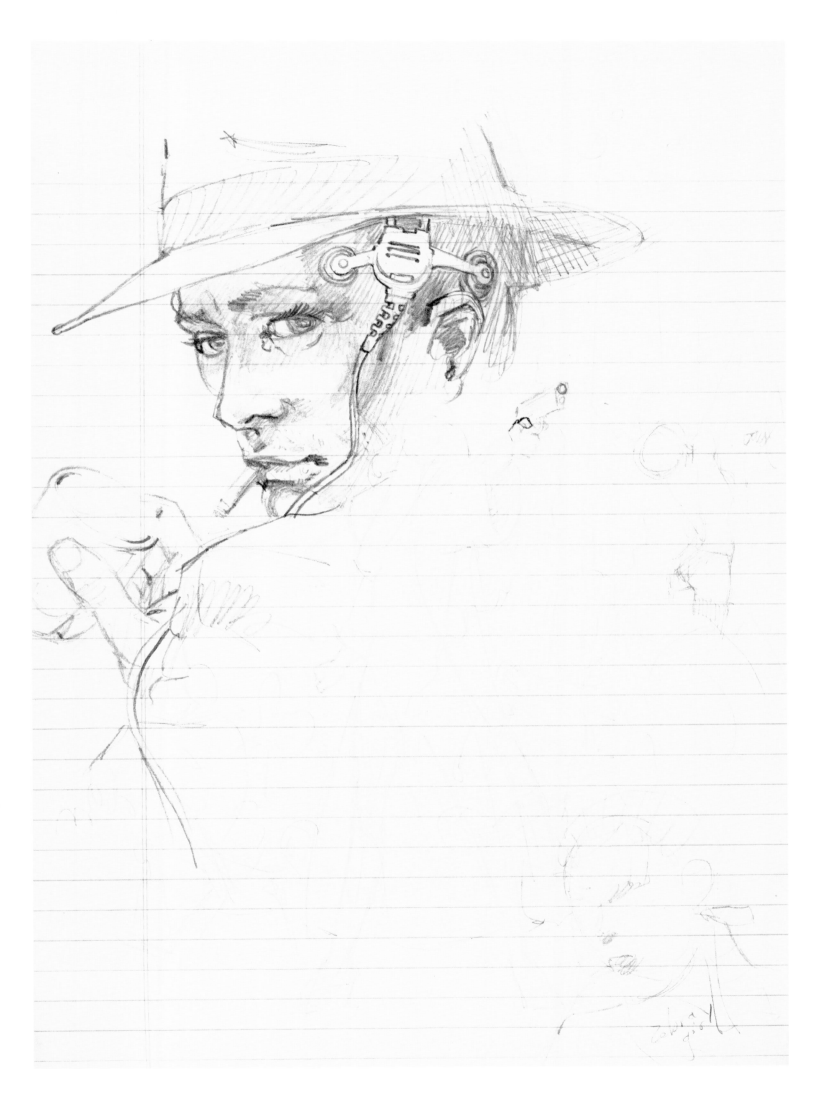

CYBERNETIC ORGANISM

I wrote the script for *The Terminator* in late 1982. Almost all my art for *The Terminator* preceded the start of production. There was like a year interregnum between the time we cast Arnold Schwarzenegger as the Terminator and when I knew we were making the movie. I hired him after he had done *Conan the Barbarian* (1982) and then the producer of that film, Dino De Laurentiis, swooped in and accelerated the sequel, *Conan the Destroyer*, because he didn't want to be in a queue waiting for Arnold to finish *The Terminator*. That put us in a holding pattern for six months, and I ended up using that time to do a lot of the design work.

Then, in fall 1983, I got my first-ever paid writing gig on *Rambo: First Blood Part II*. The problem was that I got my second paid writing gig on the same day, which was *Aliens*. I was also provisionally going to be the director on *Aliens*, but that was by no means a definite thing. When I got double-booked, I called up Giler and said, "David, what the fuck am I supposed to do here? These guys just hired me to do a script for *Rambo*, and you guys have just offered me the script for *Alien 2*." He said, "Don't be an asshole, take both jobs. Take a lot of drugs and deliver both scripts." I said, "I don't take drugs." And he said, "Well, you better drink a lot of fucking coffee then." So that's what I did.

But I wasn't able to finish the *Aliens* screenplay in time because *The Terminator* was looming, and I had to turn my attention to directing. I turned in sixty-two pages and Giler started yelling at me. I said, "David, I've got to start prep on *Terminator*. I've got to start shooting." He goes, "You're fucking us! You'll never work in this town again!" He literally said that, and I thought, "Oh, I'm fucked now." So I called Walter Hill. He goes, "Alright, this is kind of fucked, but you've got pages, right?" I sent it over to him and he calls me back the next day and says, "It's really good. We're making this movie. We'll wait for you." I said, "Really?" He says, "Yeah. Go make *The Terminator*. It'll strengthen your case to be the director on *Aliens*." I said, "Great. You got any advice?" He said, "Yeah, don't fuck it up." So, whenever a filmmaker asks me for advice, I just pass on Walter's: "Don't fuck it up."

The image on the right-hand page is my original concept for *The Terminator*, which was done before I had written a treatment for the film and way before I had met Arnold. I initially wanted the Terminator to be a very average-looking guy, slightly threatening, but certainly not a big human bulldozer. And then, of course, beneath the flesh he was going to have a robotic endoskeleton. This piece shows the Terminator after his first big shootout with Kyle Reese, where chunks of his flesh have been blown away and parts of the endoskeleton are visible. It pretty much tracks with what's in the final movie despite being conceptualized long before we started shooting.

The sketch at the top left shows a concept I discarded early on. I had this idea that when the Terminator is chasing Sarah and Kyle around the factory in the film's finale, all the lights would be off because it's nighttime. So the Terminator would reach up, pull a fluorescent tube out of a light fixture, energize it with his metal hand, and wave it around to try to find them in the darkness. But ultimately, I thought it would look too much like a lightsaber. Plus, elsewhere in the script I'd made a virtue out of him having infrared vision, so logically he'd be able to track them in the darkness anyway.

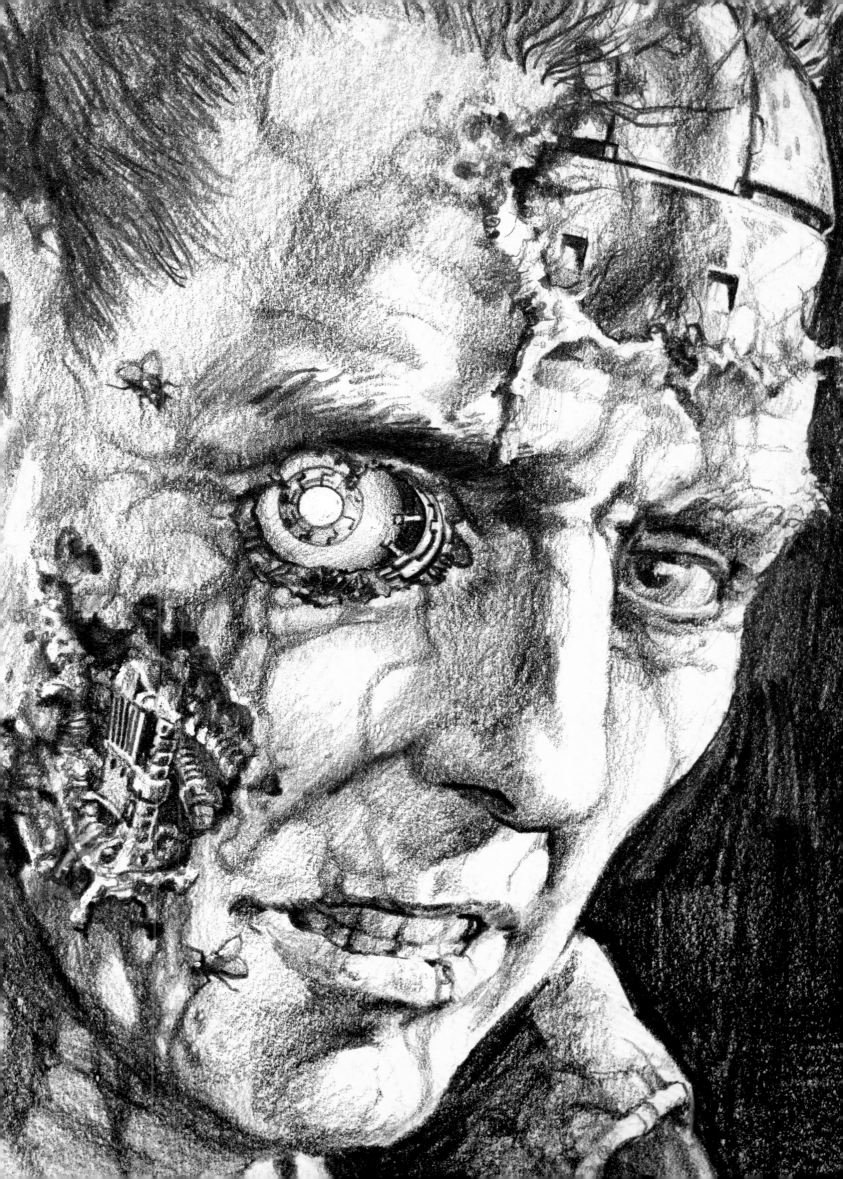

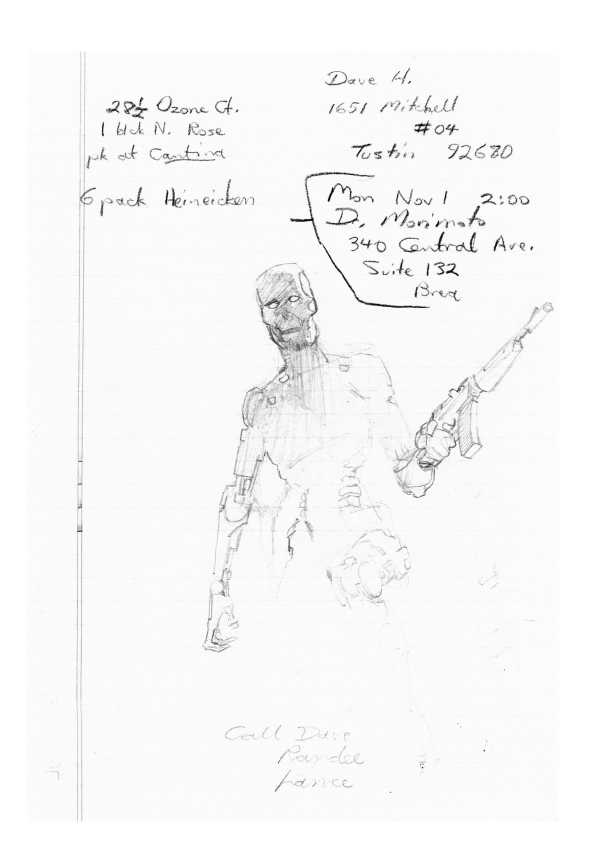

On the right is the seminal image of *The Terminator* that kickstarted the project. It came to me in a dream. Postproduction on *Piranha II* was happening in Rome, so I went over there to find out what state the film was in and try to get my name taken off it if it sucked, which I knew it would. I was broke and staying in a pensione when I got sick and had this fever dream—a chrome skeleton emerging out of a wall of fire. Dreams are pictures, but I believe they're pictures that come with coded narrative elements, so you always know what the picture means. They don't exist in a vacuum—there's a subconscious coding that goes with them, almost like captions that the dreamer can read. I interpreted the dream to mean that this robot originally looked human but the fire burned off his skin, and that's where the idea for *The Terminator* originated. When I drew this image, I added the gun as I thought it would make him look more threatening. The gun idea fell away in the actual story, though, plus he

felt threatening enough just emerging from the fire, so it wasn't needed. I did this piece before I wrote the treatment, because there are certain images that to me are non-negotiable going into the writing process, and I like to stamp them. I just stick them up on the wall, and I say, "I gotta get to that. But how? Where does the fire come from?" And from that I'll decide, "Oh, obviously it would take an exploding gas truck to generate that kind of heat." So in this case, the image came first and then I had to develop the narrative to account for it. The image was Prismacolor pencils on black. Sadly, I don't own the original, as somebody nicked it from the art department. It'll probably show up on eBay at some point after I'm dead. The image on the left-hand page is obviously a study for the final drawing, but I ended up changing the finished piece a bit. I dropped the leg down a little and made him more silhouetted, so his facial features were wreathed in shadow.

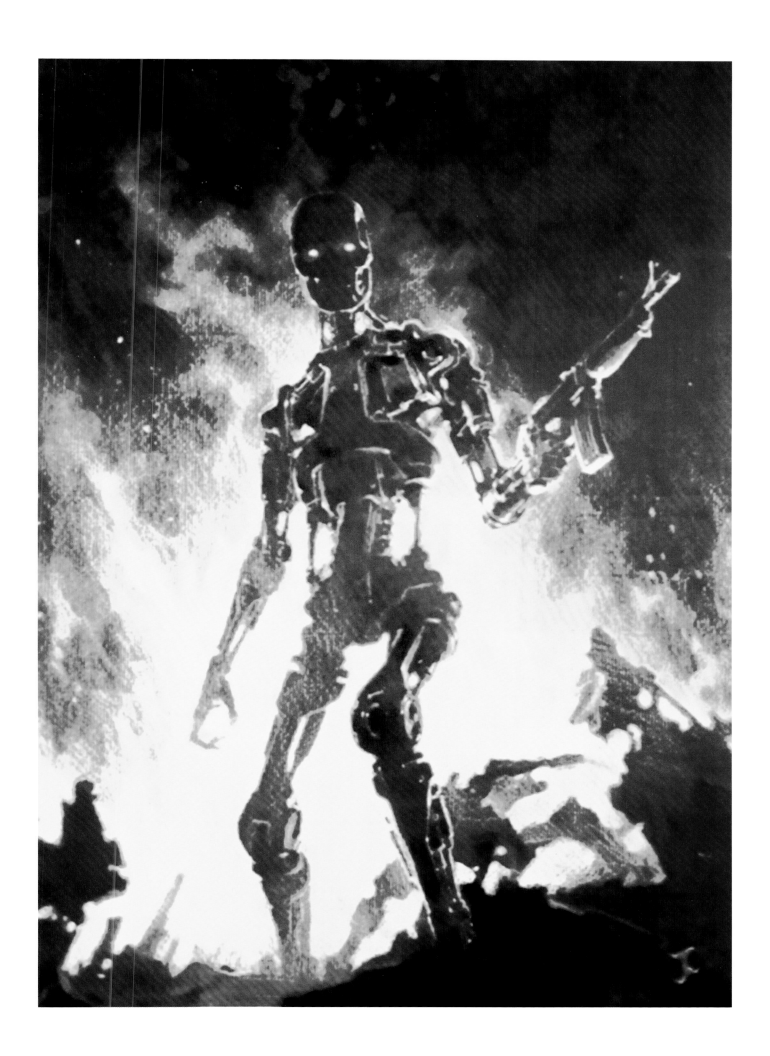

These are storyboards I created for *The Terminator* in late spring / early summer 1983. It was the interim between when I cast Arnold and when we started shooting the movie in February 1984. I was a busy little bee during this period. I was doing these storyboards, plus I was writing *Aliens* and *Rambo* and doing rewrites on *The Terminator*. It took a lot of coffee and the occasional diet pill. I didn't do speed, but diet pills came in handy when I had to do a push for an extra twelve hours with no sleep. When I worked for Roger Corman, I saw people get burned out doing speed and coke. It was brutal, and they were just dropping like flies. They just pulled the eject handle, and when they got out of rehab, they dropped out of the film industry and became carpenters or whatever. So I avoided that stuff.

I had two styles that I used at the time; one was the black paper style with Prismacolor pencils, and the other one was the brown or gray paper style. The latter allowed me to do full chiaroscuro—I could use white Prismacolor

pencils to get a higher value or use the black to get a lower tone. And I used this method quite a lot because I felt it created lucidity in the drawings. The storyboards depict the scene in which the Terminator retreats to a hotel room to repair himself after being in a gun battle with Reese, and if you compare them to the final film, you can see I hit the frames pretty exactly. I was working with Stan Winston on the special effects, but he wasn't quite visualizing what I wanted, so I included step-by-step visuals that showed how some of these effects could be achieved on set. Then it was up to his team to execute on that. The only thing that I regret is that we didn't do the forearm the way I drew it because you can see in these images that he was supposed to really flense back the skin and expose his skeletal structure. Stan's team built a good piece for the wrist, but to me it always looked like it might be a makeup on somebody's arm rather than a completely synthetic limb. But we didn't have much money and we were in a big hurry, so it was good enough for our purposes.

These storyboards show the moment where the Terminator uses a scalpel to remove his damaged eye. I asked Stan if we could make a realistic head puppet and then have his guys perform the character's arms and hands. I showed him these drawings and he got super excited. He could totally see how it worked, so it was just a case of finding people whose hands were as thick-fingered as Arnold's—having been Mr. Universe, he had these big-knuckled hands, because joints actually grow when bodybuilders put that much force on them repeatedly. But we managed to find a couple of guys that had big hands and taught them how to perform the Terminator's hand movements in frame with the head puppet. When I look at the movie now, I go, "Eh, that's totally a rubber head." It doesn't hold up. But people bought it at the time because they didn't know to look for it, I think. These days you'd have Arnold perform the scene and use digital effects to add in the cybernetic elements, but this was way before CG.

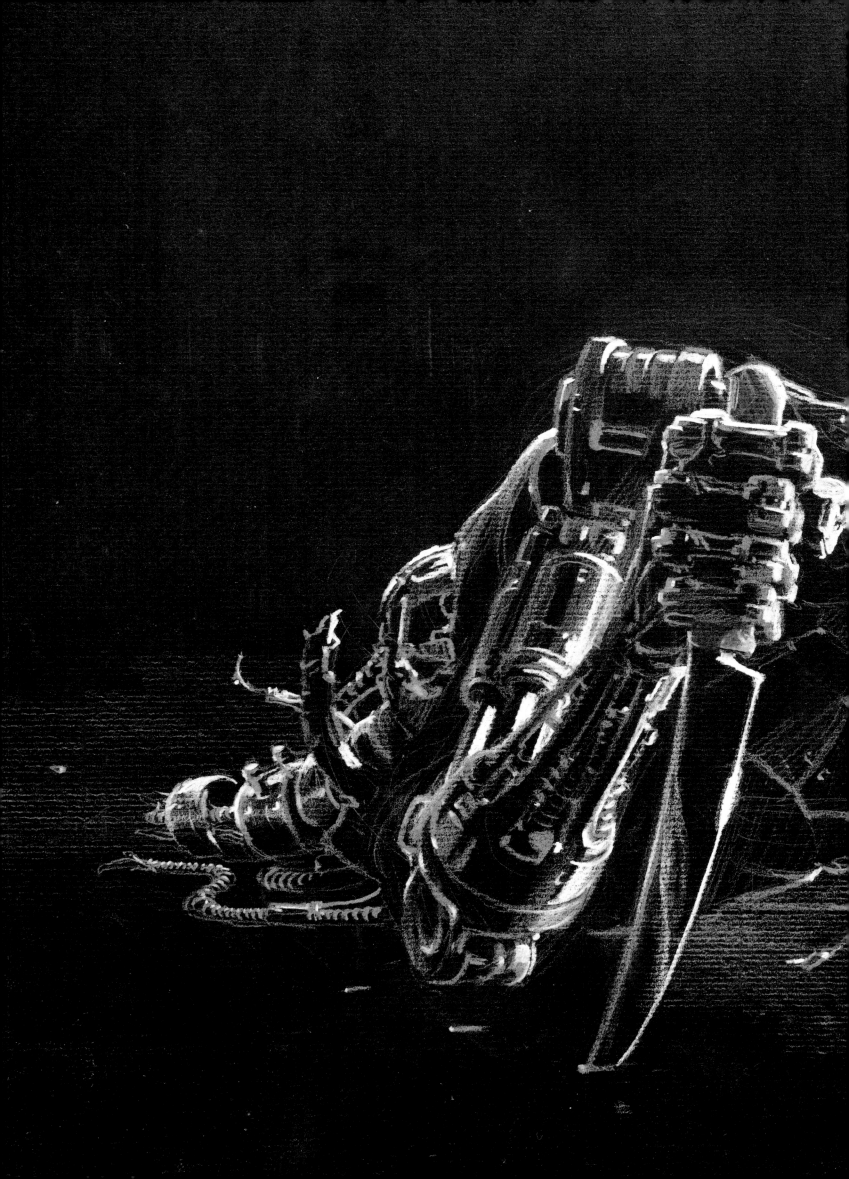

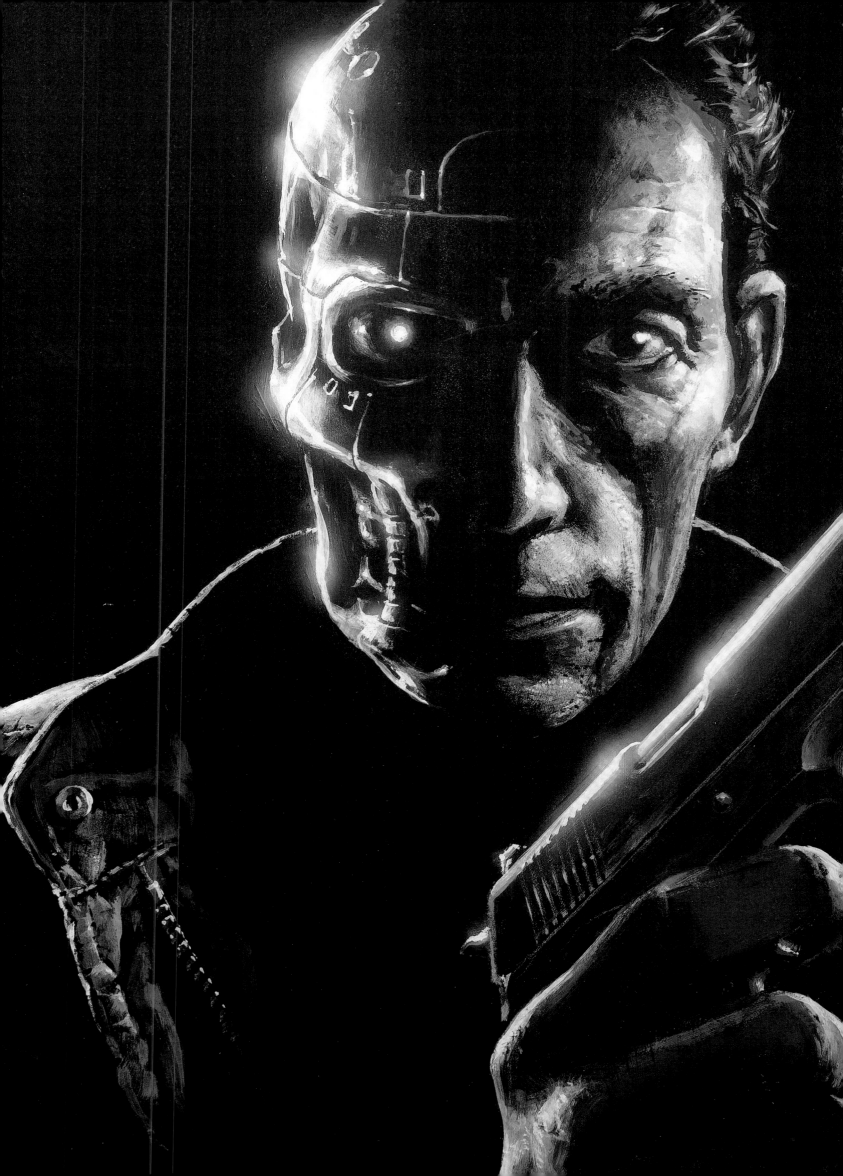

There's definitely an aspect of John Carpenter's
Halloween in *The Terminator*—the relentless Michael
Myers figure that just won't die and who kills people
with knives and household implements.

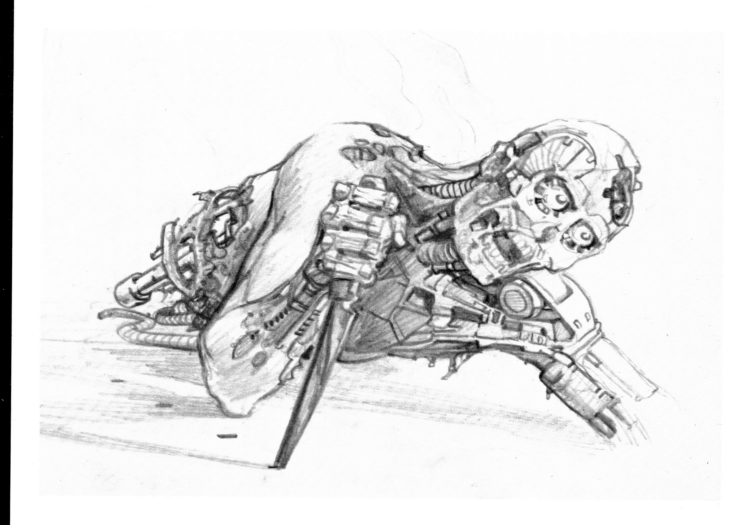

At the time I drew these images I hadn't come up with the full story for *The Terminator,* but I was basically thinking it would be a slasher horror film with a science fiction element. There's definitely an aspect of John Carpenter's *Halloween* in *The Terminator*—the relentless Michael Myers figure that just won't die and who kills people with knives and household implements. So in this image, the Terminator is revealed to be this robotic killer, and he's been cut in half. But he's still coming after his target and is using a knife to pull himself across the floor. I visualized this scene as taking place in a mundane setting, maybe a household kitchen, and just out of frame would be the girl that he's hell-bent on killing. You can even see the pick marks in the linoleum floor where he's been dragging himself along with the knife. I actually did this one after my trip to Rome. I went back to L.A. and bummed around. I had no money, so I slept on Randy's couch. But during this period, the story elements for *The Terminator* really started to come together. At one point, I had two Terminators in the story. There was the cyborg version, who gets chopped in half and killed halfway through the movie. Then Skynet sent a second Terminator, the one they were afraid to send the first time but now have no choice: a liquid metal Terminator. But when push came to shove, I knew enough about special effects and stop-motion that I couldn't imagine how we were going to do a liquid metal character. I was visualizing a very advanced version of Claymation that had projections of mercury on the surface to give it a dynamic, fluid appearance. I could imagine it, but I didn't think we could do it, so I cut it out. And of course, I circled back to the idea years later and that liquid metal Terminator became the T-1000 in *Terminator 2: Judgment Day*. So I never dispose of a perfectly good idea. I just admit defeat once in a while and put it back on the shelf.

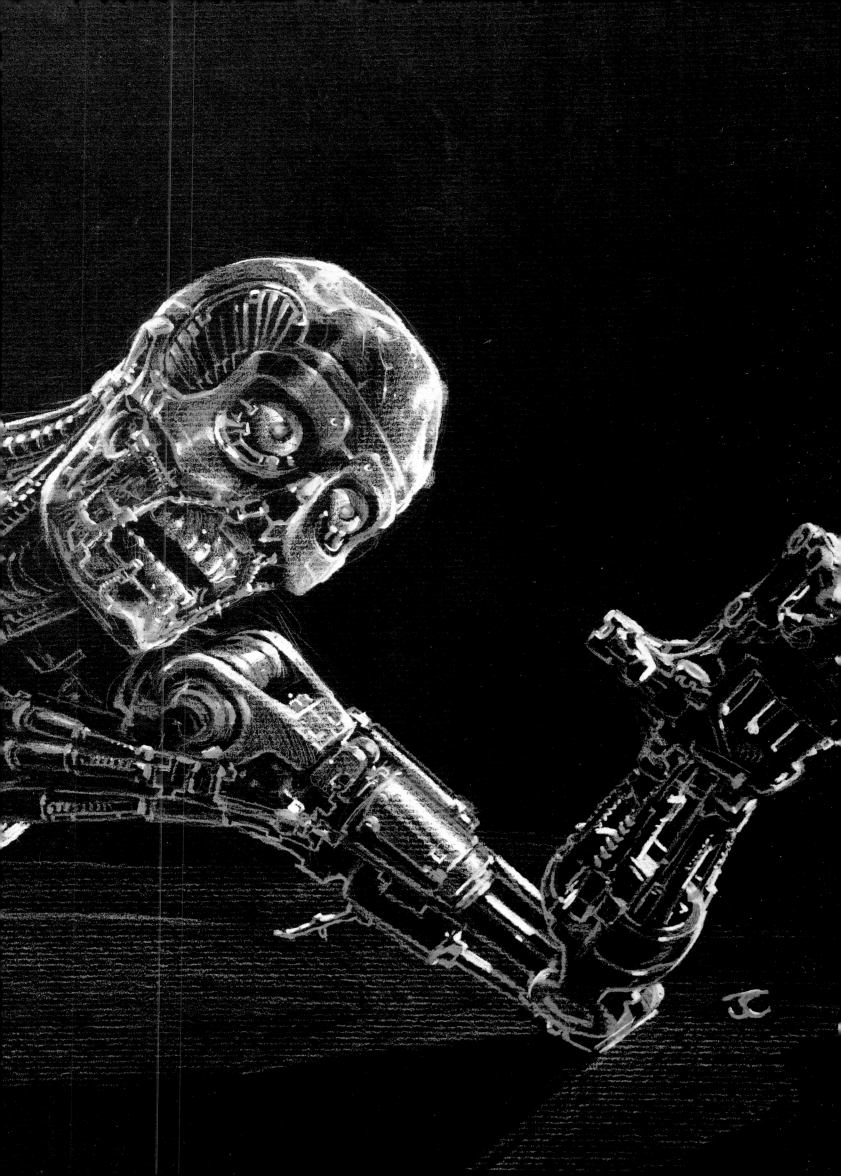

I think the image on the left was done around the time I got my first agent. I told him my idea for *The Terminator*: "Alright, there's a hit man that gets sent from the future, and he's a robot, and he's gonna kill this waitress because she's super important in the future, but she's absolutely a nobody and has no sense of greatness about her whatsoever in the present day." He said, "Terrible idea. Don't write that." Fortunately, I sensed that he was dead wrong, and I just ignored him. It's funny because I was nobody at the time: I was two rungs below the bottom of the ladder and still ignoring my agent's advice.

The guy in this image is Lance Henriksen, who would later go on to be a well-known character actor. Lance was the lead in *Piranha II* and, even though I was only on that movie for a few days before I got fired, we really hit it off. He and I stayed pals and at one point I asked him if he wanted to play the Terminator role. He said yes, so I took a photo of him and then developed it into this drawing, which was meant to be a sales piece I could use to help get the film made. At this stage, I had written a treatment for the movie, and I was still thinking the Terminator would be an average-looking, somewhat threatening guy. When I met Arnold, I totally caved and reconceptualized the character on the spot. But ultimately it was the right move, and I found Lance another role in the film, so he was happy. But Lance loved this painting, and he had a bunch of prints made. And then later I retooled the concept with Arnold, as you can see on the right-hand page. He posed for the illustration in a different position than Lance, with the gun starting to come forward to shoot, almost reminiscent of the Jack Palance *Portrait of a Hitman* poster. When I look at this now, it seems like a bit of a cartoon and his hand is way too big. But I was trying to show that a big .45 weapon would look small in the Terminator's hand. Overall, it reads pretty well, though. For years, Arnold had this picture hanging up at his Oak Productions office in Venice. Or maybe he only puts it up there when I come over . . .

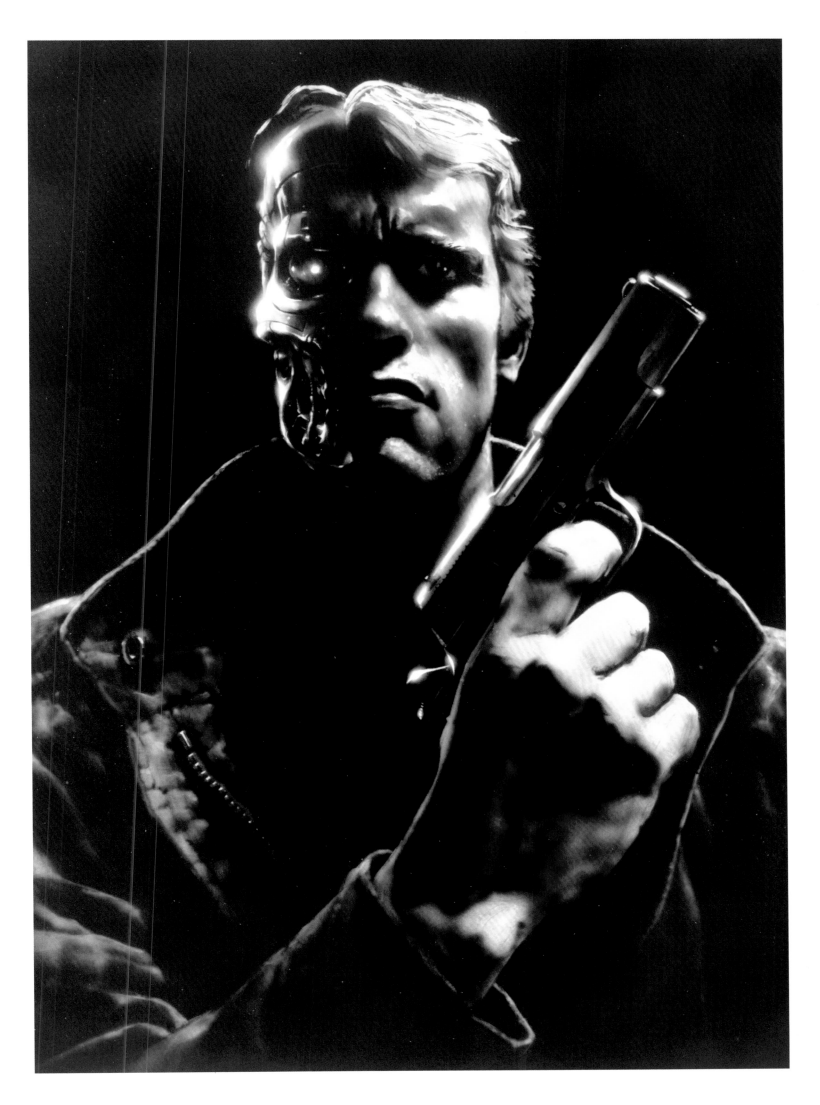

FLUID DYNAMICS

Jumping forward, these are sketches I did during preproduction on *Terminator 2* around the summer of 1990. I was working with visual effects supervisor Dennis Muren and the guys at ILM and trying to figure out how the T-1000 would re-form after being frozen and then broken into bits during the film's finale. I didn't want it to look like a plastic soldier melting into the ground and played in reverse—I thought we could do something more interesting. I wanted him arched over in a u-shape so his head is touching the ground and then to rise up that way, straightening his back, so I drew these images to illustrate that motion. But at this point in my career I was doing very little production art myself as I was in a position to hire teams of world-class artists to do it for me. We had Doug Chiang at ILM, who is now creative director at Lucasfilm. And in-house we had Steve Burg, who had worked with me on *The Abyss* (1989). Steve designed a lot of the future-war elements for the film. The Stan Winston Studio did a lot of the designs for the T-1000. We had different names for them, like Saucehead when he gets shot in the face and his head gets split in half. And Pizzaface, which is when he gets blasted in the face with a machine gun and it kinda looks like a bunch of pepperoni. Those designs were a lot of fun.

Stan Winston Studio did a lot of the designs for
the T-1000. We had different names for them,
like Saucehead when he gets shot in the face
and his head gets split in half.

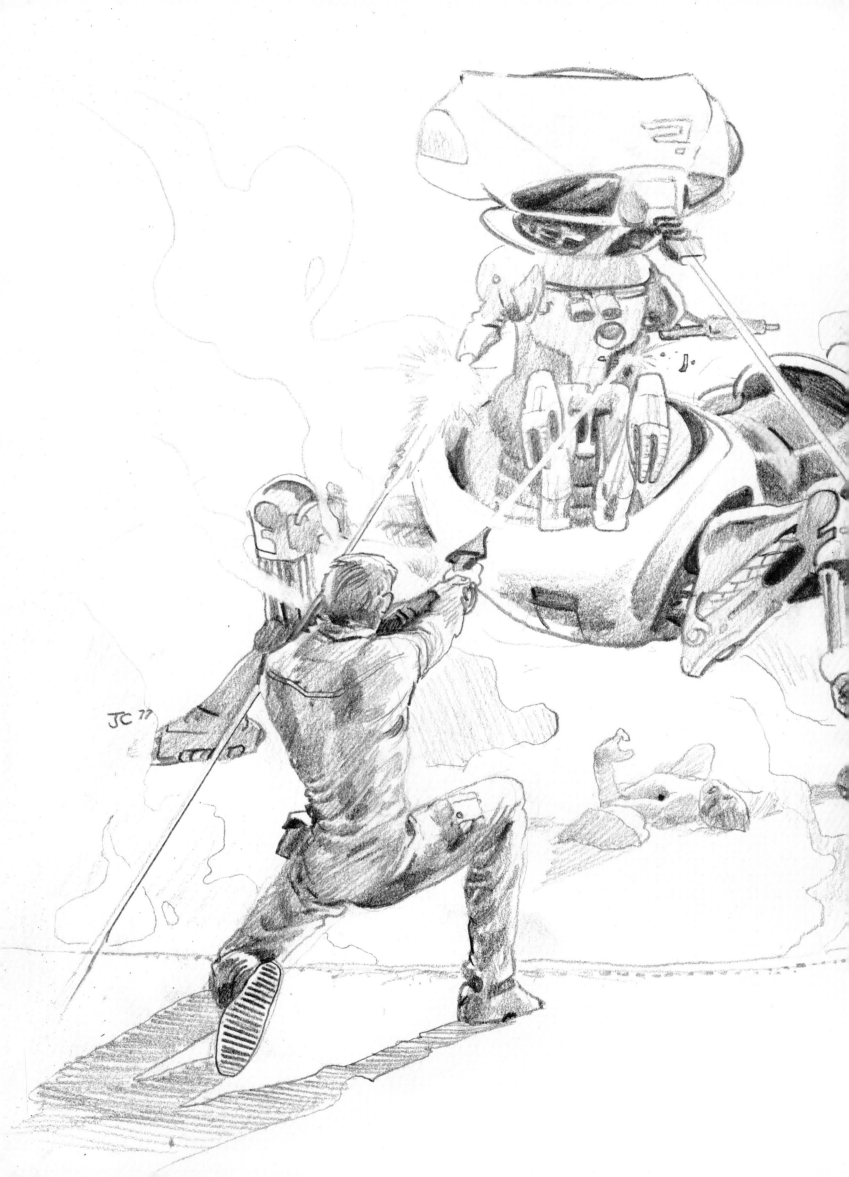

Repair scene
— radiator fin damaged, Jorden
must climb it in spider and
seal off damage before drives can
be ignited.

HUNTER KILLERS

As I mentioned, the ground-based Hunter-Killer robots from *The Terminator*'s future war scenes were a continuation of a sentry robot design I created for *Xenogenesis*. At one point in that story, the heroes visit what's left of a highly technological alien civilization that died out thousands of years before they arrived. It's maintained by these big sentry machines, and when one of them tries to kill Jorden, Lori uses a four-legged vehicle called a Spider to fight it off. If that sounds at all familiar, it's because I took the concept and put it into *Mother*, where it got scaled down slightly and became more like an exosuit. And then when I was writing *Aliens*, I scaled it up again to become the Power Loader. As I keep telling everybody who works on my movies, I only have three or four great ideas and I just keep repackaging them.

The sketch on the left-hand page is not related to *The Terminator* or *Xenogenesis*—it's just me screwing around circa 1976, but there's some similarity between the design of the robot character and the Spider, which can be seen at the top right. That image shows the Spider repairing a radiator fin on the *Cosmos Kindred*, which is the kind of task it was designed for. The idea was it had magnetic feet that would allow it to walk around the exterior of the starship and manipulators that could do repairs, so whenever the ship needed to be fixed, a human crew member was expected to pilot the Spider out there and get it done.

MOLOCH

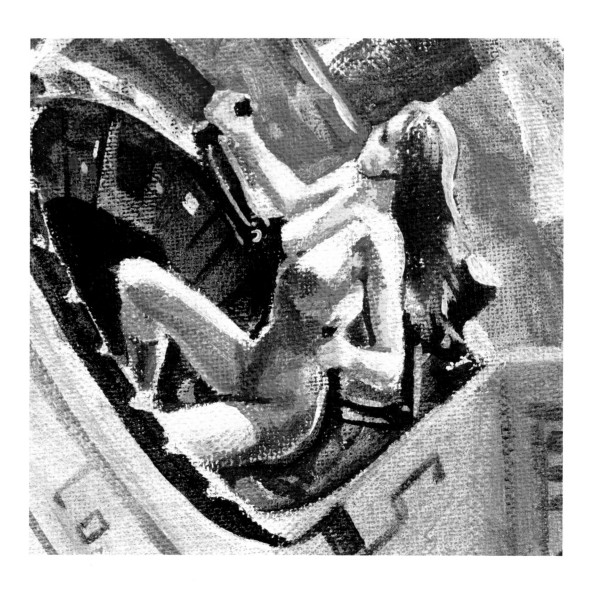

On the right-hand page is an illustration that I created of Lori using the Spider to fight the sentry robot. It was part of the batch of art I did when we were trying to get funding for *Xenogenesis*. This was around the time that *Star Wars* came out in 1977 and energized the whole science fiction scene. It made a boodle and suddenly everybody wanted to do *Star Wars*, which was great for me and Randy because when we were trying to get *Xenogenesis* off the ground, we stumbled across these guys who wanted to put up some seed money to get a feature film going. We presented ourselves as the young hotshot, superstar sci-fi guys who could design, shoot, and write movies—even though we had no proof we could do any of that stuff. But they believed us enough to give us the forty grand we needed to shoot a ten- to fifteen-minute *Xenogenesis* pilot. Now, there's no such thing as a pilot for a feature film—you make pilots for TV shows. But we called it a pilot and thought we would be able to shop it around and raise enough money to do a full feature version. So that's I how I funded my existence for a little while. We didn't take very much of the seed money ourselves; most of it went into camera rentals, set construction, and that kind of thing. I think I also ran through my wife's Visa card and she wasn't too happy about it. So I was a big-time asshole at that point.

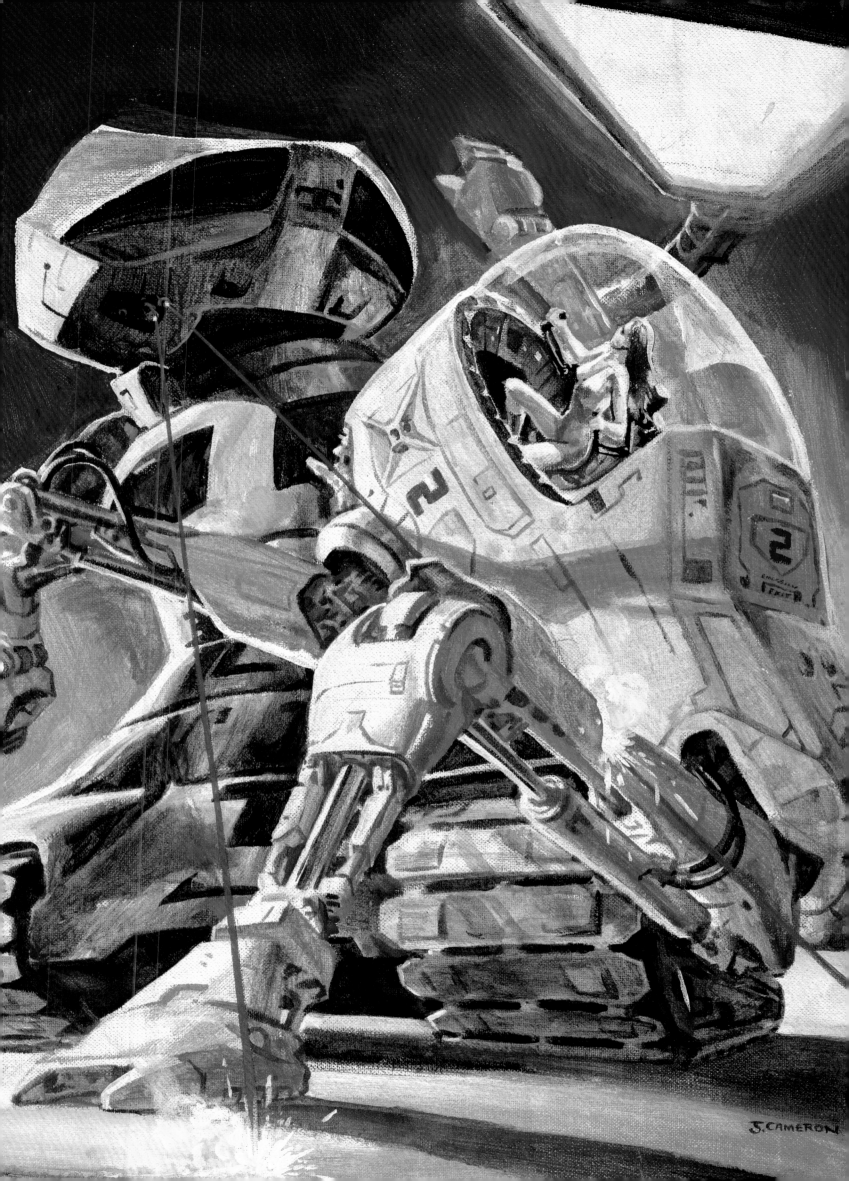

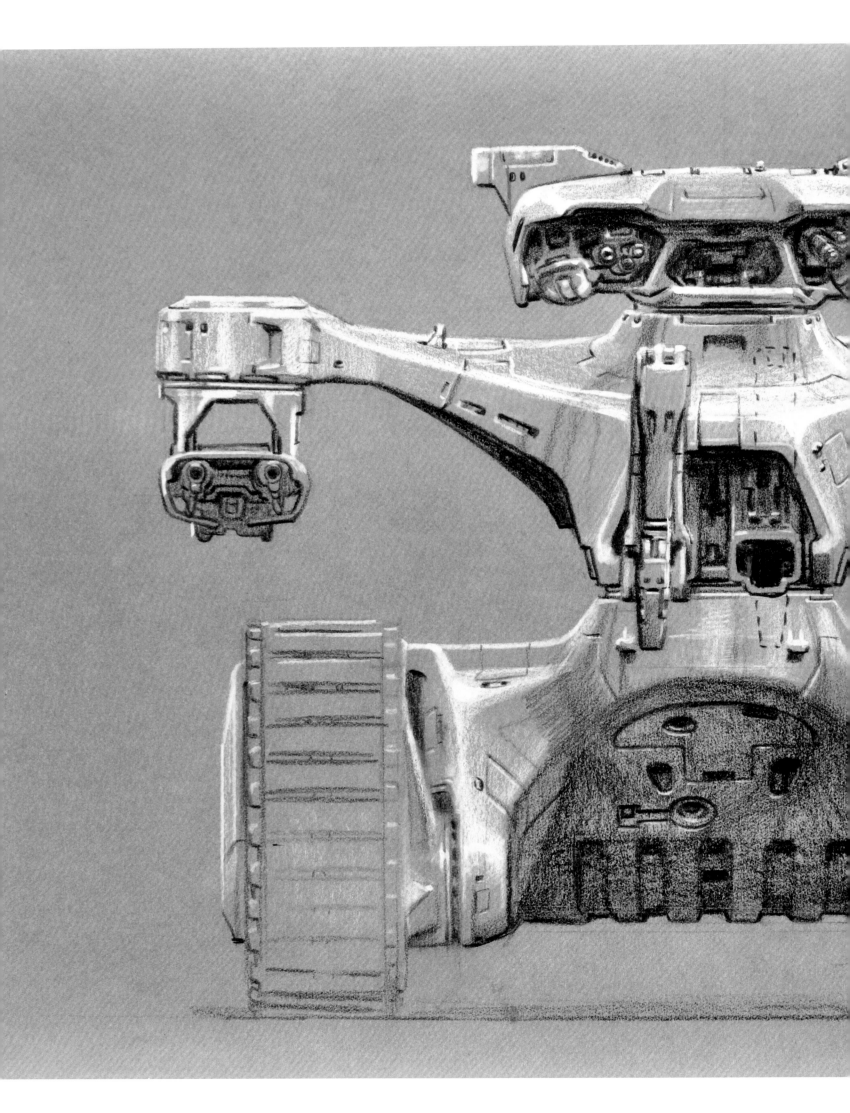

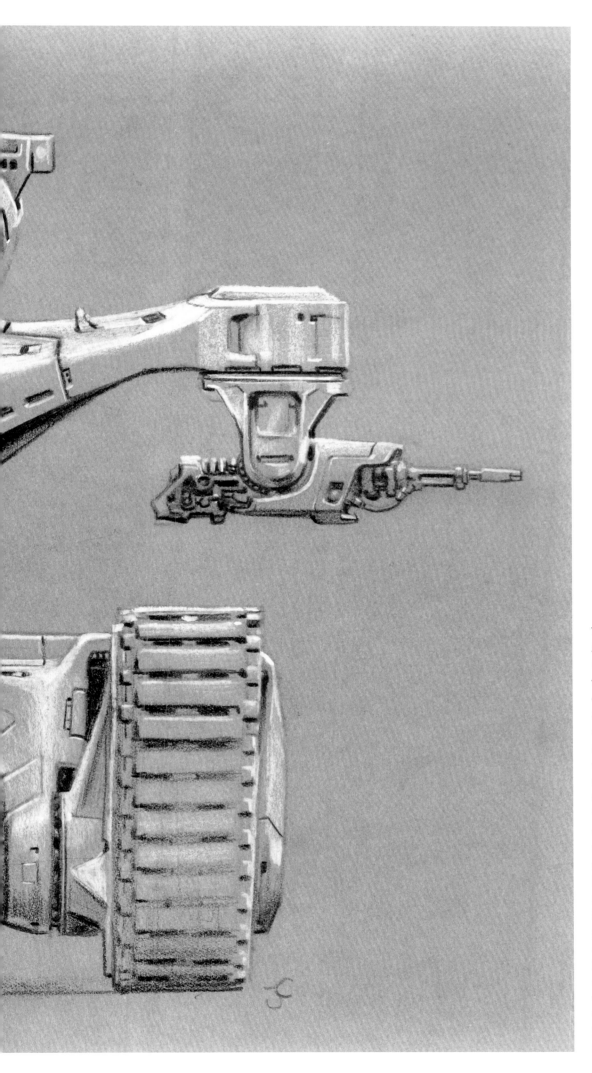

The concept for the sentry robot from *Xenogenesis* leads inexorably to the Hunter-Killer from *The Terminator*, which I would design about four years later. This drawing was done at a point when I was in active preproduction on the film and the model builders needed to construct the miniature Hunter-Killer model for the future war scenes. This is not a gestural drawing or a sales piece; this is a working illustration that I would take to the shop and say, "Build this exact thing." So it's very detailed and precise. I didn't have access to great concept designers, I couldn't afford them. We were so low-budget that I basically just did it all myself. I probably saved us a hundred grand in designers' fees by taking it all on and not charging the production. But I never did that again. On *Aliens*, which was my next film, I broke off half of the design work and got first-class designers to do it. By the time I got to the next film after that, *The Abyss*, I just worked with the designers and did very little art myself. And that's been the way I've worked ever since then.

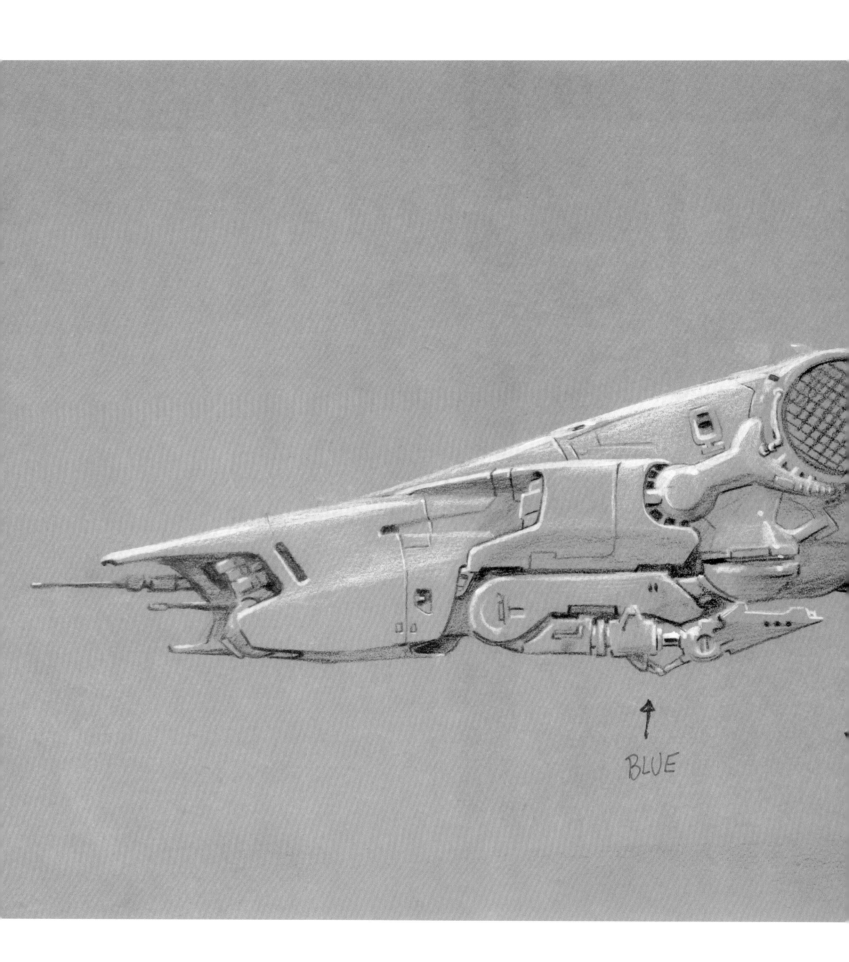

BLUE

This is a concept drawing for the flying version of the Hunter-Killer from *The Terminator*. It's a big vectored thrust vehicle with a very threatening front cowling that has optics in it that function kind of like eyeballs. It also has big insect-like legs that fold up underneath and were meant to deploy when it landed. I don't know if anybody ever picked up on that detail because we never showed it landing in the movie. But it was meant to be very insectile.

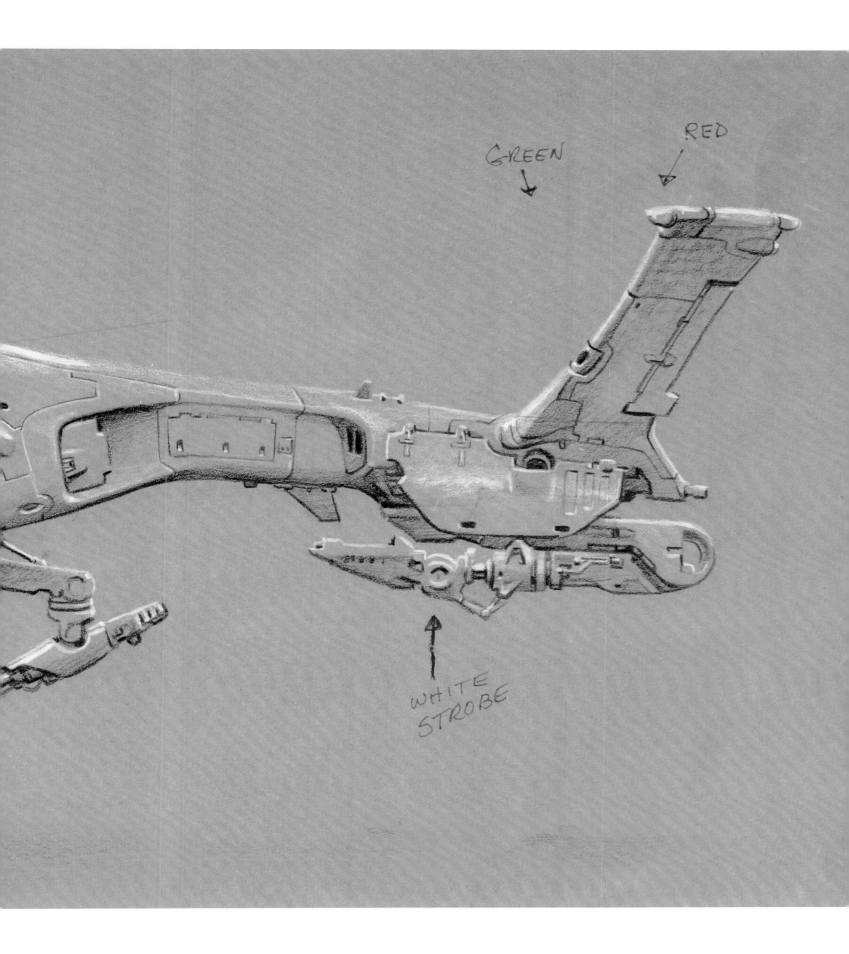

It also had big insect-like legs that folded up underneath and were meant to deploy when it landed.

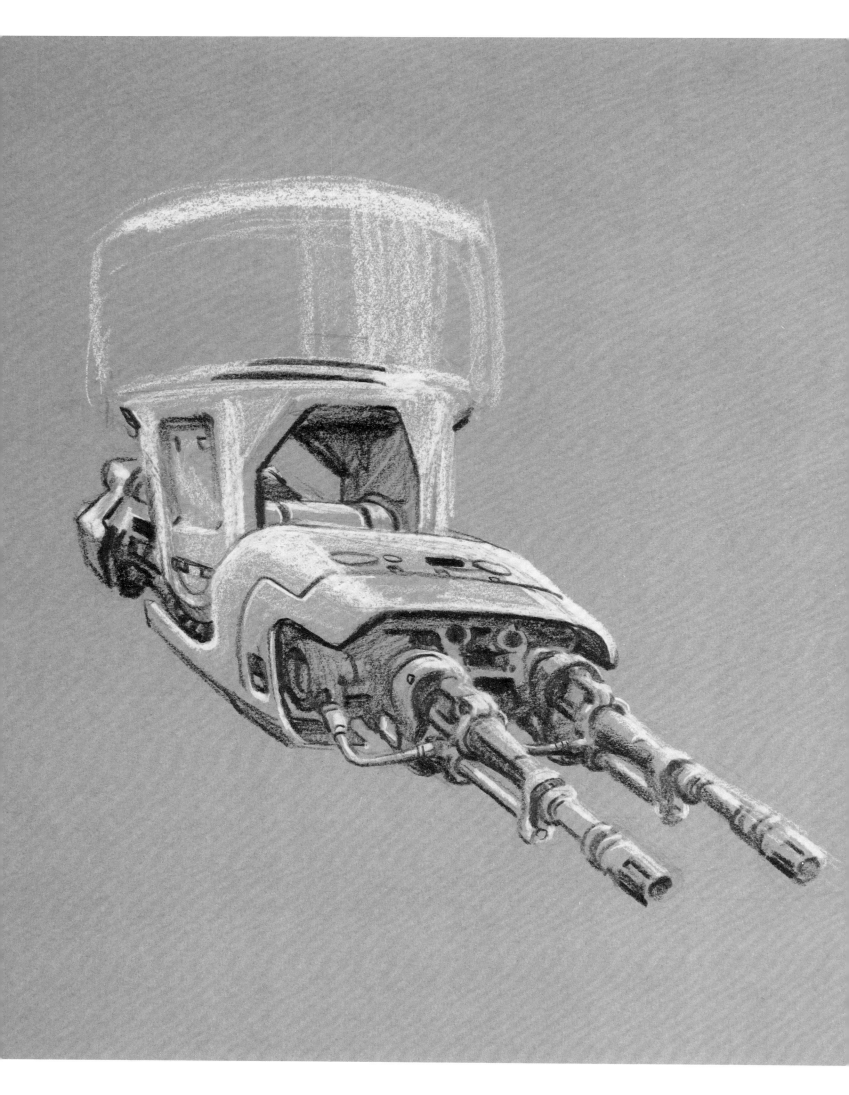

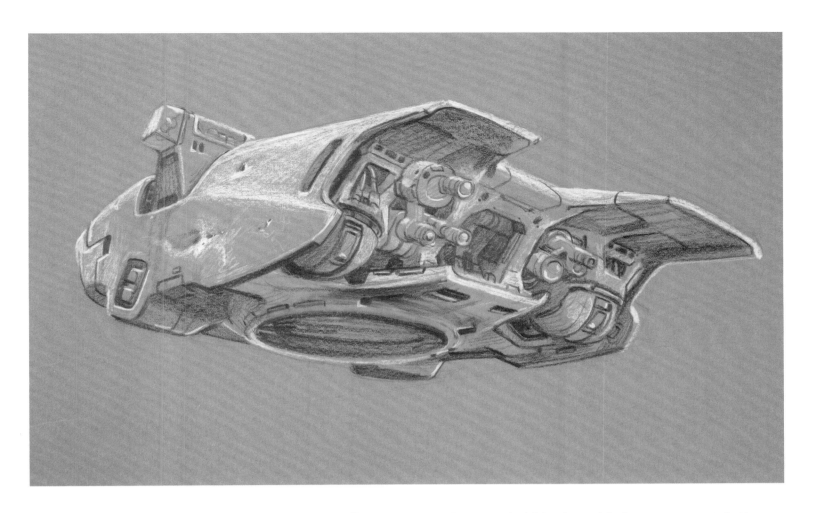

Above is my design for the headpiece of the ground-based Hunter-Killer. Its gun turret can be seen on the left-hand page. It had two separate turrets that hung from its shoulder pods. At the bottom is my design for the underside of the flying Hunter Killer. This was a working drawing for the benefit of the model shop, so I didn't even bother to finish one side of the tail fin because the design was symmetrical. The landing gear can be seen folded up, praying mantis–style, on the underside. You can tell this image was hanging up in a shop somewhere, as it's been sprayed with paint or some other substance. But these were practical, working drawings, and sometimes they'd get trashed during the course of making a film.

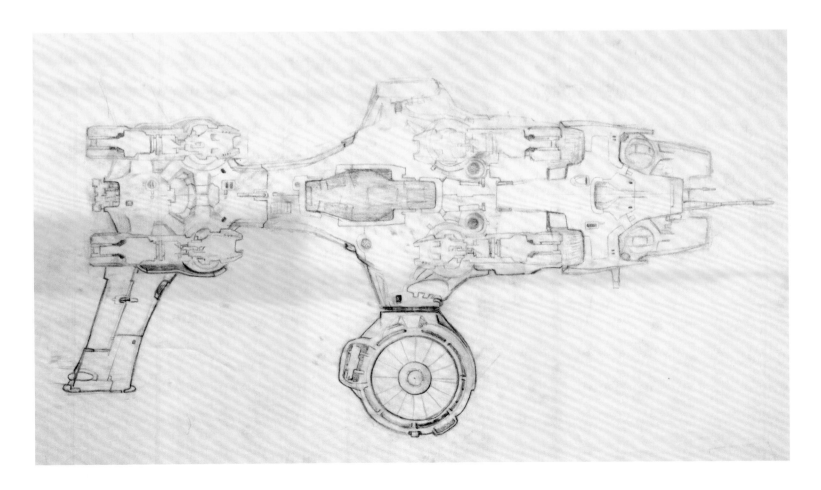

Xenomorphs

Having spent his teenage years devouring science fiction novels, it's perhaps no surprise that alien creatures would later figure prominently in Cameron's work. While his school notebooks are filled with sketches of outlandish creatures from all over the universe—some fearsome, some comical—it was Xenogenesis that gave Cameron the opportunity to fully unleash his creativity on a menagerie of extraterrestrial beasts.

But even during his school days, Cameron took a unique approach to his aliens that would become a cornerstone of his creature design technique: Every aspect of each alien's biology had to be logically considered and grounded in science, from the impact of the environment on its physiology to the physical characteristics that would actuate its abilities.

This method notably came into play when Cameron was hired to write and direct Aliens. Expanding on the work of Alien director Ridley Scott and H. R. Giger, designer of the film's titular xenomorph, Cameron extrapolated on the creature's life cycle to take the next logical step—introducing the creature that had given birth to the eggs seen in the original film. But although the Alien Queen would be a work of staggering imagination, her physical characteristics would be cribbed from real-world biology, one of Cameron's specialist subjects. Anchoring the look and behavior of the Alien Queen in the familiar yet nightmarish world of insects and killer sharks, Cameron developed a classic movie monster even more terrifying than its offspring.

While he oversaw the designs for the subaquatic extraterrestrials seen at the end of The Abyss, Cameron's true alien epic would have to wait until real-world technology caught up with his imagination. The world of Avatar would require not just alien designs, but a whole interrelated biome in which the people of Pandora, the Na'vi, live in perfect harmony with the environment and its creatures, even interfacing with the flora and fauna through a form of neural connection. Again, Cameron applied a thorough logic to the design of the creatures of Pandora. Not only would they need to look dynamic and exciting, but they would need a function within the ecosystem that he was creating. What was their place within this world? And how did they relate to the other creatures of Pandora and the Na'vi themselves?

The sheer level of detail that Cameron brings to his alien creations might not be immediately apparent to the average moviegoer, but subconsciously these creatures take root in our memories because they are beings that we believe in. In approaching his creatures like living things, Cameron invites us to do the same, ensuring that his creations are vivid enough to enter both our dreams and our nightmares.

This is one of many random alien designs that I did around the time that Randy Frakes and I were developing *Xenogenesis*, somewhere between 1976 and 1978. It was a very fertile period when I was imagining all kinds of alien creatures.

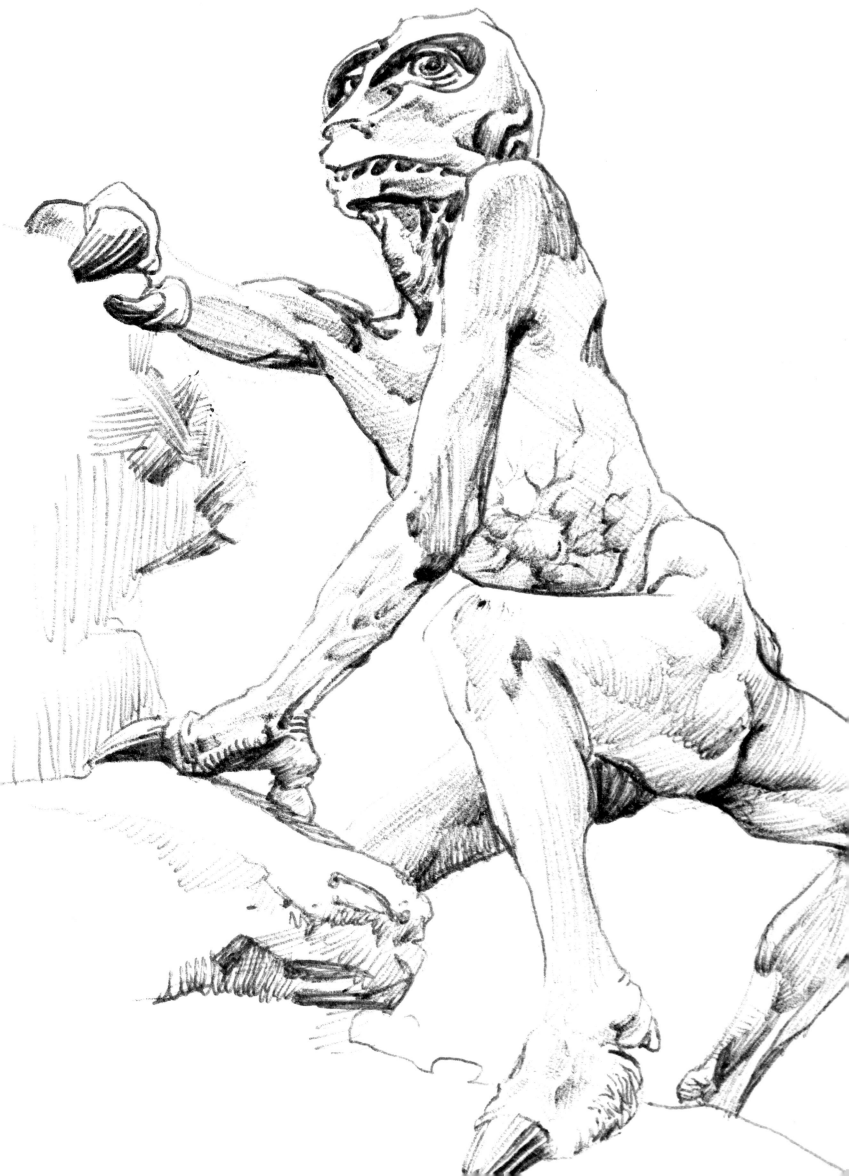

Really, it was just an excuse for Randy and me to pack the story with a lot of cool planets, and so we needed a lot of cool aliens to populate those planets, too.

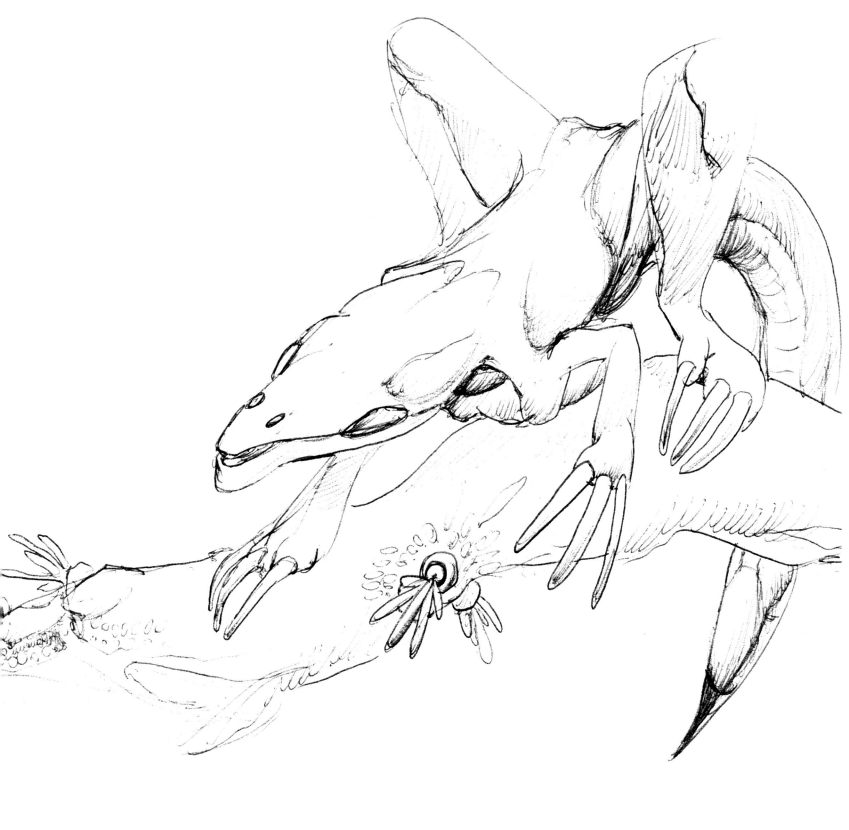

These are additional concepts for *Xenogenesis* showing creatures in a variety of environments. It's a very episodic story: The characters go to a techno planet, they go to a luminous world, a desert world, a world with an amoebic ocean. They're looking for a planet to colonize but they discover each of these worlds are too hostile to settle. Really, it was just an excuse for Randy and me to pack the story with a lot of cool planets, and so we needed a lot of cool aliens to populate those planets, too.

The image above was specifically designed for *Xenogenesis*, but it's an idea that first came to me in a dream when I was nineteen. In the dream, there was a glowing, bioluminescent forest populated by fan-like flying lizards that span around like living Frisbees. I ended up using the lizard and the forest ideas in a section of *Xenogenesis*. Much later, I would reuse the lizard and forest ideas for *Avatar*. After the movie came out, we were hit with a bunch of lawsuits claiming that we'd ripped off other stories. We actually used this flying lizard sketch to defend ourselves. The attorneys who had taken on the suits thought we were a big fat stupid target, but they soon discovered we had provenance on the designs going back over 30 years. So all the lawsuits quickly got kicked to the curb.

Growing up, I was endlessly fascinated by aliens and dinosaurs. This image of the amphibious-looking alien was something I just did for a joke in high school.

MAYBE IT DID LOOK CARNIVOROUS, BUT THEY'LL NEVER ACCEPT US AS PEACEFULL EMISSARIES NOW!

LET'S COME BACK LATER, WHEN THEY'R ALL AWAKE.

These drawings are from high school, around the eleventh or twelfth grade. I was just having fun with cartoon ideas and a science fiction theme—creating cutesy characters and playing with styles influenced by everything from *MAD* magazine to *National Lampoon*.

... AND, AS SPECIAL AMBASSADOR OF THE COUNCIL OF LORDS OF THE GALACTIC EMPIRE, DO HEREBY DECLARE ACCEPTANCE OF THE CIVILIZED RACES OF EARTH INTO THE FEDERATED GALACTIC ASSOCIATION OF......

The image below is from senior high school in 1971 and was just me screwing around and having fun with ironic motifs. The image on the left-hand page is very specific. It's a scene from a book called *Half Past Human*, by a writer named T. J. Bass. In the story, there's a breed of human beings called Nebishes who have four toes and live in hermetically sealed hives. In the wilderness outside the hives live the original five-toed humans who are in conflict with the Nebishes. For being a good little Nebish, the guy in the illustration gets to have a day outside the Hive. He has to train for it for weeks and wear a suit and a visor, as Nebishes are so poorly adapted to nature. And, as part of his vacation, he gets to use a crossbow to hunt a five-toed human. It's a really great, prescient book that impressed the shit out of me and I ended up drawing a lot of images related to it.

Although they came in order to help us, they hesitated to free me.

The image at the bottom is from around tenth or eleventh grade—I can tell because of the pen–and–ink style. The illustrations at the top are from college and were probably just me screwing around doing a cool alien in English class. The notebook page on the left is from the tenth grade. The reason I know is because I studied Latin at that age, and I can see that I'm practicing it on the back of the paper. At the time, I was just coming up with aliens in different kinds of environments but not with any particular project in mind. I would read at least one science fiction book a day; I'd sometimes read one on the way to school and finish it in class, with the book hidden behind my math book. Then I'd read one on the hour-long bus ride back and finish it when I got home, usually instead of doing my homework. So my head was full of this kind of sci-fi imagery. The top image on the left–hand page is an intelligent fish that's starting to evolve precursory hands so that it can manipulate its environment. The guy at the bottom of that page is a denizen of an high-gravity planet—today astronomers would call it a Super-Earth exoplanet. I'd read Hal Clement's 1954 book *Mission of Gravity,* which is about a planet where the surface gravity is so heavy that its creatures can't even stand up on legs—they have to kind of pull themselves over the ground. So this was my take on that idea. I based this creature on a sloth, but I also gave him a mucous coating like an amphibian.

AIR SHARKS

The Air Shark creatures above and on the right-hand page were created for *Xenogenesis* but ended up becoming the basis for the banshees seen in *Avatar*. When I started writing *Avatar*, it became this big salad of leftovers from a bunch of other projects. I thought, "Alright, I've got to write an alien planet story. Well, I've got tons of planet stories. Let me make a list of all the cool shit I've come up with throughout the years." My list included the bioluminescent world and the flying lizards from my dream back in the 1970s, plus, from *Xenogenesis*, these big floating medusoid creatures, along with flying predators that I called Air Sharks, although at one point I changed their name to Wind Sharks and then Windrays. In the image on the right-hand page, Russell Jorden is fighting them off with his cybernetic arm.

The design of the Air Shark is very different from the concept for the banshee, but there is one element that survived into *Avatar*: Both the Air Shark and banshee articulate their teeth like rattlesnakes and can fold them up inside their mouths. They both have a racking bone, similar to a snake's quadrate bone, that pushes the teeth forward when they are ready to strike. The great white shark has a very similar feature where its mouth pushes out, sometimes up to six inches, before it bites. It's incredible. Biologists didn't even realize it was happening until documentarians started shooting the great white with high-speed cameras. In these images you can see the Air Shark with its mouth closed and its mouth open. When its mouth is closed you can't even see the teeth, but when it opens its mouth, the teeth open outward.

When I wrote *Avatar*, I just took the Air Sharks and stuck them in the story.

I wanted to give them a vocalization that was chilling and that would become a signature for the creature, so I figured they could scream like the banshee in Irish folk mythology, a demon spirit that you hear wailing up in the hills. And because at the time I was thinking they would be ray-like, I initially called them banshee rays. Then, over time, the banshee ray design became more pterodactyl-esque and birdlike. But to preserve that birdlike beak when the banshee's mouth was closed, I said, "Well, let's give it big teeth that evert but come out on a racking bone like a rattlesnake." So that's why in the final film the banshee moves in a very birdlike way at times but it's got a tooth structure that's more primordial. And in fact, we even proposed that the banshees had evolved from flying fish, which is why they have the flow-through ventilation holes like a fish's gills, as opposed to lung-type breathing. So there's a clear through line from *Xenogenesis* to *Avatar*, even though the Air Sharks and the banshees look very different.

The banshees were not the first time my rattlesnake idea was used in a movie, though. Somewhere around 1986, I was on a plane with Stan Winston flying back to L.A. We're sitting side by side and he's sketching a monster. I look over and go, "That's pretty good. What's it for?" He said, "Oh, I'm doing *Predator*." I said, "Ah, Stan, I got an idea! You know how all monsters have fixed teeth? What you gotta do is, you gotta fold the teeth in, so that the face looks one way when the mouth is closed, but when he snarls, it opens up and the teeth come out." He goes, "That's great!" So he throws that first sketch away and starts drawing upper and lower teeth surrounding the creature's mouth. When he was done, he'd designed the look of the Predator we know today.

VIPERWOLVES AND THANATORS

On *Avatar*, the bulk of the creature designs were created by my concept art team, but there are two significant concepts that I contributed. Above and right are my designs for the viperwolf. I wanted this creature to have a slinky, hyena-like quality, with an elongated body and the suppleness of a weasel or a ferret. But I also wanted it to have a high shoulder and low-positioned head like a stalking hyena. In addition, I envisioned its forepaw to be something like a monkey hand that could grasp, because the viperwolves not only moved along the ground—they were also climbers. All the creatures on Pandora have six legs, so along with the monkey-like hands, I wanted the viperwolf to have a back paw that was more dog-like and then a middle paw that was somewhere between those two things. It was a very specific concept and the art team was not really getting it, so I drew this for them to show what I wanted.

The thing that was most difficult on the viperwolf was getting across the idea that it had this thin layer of flexible armor that had the density of a fingernail—it's armored, but the surface is more like a snake's belly than traditional armor, with overlapping sheets that are flexible but tough. I didn't want big bumpy armored plates that changed the shape of the creature—it needed to have a sleekness to it. So once I compared the armor to a snake's belly, the design team got it and we nailed it. We then applied the armor to other creatures in the film, including the direhorses and the thanator.

The thanator to me was the Alien Queen of *Avatar*—it was the big, scary, badass motherfucker in the forest. But design-wise, I didn't specifically know what I wanted. I had initially written it as this big, armored panther creature with a scorpion-like tail, but I eventually realized the tail was kind of like putting a hat on a hat. So I said to myself, "If you want to do a panther, do a panther." I always ask concept designers, "What's the metaphor for the creature you are creating?" The metaphor for the direhorse was a horse, even though it's not a horse at all—it's a strange dinosaur version of a horse-like creature. And if the metaphor for the thanator was a panther, I thought that adding in a scorpion tail would turn it into some kind of chimera.

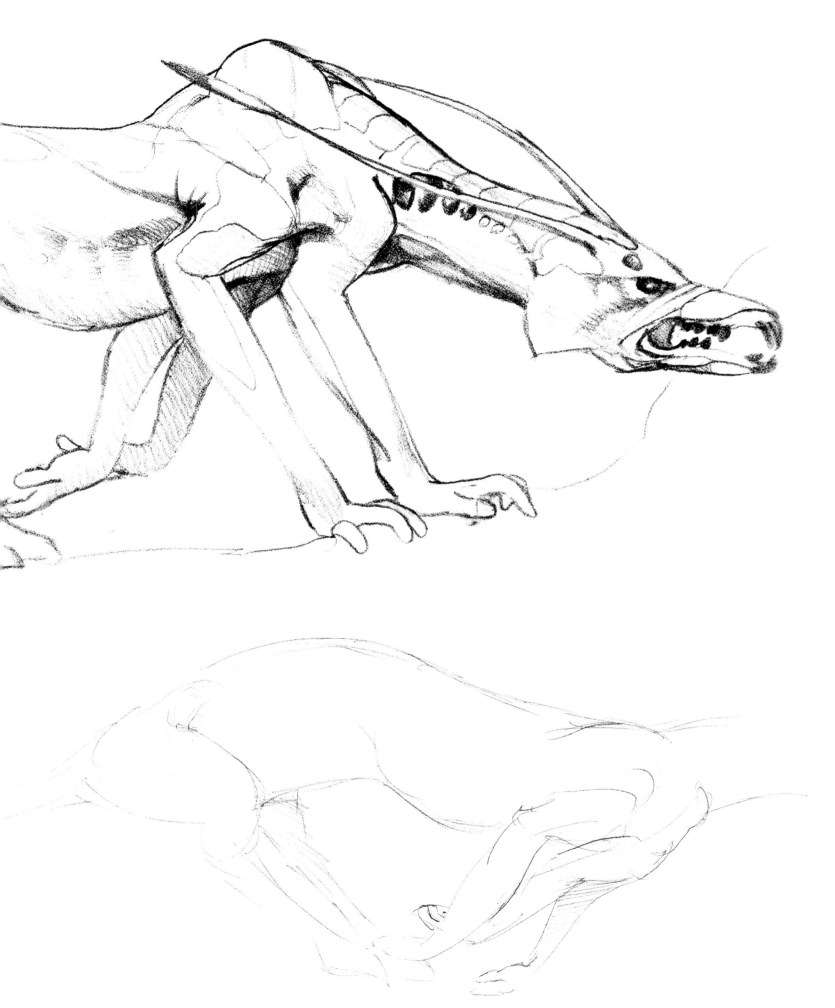

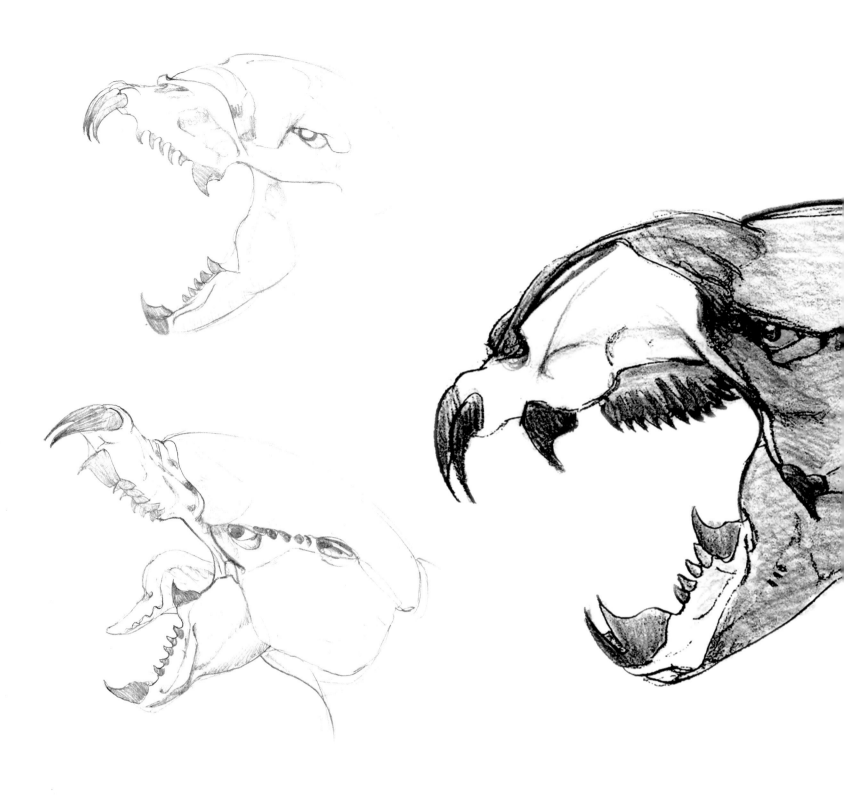

I also considered giving the thanator praying mantis–like inverted front arms that it could use to catch its prey. But then I thought the praying mantis has a very small head and very long arms for catching prey, and it just kind of nibbles on its victims. The thanator is this big alpha predator so it needed to be more like a *T. rex*. Stan Winston and I made our bones with the Alien Queen, and he went on to build the animatronic *T. rex* for *Jurassic Park*, and both those creatures had these amazing big heads that made them seem like ferocious, dominating predators. So I put my focus on designing the thanator's head. When I was developing it, I had the *Dunkleosteus* in mind—the prehistoric armored fish that had big saw-like teeth. Also, I wanted all the creatures of Pandora to have black teeth that were onyx-like and set in a white gum because I had never seen that before, so I also applied that to the thanator. And then in the top left, you can see I explored adding the shark-like extensible mouth that I used for the Air Shark design. But then I thought, "Well, I don't need to be that prehensile." I basically

landed on the top right illustration, eventually, after about thirty drawings. This version of the thanator also had a display frill like *Styracosaurus* or triceratops. Paleontologists used to think it was for neck protection, but it's probably more of a threat display frill—they'd tip their heads down to make themselves look bigger. It's similar to the way a lion uses its mane to attract females and dominate other males—the bigger your mane, the more you are seen as the big dude in the jungle. I gave the display frill separated plates that were motile. I then added what I called sensor quills to the frill which I thought might be chemosensors that could catch the scent of prey in the wind. I also gave it everting lip plates that came down and covered the teeth in a way that made the creature look benign. When terrestrial animals snarl, the lip lifts upward to reveal their teeth. But I thought, why not have the upper lip flip out of the way? Nobody's ever seen that before. When it happens, you're suddenly looking at something very transformed and deadly looking.

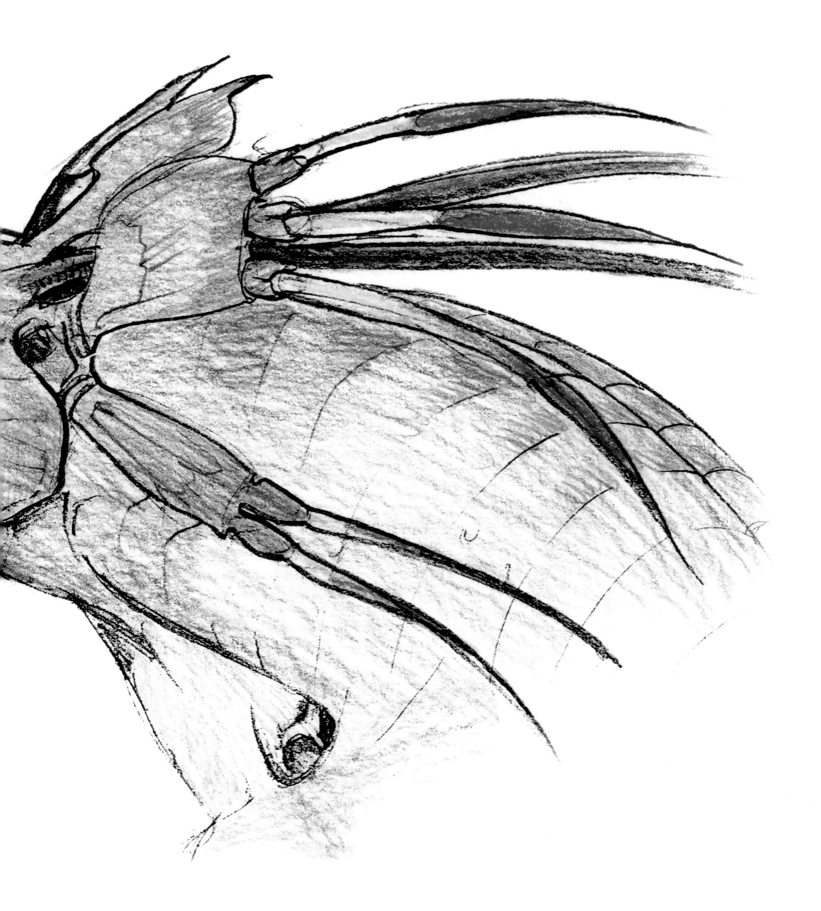

I gave the display frill separated plates that were motile. I then added what I called sensor quills to the frill, which I thought might be chemosensors that could catch the scent of prey in the wind.

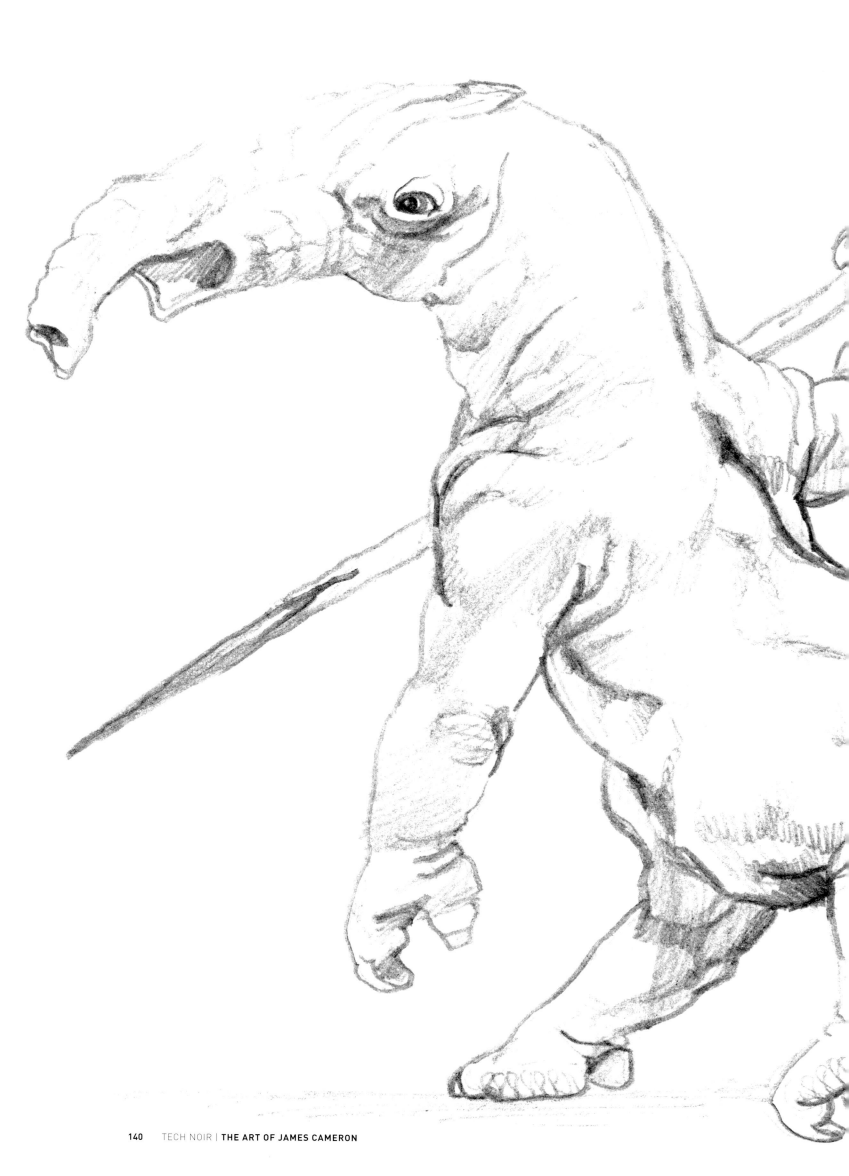

"This guy is clearly not technically advanced, but he's using a spear, so it's clear he's got some intelligence."

This is another alien that was developed in that general spate of creatures that I created for *Xenogenesis* around 1976/1977. This guy is clearly not technically advanced, but he's using a spear, so it's clear he's got some intelligence. In some ways, my viperwolf design from 2006 tracks back to this guy—a six-limbed creature with the forepaws evolved into handlike graspers. Is his forebody always upright like a centaur? I imagined that when he really wanted to haul ass, he got down on all six and galloped.

I designed this *Xenogenesis* alien's head to be like an acoustic dish antenna. I thought if the FBI can surveil a house from a distance using a dish antenna and record dialogue through a windowpane, why couldn't an animal evolve similar abilities? It would just need a big focusing dish and a receptor—which is basically what our ears are, it's just that the receptor is buried inside our heads and the dish is on the outside. But what if the entire cranium became a dish? I thought maybe this creature would live on a planet that was in perpetual darkness and so it would need to be able to hear its prey moving a thousand meters away.

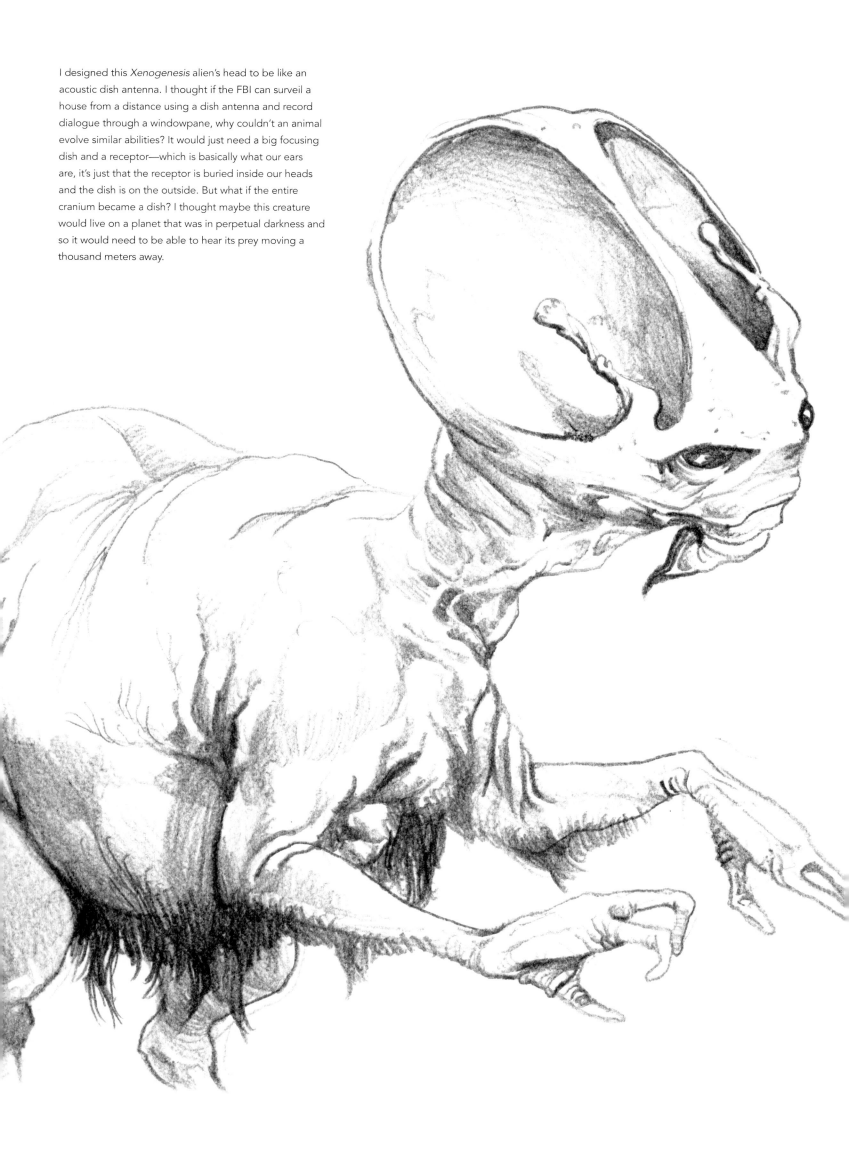

THE SCHMAL

You may notice that this creature has some similarities with the heavy-gravity slug alien on page 132. I never forgot that guy and developed the idea further when I was creating creatures for *Xenogenesis*. After we completed our *Xenogenesis* pilot in 1978, we found a movie theater that would let us screen it after hours. We invited everyone who was tangential to the project and our guests all brought someone else they knew. In the audience that night was a kid named Alec Gillis. After the screening, he found me and we got talking. We were both big Ray Harryhausen fans, and he really wanted to work in stop-motion animation. I had done the stop-motion Spider and sentry robot for the *Xenogenesis* pilot, despite having no idea what I was doing. He was farther down the path than me because he was actually building armatures and animating biological creatures like dinosaurs. I didn't know anything about sculpting a creature in clay around an armature and making molds. I'd read about it and knew the theory, but I'd never actually done it. Alec said, "I'll show you how. You got an oven? If you can make a pizza, you can make a creature. But you gotta make a creature that'll fit in your oven." So we designed the slug creature in this drawing at a size that would fit in my oven. It was gorgeous and had these very human-like hands that could grasp and pull. He had this slug-like membrane and a pathetic, tragic expression because he's unable to even lift himself off the ground. We named him the Schmal after one of the guys who funded the *Xenogenesis* pilot, a tax lawyer named

Al Weinberg. Al was a crack-up. He would come and see us because he wanted to hang out with Hollywood people. We didn't want to break it to him, but we were about as far from Hollywood people as you could get. He'd say, "You guys need anything? Any hookers?" And we were these complete geeks. We'd say, "No Al, we don't need any hookers. We're okay." We wouldn't have known what to do with a hooker. We were always calling him Al the Schmal for some reason. Then, when we were trying to come up with a name for the slug creature, the Schmal seemed like the perfect fit.

Shortly after we built the Schmal in 1979, Alec and I both got hired by Roger Corman to work on *Battle Beyond the Stars*. I'd been trying to shop around the *Xenogenesis* pilot, but I wasn't getting anywhere so I needed a job. Alec's sister was dating a guy who worked at the Corman model shop, and he heard they were looking for people. So we went down there and showed them the *Xenogenesis* pilot even though Alec didn't work on it. We also showed them the slug creature model we had done and some of the other designs we had created, and it turned out we were exactly their kind of geeks. They knew they had to hire us, but they couldn't figure out exactly where to put us. There wasn't an opening on any of their effects camera miniature stages, which is what I really wanted to do. So they said, "You can start in the model shop." And that's how I got my first job in the film industry, building spaceship models and planet sets for Roger Corman.

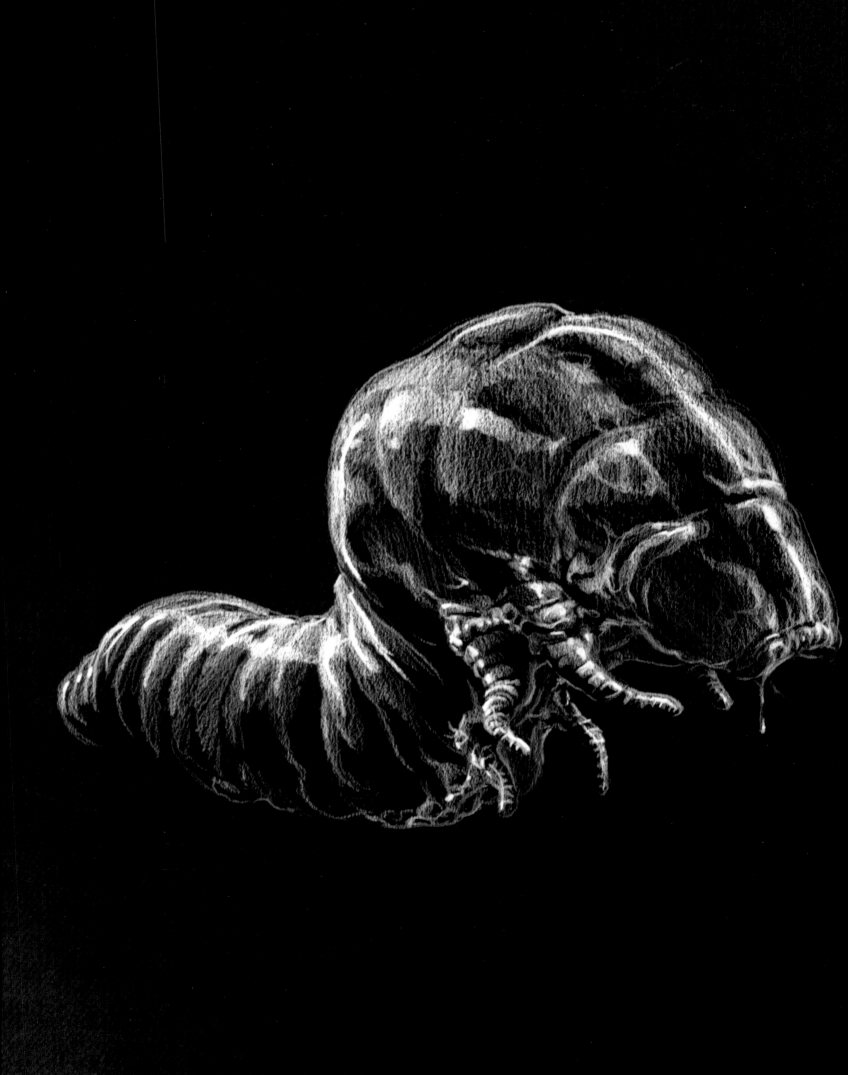

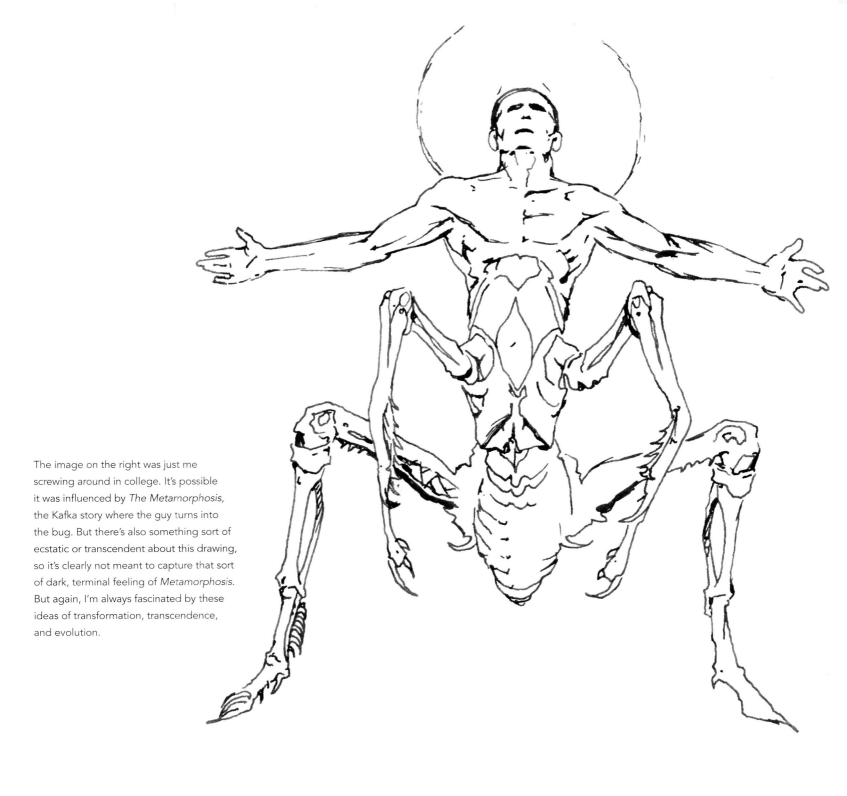

The image on the right was just me screwing around in college. It's possible it was influenced by *The Metamorphosis*, the Kafka story where the guy turns into the bug. But there's also something sort of ecstatic or transcendent about this drawing, so it's clearly not meant to capture that sort of dark, terminal feeling of *Metamorphosis*. But again, I'm always fascinated by these ideas of transformation, transcendence, and evolution.

CORMAN'S MAGGOT

This is the rapist maggot from Roger Corman's *Galaxy of Terror*, and I have to say it represents one of the darkest moments in my film career. Corman's MO was to create knockoff versions of popular films to cash in on their success. So *Battle Beyond the Stars* was Corman's attempt to cash in on *Star Wars*. *Galaxy of Terror* was his answer to *Alien*, which had been a huge hit in 1979. He had the perfect people working on *Galaxy of Terror*, because I was a huge *Alien* fan, as were Robert and Dennis Skotak, whom he had hired to oversee the special visual effects. We knew all the reference points, but we wanted to do our own version of *Alien* and not slavishly follow it. But there was a scene in the film where this giant maggot rapes and kills one of the crew members, played by Taaffe O'Connell. This poor actress was getting her break in the movies, but she wound up naked, covered with slime, and underneath a big rubber monster. Corman always had some form of sexual attack in his movies and it was really dark shit. At the time, we just kind of accepted it because it was

Corman and that's what he did. For him, it came down to what sold the best at drive-in movies in the South or wherever. He always believed in pandering to the lowest common denominator whether it was sex, bikers, drugs, or whatever was considered dark and edgy in the zeitgeist at the time.

A lot of this stuff was totally unacceptable by present standards, but these movies were our shot at getting into the industry and we would just pour our hearts into them. And when you're on a Roger Corman movie, you separate your own creativity and intentions from the ideas of the movie and do the gig to the best of your ability. So ultimately, I had to design the goddamn creature. I decided to give it a particularly penile-looking head because Freudian imagery was not lost on me, especially after seeing H. R. Giger's designs for *Alien*. I felt like I could at least impose some good ideas on the project through my designs, but there was no way I was going to be able to take a rapist maggot out of a Roger Corman film.

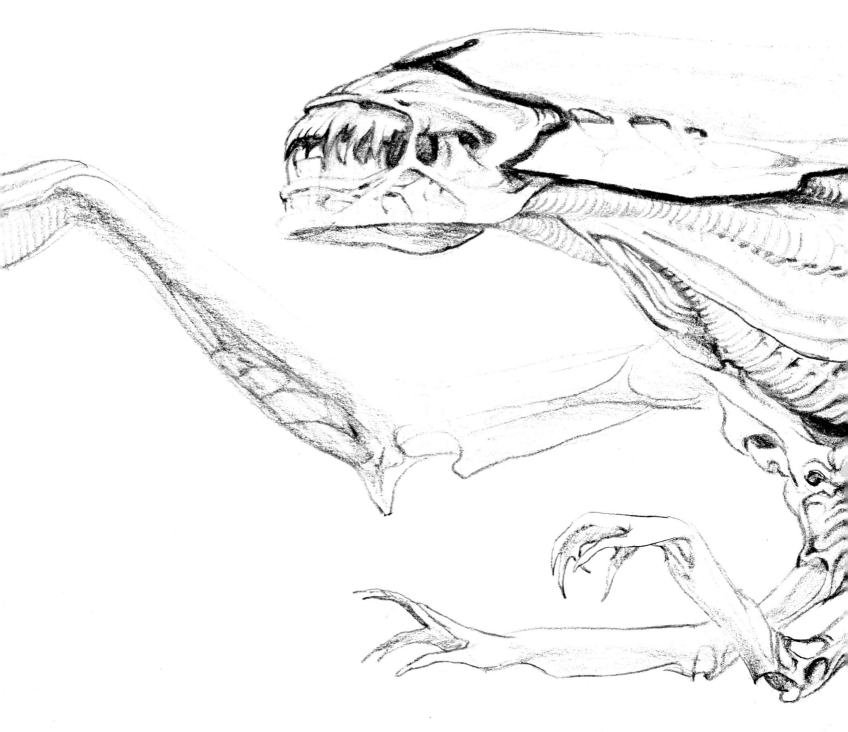

QUEEN OF THE TRASH BAGS

This is an illustration of the Alien Queen that I created during preproduction on *Aliens* specifically for Stan Winston and his team. I'd come up with a basic concept for how the Alien Queen puppet would work, but next we had to figure out how to do it. There was going to be two guys inside the puppet, one on each side of the chest. So one would be on the left with his head inside her chest, essentially, and his right arm operating the Queen's left front arm—one of the small *T. Rex*-style arms at the front. Then his left arm would operate the Queen's main upper arm. And of course the guy on the right-hand side would be doing the same. Now, Stan thought that this was the dumbest idea he'd ever heard. I said, "Let's test it." So we very quickly built a belly pan from fiberglass that was molded to the shape of two guys. We hung it on a crane, laid the two puppeteers on it, and started covering them with trash bags and foam core. We built a big, eight-foot-long foam core Alien Queen head, stuck it on there, and covered it with trash bags. We also created some arms made from brooms and then covered those with trash bags. So at this point everything was glistening and black because of the trash bags, a very rough approximation of how the Queen's skin would look in the film.

Once we had two of Stan's guys positioned inside—Shane Mahan and Dick Warlock—I said, "Move your arms around!" And the guys start moving the two main arms around, swinging them back and forth. Then I said, "Move the little *T. rex* arms around." And they started moving those in conjunction with the larger arms. And all of a sudden this thing came to life in front of us. Then Stan said, "What about the legs?" So we got more foam core, cut it into leg shapes, covered those with trash bags, and just wired them onto the Queen. Then I got a couple of guys to move the legs around with a stick, Bunraku-style. And to complete it, we created a tail which I got another of Stan's guys to operate with a fishing pole.

It took us about four hours, but at the end of the test we had a living, breathing, moving Alien Queen. It could be puppeteered and it was directable; the only issue was that it lacked any articulation in its head. But Stan said, "We can just run all the pneumatics and hydraulics cables out the ass of the puppet and away from the camera. The Queen's tail will whip around and be a misdirect that hides that interface. We can do this." I said, "Fuckin' A, right. Let's do it."

So, with the drawing on pages 146–147, I'm packaging all these ideas into a practical design and presenting something finite to Stan's team that they could sculpt. Up to this point I had drawn a lot of notional designs for the Alien Queen, but with this drawing I was getting down to the practical details. I'm showing the ribs in the neck and the gill-like structures, and the biomechanoid structures above those that are kind of an homage to H. R. Giger's detailing. And then the big carapace, which, like the thanator's, was influenced by a triceratops frill. I also designed a forepart of the head that would emerge from under the carapace. I wanted to take the mouth-within-a mouth concept from *Alien* a step forward, so the entire head extends out unexpectedly and then she also has the interior jaw like the other xenomorphs. I thought it would create a cool reveal when Ripley comes face-to-face with her for the first time.

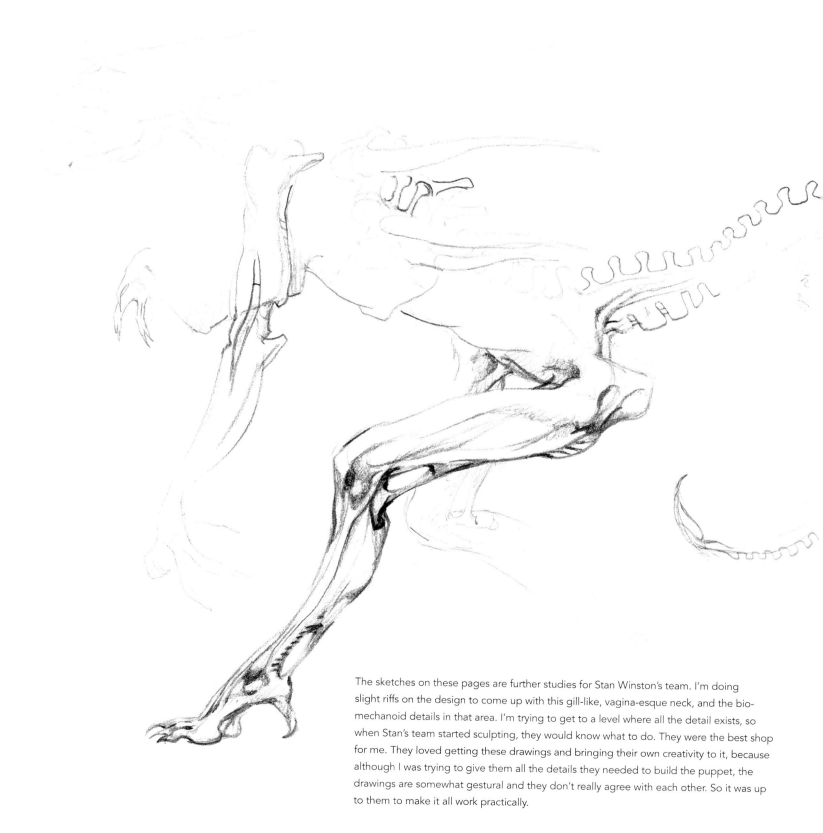

The sketches on these pages are further studies for Stan Winston's team. I'm doing slight riffs on the design to come up with this gill-like, vagina-esque neck, and the bio-mechanoid details in that area. I'm trying to get to a level where all the detail exists, so when Stan's team started sculpting, they would know what to do. They were the best shop for me. They loved getting these drawings and bringing their own creativity to it, because although I was trying to give them all the details they needed to build the puppet, the drawings are somewhat gestural and they don't really agree with each other. So it was up to them to make it all work practically.

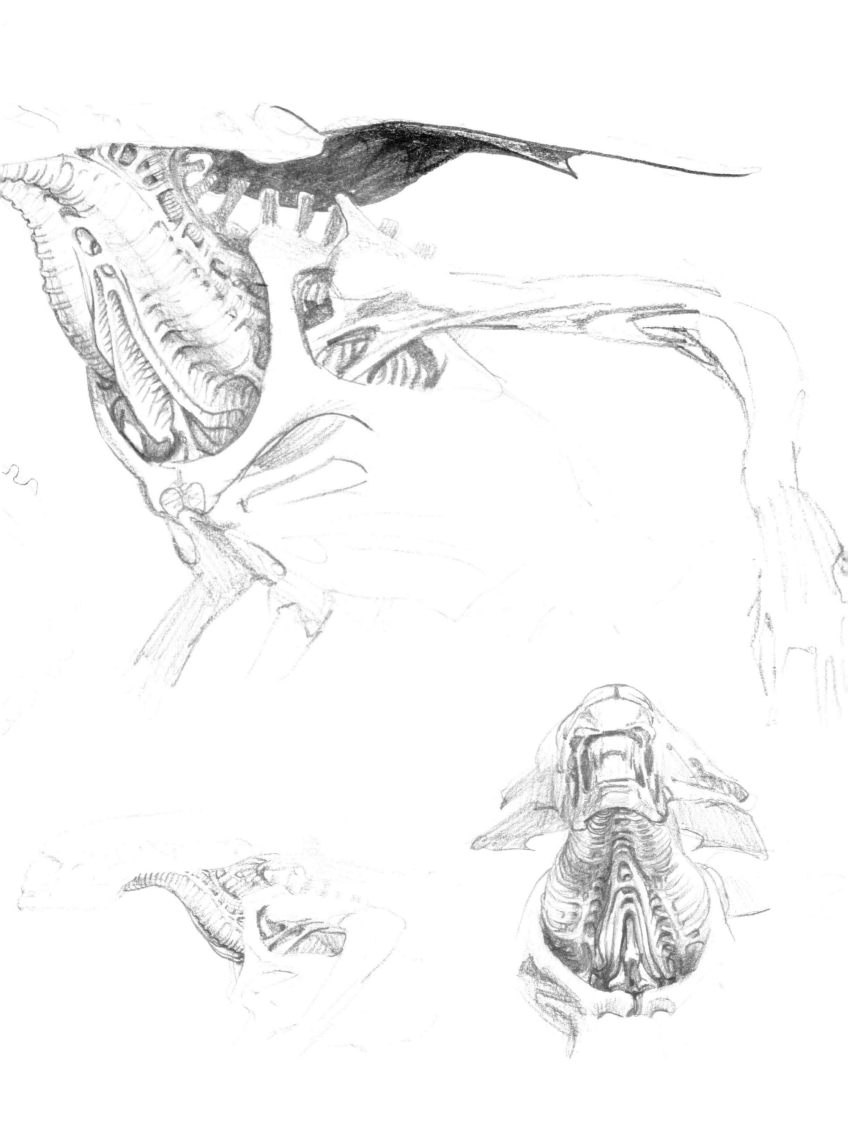

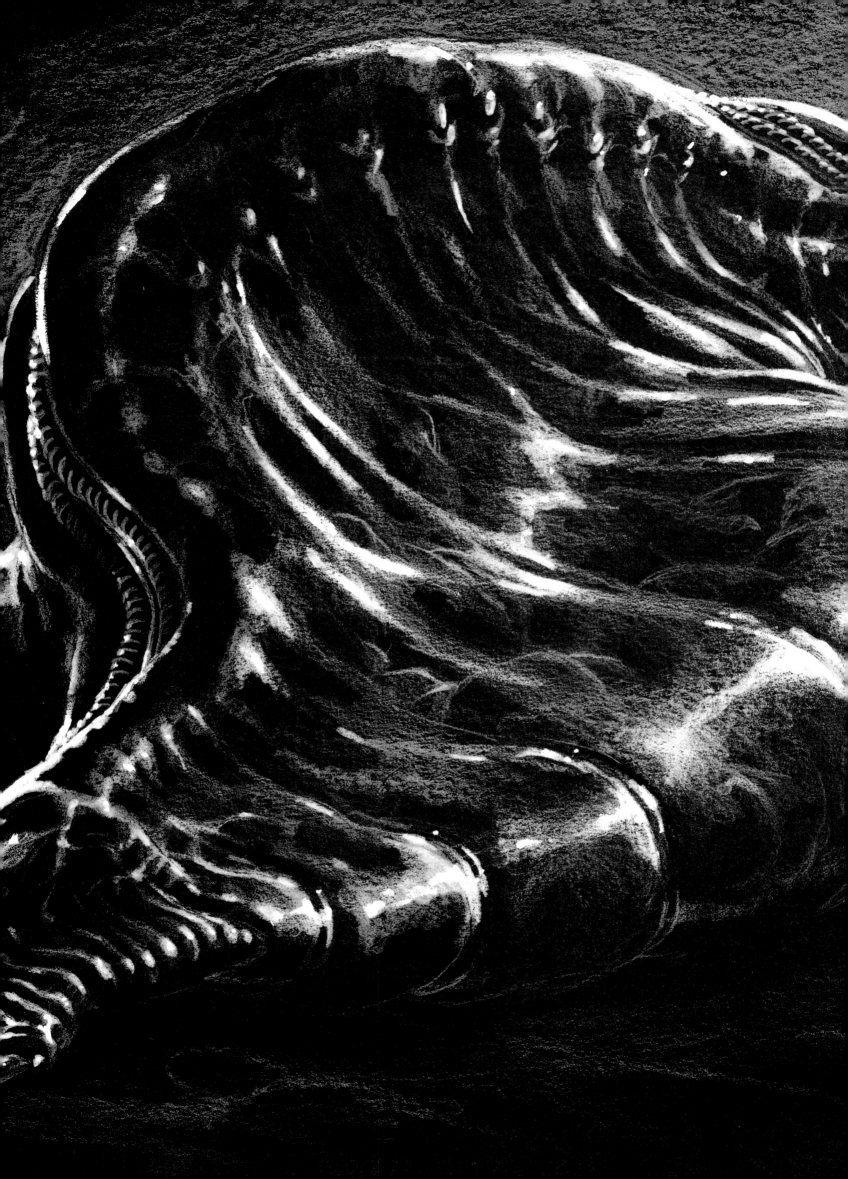

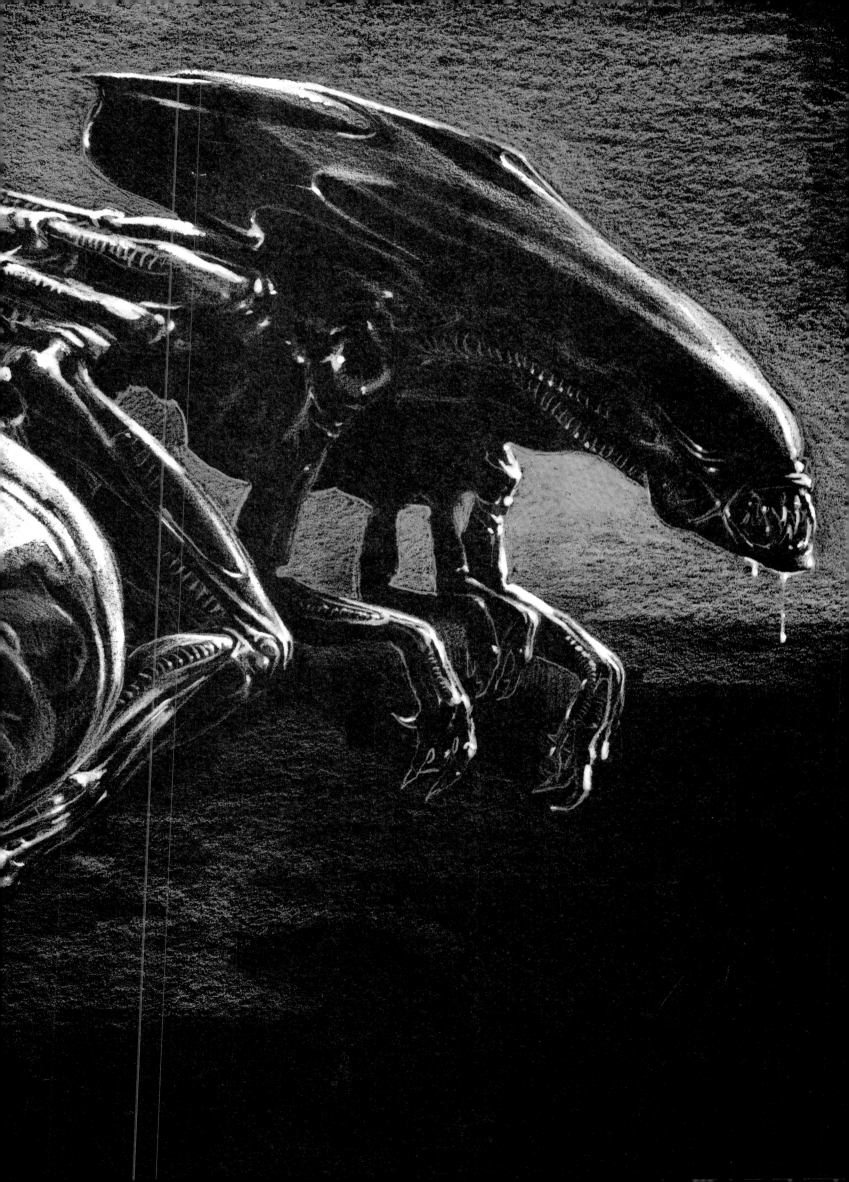

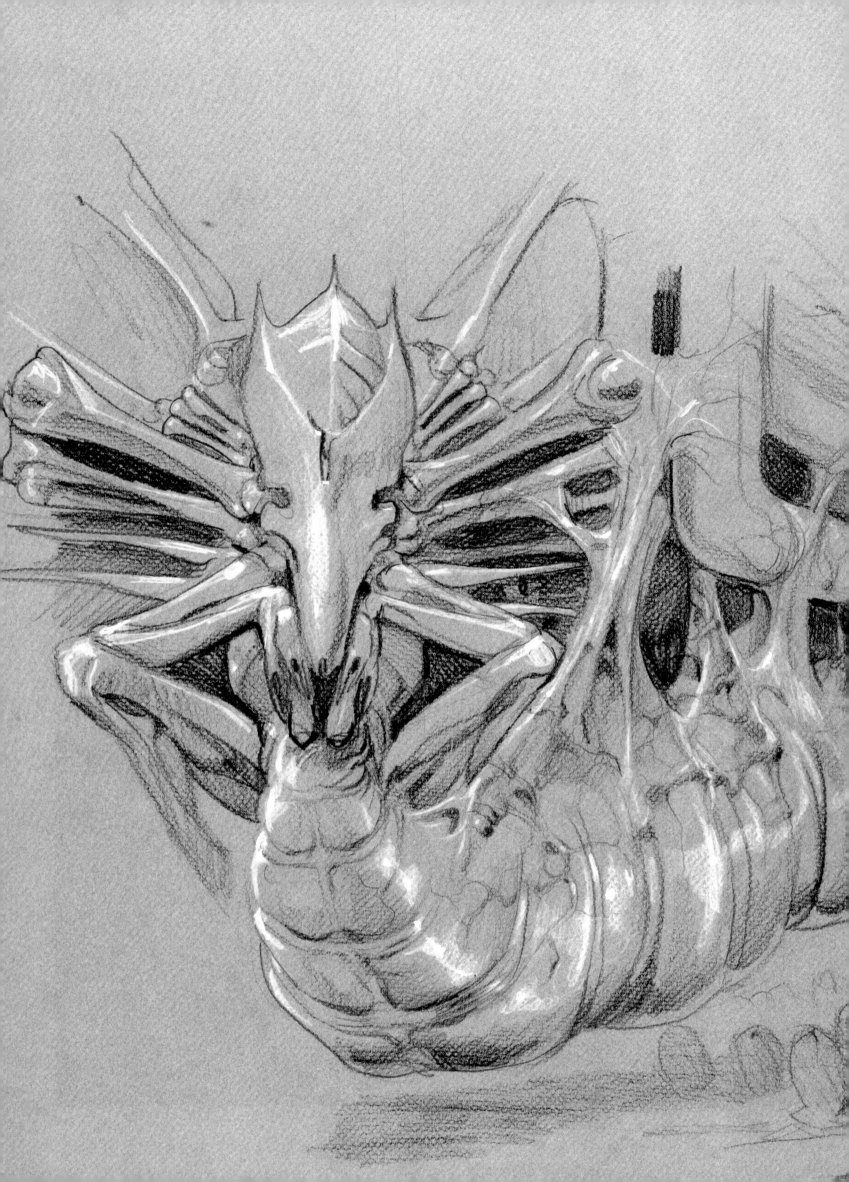

THE EGG CHAMBER

Originally, I figured that when we first see the Alien Queen in her chamber—which is situated within the colonists' Atmosphere Processing Station—she would be seated on the ground with a giant egg sac attached to her rear end, like a termite queen. I initially created the concept on pages 150–151 to illustrate this idea, but then I realized it wasn't very cinematic. I was very inspired by the principles of *Alien*, in particular the scenes where Ridley Scott hid the creature in plain sight. At the end of the movie, in true gothic horror/slasher film style, Ripley is in the escape ship, taking all her gear off and looking sexy, and the creature is right there in amongst the machinery of the ship. The design of the *Nostromo* spaceship was reverse engineered from the design of the creature so the xenomorph could blend into the background. I wanted to apply that principle to *Aliens* and reveal the Alien Queen in a way that when she first appeared, the audience wouldn't even know what they were seeing. I came up with this idea of giving her a throne constructed from

radial bone-like structures that she's presumably built to protect or support herself. That way, when she's first introduced in the film, she would be hidden within that structure. I also decided to suspend her egg sac from the station's pipes—the idea is that her worker drone aliens attach the egg sac to the ceiling as it grows. Then I made her ovipositor this dangling, elephant–trunk thing that can put the eggs down in different places. These ideas led to the drawing on these pages, which I gave to Bob and Denny Skotak, the two special effects guys from my Roger Corman days who I hired to work on the visual effects for *Aliens*. I put them in charge of building the miniature Alien Queen puppet along with the throne structure and the egg sac for this scene. When I gave them the design, I remember they said, "Okay, number one, we really love this. And number two, we have no idea how to do this." I said, "Of course you do, it's just a big model." They said, "Ooookay." And they went and built it perfectly.

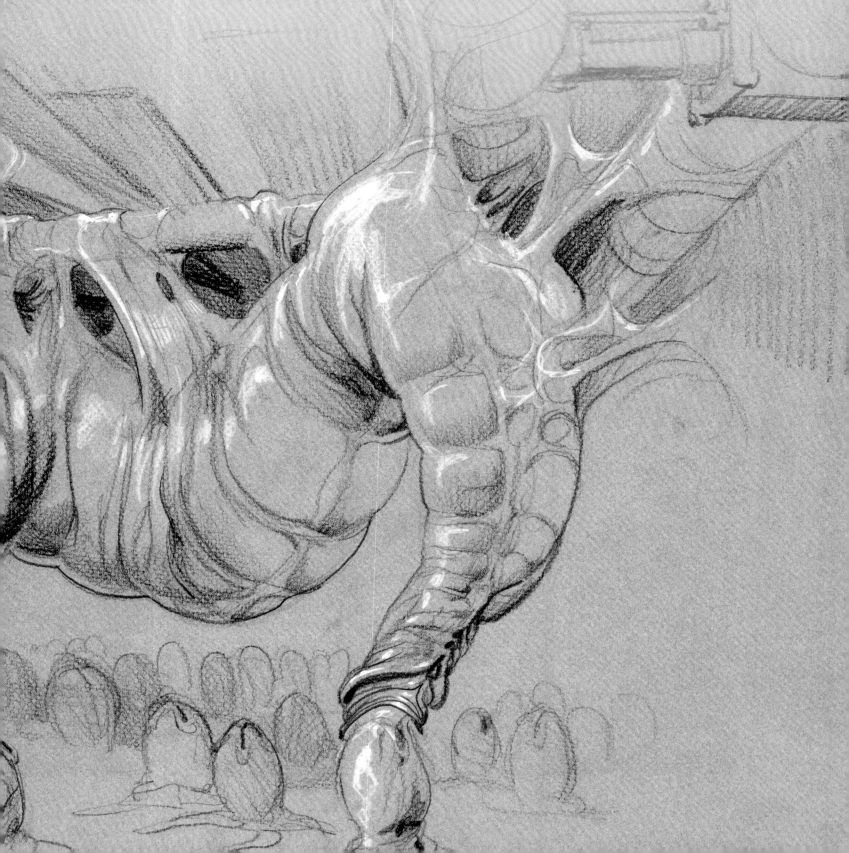

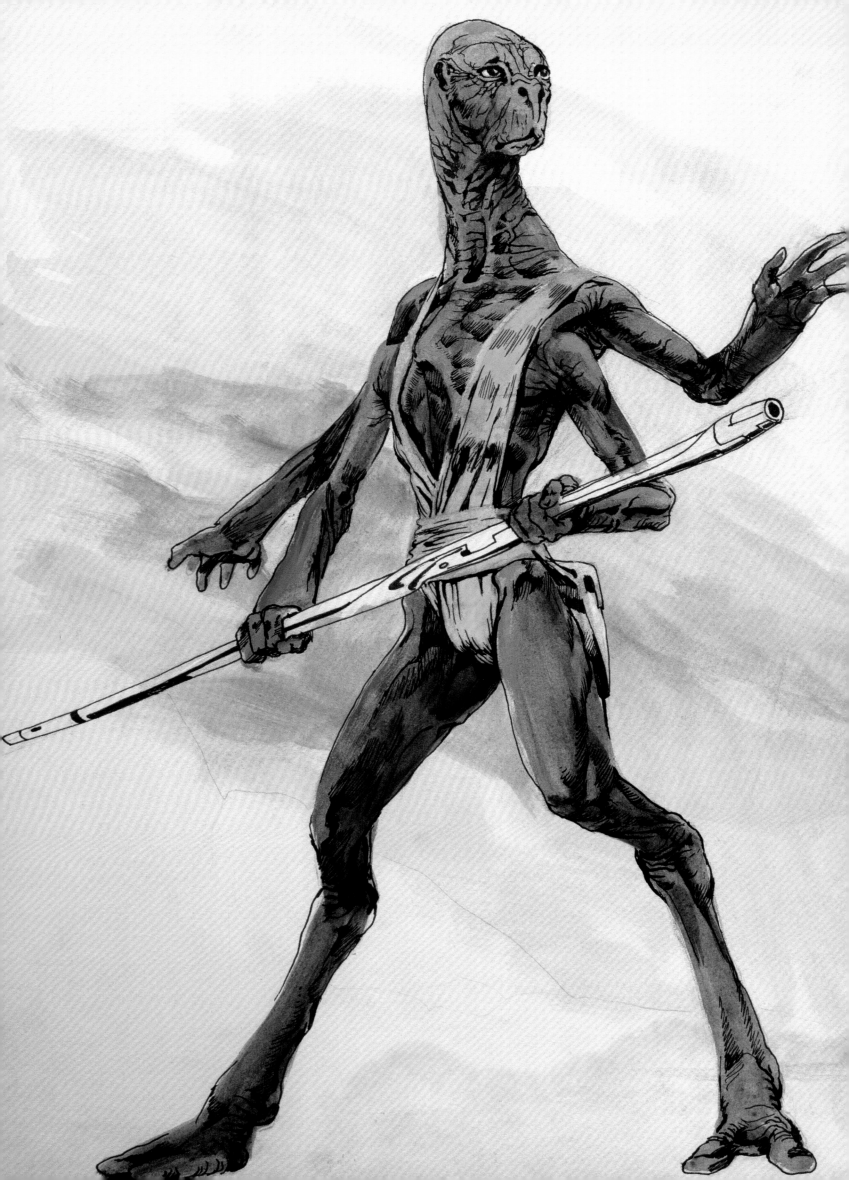

SID

This is Sid, a key alien character from *Xenogenesis*. His true alien name is unpronounceable in our tongue, so the human characters call him Sid, which is the only part of his long alien name that they can pronounce. They first meet him on the techno planet where Jorden is attacked by the sentry robot. All the other members of Sid's race have been dead for thousands of years, but he's knocking around on this planet that was once dominated by an ancient technological culture because it's his job to observe this world's history. Within his species, he's a member of something called the Historian Guild. These Historians are meant to experience history firsthand by living forever and writing about what they see—the regular members of their race don't live forever, just the Historians. But everyone is dead on the planet and none of the shit works, so Sid is very happy when Jorden and Lori show up and take him with them on their quest.

At the age of about two hundred—which is about how old Sid is when we first meet him in *Xenogenesis*—Historians form a chrysalis around themselves. When they emerge, they are nineteen again, reborn with the same memories. The image at top left is Sid within the chrysalis. The image on the right is an early concept for Sid in a wizened state. Ultimately, I went for a much different design, and he became a four-armed character who carried a staff that he could use to fight off attackers, as you can see on the left-hand page. Sid may be old, but he's still got game. At one point in the story, the group gets into a fight with some aliens on another planet and he starts whipping his staff around and cutting a swath.

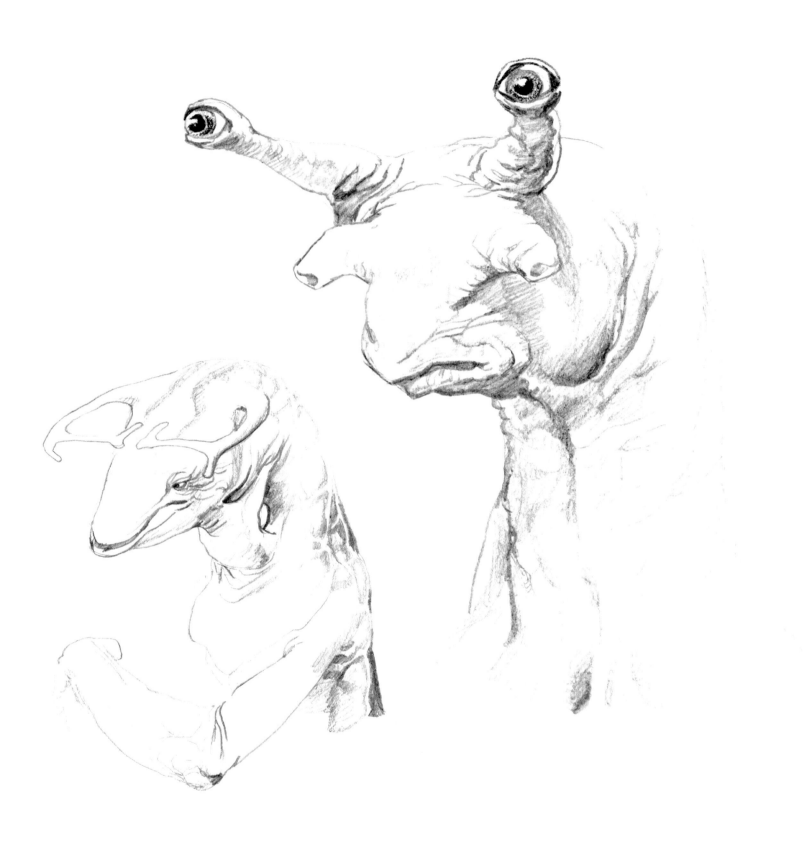

I figured it would be a very dynamic and expressive face, and fun for the prosthetics guys to build.

I had a clear idea of Sid's six-limbed body, but his head was still in flux for a long time. In the image at top right he's got long inquisitive eye-stalks and twin olfactory trunks. I figured it would be a very dynamic and expressive face, and fun for the prosthetics guys to build. And on the left there's a more lizard-like version with elaborate antennae, possibly chemosensors or exotic hearing organs—plus a separate gullet from the main neck. Just crazy experiments.

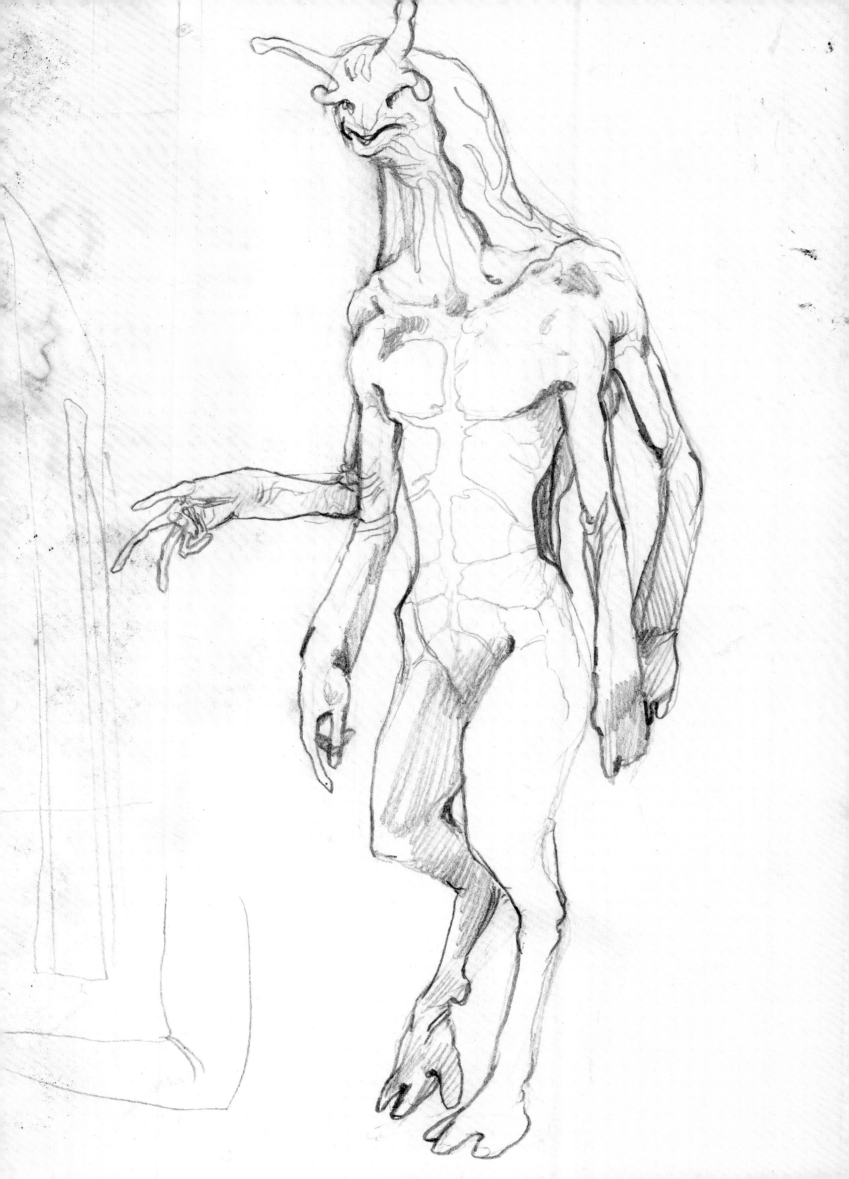

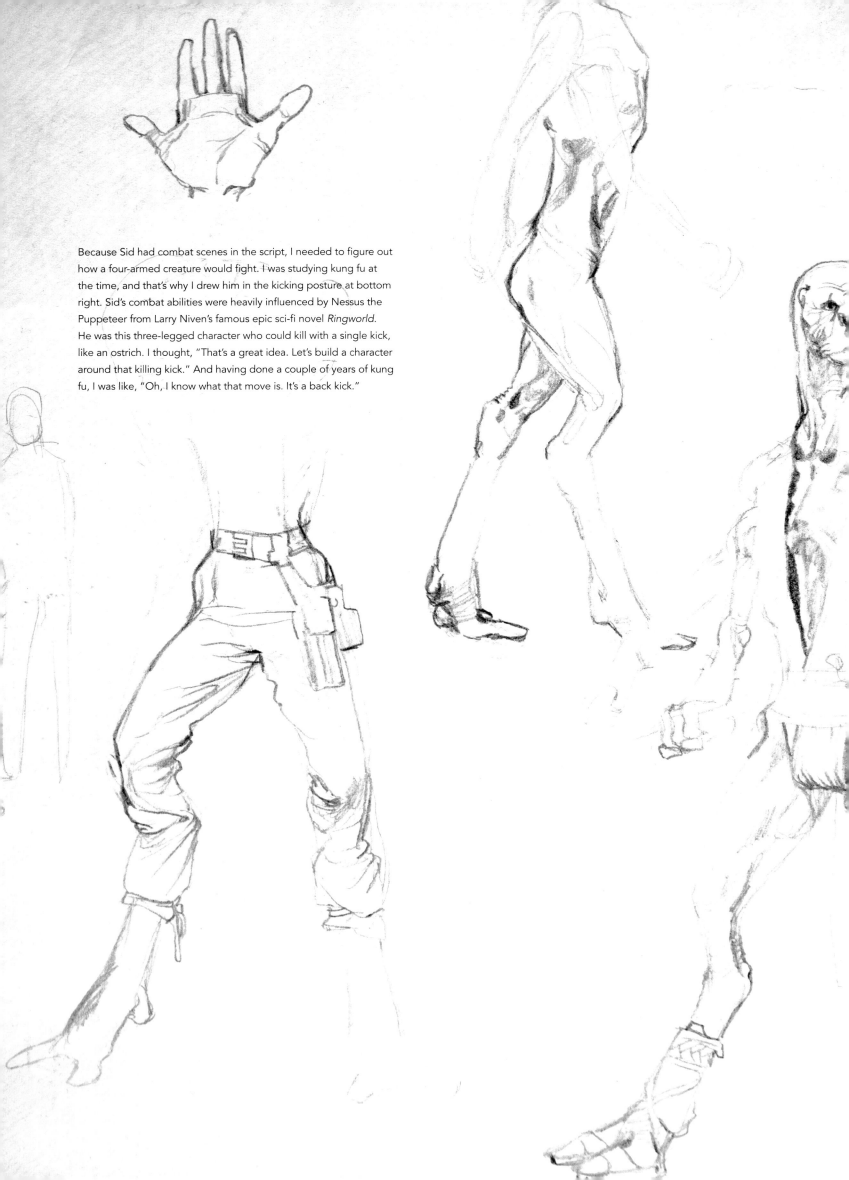

Because Sid had combat scenes in the script, I needed to figure out how a four-armed creature would fight. I was studying kung fu at the time, and that's why I drew him in the kicking posture at bottom right. Sid's combat abilities were heavily influenced by Nessus the Puppeteer from Larry Niven's famous epic sci-fi novel *Ringworld*. He was this three-legged character who could kill with a single kick, like an ostrich. I thought, "That's a great idea. Let's build a character around that killing kick." And having done a couple of years of kung fu, I was like, "Oh, I know what that move is. It's a back kick."

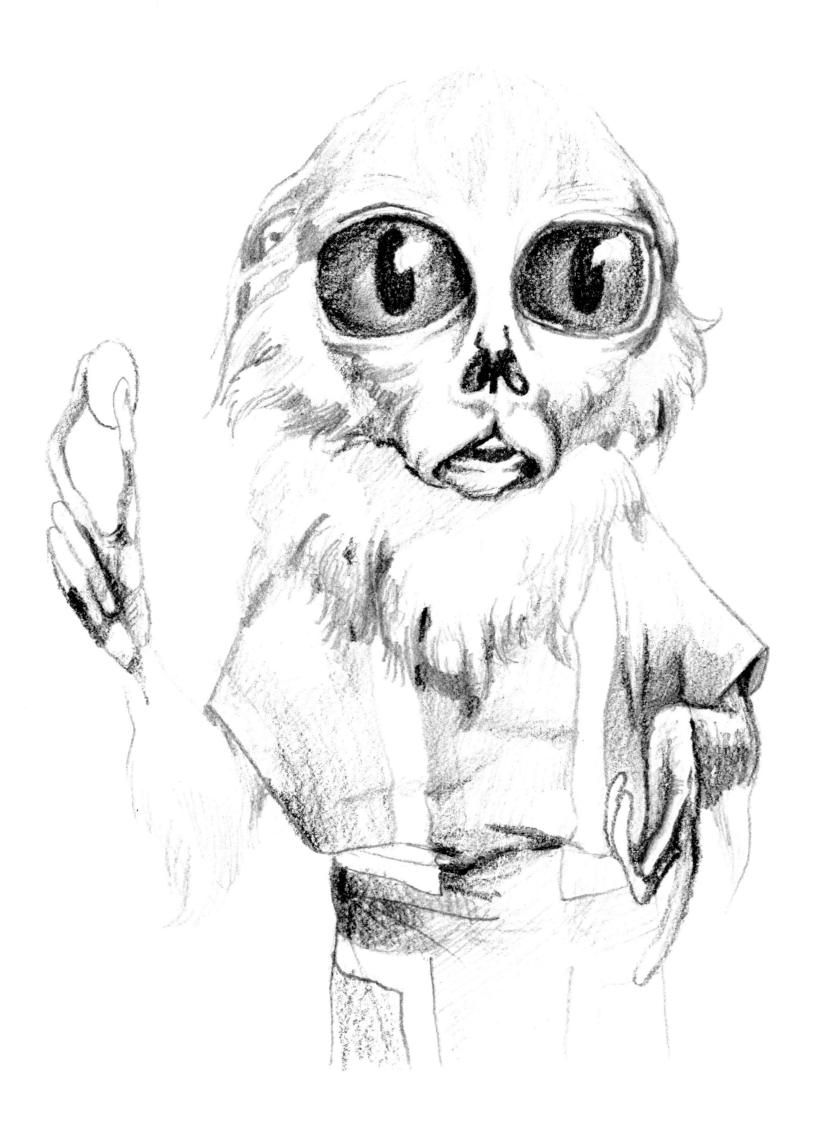

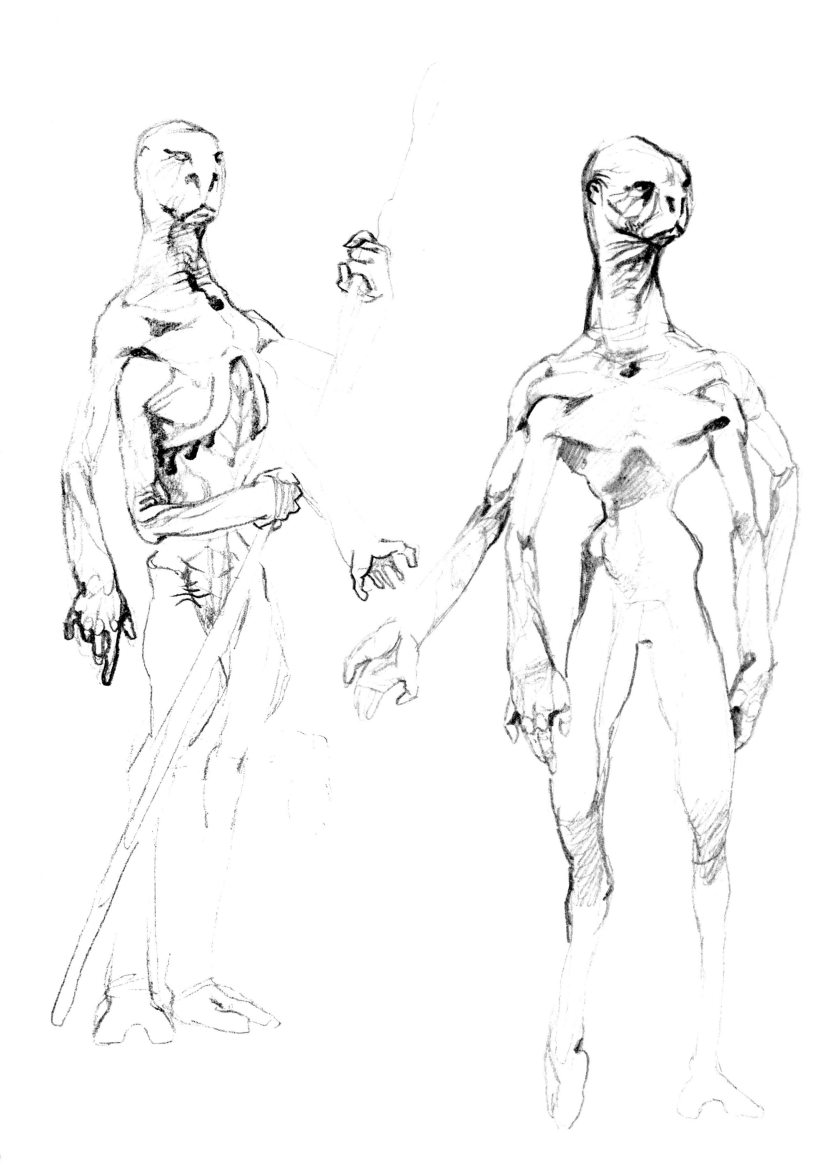

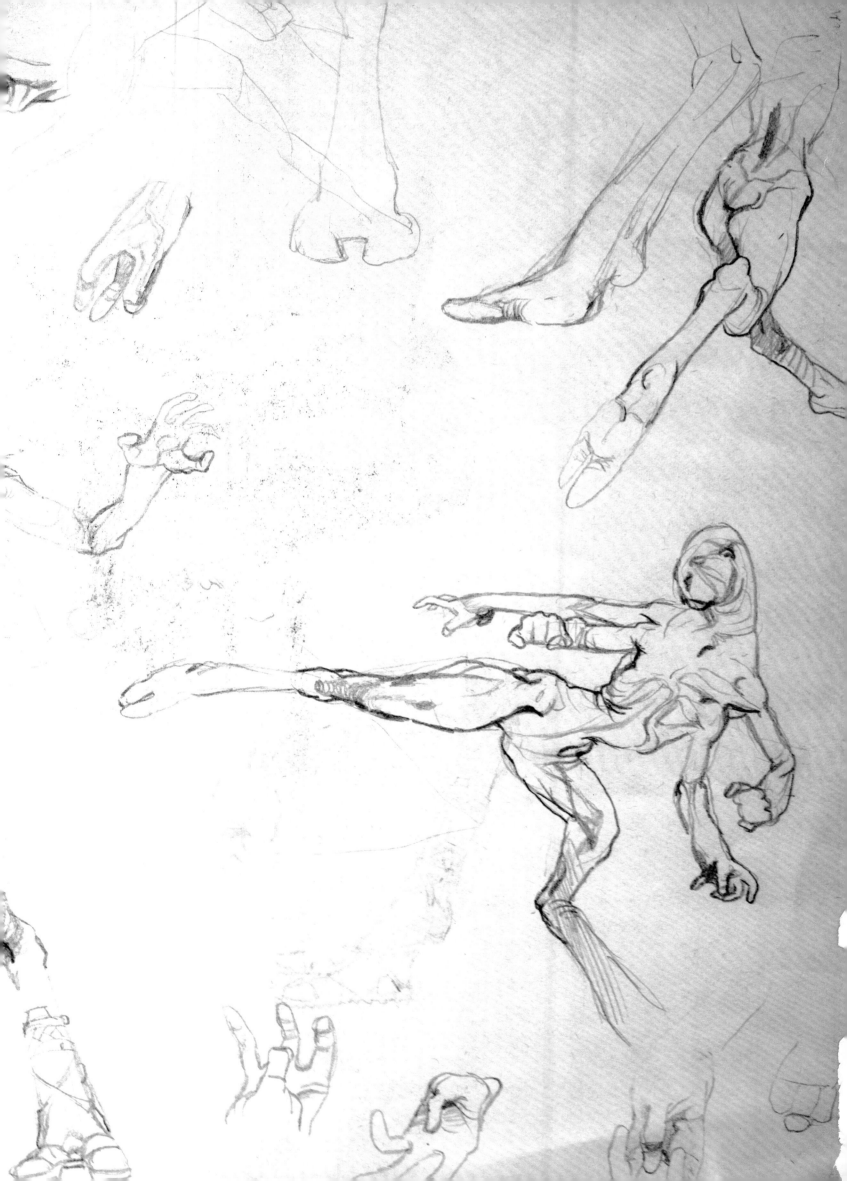

THE POMERALIEN

These were early ideas for Sid based on my then-wife Sharon's Pomeranian, Taffy. I dubbed these versions the Pomeralien. There's an important plot point in these pics: The Pomeralien is holding up an egg-shaped device that allows the people of his race to plug into a virtual world. But the problem is that his people plugged into it and never came out. It became so compelling, so interactive, that they decided they preferred to engage with each other in that world, so they stayed there forever. These were drawn somewhere around 1978, so there's no *The Matrix* at this point. There's not even William Gibson. But we were addressing similar themes. What if you could live in a video game? What if you never came back? In this case, Sid's entire civilization dies out because they retreat into a virtual world and forget to reproduce.

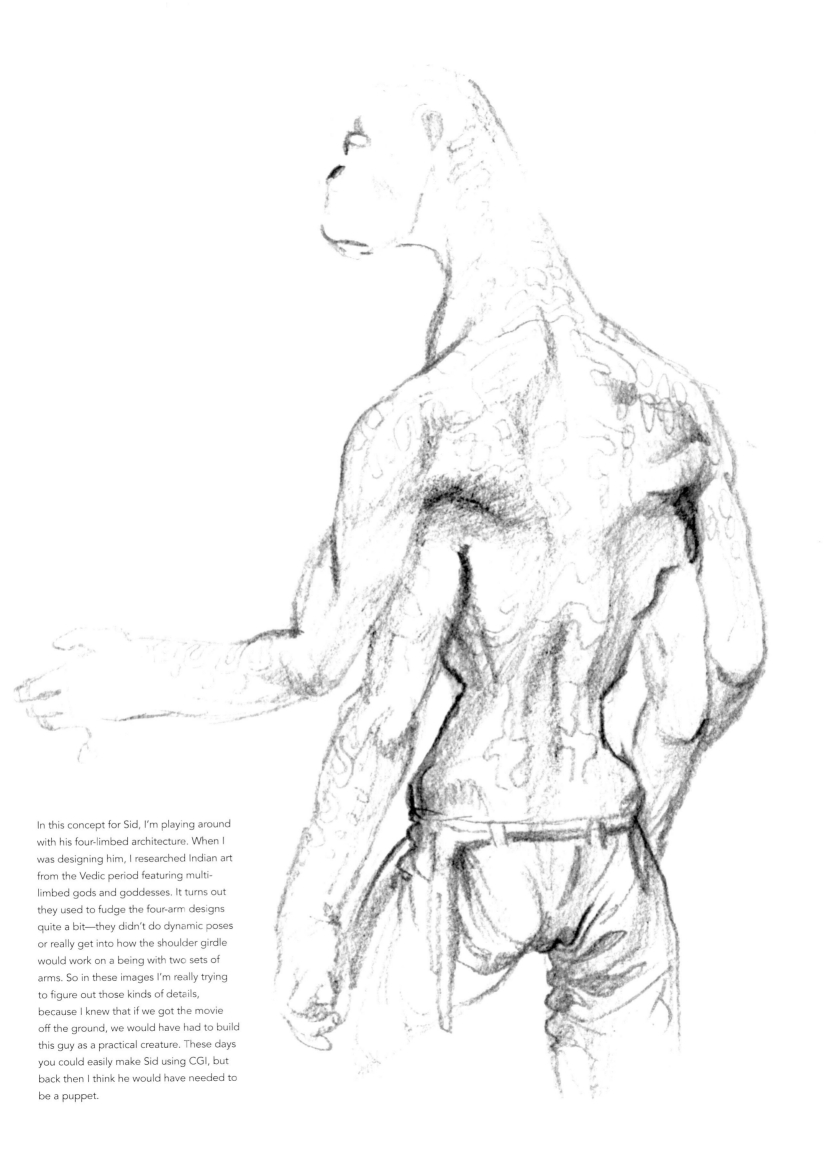

In this concept for Sid, I'm playing around with his four-limbed architecture. When I was designing him, I researched Indian art from the Vedic period featuring multi-limbed gods and goddesses. It turns out they used to fudge the four-arm designs quite a bit—they didn't do dynamic poses or really get into how the shoulder girdle would work on a being with two sets of arms. So in these images I'm really trying to figure out those kinds of details, because I knew that if we got the movie off the ground, we would have had to build this guy as a practical creature. These days you could easily make Sid using CGI, but back then I think he would have needed to be a puppet.

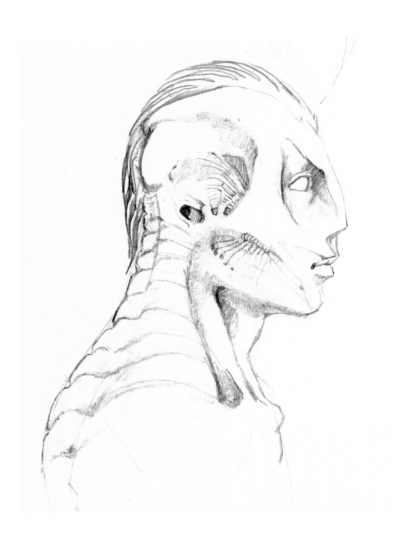

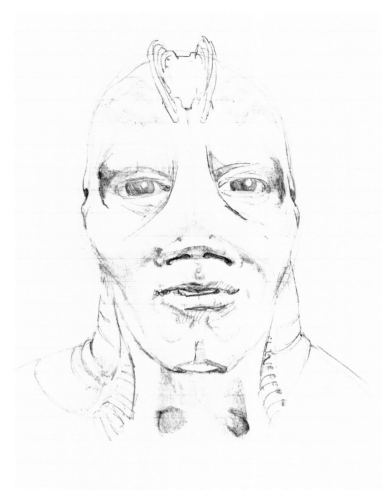

FUTURE TENSE

These are my design for what became *Alien Nation* (1988). My wife at the time, Gale Ann Hurd, who was the producer of *The Terminator*, *Aliens*, and *The Abyss*, optioned a script called *Outer Heat*. The concept was that a spaceship crashes on Earth filled with aliens. These extraterrestrials don't know how to fix spaceships; they are just laborers, so they end up stuck on our world. They need our help, so the government puts them in a camp just outside L.A., and then they're slowly integrated into society in low-level jobs. It was a clever socioeconomic comment on the way immigrants are exploited and basically a precursor to *District 9*, which would come along about twenty years later.

At its heart, though, it was a buddy cop film: The main plot revolved around a human detective who is forced to work with an alien partner to solve a murder in the E.T. community. And to help Gale get the movie made, I did an uncredited rewrite on the script and retitled it *Future Tense*, because it was essentially about racial tension, and it was taking place in the future. After the rewrite, I had a clear idea of what the alien characters should look like, so I decided to design them. They were supposed to be laborers, so I thought they should have a big thick neck, broad shoulders, plates down their back, and a display crest at the top of the head. I thought it was a pretty cool creature design.

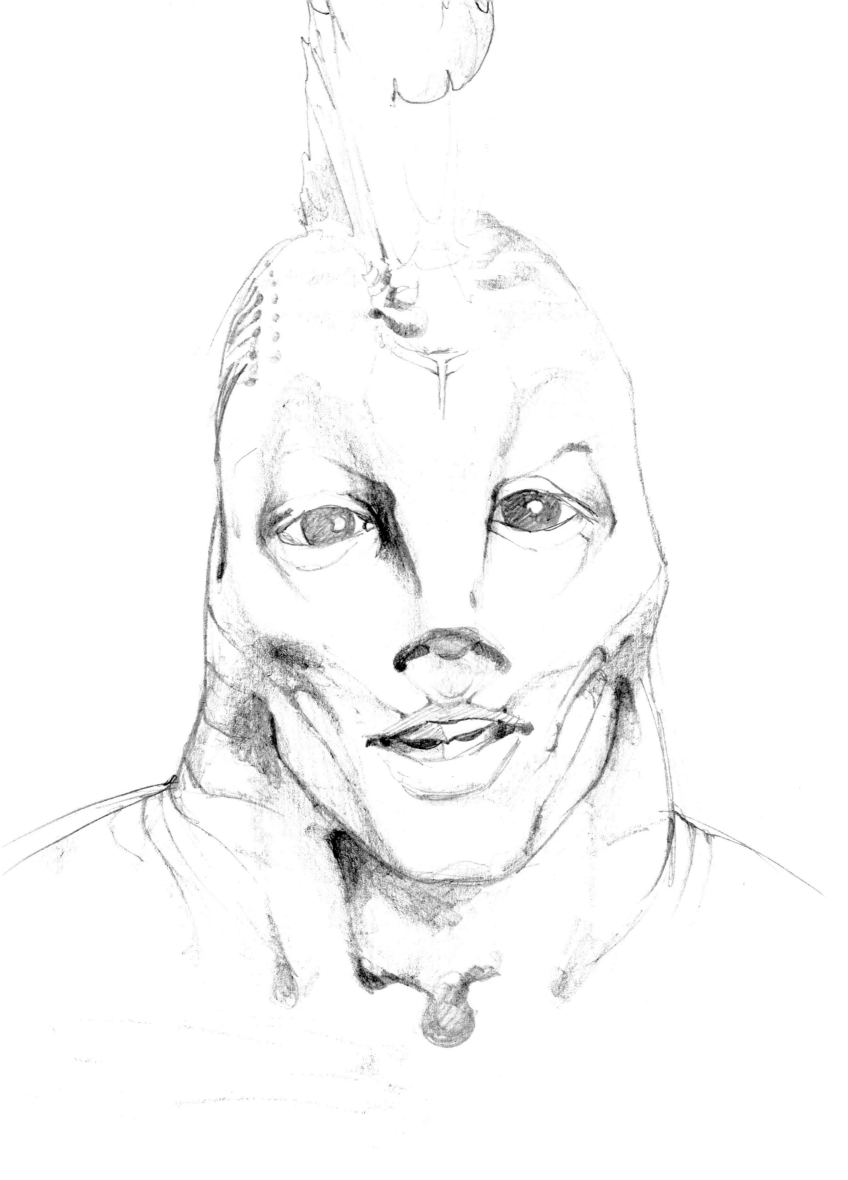

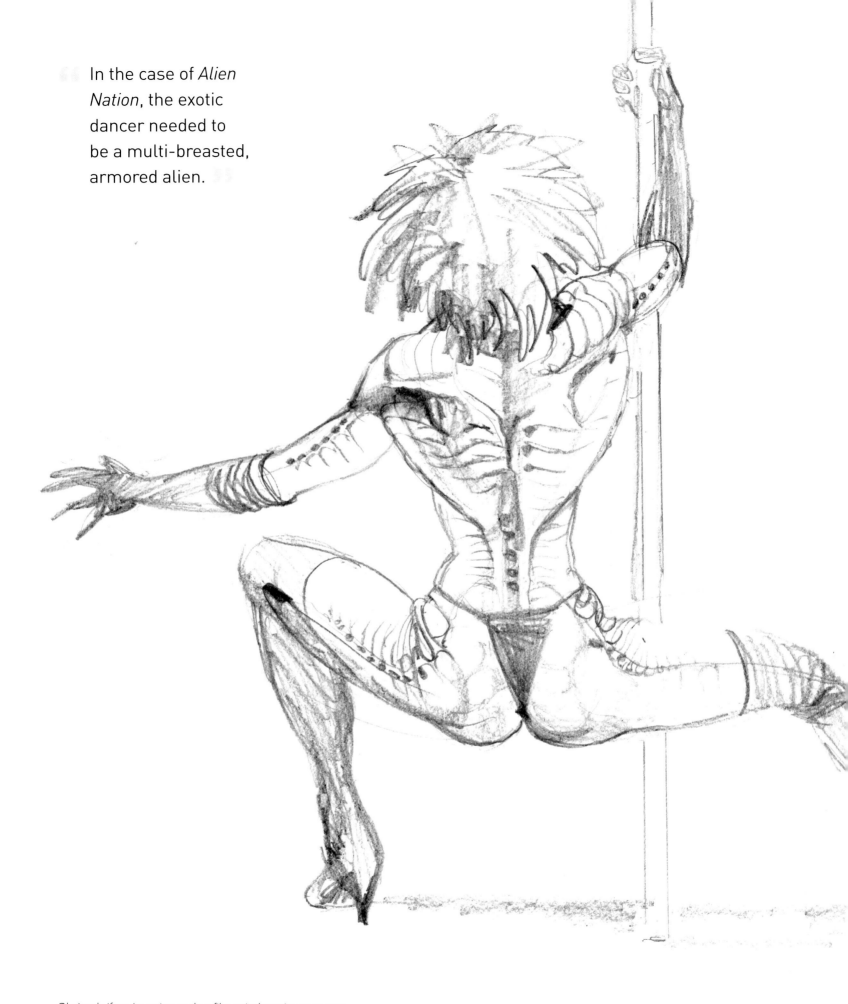

> In the case of *Alien Nation*, the exotic dancer needed to be a multi-breasted, armored alien.

Obviously if you're going to do a film noir detective story, you have to include a club dancer that the cops interview at a titty bar. In the case of *Alien Nation*, the exotic dancer needed to be a multi-breasted, armored alien. So here I was playing by the rules of the genre but obviously transposing the metaphor into a science fiction setting.

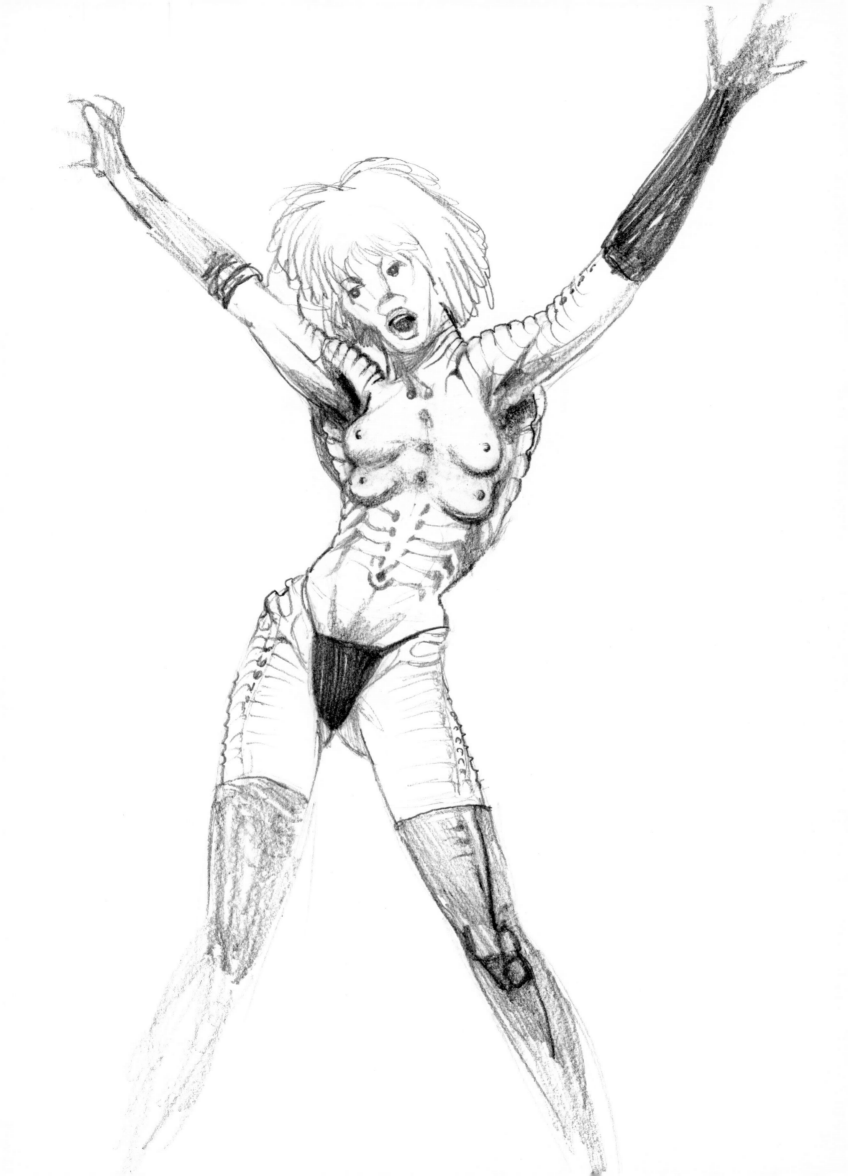

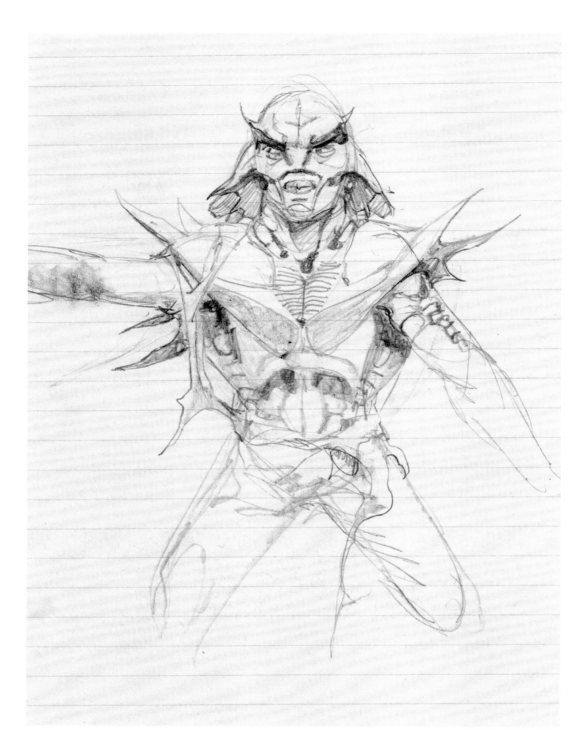

In *Alien Nation,* there's an illegal drug that some of the alien characters use. Taken in small quantities it gives them a high, but at the end of the film, the main villain chugs a whole damn bottle of this stuff. At this point he goes from drone class to warrior class and metamorphoses into an unstoppable superbeing. And this is my version of that transformed state—a pretty scary-looking dude. It's obviously based on medieval Japanese battle armor—particularly the head, which is reminiscent of a samurai helmet. This is post-*Aliens,* so I was thinking that, like the Alien Queen, the creature should have some kind of cool projections around the head that would change its whole silhouette.

I also figured this design could be developed into a practical suit that an actor could wear. In 1985, Ridley Scott had released the fantasy movie *Legend,* which featured Tim Curry in this incredible makeup created by Rob Bottin. It had these huge devil horns that completely changed Curry's silhouette, and I still think it's one of the most amazing makeups in film history. So I was thinking it would be cool to do something similar for this supercharged alien character. Overall, I was trying to infuse my designs with the same level of detail that I would bring to one of my own projects and create a believable ecosystem. But ultimately, they just kind of thanked me and told me to go away. I wasn't really involved in the final production, and I was pretty disappointed by the designs they ended up going with and the film itself. But you know, that's Hollywood.

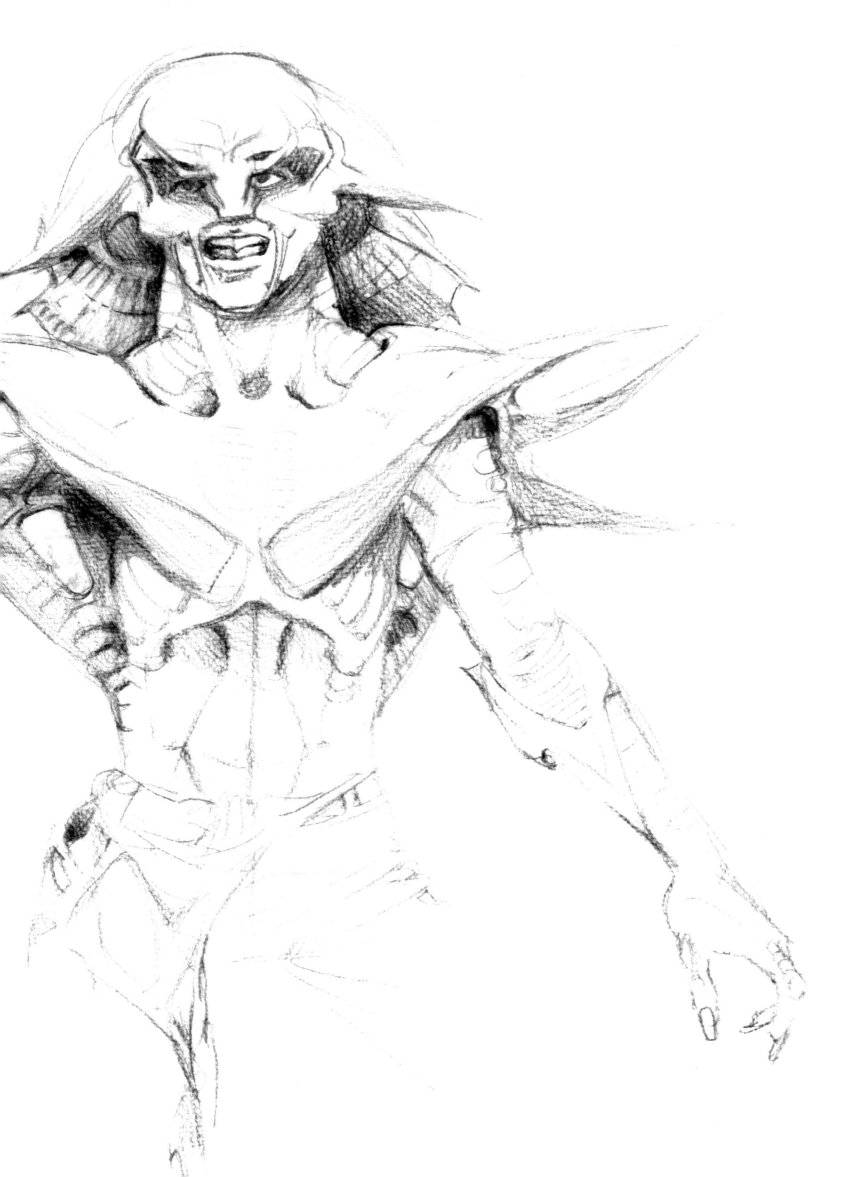

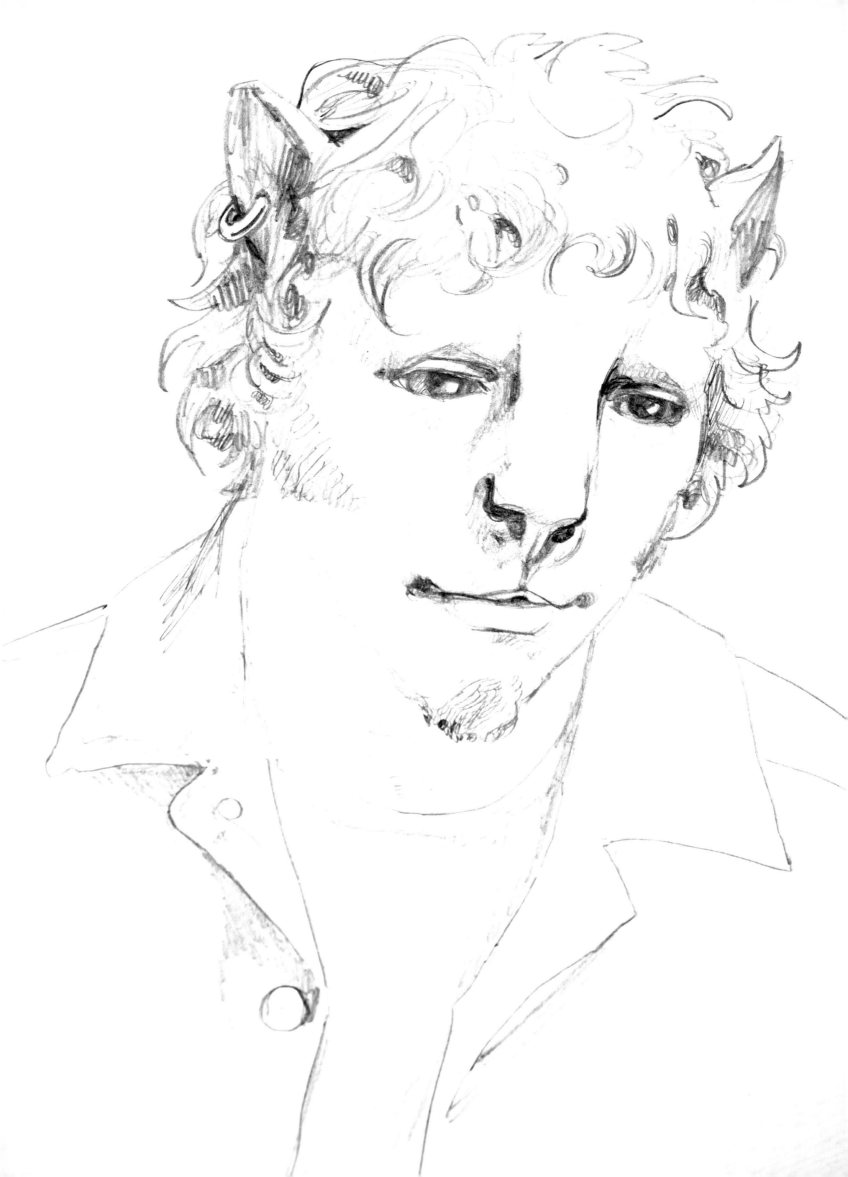

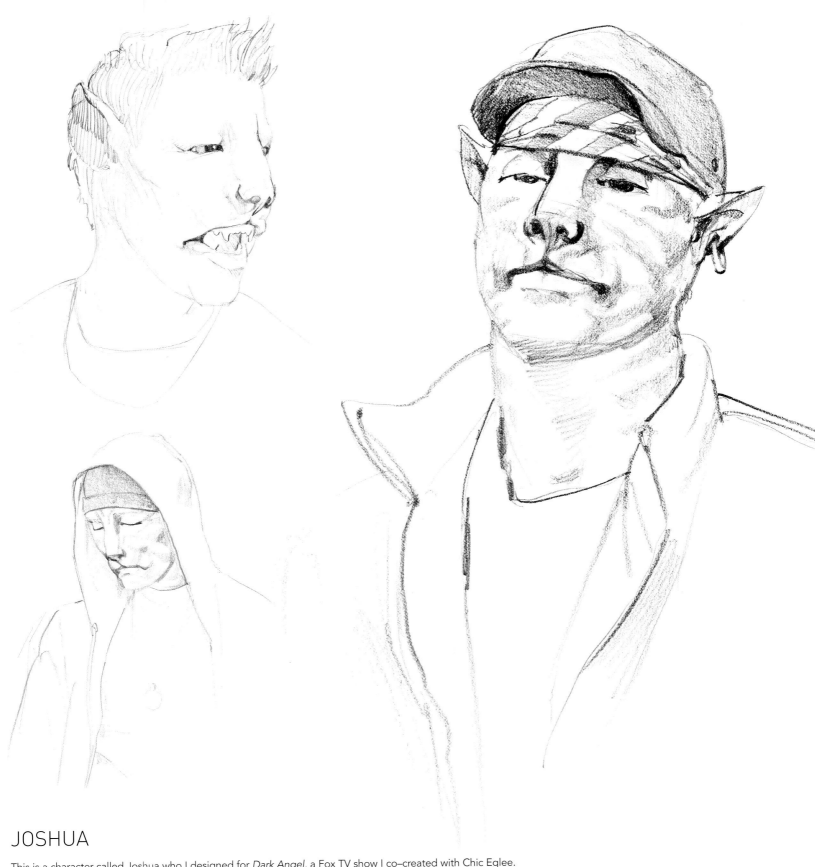

JOSHUA

This is a character called Joshua who I designed for *Dark Angel*, a Fox TV show I co–created with Chic Eglee.
I'd become friends with Chic after I reworked his *Piranha II* script back in the day. I remember working on these
concepts at sea when I was on an expedition to the wreck of the *Titanic* back in 2001. Joshua was a genetically
altered dog guy. I'd seen a lot of human/dog hybrid designs over the years, and I thought they all sucked. I
wanted to see a street version of a dog guy—like a grunge or hip-hop dog guy. So the first thing I drew was the
image on the left-hand page, which was sort of based on Eddie Vedder, the singer from Pearl Jam. Then I went
further down that path, and I gave him a hat with a bandana underneath and a big coat and hoodie. I was trying
to design a guy that you might walk past on the street and not look at all that closely. But if he walked under a
streetlight and flipped that hoodie down, he was a dog guy. I didn't want to do a werewolf—it wasn't about being
a wolf, it was about being a human dog. Obviously, his teeth were going to be important—they don't call them
canines for nothing. The prehensile ears and bifurcated upper lip were givens, too. We all loved this character on
the show, and they did a great makeup for him. The actor, Kevin Durand, was great, too. So, for me, Joshua was a
success story. And by the way, we experimented with a bifurcated upper lip when designing the Na'vi for *Avatar*.
We ultimately decided not to do it, though.

THE NA'VI

The roots of the Na'vi design can be traced all the way back to *Xenogenesis*. At the end of the story, Jorden finally finds a planet to colonize, but its air is not breathable to humans. However, CENCON is able to use the technology aboard the *Cosmos Kindred* to extract some of the genome from the planet and adapt the colonist embryos to this new world. So the new generation, who are raised by CENCON, have a different type of circulation—a copper-based version of hemoglobin which gives their skin the blue coloration. Jorden ultimately dies at the end of the story—he decides to expose himself to the planet's atmosphere and dies of asphyxiation. But he's grown old and that's his exit strategy. It was a pretty poignant love story, and many of these narrative elements eventually made it into *Avatar*, including Pandora's air not being breatheable and the fate of the Jake Sully character.

The blue girl from my mash-up *Xenogenesis* painting (detail at bottom left) also came in handy after the release of *Avatar* when people crawled out of the woodwork claiming that because they had done stories featuring blue people, we needed to pay them tens of millions of dollars. I was able to hold up that painting and say, "1977. Right here, baby. Fuck you." It's really my mom that saved my ass on this because the idea came from her. One day she had this dream about a blue goddess with six breasts. She thought it was amazing, and she went on and on about it. It must have stuck with me, as I ended up using it in *Xenogenesis*. We eventually ditched four of the six breasts, although I did draw the six-breasted version at one point. It wasn't quite as appealing as it sounds.

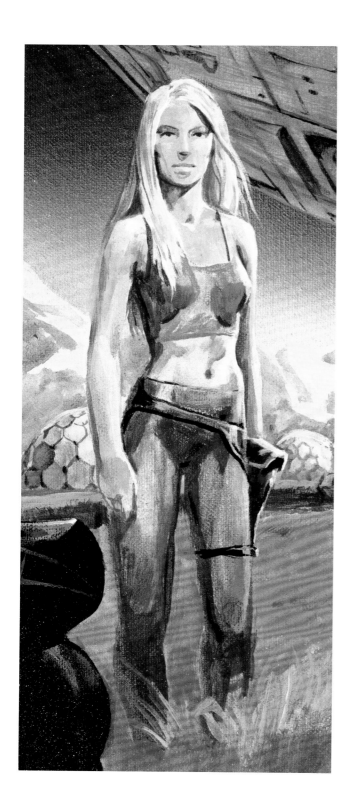

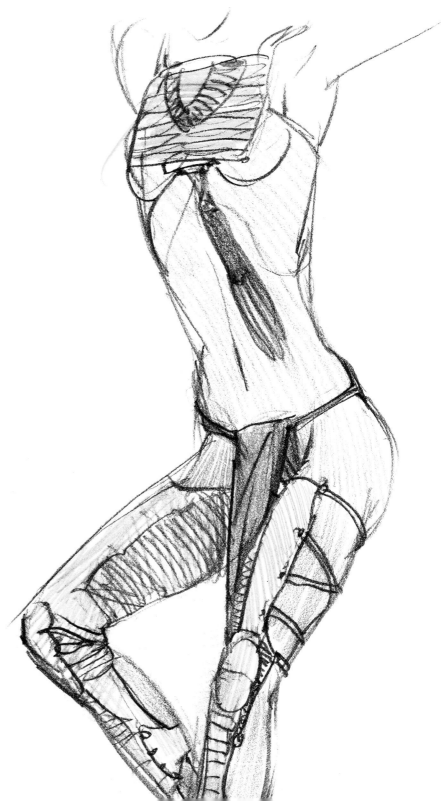

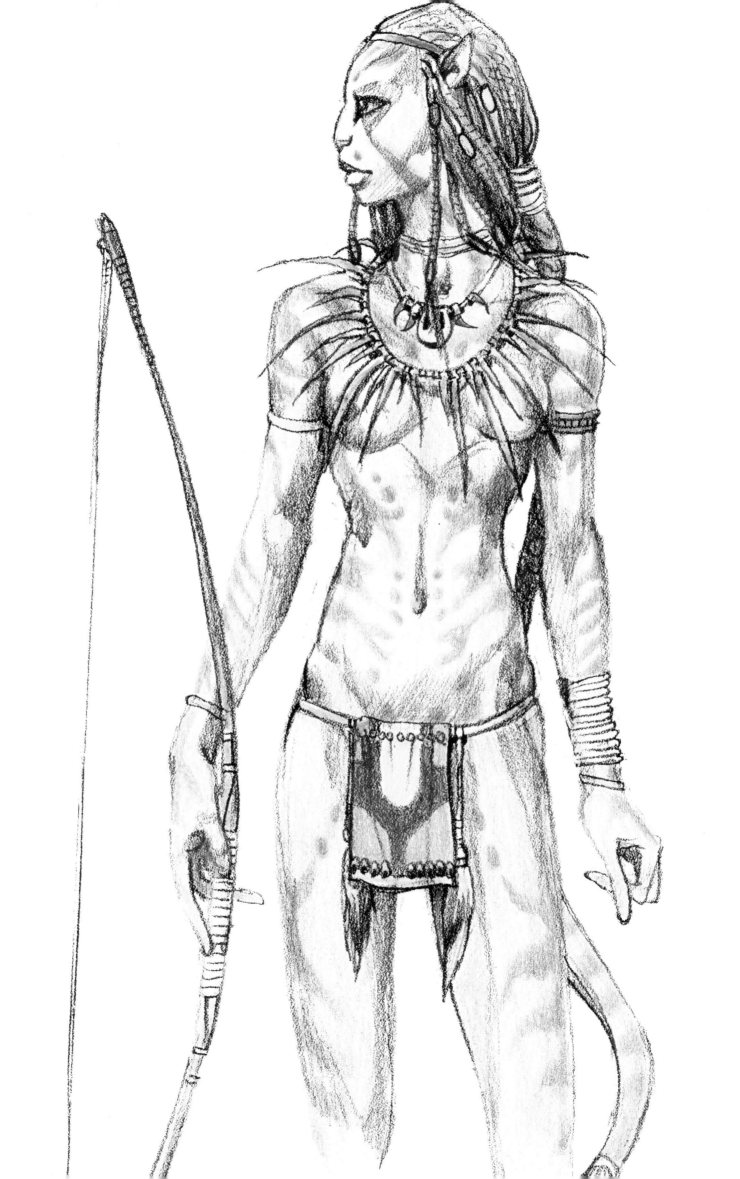

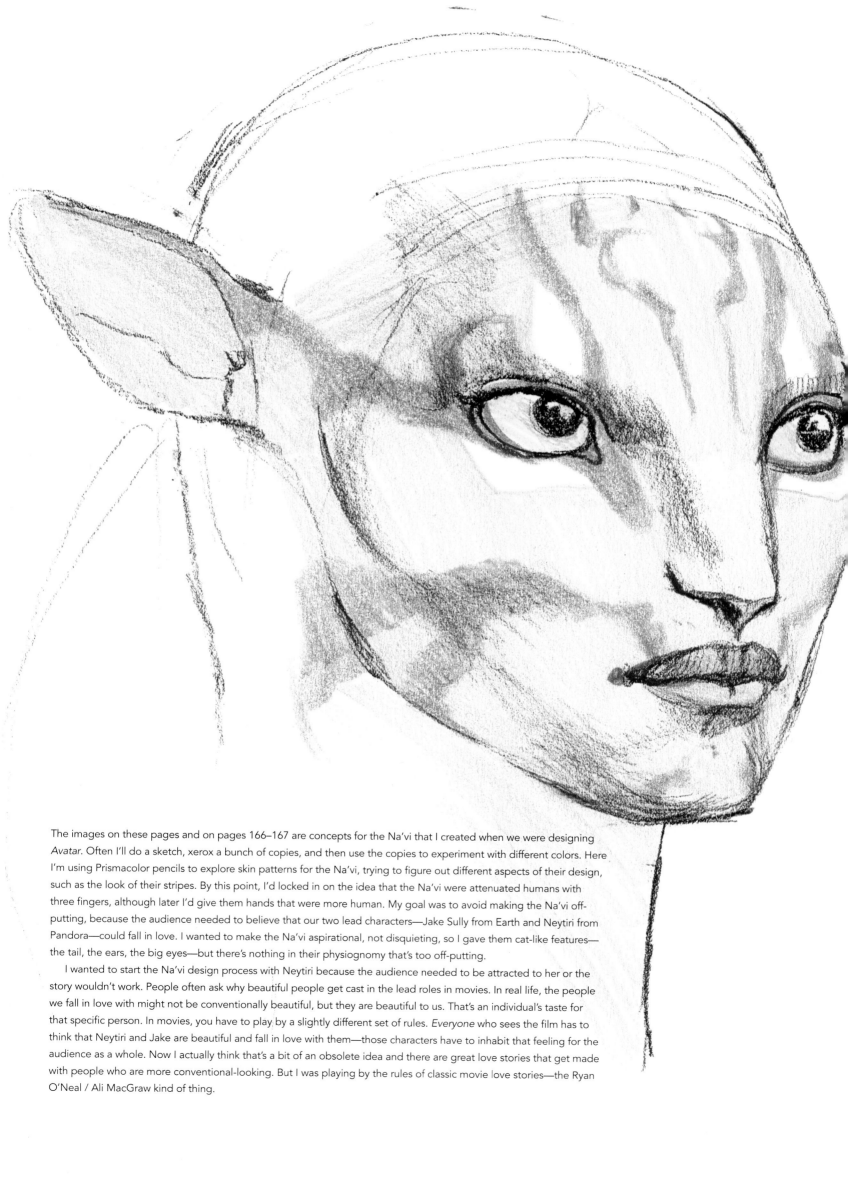

The images on these pages and on pages 166–167 are concepts for the Na'vi that I created when we were designing *Avatar*. Often I'll do a sketch, xerox a bunch of copies, and then use the copies to experiment with different colors. Here I'm using Prismacolor pencils to explore skin patterns for the Na'vi, trying to figure out different aspects of their design, such as the look of their stripes. By this point, I'd locked in on the idea that the Na'vi were attenuated humans with three fingers, although later I'd give them hands that were more human. My goal was to avoid making the Na'vi off-putting, because the audience needed to believe that our two lead characters—Jake Sully from Earth and Neytiri from Pandora—could fall in love. I wanted to make the Na'vi aspirational, not disquieting, so I gave them cat-like features—the tail, the ears, the big eyes—but there's nothing in their physiognomy that's too off-putting.

I wanted to start the Na'vi design process with Neytiri because the audience needed to be attracted to her or the story wouldn't work. People often ask why beautiful people get cast in the lead roles in movies. In real life, the people we fall in love with might not be conventionally beautiful, but they are beautiful to us. That's an individual's taste for that specific person. In movies, you have to play by a slightly different set of rules. *Everyone* who sees the film has to think that Neytiri and Jake are beautiful and fall in love with them—those characters have to inhabit that feeling for the audience as a whole. Now I actually think that's a bit of an obsolete idea and there are great love stories that get made with people who are more conventional-looking. But I was playing by the rules of classic movie love stories—the Ryan O'Neal / Ali MacGraw kind of thing.

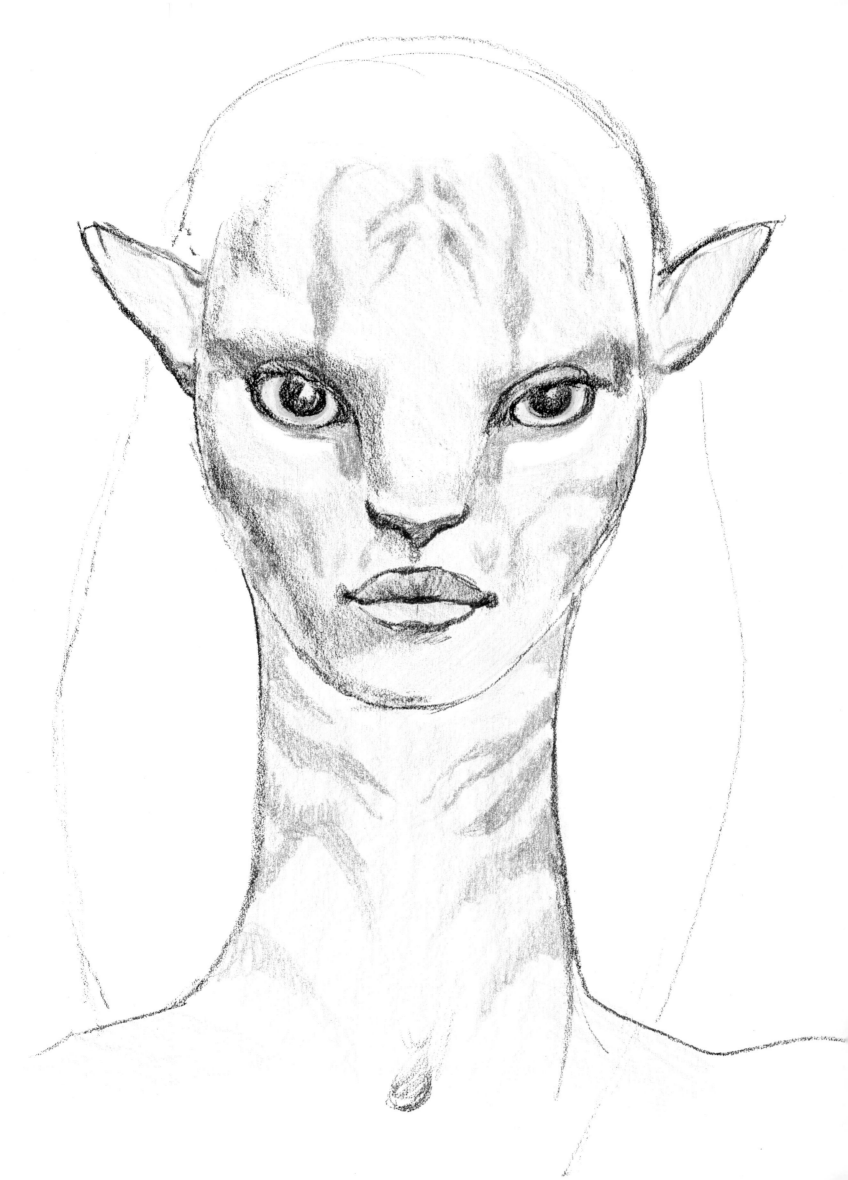

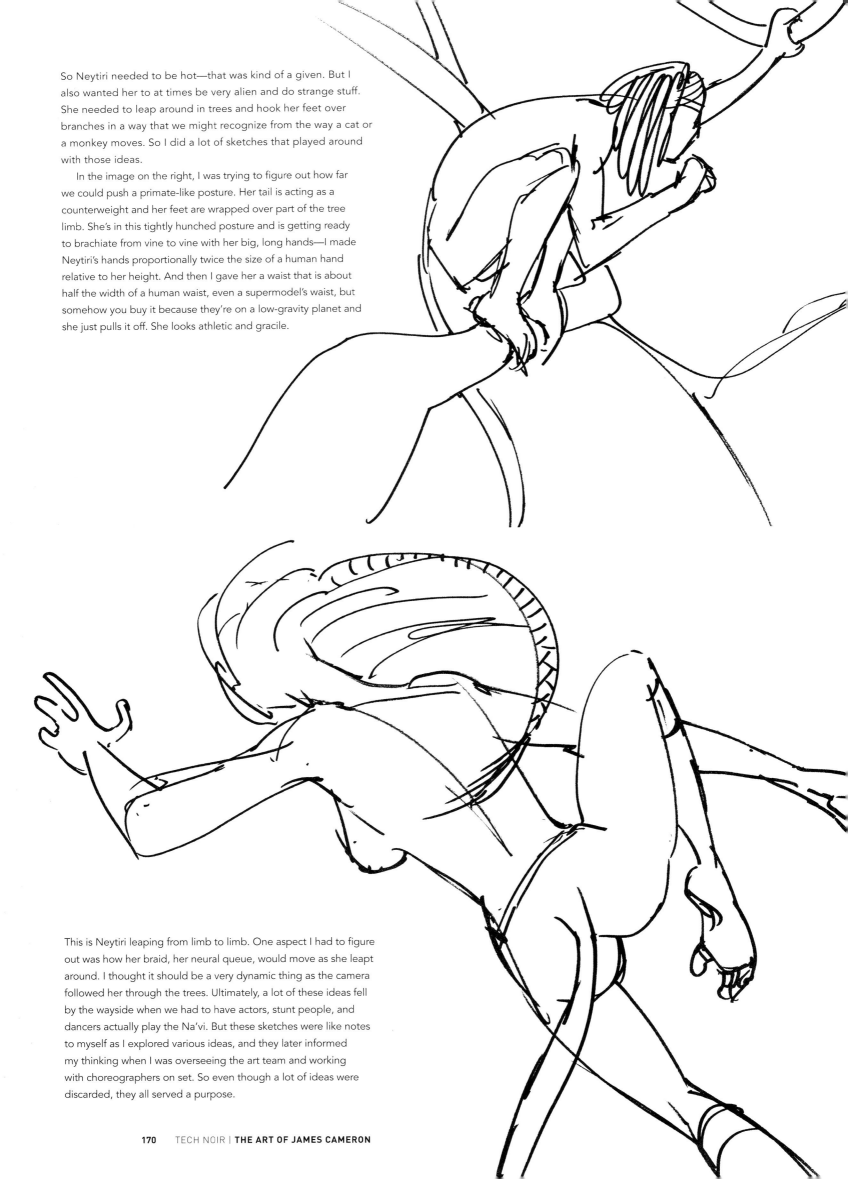

So Neytiri needed to be hot—that was kind of a given. But I also wanted her to at times be very alien and do strange stuff. She needed to leap around in trees and hook her feet over branches in a way that we might recognize from the way a cat or a monkey moves. So I did a lot of sketches that played around with those ideas.

In the image on the right, I was trying to figure out how far we could push a primate-like posture. Her tail is acting as a counterweight and her feet are wrapped over part of the tree limb. She's in this tightly hunched posture and is getting ready to brachiate from vine to vine with her big, long hands—I made Neytiri's hands proportionally twice the size of a human hand relative to her height. And then I gave her a waist that is about half the width of a human waist, even a supermodel's waist, but somehow you buy it because they're on a low-gravity planet and she just pulls it off. She looks athletic and gracile.

This is Neytiri leaping from limb to limb. One aspect I had to figure out was how her braid, her neural queue, would move as she leapt around. I thought it should be a very dynamic thing as the camera followed her through the trees. Ultimately, a lot of these ideas fell by the wayside when we had to have actors, stunt people, and dancers actually play the Na'vi. But these sketches were like notes to myself as I explored various ideas, and they later informed my thinking when I was overseeing the art team and working with choreographers on set. So even though a lot of ideas were discarded, they all served a purpose.

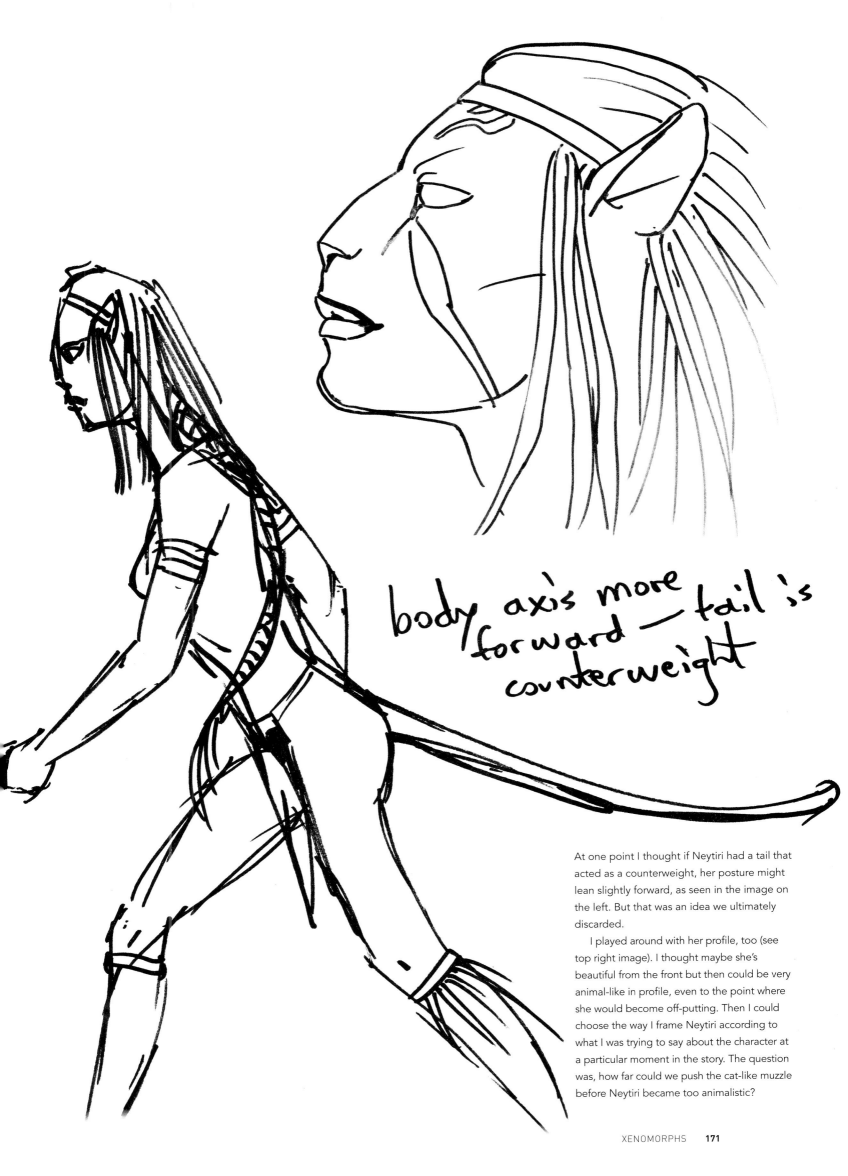

body axis more forward — tail is counterweight

At one point I thought if Neytiri had a tail that acted as a counterweight, her posture might lean slightly forward, as seen in the image on the left. But that was an idea we ultimately discarded.

I played around with her profile, too (see top right image). I thought maybe she's beautiful from the front but then could be very animal-like in profile, even to the point where she would become off-putting. Then I could choose the way I frame Neytiri according to what I was trying to say about the character at a particular moment in the story. The question was, how far could we push the cat-like muzzle before Neytiri became too animalistic?

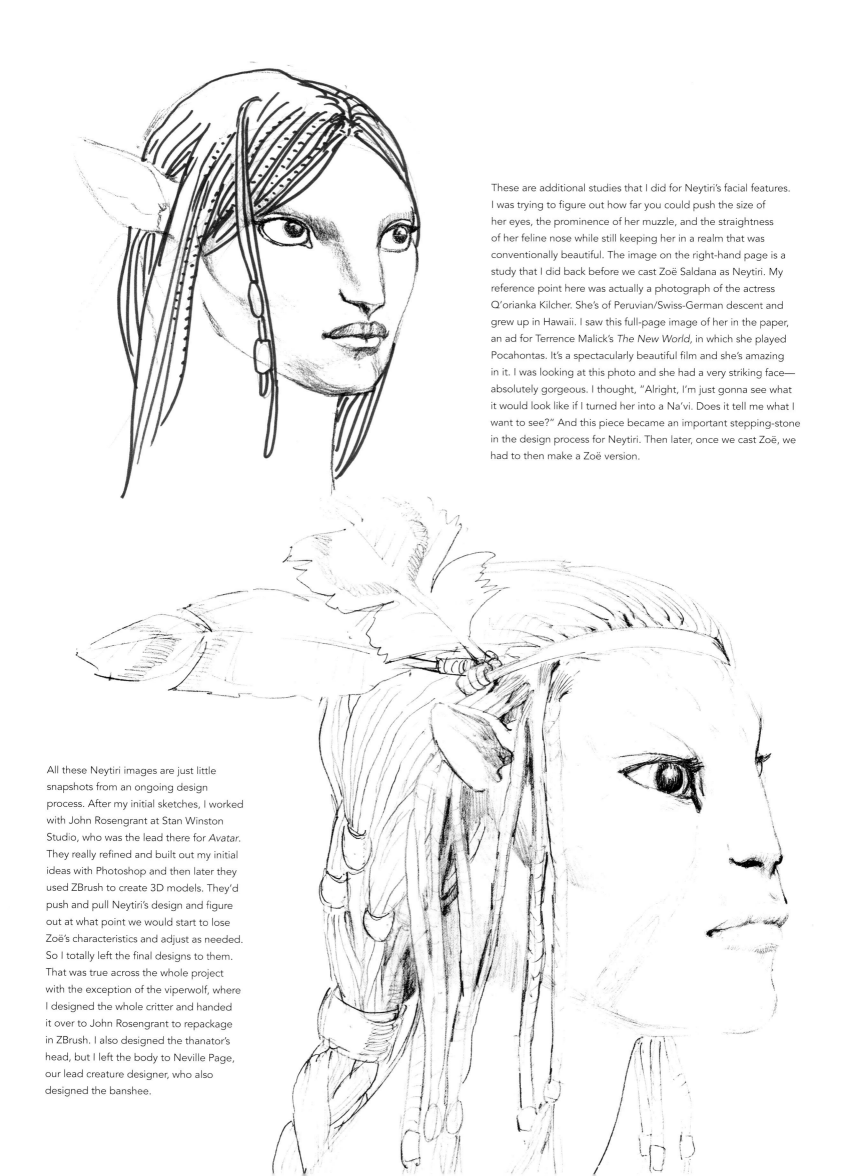

These are additional studies that I did for Neytiri's facial features. I was trying to figure out how far you could push the size of her eyes, the prominence of her muzzle, and the straightness of her feline nose while still keeping her in a realm that was conventionally beautiful. The image on the right-hand page is a study that I did back before we cast Zoë Saldana as Neytiri. My reference point here was actually a photograph of the actress Q'orianka Kilcher. She's of Peruvian/Swiss-German descent and grew up in Hawaii. I saw this full-page image of her in the paper, an ad for Terrence Malick's *The New World*, in which she played Pocahontas. It's a spectacularly beautiful film and she's amazing in it. I was looking at this photo and she had a very striking face—absolutely gorgeous. I thought, "Alright, I'm just gonna see what it would look like if I turned her into a Na'vi. Does it tell me what I want to see?" And this piece became an important stepping-stone in the design process for Neytiri. Then later, once we cast Zoë, we had to then make a Zoë version.

All these Neytiri images are just little snapshots from an ongoing design process. After my initial sketches, I worked with John Rosengrant at Stan Winston Studio, who was the lead there for *Avatar*. They really refined and built out my initial ideas with Photoshop and then later they used ZBrush to create 3D models. They'd push and pull Neytiri's design and figure out at what point we would start to lose Zoë's characteristics and adjust as needed. So I totally left the final designs to them. That was true across the whole project with the exception of the viperwolf, where I designed the whole critter and handed it over to John Rosengrant to repackage in ZBrush. I also designed the thanator's head, but I left the body to Neville Page, our lead creature designer, who also designed the banshee.

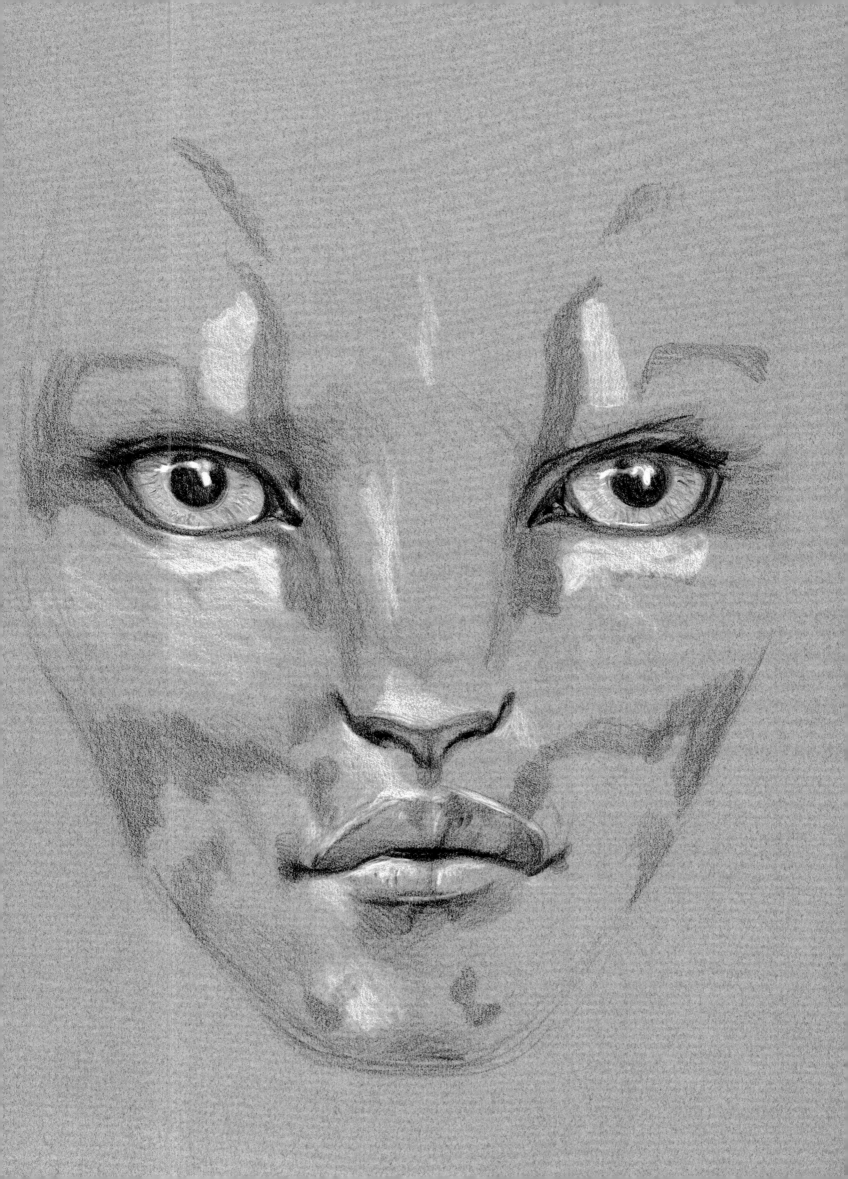

Into the Cosmos

Born at the dawn of the Space Age, James Cameron was entranced by the possibilities of interstellar travel from an early age. Over the years, this interest would develop beyond a typical boyhood passion to become an area of great expertise. Following deep research into topics such as rocket propulsion, avionics, and aerodynamics, Cameron became an expert in the field, so much so that in 2005 he was invited to sit on NASA's Advisory Council.

Typically, Cameron's approach to space travel in both his early art and his later film work is grounded in scientific reality. When writing Xenogenesis *in the late '70s, Cameron concerned himself with how his protagonist, Russell Jorden, would be able to deliver a spaceship filled with colonist embryos to a distant star system without dying of old age along the way. The solution, a cryogenic hibernation process, became a key part of the script—not just an opportunity to include compelling sci-fi technology but a means of conveying the tragic love story at the heart of the script. In later years, Cameron would return to similar ideas of interstellar stasis in both* Aliens *and* Avatar.

The vehicles needed to carry out space exploration also became a point of fascination for Cameron. The ship Jorden pilots in Xenogenesis, *the Cosmos Kindred, is the summation of years of theorizing on the functionality of such a craft, with real-world scientific principles influencing both its design and its role within the story. For* Aliens, *Cameron co-designed the assault helicopter-style Dropship that would carry the grunts to the surface of the planet, another dynamic piece of sci-fi tech but one entirely grounded in aerodynamic principles and combat-ready design protocols.*

Although Cameron chooses to draw a line between his filmmaking and his celebrated career as a deep-sea explorer, there are clearly parallels between these two sides of his life. The ability to envision and oversee the creation of a deep-sea vehicle that can reach the depths of the Marianas Trench—a feat Cameron achieved in 2012—is perhaps not so far removed from the ability to conceive of a deep-space vehicle that could reach distant solar systems. While the latter concept is purely theoretical, Cameron's boundless curiosity and fascination with discovering the unknown drove both ventures.

This fascination with the outer reaches of scientific knowledge is manifest in Cameron's early space art, as is his logic-based approach to building vessels that bring humankind closer to the answers it seeks. But the thread that links all of Cameron's endeavors is the ability to not only imagine something fantastic but also execute on it, dragging it from the dream space into reality, be it through art, filmmaking, or engineering. The images in this chapter are a testament to the first step on that creative journey.

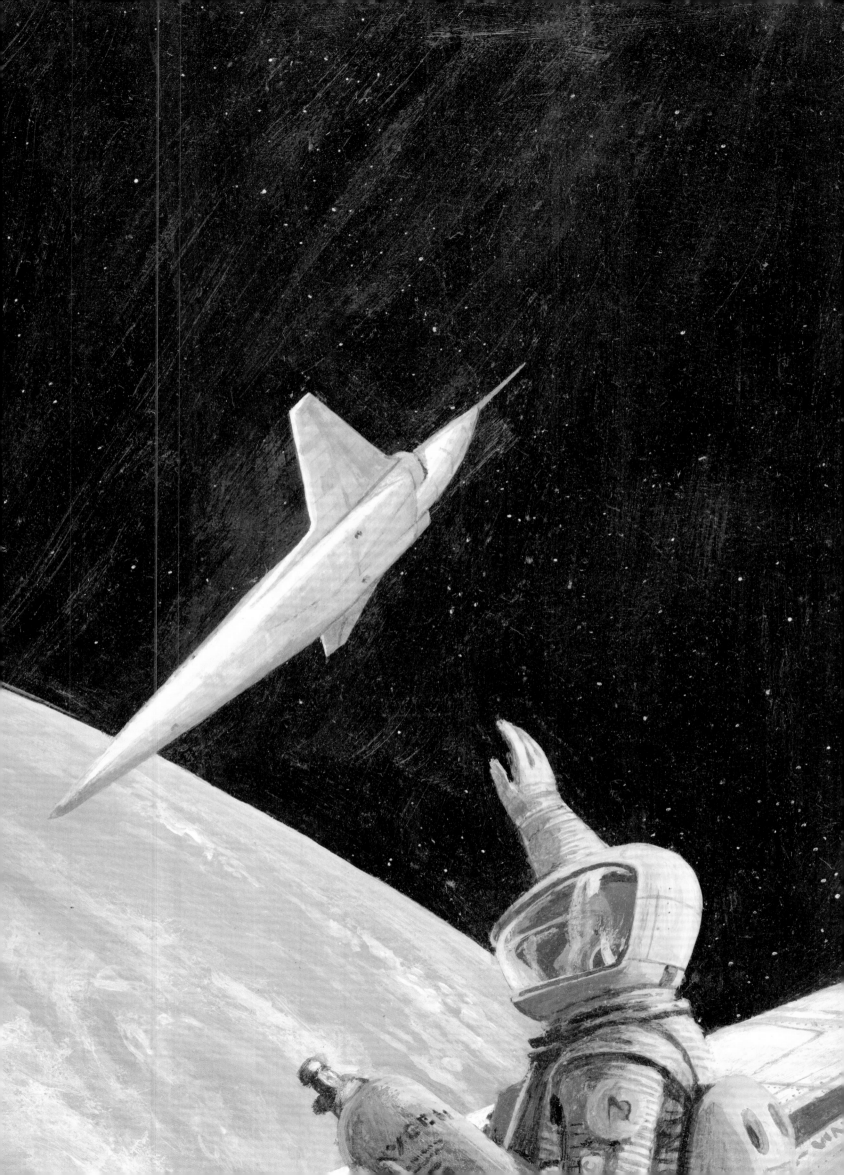

I was a real space maniac when I was a kid. I'd read anything I could get my hands on about space science, rocket propulsion, interplanetary exploration—all of that stuff. I was voracious. I'd always loved space, but when I saw *2001: A Space Odyssey* in 1968, it kicked my enthusiasm to an even higher level. And that year was such a seminal time for space exploration. Apollo 8 orbited the moon in December 1968—the first time humans had left Earth's gravity well and traveled to another body. The astronauts brought back the iconic earthrise photo, which blew my mind; I remember doing a big mural painting of it at my high school. I was fourteen when Apollo 11 landed on the moon in July 1969. I remember I was at my grandmother's house when it happened, and I followed every step of the process through the landing. I had even built the Revell model kit of the entire Saturn V launch vehicle and lunar lander so I could follow along with Walter Cronkite's crappy moon landing animation.

It was such an amazing period, when space travel was not only happening for real, but also happening on the big screen in this incredibly lucid way. The image on page 175 is obviously inspired by *2001: A Space Odyssey* and features a spaceship and spacesuit based on the ones I'd seen in the movie. The segmented spacesuit image on page 174 is also inspired by the Kubrick film. I was putting my own swerve on the designs from *2001* but you can clearly see what they are based on. I was just so overwhelmed by that movie and feeding it back out into my art.

The gold antigravity ship below is the opposite of the near-future, *2001*-inspired tech. This is distant–future, highly advanced. We don't see if the pilot who made the footprints is human or alien.

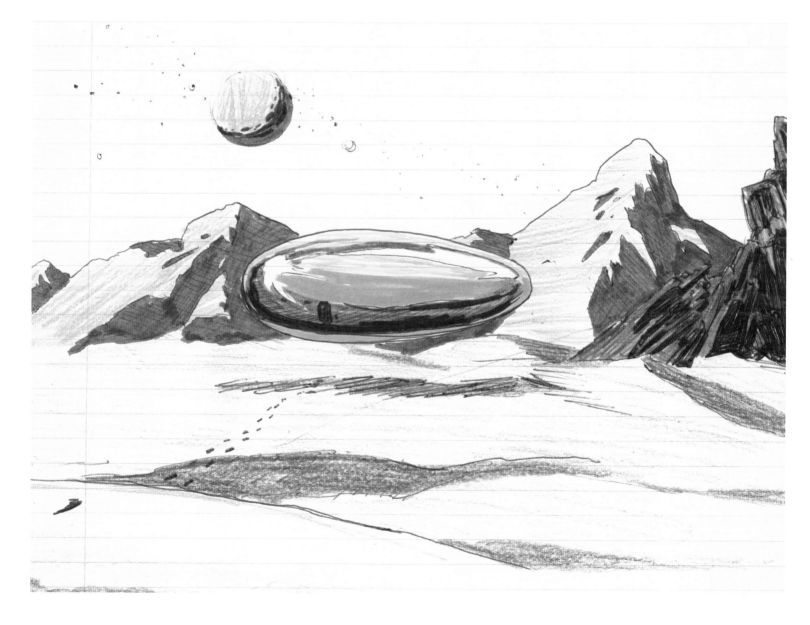

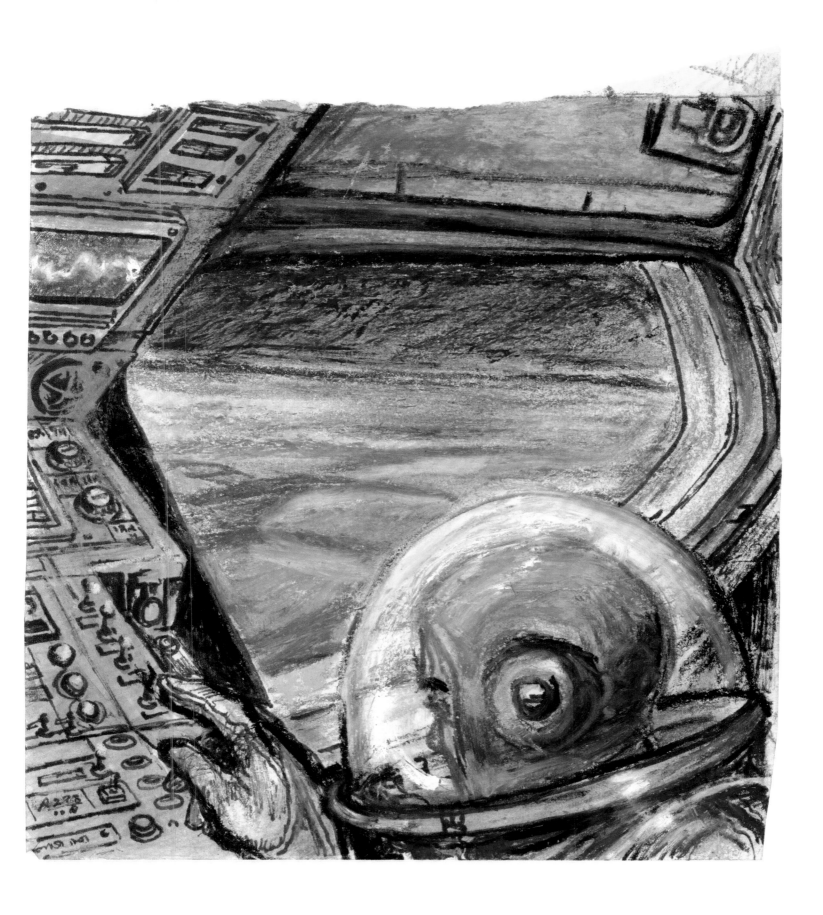

I drew the above image around eighth grade. I remember seeing a *Collier's* magazine spread that had paintings of future space travel, including an astronaut on Mars looking out the viewport of his spacecraft. So, this is my own version of that idea. I was thinking a lot about what it would be like to travel to Mars at the time. In the 1960s, *Collier's* published a lot of really amazing speculative space art by the famed astronomical artist Chesley Bonestell. His work depicted futuristic space stations, spaceships, lunar colonies, and so on, and that kind of stuff was fascinating to me at the time because I was such a space nerd.

"In the 1960s, *Collier's* published a lot of really amazing speculative space art by the famed astronomical artist Chesley Bonestell."

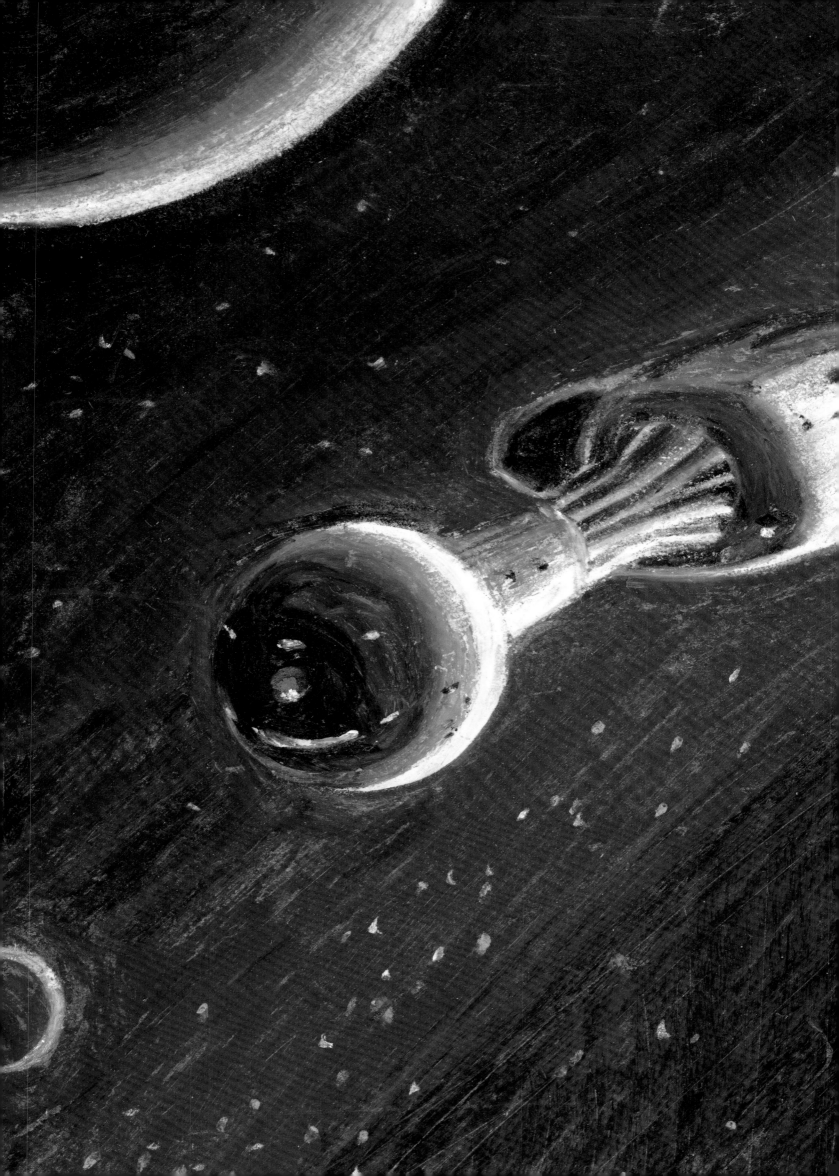

These are from around mid–high school, probably the tenth grade. I'm playing around with oil pastels and just learning how to draw and paint. On the left you can see I'm starting to develop my fusion ramjet spacecraft design with scoops on the side that I would later take much further when designing the *Cosmos Kindred* for *Xenogenesis*. The front end of the ship is clearly influenced by the *Discovery One* spaceship from *2001: A Space Odyssey*. On the right is a painting I did of Saturn during the same era.

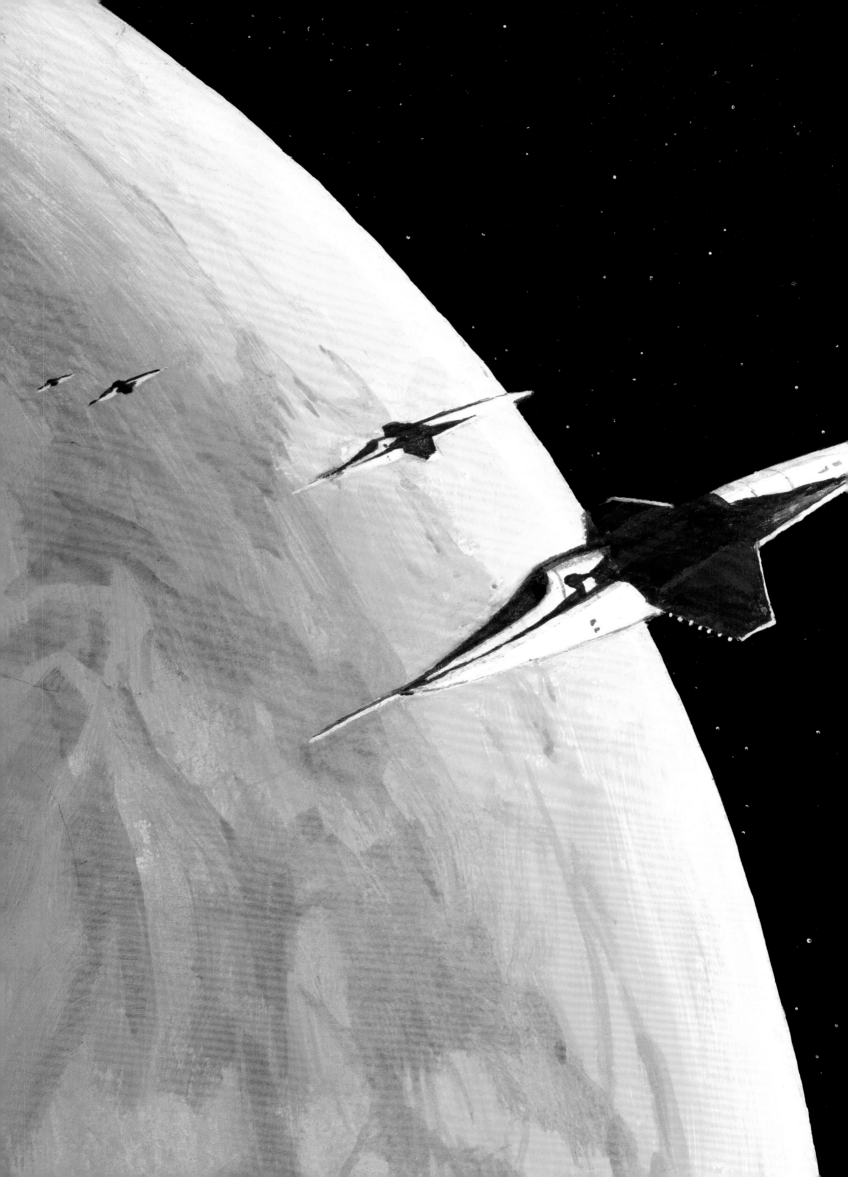

On the left-hand page is another image inspired by *2001: A Space Odyssey*—multiple Pan Am space clippers from the film. I'm basically learning to use acrylics at this point. On the right is some general space-themed art from around the same period.

The designs on pages 182–183 are from my final twelfth grade science project in which I outlined every type of space propulsion that was known at the time. The image on the right-hand page is a NERVA, which stood for Nuclear Engine for Rocket Vehicle Application. The basic idea is that you take a reactor and use a turbo pump to drive liquid hydrogen through its core so it comes out super expanded. So essentially it was a nuclear engine that would go about twice as fast as any chemical rocket. NASA and some other agencies were developing this project for about two decades, and they successfully built one and fired it down a big mine shaft at one point. But ultimately they canceled the whole nuclear propulsion program for political reasons during the time when nonproliferation was a big issue. It's a shame because I think they could have landed on Mars by 1985 if they had just kept the pedal to the metal.

a large, inflatable structure with room and life support equipment for 6-12 men which could keep the crew alive long enough to allow pick up by a rescue pod from an orbiting space station; or it could have a small thrustor system for self-maneuvering.

retrorocket

timer

firing mechanism

handgrip

window

zipper

Inner sphere bladder

outer bladder

insulation

heat shield

Parachute

Oxygen supply

Fig. Spherical escape system inflated by nitrogen for reentry

Fig (below) A space parachute during re-entry

(31)

Schematic Diagram
of a
Nuclear rocket engine
as designed by
Project NERVA:

Nuclear
Engine for
Rocket
Vehicle
Application

Liquid hydro-
-gen propellant

Heated gas
(spurts flamelessly
through a De Lavall
nozzle)

KEY
1. Hydrogen Propellant
2. Propellant pump
3. propellant line to nozzle
4. nozzle reinforcing bands
5. cooling jacket (inside nozzle)
6. De Lavall-type nozzle
7. turbine feed-line
8. reactor sheilding and reflector.
9. turbine exhaust nozzle
10. Cadmium control rods
11. turbine (powers the pump)
12. Reactor core (U-285+graphite)
13. Channels bored in graphite core.
14. Flameless super-heated hydrogen gas

NUCLEAR ENGINE

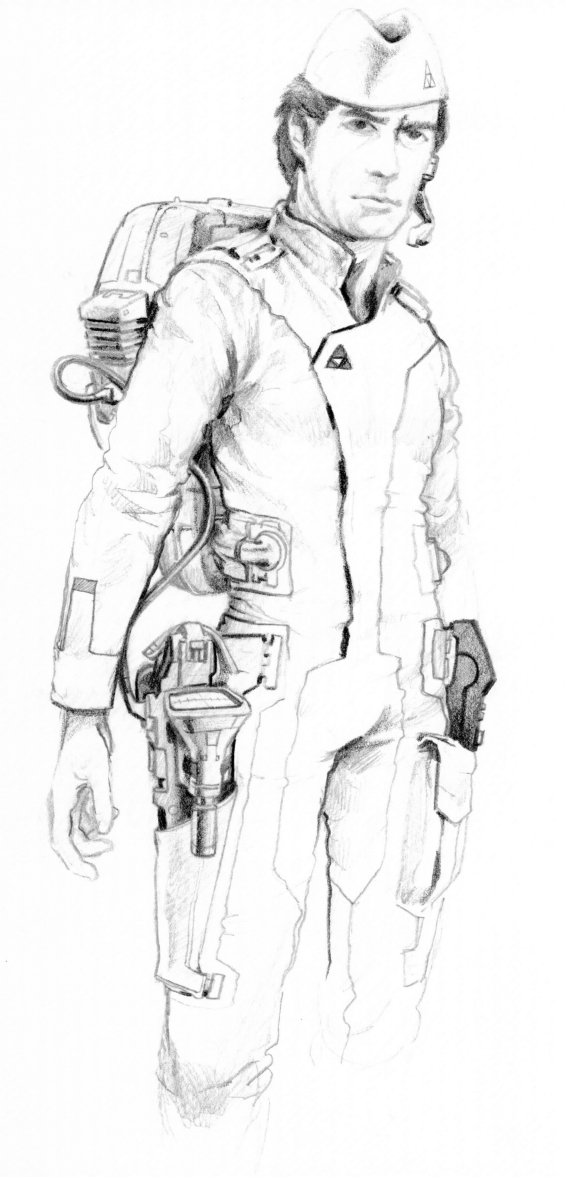

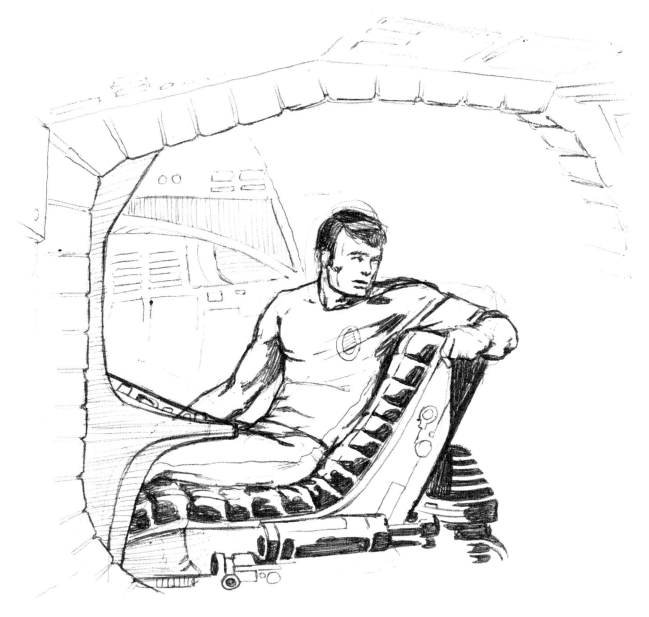

The image on the left-hand page is one of my designs for *Xenogenesis*. This is the lead character, Russell Jorden, wearing his space fatigues and a kind of military cap. He has a sidearm integrated into the pack on his back, which in the script is known as an outpack. It's an important bit of space exploration gear in the story—it creates a kind of force bubble around the characters that allows them to walk around on planets with no oxygen. I thought it was a cool narrative work-around because it allowed the characters to visit lots of different planets and all they'd need to do to be able to breathe in the various atmospheres is put on the outpack. I'd planned to show this faint energy glow around the characters when they were using the outpack, but we didn't make the film, so we never got to implement that idea. Above is another *Xenogenesis* concept—a sketch for an acceleration couch aboard the *Cosmos Kindred*. Chair design is very important for spaceships. You'll be pulling high g's, and it has to look like the future, plus actors spend a lot of time in chairs pushing buttons and speaking techno-babble, so the chair will be seen in close-up. Kubrick taught us that you better have badass chairs—with a lot of tuck-and-roll upholstery and incomprehensible fixtures. Dan O'Bannon even joked about it in *Dark Star*, the sci-fi film he wrote before *Alien*, when he casually mentions that the captain died in a "tragic chair accident."

I can tell by the pen technique that the sketch on pages 186–187 is from around the ninth grade. It's just a derelict spaceship crashed on some alien planet and overgrown by vines. Like I said, I only have three or four ideas and I just keep repeating them . . .

CONSTRUCTION DIAGRAMS

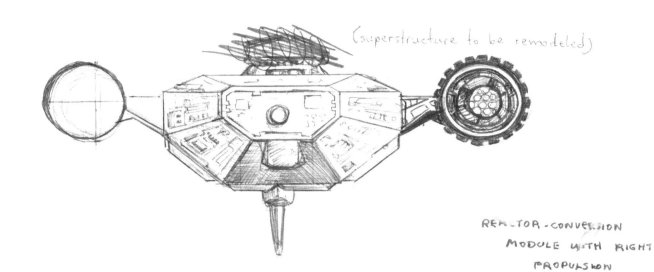

(superstructure to be remodeled)

REACTOR-CONVERSION
MODULE WITH RIGHT
PROPULSION
MODULE

(rear view)

Engines mounted here (to be redesigned)

REACTOR-CONVERSION
MODULE

PERSPECTIVE SKETCH
(OBLIQUE VIEW; REAR)

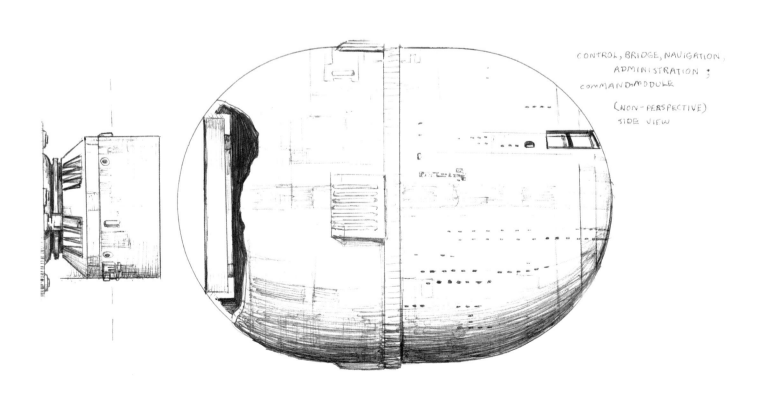

CONTROL, BRIDGE, NAVIGATION,
ADMINISTRATION;
COMMAND-MODULE

(NON-PERSPECTIVE)
SIDE VIEW

The drawings on the left-hand page are all from twelfth grade. At the time, I wanted to make a film that had some very *Xenogenesis/Necropolis*-like ideas. It was about a starship that had a bunch of passengers frozen in stasis. They crash-land on a new planet and lose all their technology, so they have to live in a more primitive way. Then, at the end of the movie, you realize the planet is Earth and the human race evolved from these people who crashed here millions of years ago. Kind of a dumb idea but not too far away from Ridley Scott's *Prometheus* (2012), which has a similar premise where life is seeded throughout the universe by intelligent aliens. So these are my designs for the starship from that story: In the top image, the two structures on the side are magnetic intakes for the ship's fusion ramjet engines; the middle drawing is the propulsion section; the habitability section can be seen at the bottom—it would be on the end of a long neck to keep it away from the nuclear section of the ship, which is an idea I'd later use for the *Cosmos Kindred*. It was all very well thought out. I really knew my interstellar propulsion at that point and a lot of thought went into these dumbass drawings.

I started designing different kinds of airframes and spaceships that didn't have any particular basis in science but just looked great.

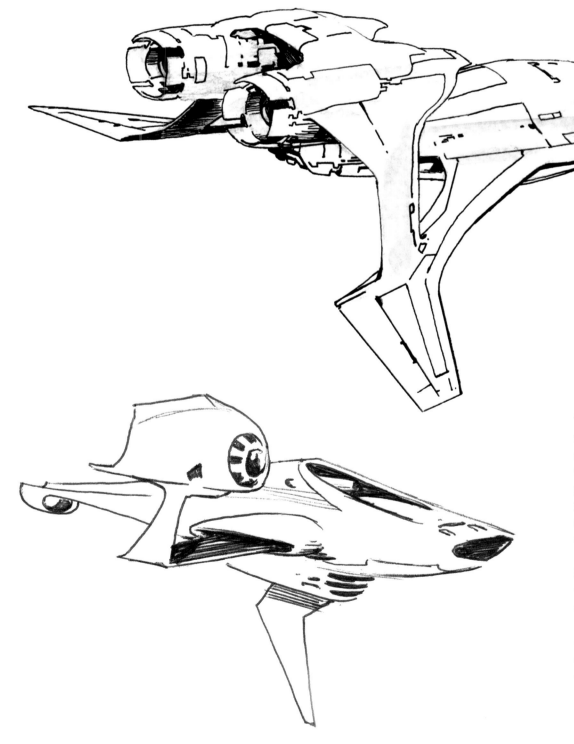

Years later, after seeing *Star Wars*, I started to go in a much more fanciful direction with my spacecraft designs because I realized that people don't care about the real physics and mechanics of starships. They just want cool, gestural shit. Everybody still loves the damn TIE fighter, and you can't get more gestural than that design. It's a big, hexagonal thing, and nobody knows how it can fly or why it makes that screaming noise when it flies by. But nobody cares because it's cool. So, I was like, "Okay I can do cool gestural shit." So I started designing different kinds of airframes and spaceships that didn't have any particular basis in science but just looked great.

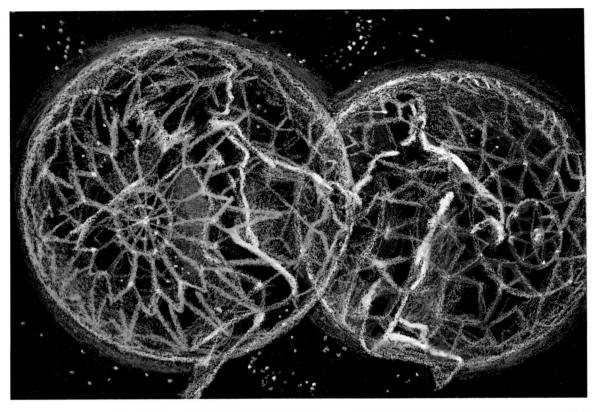

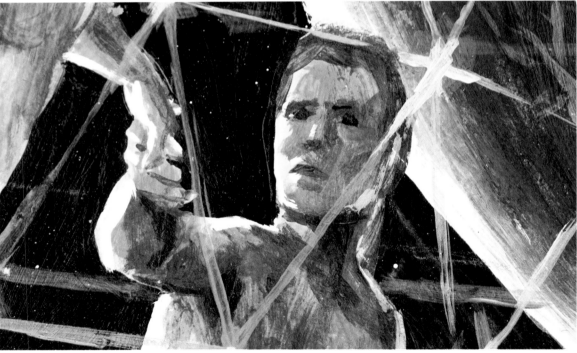

THE YANTRASPHERE

Xenogenesis includes a zero-gravity sex scene, which at the time I thought was *absolutely* critical. In the story, Jorden has a medallion device that projects something we called the yantrasphere—a field of pulsing, geometric lines that surrounds the user and assists them in meditation. At one point, Lori builds her own version while Jorden is suspended in stasis within a cryocapsule. When they finally get together, there's a weightless lovemaking scene in which they both use their yantraspheres. I figured the geometric patterns could be strategically positioned to hide that which we wouldn't want to see, but I had absolutely no idea how to shoot it. You can see in the right-hand image that when the two yantraspheres come together and overlap, it looks like cell division in reverse. It's all very symbolic.

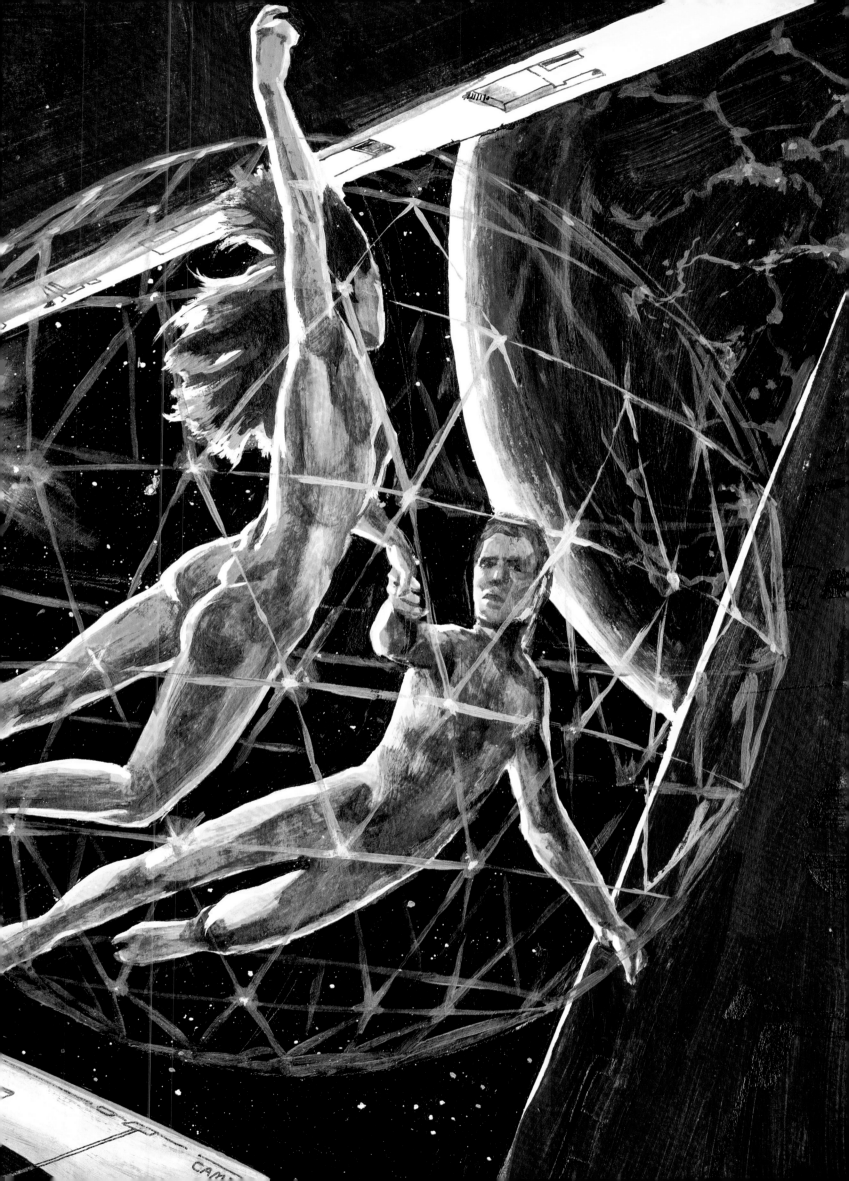

ESPER NAVIGATION

The image on the right-hand page is a key scene from *Xenogenesis*. At the start of the story, Russell Jorden is selected to pilot the *Cosmos Kindred* and its cargo of human embryos on a mission to find a new home for humanity. A black hole—Koslow's Collapser, known to many as The Rogue—is going to come crashing through the solar system at 70,000 mph, fuck the whole place up, and keep on going for millions of years. So Jorden has to pilot the *Cosmos Kindred* around this gravity whirlpool. He's been specially selected out of hundreds of thousands of pilots because he has the ability to fly the ship using what is known as esper navigation—he can close his eyes and pilot the ship telepathically. The concept was a little like the Force from *Star Wars*, but in *Xenogenesis*, scientists have actually applied empirical methods to the study of these mental powers and they can measure them. And what they know is that a machine can't do it—they need a person with this extrasensory ability to get the ship safely around the black hole and back out.

The scientists figure out that the only way that Jorden is going to be able to hopscotch between potentially habitable planets is to reach a globular cluster where the stars are about fifty times closer together than the ones in our part of the galaxy. So he has to fly the starship as close to the event horizon as he can and use the time dilation effect to travel with the black hole for ten thousand years. And Jorden has to go into suspended animation when traveling between these star systems because they're going at a small fraction of the speed of light—twenty percent or something like that. The idea is that they will pop out in a globular cluster and fly around all these different planetary systems to try to find a new planet for humanity to live on. It's kind of a cool concept.

Above is an image I drew for my *Necropolis* project in tenth grade. It preceded *Xenogenesis*, but the design for the starship is very similar to the *Cosmos Kindred*.

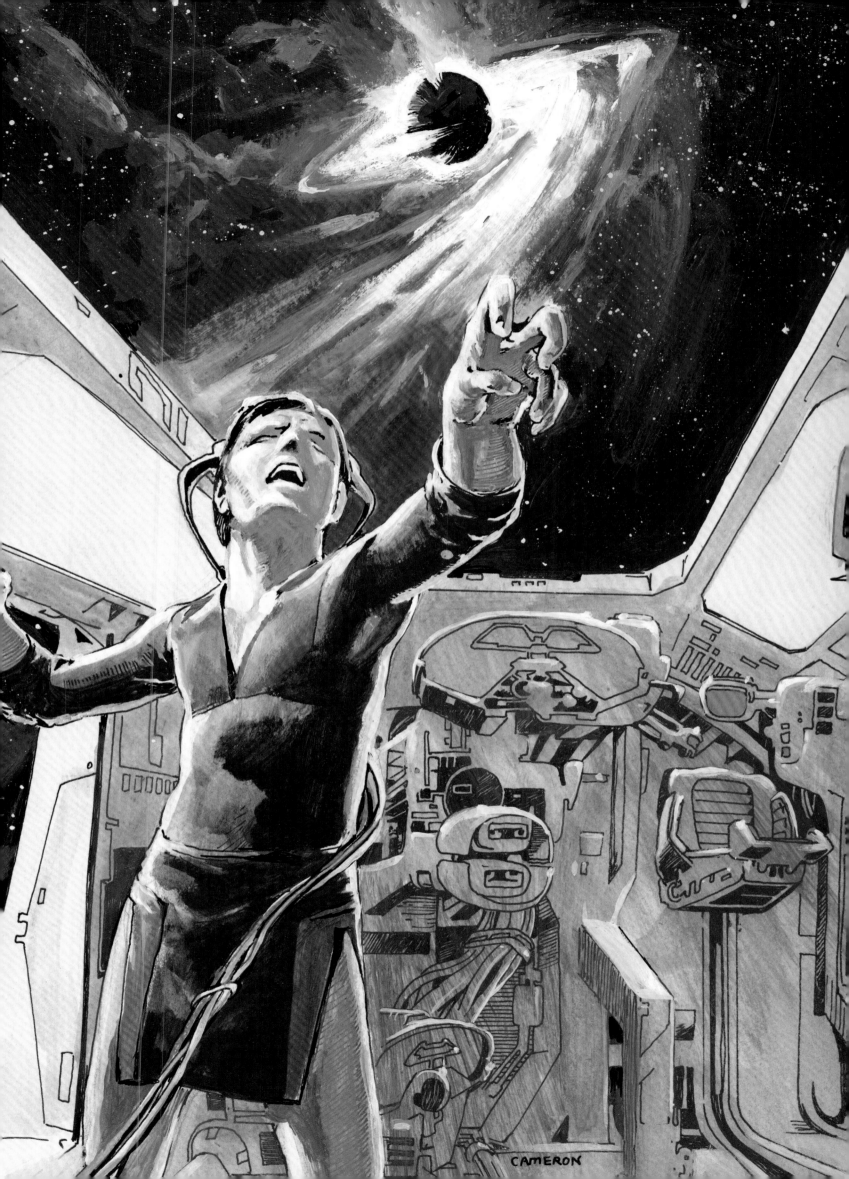

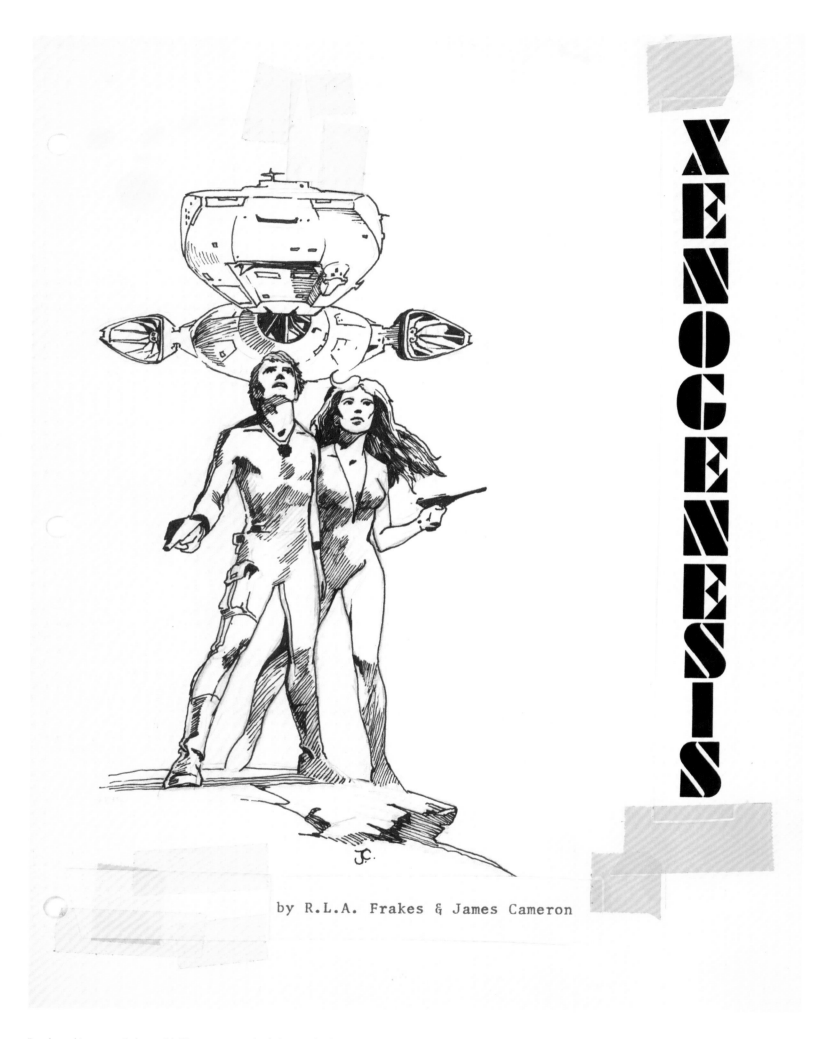

by R.L.A. Frakes & James Cameron

Randy and I were so in love with *Xenogenesis*. It had aliens. It had planets. It had spaceships. All the shit that we loved. We were very enthusiastic. When we submitted it to potential investors, I created this art for the cover page of the script depicting Jorden, Lori, and the *Cosmos Kindred*.

The image on the right is an early design for the *Cosmos Kindred*. At one point it was named the *Lex Taulman* after the character who designed the ship in the story. I think he was a pioneering Wernher von Braun type.

"The engine area is highly radioactive, so the ship has to have this two-thousand-foot neck to separate it from the front of the ship where the passengers live."

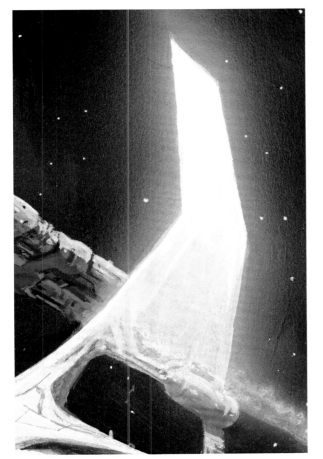

COSMOS KINDRED

I created the *Cosmos Kindred* art on pages 196–197 as part of our presentation for potential investors, and it's one of the few finished concept pieces that I did for *Xenogenesis*. I gave it a fusion drive, enormous magnetic intake scoops, and big radiators to disperse the heat. At the back it has a giant engine section that is highly radioactive, so the ship has to have this 2000-foot neck to separate it from the hab module at the front of the ship where the passengers live. It's actually a pretty viable design concept and similar to the way the *Discovery One* spaceship is laid out in *2001: A Space Odyssey*—nuclear engines at the back, a long truss with cargo modules on it, and then the habitability portion at the front of the craft.

The idea was that the *Cosmos Kindred* was being built to go to Alpha Centauri someday. Ironically enough, the *ISV Venture Star*—the huge spacecraft that carries Jake Sully to Pandora at the start of *Avatar*—is also going to Alpha Centauri. In fact, quite a few ideas from the design of the *Cosmos Kindred* also got recycled for the *Venture Star*, most notably the big radiator fins that get so hot they are still glowing at the end of the ship's journey.

The *Cosmos Kindred* wasn't originally designed to be fast enough or powerful enough to escape the black hole—it's in the process of being built to travel to Alpha Centauri when they learn that Koslow's Collapser is about to destroy the solar system, so they have to hurry up and get it finished. To make it fast enough, they come up with the idea of bolting on four fusion tugs that can be used as strap-on boosters. Jorden would just light these things up, the ship would go like hell, and he'd be able to break free of the gravity well. Of course, my physics was a little weak. The actual amount of energy required to break free of a black hole would be way beyond fusion technology. It would probably be way beyond anti-matter propulsion, too. But it looks pretty fucking spectacular.

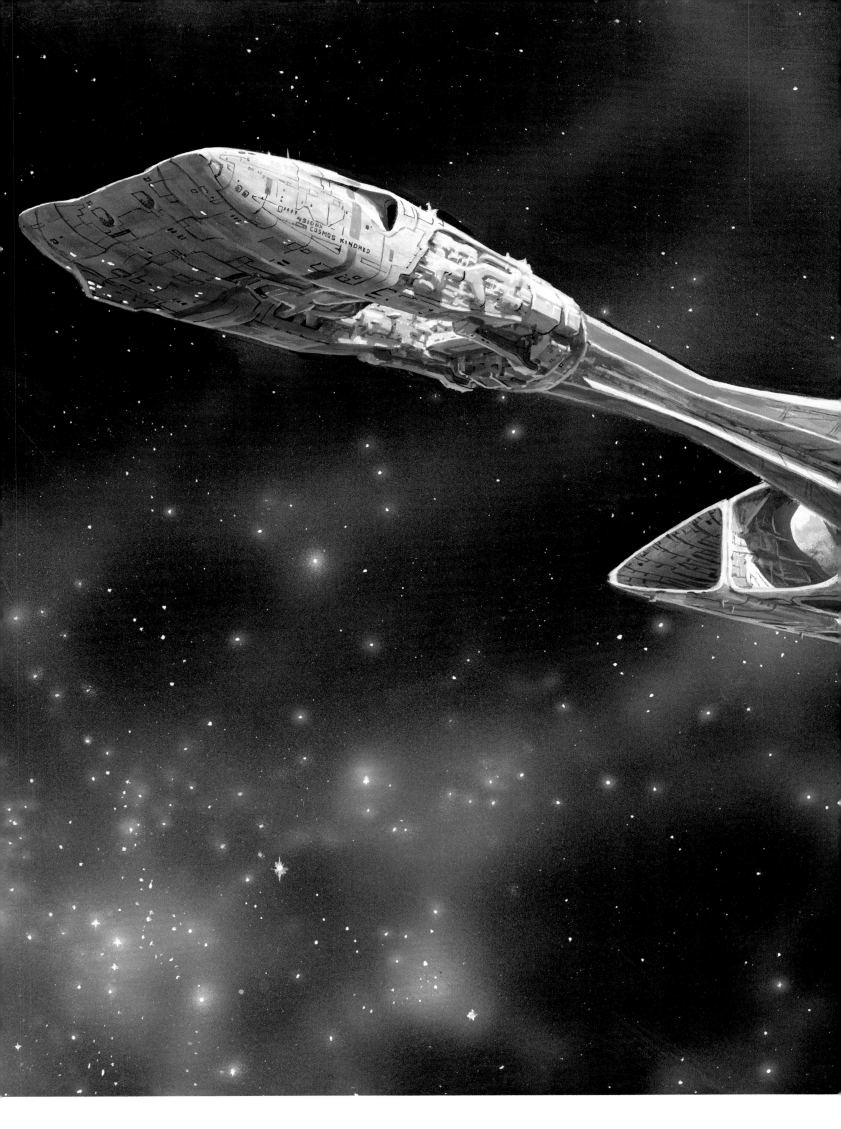

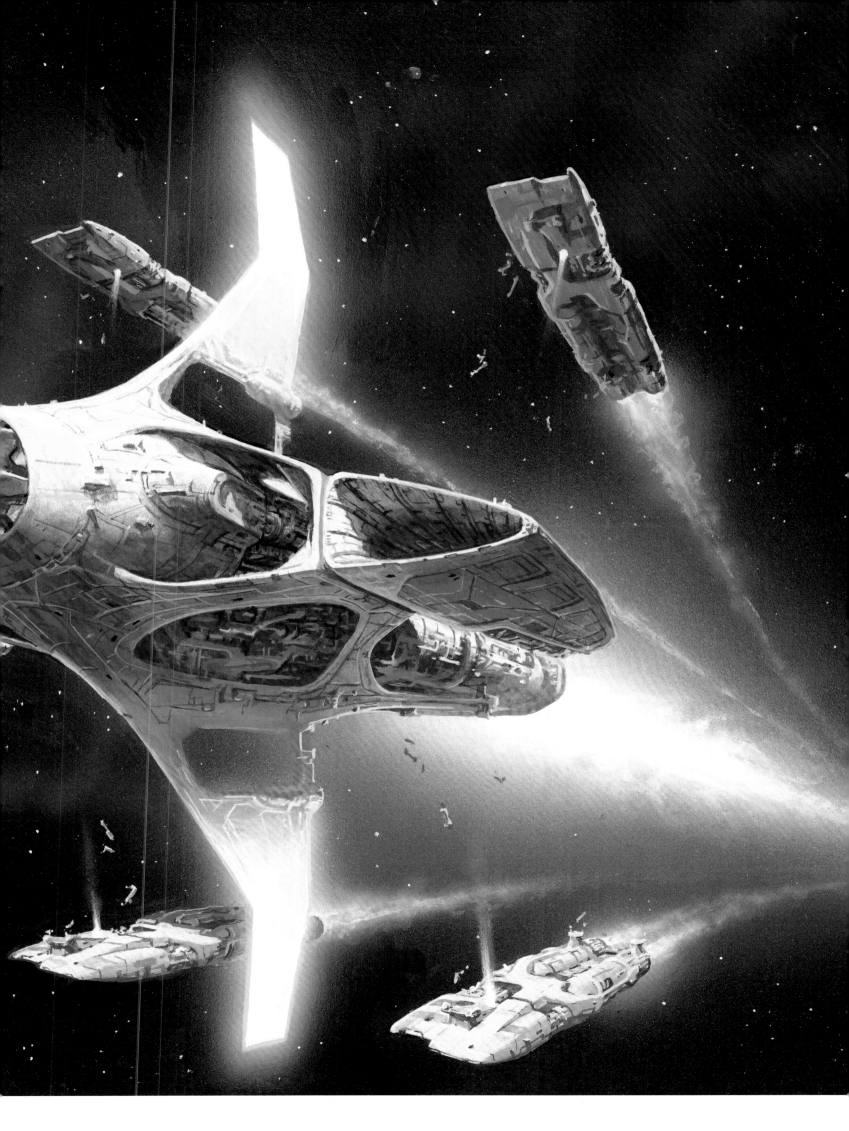

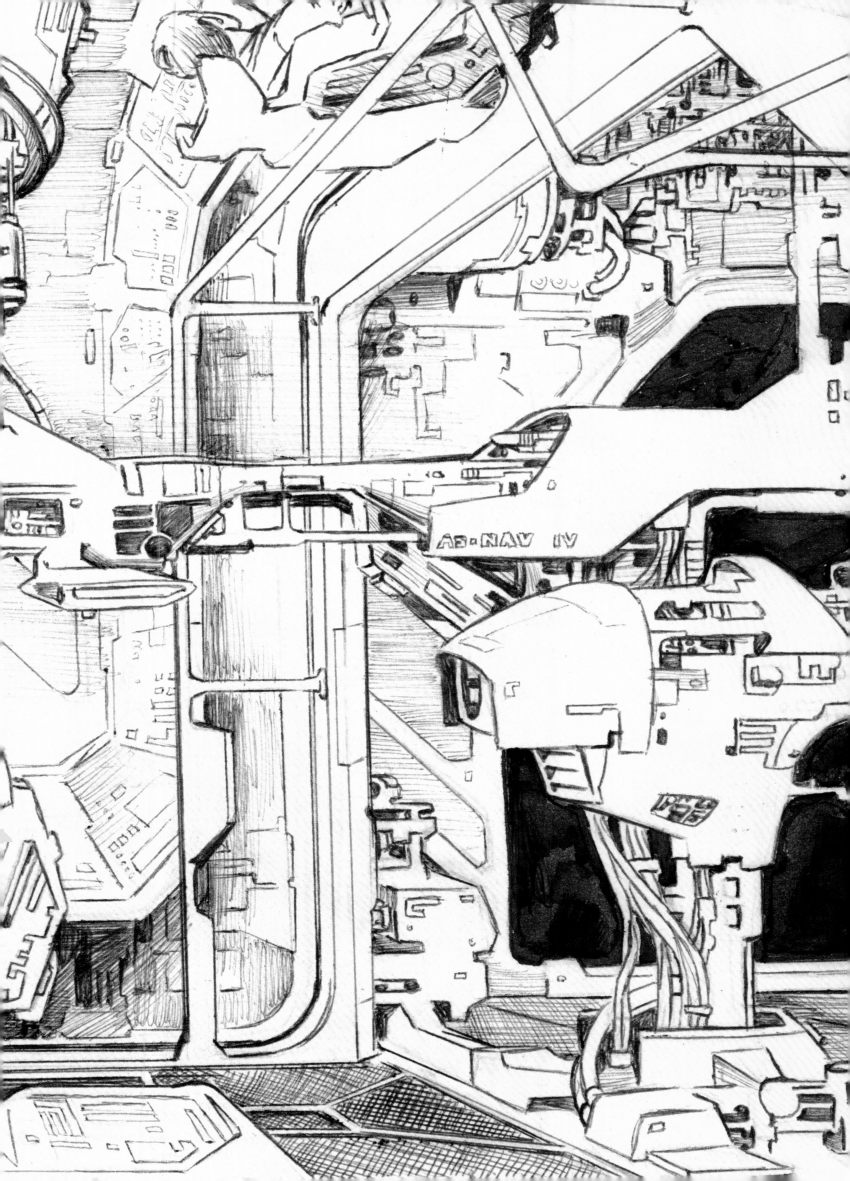

My design for the bridge of the *Cosmos Kindred* is on pages 198–199. It's heavily influenced by Jack Kirby, who was the master of weird, super-complex alien machines. I totally went to school on that design idea. What's also interesting about it is the M. C. Escher aspect of the design: The guy in the bottom left is orientated to one gravity vector, and the character in the top right is oriented to a completely different gravity vector, which creates a cool effect.

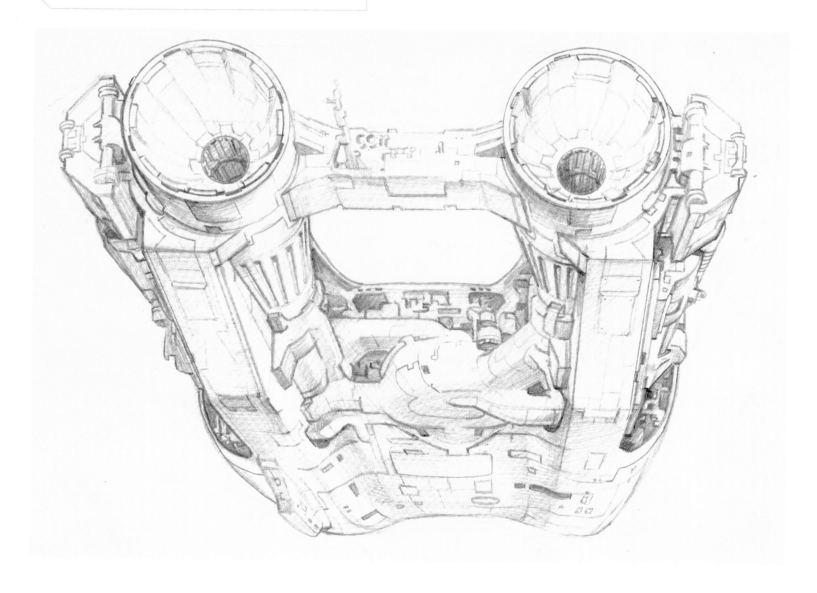

The front section of the *Cosmos Kindred* doubles as a detachable landing craft that the crew can use to investigate new worlds. My designs for this lander are very specific and detailed, because we really thought we'd get to make this movie and I would have to build the ship at some point. The top image is an earlier design for the lander with a big intake on the side and a reentry shield at the front. The image at the bottom of page 200 shows the craft's engine propulsion section which has an asymmetric design. The overall lander concept evolved over time and became influenced by car design—the image below was inspired by a Corvette and also has an asymmetric superstructure. I was fascinated by machinery and the strange way that human designs, even for things like rockets, were often asymmetric—they'd have a component on one side but not the other—and so I'd try to introduce that into my designs.

These are *Xenogenesis* storyboards that I drew in 1979, just before I was hired to work on *Battle Beyond the Stars*. We came up with a space battle sequence in which the heroes go up against drone fighters sent by the ancient civilization from the techno planet. So even though all Sid's fellow aliens are dead, their technology remains, including the planet's defensive systems. It's a concept I got from *Ringworld*—I never saw an idea I didn't think I could repackage better! I would never rip off something, but I would take the basics of an idea and develop it in a different direction.

It's important to know your reference points. For artists, nothing comes fully formed in the moment. For example, I think people have latched onto the idea that *Avatar* came to me in a dream. Now, the idea of a luminescent world and the flying fan lizard did come to me in a dream, but the story of Jake Sully meeting Neytiri on Pandora did not. In the dream, the luminescent world was an isolated setting. There were no characters in it. So the dream was just a starting point and the idea developed way beyond it.

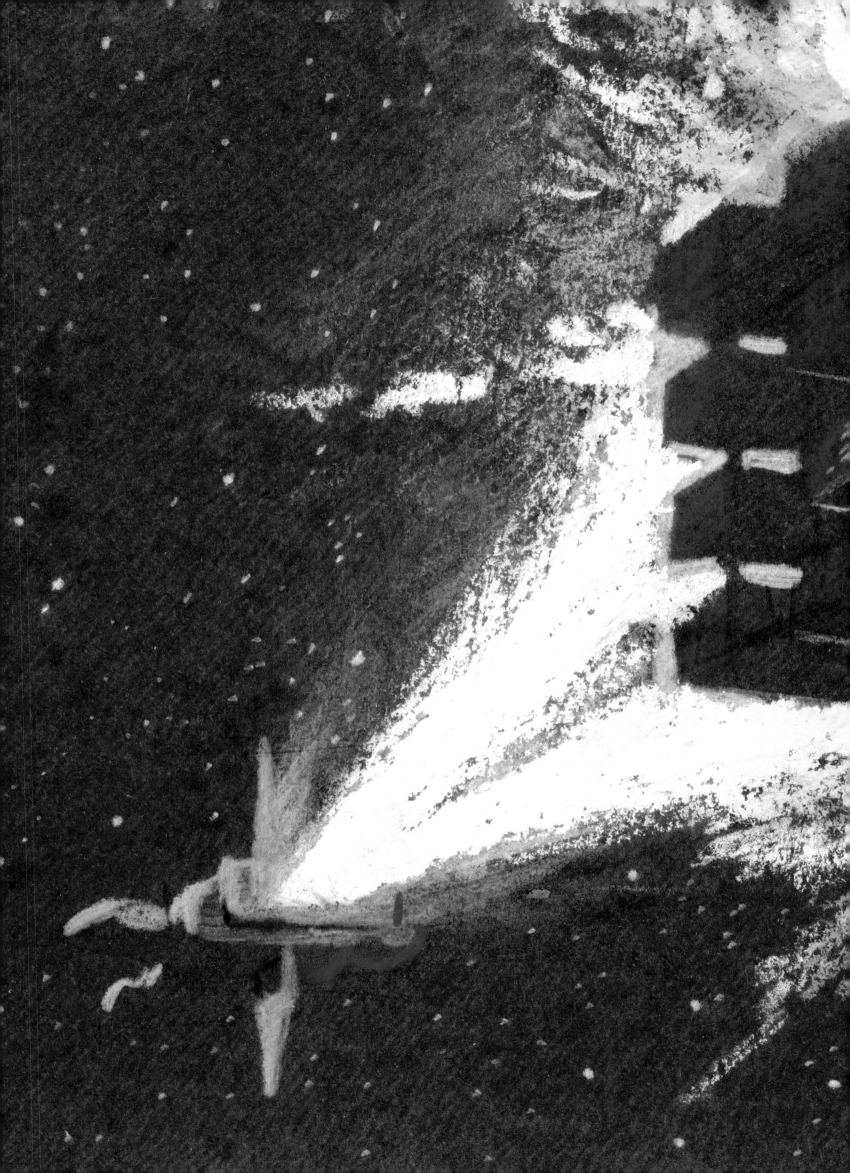

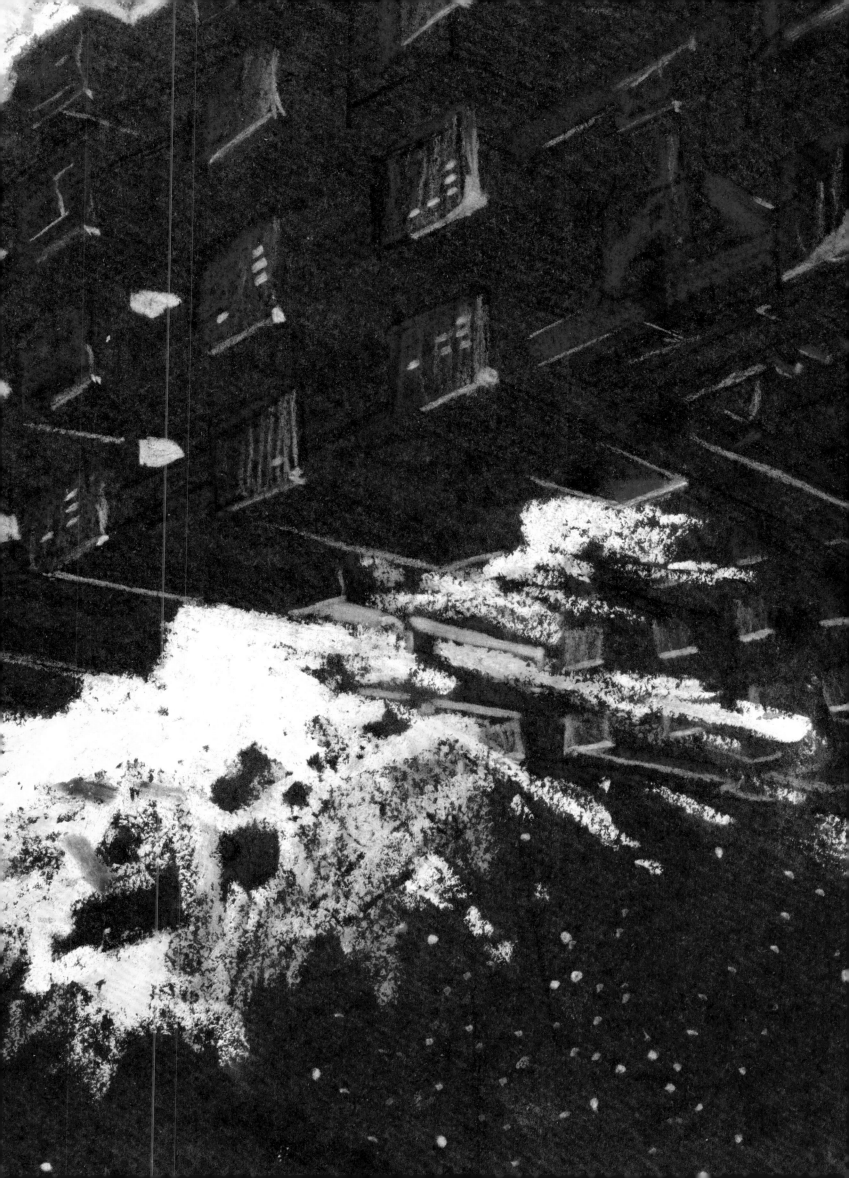

Nell was a sentient spacecraft with a female personality so I kind of thought, well, I'm working on a Roger Corman movie, so it needs to have a female figure.

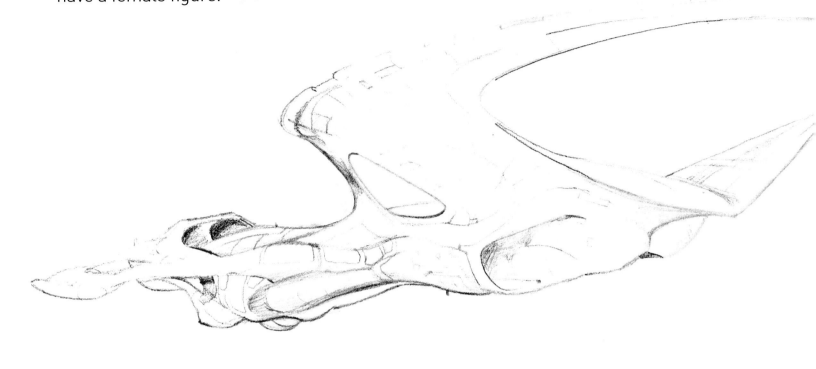

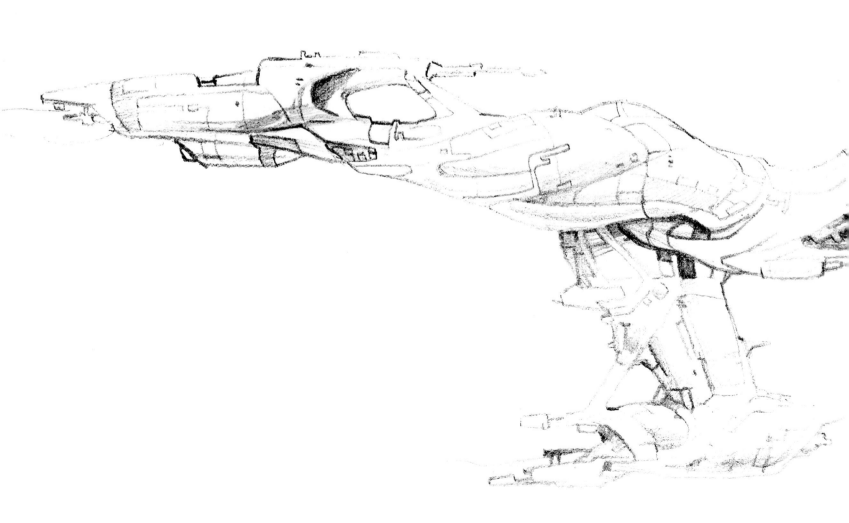

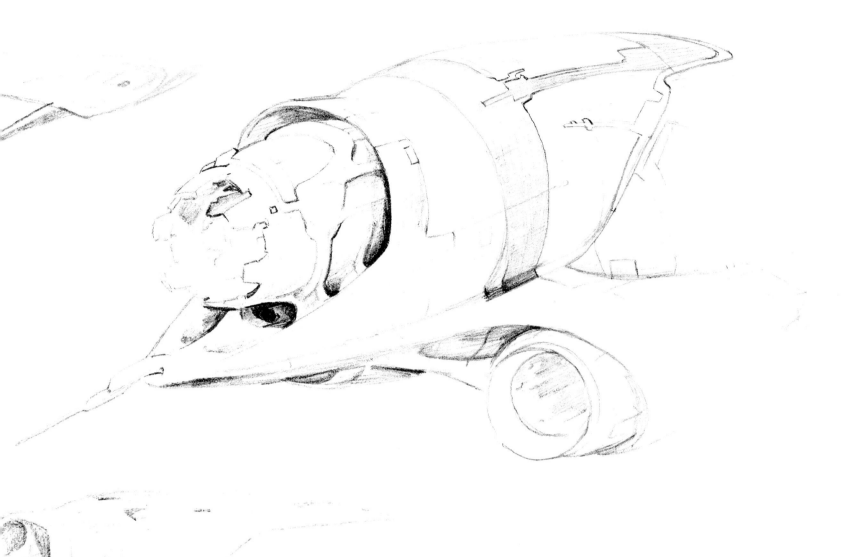

NELL

These are concept designs for *Nell*, the main spaceship from Roger Corman's *Battle Beyond the Stars*. *Nell* was a sentient spacecraft with a female personality so I kind of thought, well, I'm working on a Roger Corman movie, so it needs to have a female figure. One time, Roger came through the model shop and in his deep voice he goes, "Where's Shad's ship?" Shad was the main character in the movie, Corman's answer to Luke Skywalker. He goes, "You've shown me all the other ships. But where's Shad's ship? He's the hero of the goddamned film!" So everybody is like, "Uh, we've been . . . doing some drawings . . ." And he was like, "Alright, this is absolute bullshit. We're gonna design Shad's ship in the next three days and I want everybody in this shop to do a design. I'll pick it and we'll get this done." Then he stormed out. I'm like, "Fucking design contest, are you kidding me? I win design contests for a living! Alright you motherfuckers, it's *on*." And so everybody starts drawing.

Now, these guys were really good sculptors and model builders, but they weren't so great at illustrating, so I figured I was gonna ace this. I started drawing designs that had a biomechanoid, somewhat sexual element and were very influenced by H. R. Giger's work. The image at the bottom left is clearly a female figure, but what I didn't realize at the time was that she is in a yoga pose—one leg bent, body slightly arched, breasts forward, arms turned into the cowl-like structure at the front. She also has a butt and thigh area and then her leg turns into thrusters. So the whole thing is vaguely suggestive. Then in the top left drawing, I'm playing with female forms and again integrating butt and breast areas in this very feminine-looking design. The front part of this ship, the left-hand side with the breasts, pretty much ended up in the final design. Then the design at the top right became the back of the ship. If you look closely at that image, you can see it has a hip-pelvic configuration. There's a strip running down the midsection that's reminiscent of the top of a stocking with a garter belt attached. Then at the back you have the mons pubis, and the thrusters are designed to look like thighs. My design won the contest, but sadly I don't have the final *Nell* drawing. I do have a photocopy (see pages 208–209) but unfortunately the guys in the model shop took it upon themselves to decorate it like a Safeway ad because they thought the design looked like a side of beef.

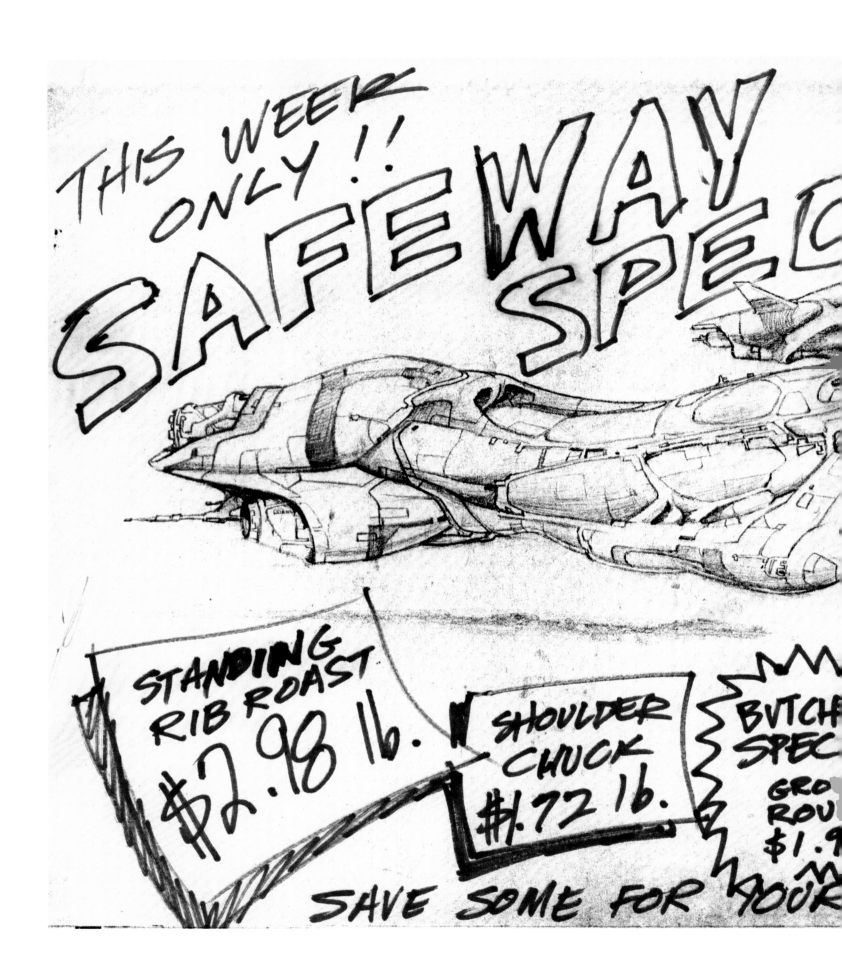

Unfortunately the guys in the model shop took it upon themselves to decorate it like a Safeway ad because they thought the design looked like a side of beef.

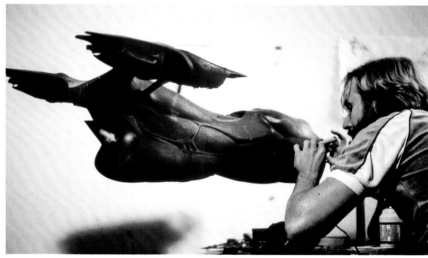

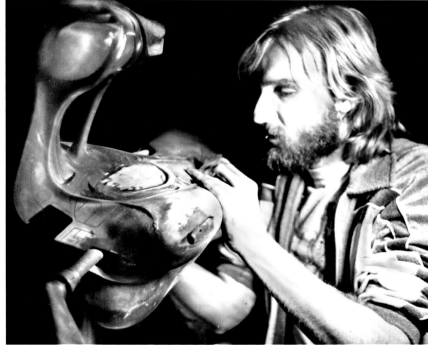

ABOVE During production of *Battle Beyond the Stars,* James Cameron works on the *Nell* miniature model.

"I came up with this concept that was almost like a World War I biplane, and then the Skotaks took my design and reinterpreted it when they were building the miniature model for the shoot."

THE *QUEST*

I also designed the *Quest*, the main ship from *Galaxy of Terror*. I came up with this concept that was almost like a World War I biplane, and then the Skotaks took my design and reinterpreted it when they were building the miniature model for the shoot. The image on pages 212–213 is the landing foot of the *Quest*. It was very *Alien*-inspired. We actually built it as a full set so we could show the crew disembarking in the film, a lot like the way the crew from *Alien* leaves the *Nostromo* to explore the planet.

On pages 214–215 is a design I did for the bridge of the *Quest*. It's kind a scaled-down version of the *Cosmos Kindred* bridge. I had worked out a way

to make structural beams super cheaply. I'd take a big sheet of foam core, cut a V-shaped groove in the back with an X-Acto blade guided by a steel ruler, and then bend it. It would form a perfect radius bend—just like the edge of an extruded steel beam. Then I'd shoot the foam with automotive lacquer and it would look like steel. So that's how I built the beams you can see in the illustration—they were super light and not really structural, but on camera it worked a treat.

Before I got to *Galaxy of Terror*, I had really learned my lesson working as art director on *Battle Beyond the Stars*. On a Corman production, we always had

one night to build a set. The minute the shooting crew walked off set at, like, 7 or 8 p.m., the construction boss would come in with a skip loader, break up the set with the scoop, and push it out into the parking lot. This would take him about twenty minutes, and then we'd start building the next set, which had to be ready for shooting the next morning at 7:30 a.m. And, of course, this was an impossible task. They had already fired one art director on *Battle Beyond the Stars* and hired me to take his place, so I had to think fast because I didn't want to be next.

I thought, I need to use paint that's going to dry really fast. I'd done a lot of automotive work at this point, including custom painting, and I knew that automotive lacquers dry almost instantly. So I said, "Alright, we're only going to use automotive lacquers to paint the set. So get me a bunch of acrylic lacquer, a Binks gun [which is a brand of spray gun used for automotive painting], and a big air compressor, and I'll paint the set." So we'd bring in all the pre-built sections of the set and then start sliding them around and assembling it. It's just absolute madness. We'd be taping over things and trying to stick it all together and then at a certain point I'd just blow a whistle, which meant it was time for everybody to leave the set. I'd walk in with the Binks gun and paint the whole fucking set copper or metallic gray or

whatever was required. If the crew had any time, they'd try to mask off parts, like starship control props, before I started blasting everything.

I remember Roger came in one morning and we were a little behind because we were exhausted. He sees this unfinished set that was supposed to be a futuristic operating room of some kind and he goes, "Jim, why isn't the set up?" I said, "Well, Roger, we've been working all night." He goes, "This is just a shitty little set, and now we're gonna lose time. You're fired!"

So I'm like, "Okay, well, it was fun while it lasted—not." I leave and I'm walking down the street when the producer, Mary Ann Fisher, runs after me. She was like, "Jim! Jim! You gotta come back because nobody else knows how to do this stuff and get it done on time." I said, "I just got fired!" She said, "I'll handle it. Just come back." So I went back to work.

Then we got to the big finale of the film and needed to build the deck of the bad guy's *Death Star*–style ship. On the last day of the shoot, Roger

❝ We actually built [the landing foot] as a full set so we could show the crew disembarking in the film, a lot like the way the crew from *Alien* leaves the *Nostromo* to explore the planet. ❞

comes in and says, "What is this? This is terrible. Just break this up." I said, "Roger, you can't break this up. We rented this console from a prop house." He said, "Break it up! Get it out of here! This is shit! And you're fired!" I guess he figured he could fire me because it was the last day of the shoot; what he didn't realize was that they needed me to run one of the motion control camera units for the next three months in postproduction. So I walked out again, and the head of the effects department, Chuck Comisky, came after me and said, "You're not really fired. I'll take care of it. Just go and get some sleep and come back tomorrow."

And that's what it was like working on *Battle Beyond the Stars*. So when I did *Galaxy of Terror*, I knew what I was getting into and tried to design things that would be easy to build quickly. But ultimately, I didn't do a very good job of constraining myself because I ended up designing shit that nobody knew how to build.

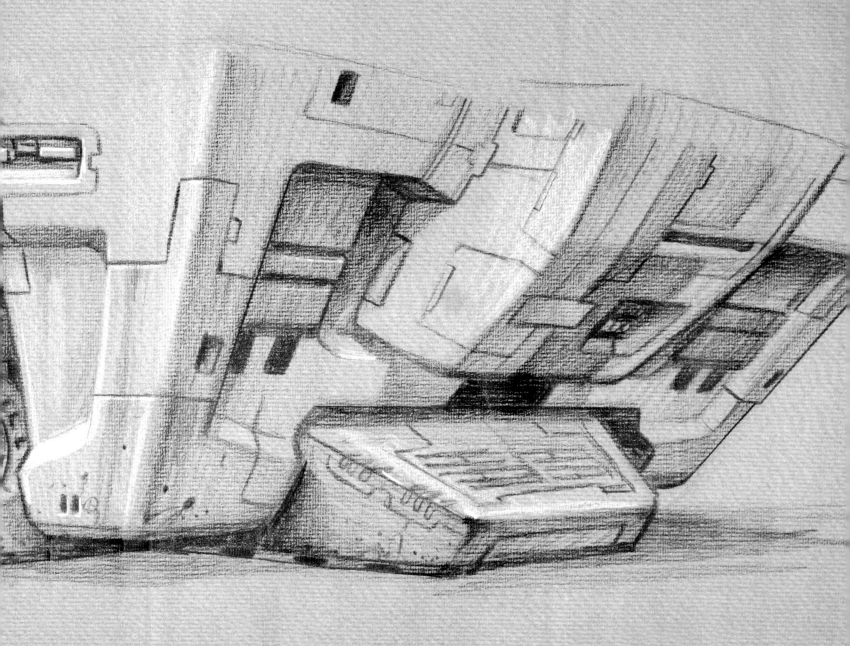

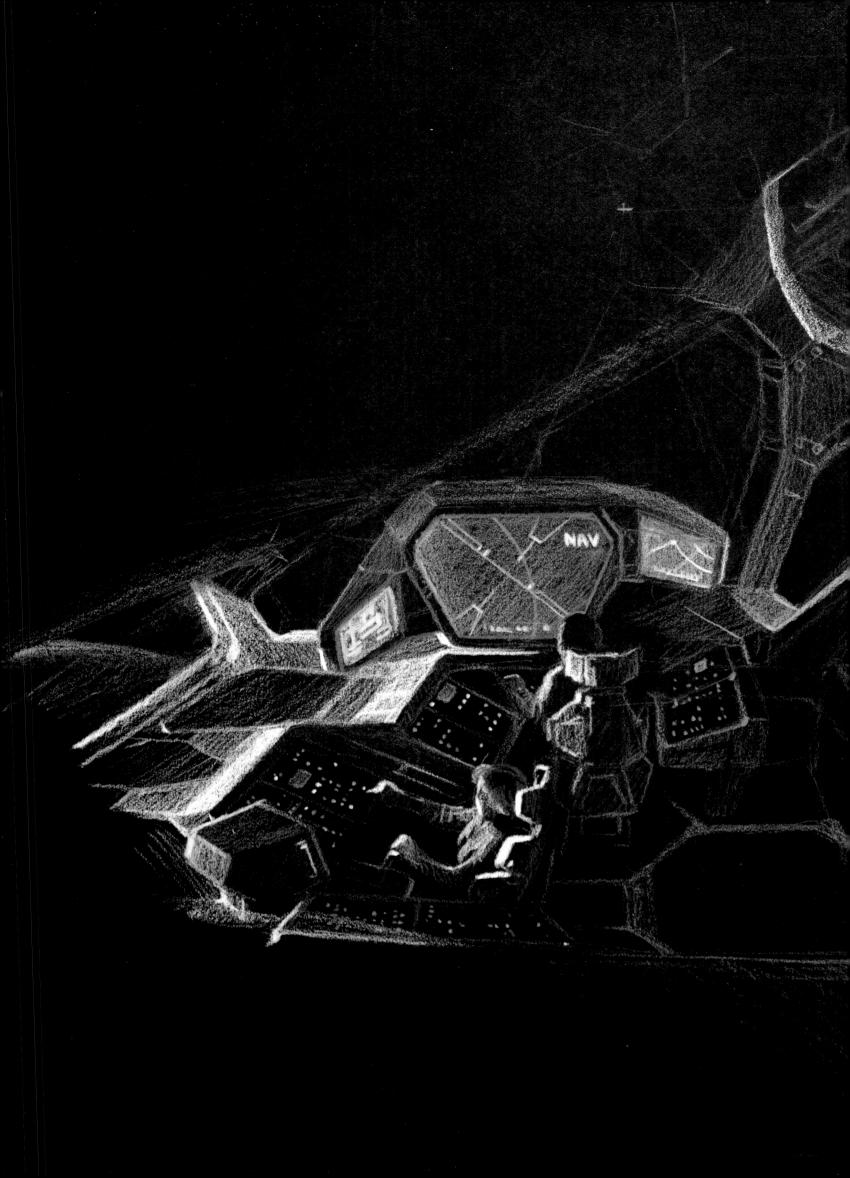

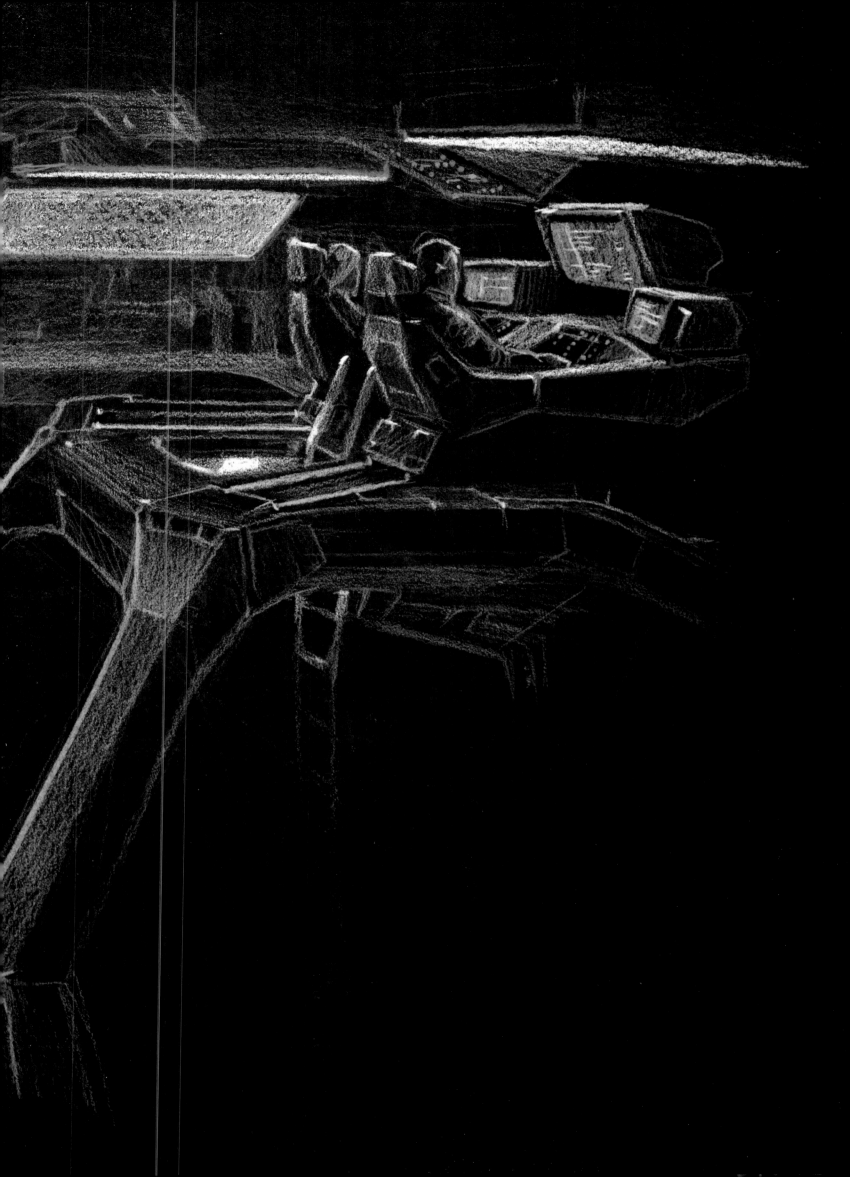

These are my thumbnail storyboards for the first scene of *Aliens*. Panels 1 through 3 are the opening shot, showing the *Narcissus* drifting through the cosmos and the camera approaching it. The next three images show the salvagers entering as enigmatic silhouettes, the gloved hand wiping ice crystals off Ripley's capsule, and her face being revealed within. Image 4 on the right-hand page even has the dialogue: "Well, there goes our salvage, guys." This is the sequence exactly as it appears in the film. The last two images show the dissolve transition between Ripley's profile and planet Earth—her return home. I know what every line of these sketches means, even now, thirty-six years later, but they weren't meant for the rest of the team, just a guide from me to me.

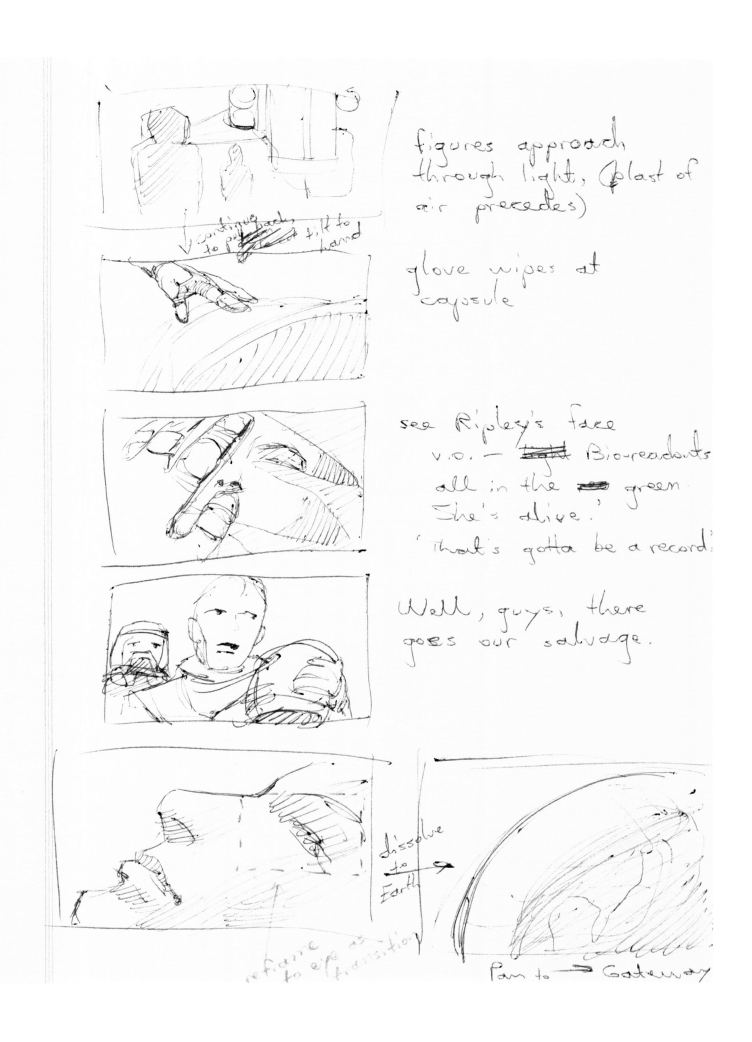

figures approach
through light, (blast of
air precedes)

glove wipes at
capsule

see Ripley's face
v.o. — ~~light~~ Bio-readouts
all in the ~~red~~ green.
'She's alive.'
'That's gotta be a record.'

Well, guys, there
goes our salvage.

continue back
to pull ~~out~~ tilt to
hand

dissolve
to
Earth

reframe at
to off transition

Pan to → Gateway

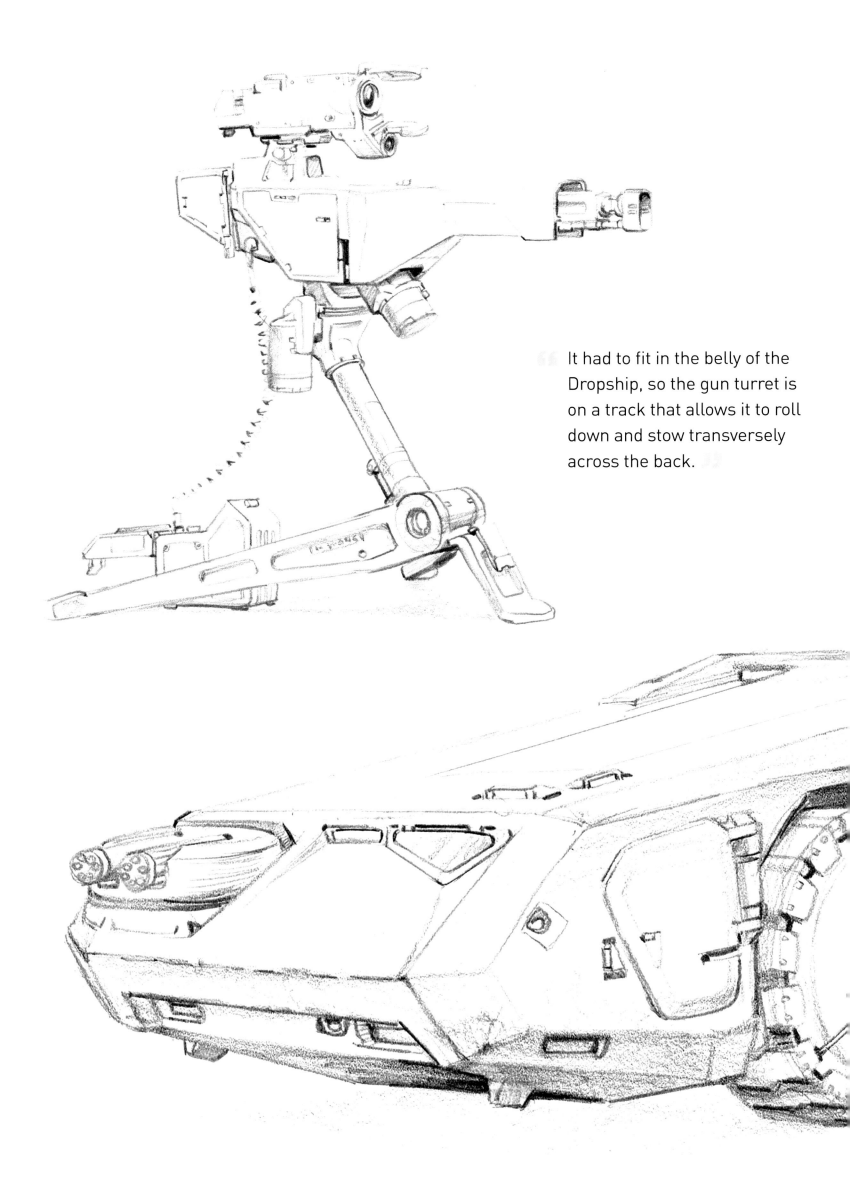

It had to fit in the belly of the Dropship, so the gun turret is on a track that allows it to roll down and stow transversely across the back.

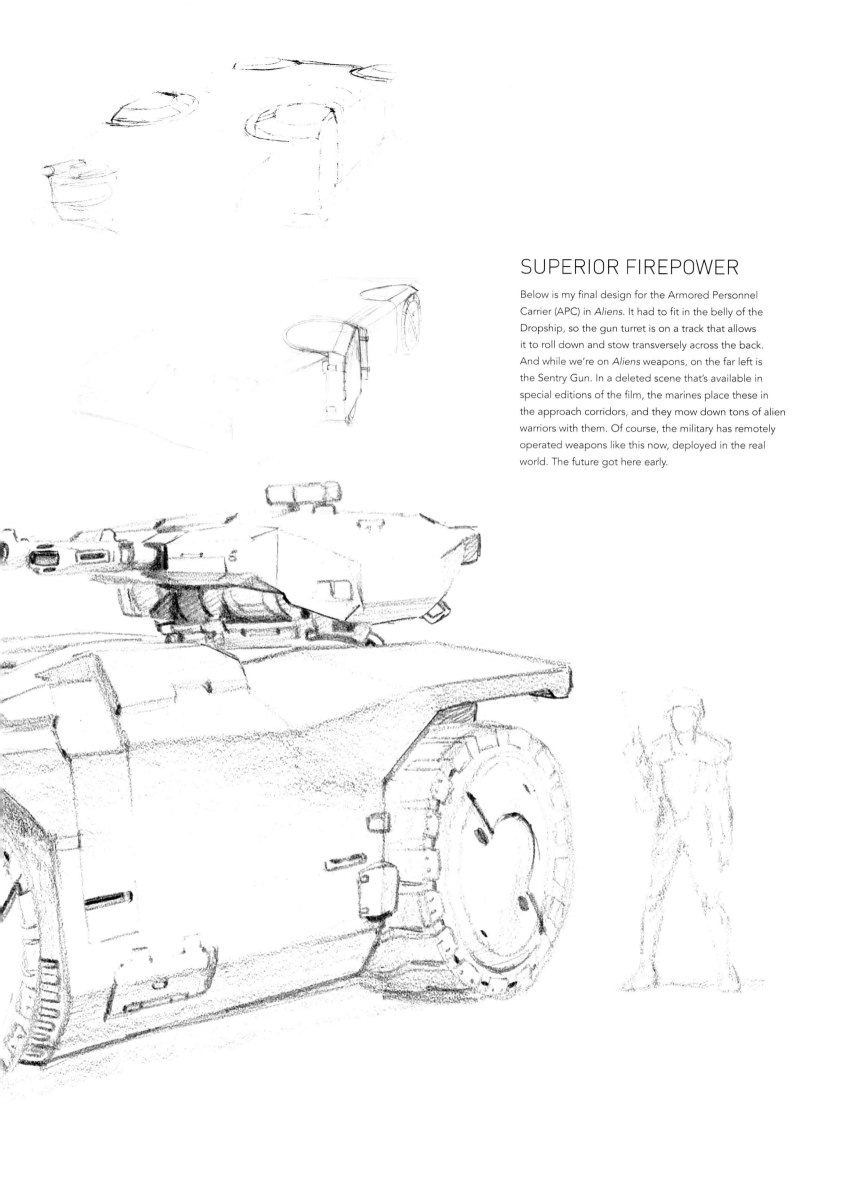

SUPERIOR FIREPOWER

Below is my final design for the Armored Personnel Carrier (APC) in *Aliens*. It had to fit in the belly of the Dropship, so the gun turret is on a track that allows it to roll down and stow transversely across the back. And while we're on *Aliens* weapons, on the far left is the Sentry Gun. In a deleted scene that's available in special editions of the film, the marines place these in the approach corridors, and they mow down tons of alien warriors with them. Of course, the military has remotely operated weapons like this now, deployed in the real world. The future got here early.

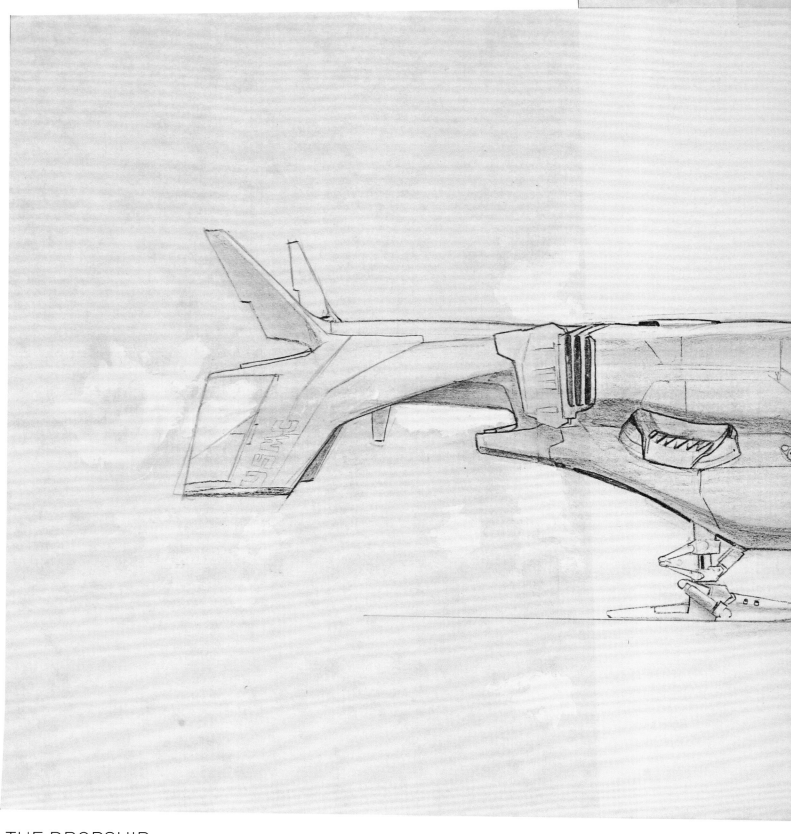

THE DROPSHIP

This is my design for the Dropship from *Aliens*. I really liked the split-tail configuration I'd previously used on the flying Hunter-Killers in *The Terminator*, so I incorporated it into the Dropship, too. I added big louvered intakes just before the tail and vectored thrusters near the rear landing gear—so it's got elements of an Apache helicopter and a Harrier jet. Where I got bogged down was designing the Dropship's weapons pods and the way they would deploy. I wanted it to be like a Transformer—it would be really sleek when it dropped from the *Sulaco*, the ship that carries the marines to the alien planet. But when it entered the planet's atmosphere and got closer to its target, the Dropship would deploy these weapon arms and take on a really aggressive X-shape. But I couldn't quite get it to where I wanted it to be. I even built little foam core models to help figure out how it would open up. Eventually I got one of our

Aliens concept artists, Ron Cobb, to help me out and he nailed it.

The sketches on the following pages are me exploring different designs for the Dropship. I really went to school on military tech because I wanted it to be sleek enough that it looked like it could get through the atmosphere but chunky enough that it felt threatening. There are a lot of flat planes on the side of the Dropship, which helped give it the feel of an attack helicopter, meaning that it's designed to be skinny so there's less chance of the chopper being hit by projectiles. The landing gear sketch is based on a real one. Peter Lamont, our production designer, found one from what I think was a Vulcan bomber and brought it to the studio. I was like, "Alright, I'll try to integrate it into the design." And I think it was at this point that I handed it over to Ron Cobb, and said, "Ron, save me!"

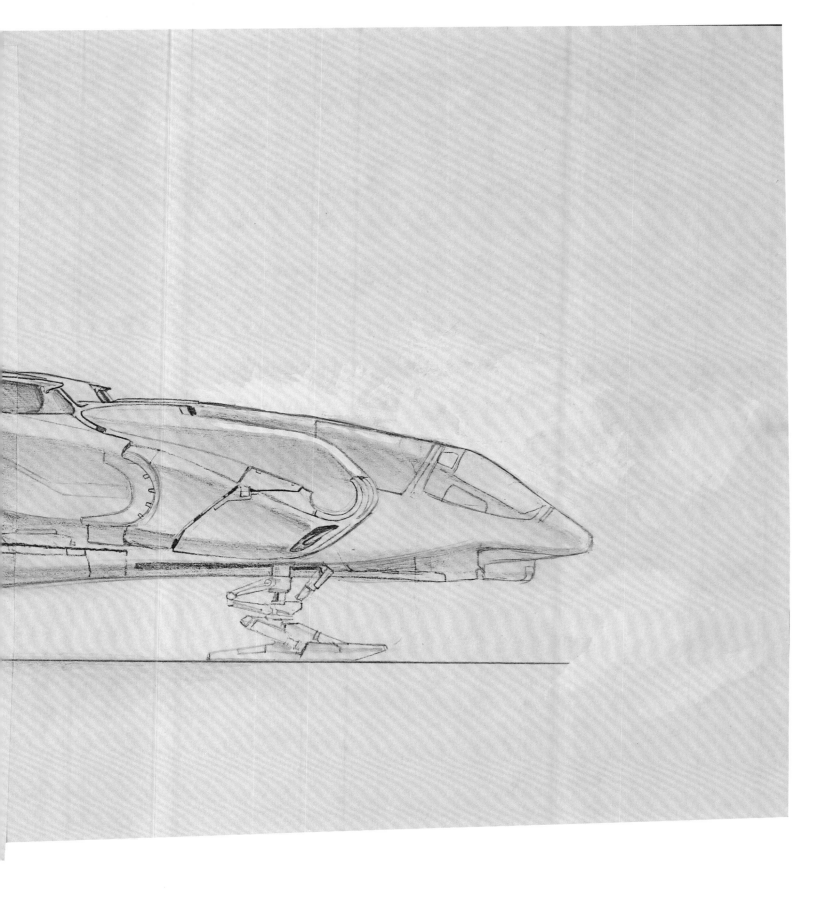

I really went to school on military
tech because I wanted it to be
sleek enough that it looked
like it could get through the
atmosphere but chunky enough
that it felt threatening.

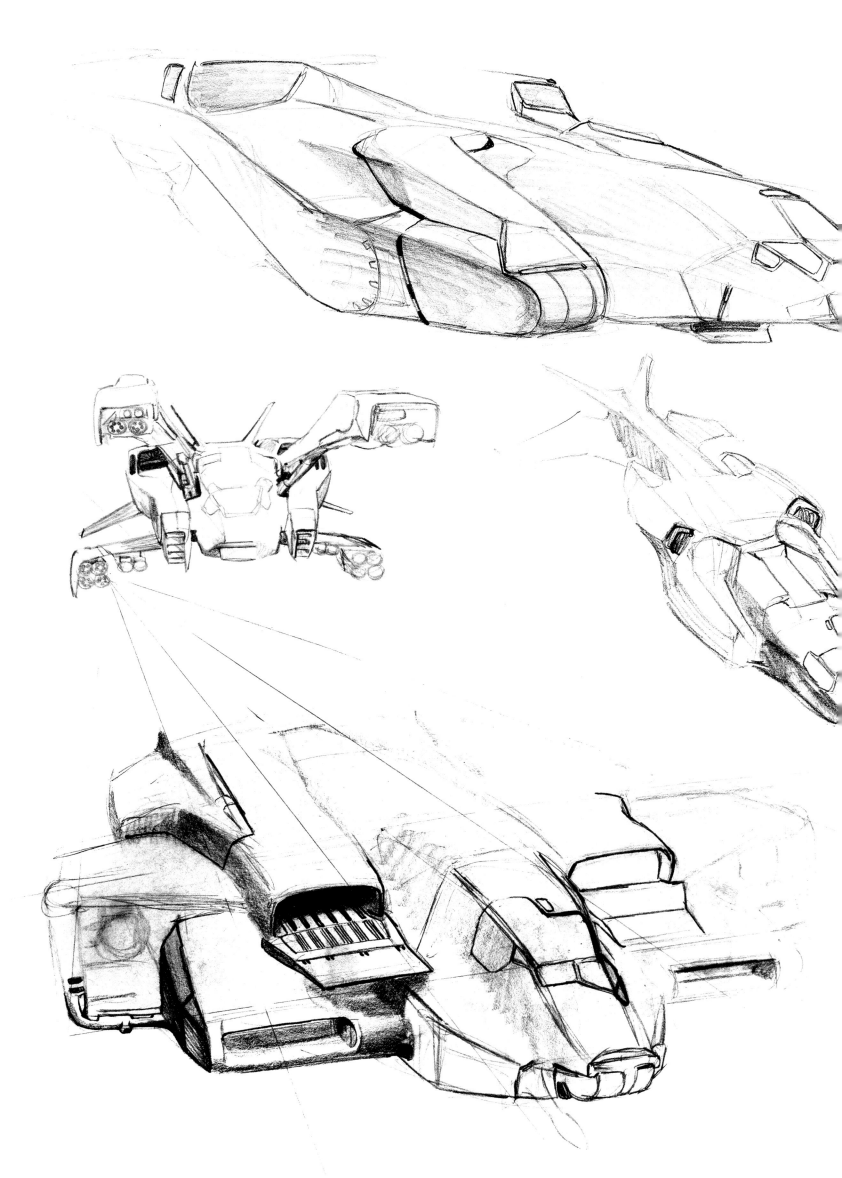

We proposed that a lava flow or earthquake had broken it open in the intervening fifty-seven years.

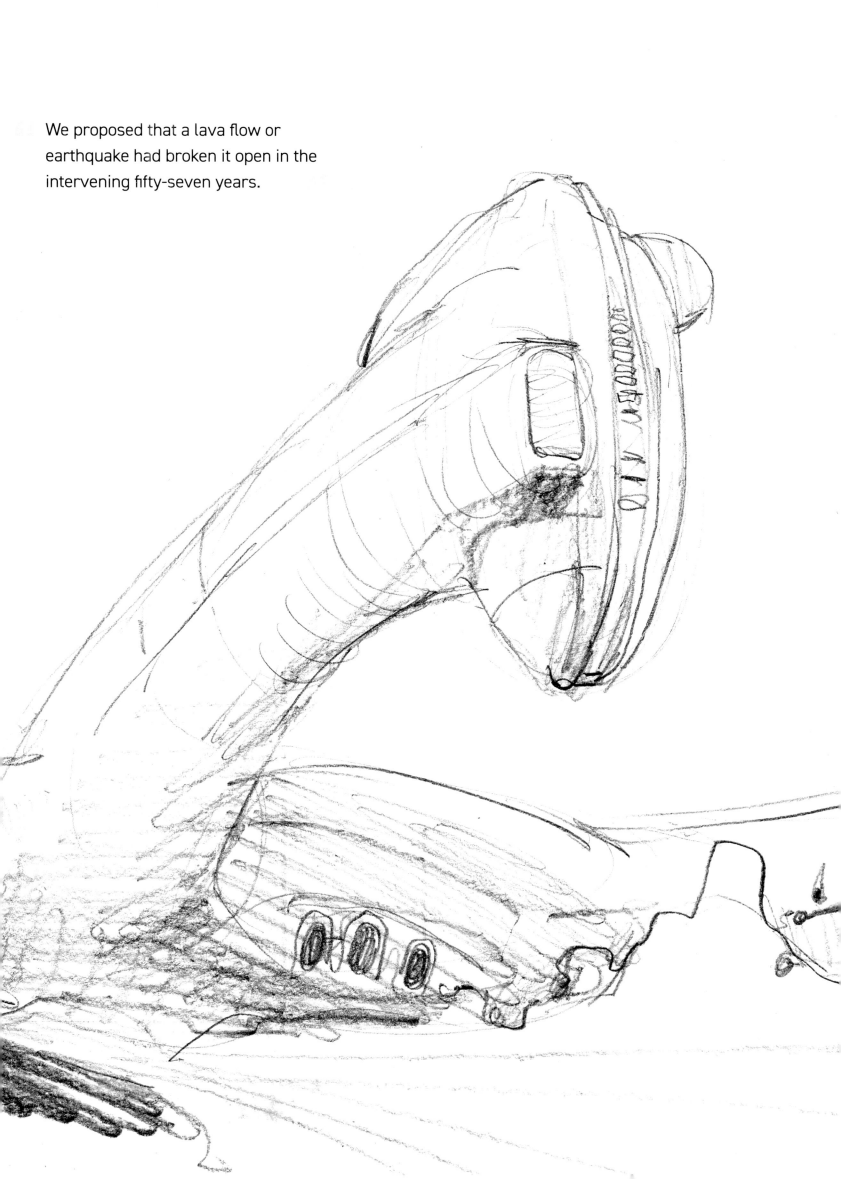

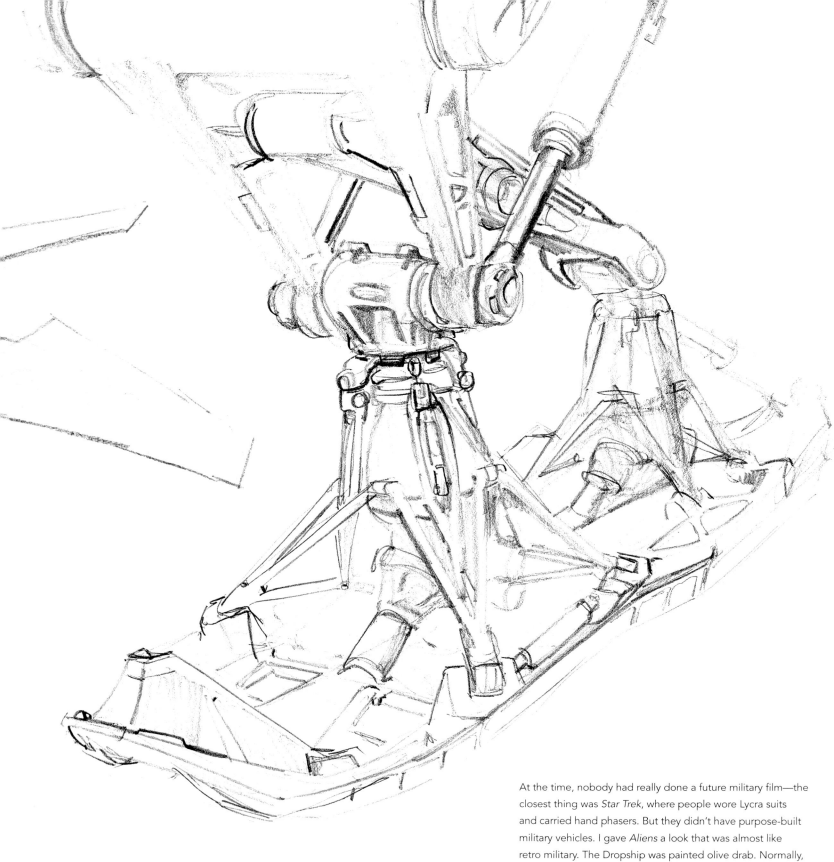

Normally, spaceships are white in movies because in real life spaceships have to be white so they reflect sunlight and don't overheat. But the Dropship was a planetary surface landing craft, so why not paint it olive drab?

At the time, nobody had really done a future military film—the closest thing was *Star Trek*, where people wore Lycra suits and carried hand phasers. But they didn't have purpose-built military vehicles. I gave *Aliens* a look that was almost like retro military. The Dropship was painted olive drab. Normally, spaceships are white in movies because in real life spaceships have to be white so they reflect sunlight and don't overheat. But the Dropship was a planetary surface landing craft, so why not paint it olive drab? It was kind of radical at the time, but it was also derivative. I knew my reference points, namely Robert A. Heinlein's *Starship Troopers*, a super gung-ho book about warriors in the future. Heinlein was way more radical than I was in *Aliens* because he gave his soldiers jump packs and exosuits so they could leap from building to building. They were also equipped with a thing called a Y-rack so they could launch mortar rounds from their backs. The guy was insane! He wrote that book in 1959 and I'm reading it in high school thinking, "Fuck. I want to see that." In my febrile teenage mind, there was nothing cooler.

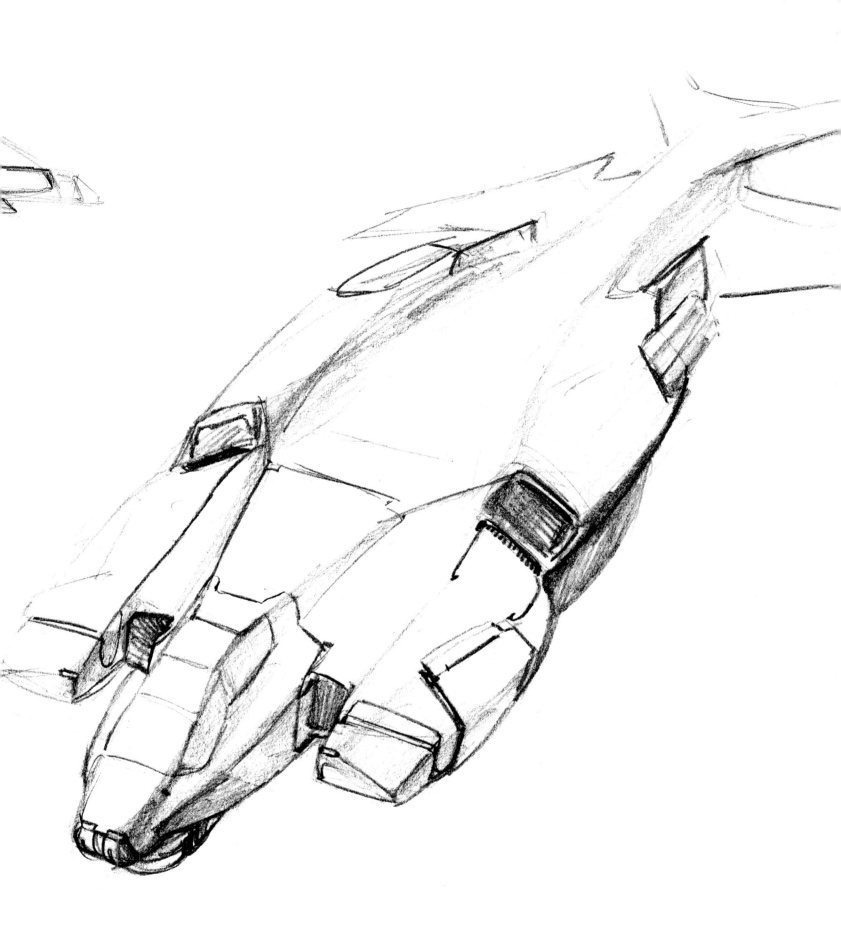

THE DERELICT

These sketches were based on the actual model of the derelict ship used in *Alien*, which we had managed to find and were going to use. We proposed that a lava flow or earthquake had broken it open in the intervening fifty-seven years between the events in that film and those in mine, so the Jorden parents enter through a different route than John Hurt and the others in the Ridley Scott movie.

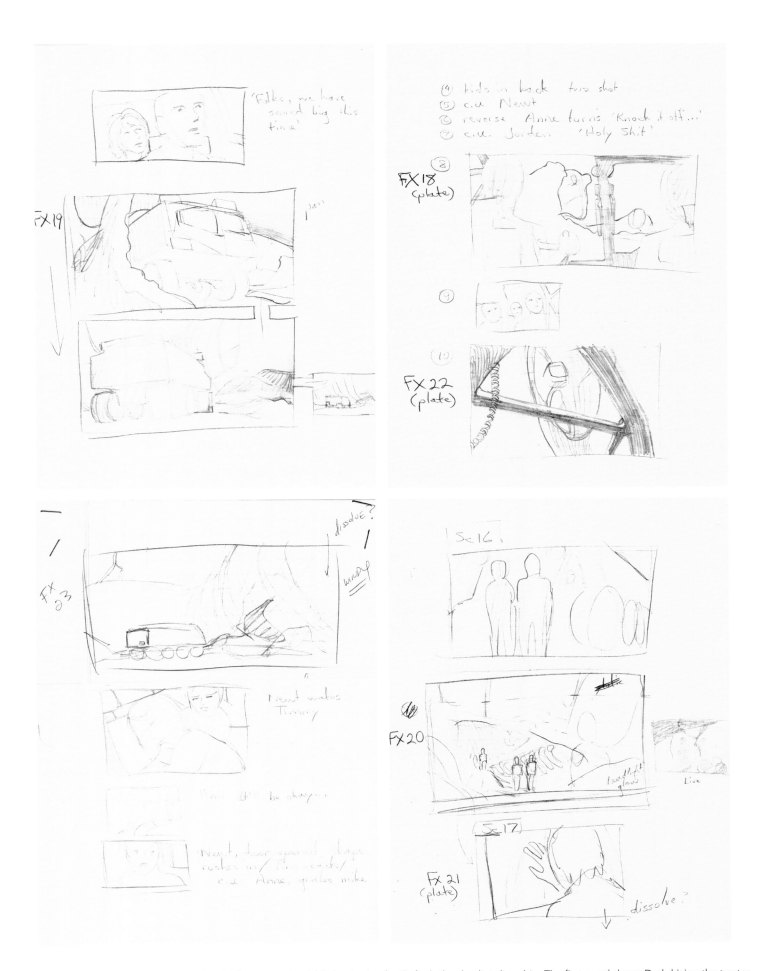

These are my thumbnail boards for the deleted *Aliens* scene in which the Jorden family finds the derelict alien ship. The first panel shows Dad driving the tractor, with Newt looking over his shoulder, then a model shot panning the tractor to reveal the derelict. The page of images at top right shows Newt's perspective over her dad to the derelict outside, and then looking up through the windows as they drive under the enigmatic "hammer" end of the ship. These were designed as rear projection shots; that way we could hand-hold the camera, so you'd feel like you were really bouncing along in this big all-terrain vehicle. In the later panels, we see Newt and her brother watching their parents disappear inside the ship. The final scene followed these boards precisely.

Untamed Worlds

When Avatar hit theaters in 2009, it set a new bar for cinematic immersion. The world of Pandora was so detailed, so nuanced and believable, that like Jake Sully in the film, audiences felt they had been transported directly into the wilds of an untamed alien world.

Although it was the groundbreaking visual effects that finally allowed Cameron's vision for Pandora to be fully realized, he had been exploring the concept of a lush alien planet filled with exotic flora and fauna since his childhood.

Cameron's personal art archive features numerous paintings and sketches of alien vistas, some abstract and experimental, others created for very specific projects. A number of the most notable pieces are planet environments he designed for Xenogenesis, a story that saw its protagonists visit multiple alien worlds in their search for a new home for humanity. The DNA of Pandora runs through much of this work, featuring creatures and foliage that would later be developed into the environment of the Na'vi people from Avatar. When Cameron and writing partner Randall Frakes were developing Xenogenesis, the means to create the kinds of worlds they were envisioning simply did not exist, despite their efforts to persuade investors otherwise. But Cameron would bide his time, becoming a major force in driving visual effects into the digital age, first through The Abyss and then, even more significantly, through Terminator 2: Judgment Day. T2 would be the turning point, the film that gave effects house Industrial Light & Magic the tools they needed to create Steven Spielberg's dinosaurs for Jurassic Park (1993), revolutionizing the industry and ushering in a new digital age of visual effects.

But these great feats of technological advancement are a means to an end for Cameron, who in essence is simply a visual storyteller, albeit one who insists on using the most dynamic means possible to bring his stories to life. And if the technology doesn't exist to transport these visions to the screen, then Cameron will push that technology until it catches up with his imagination. The road from Cameron's classroom drawings of alien worlds to his designs for the planets of Xenogenesis and his remarkably holistic vision for Pandora is a story of rapid technological escalation driven by his need as an artist to share the worlds he sees in his mind's eye. This pursuit might have changed the very nature of cinema, but it all began with some pencil sketches in a school notebook over fifty years ago.

This is either from my senior year of high school or my first year of college, somewhere around 1970–1972. It's just me using oil pastels and screwing around with transcendental sort of ideas. I really liked oil pastels.

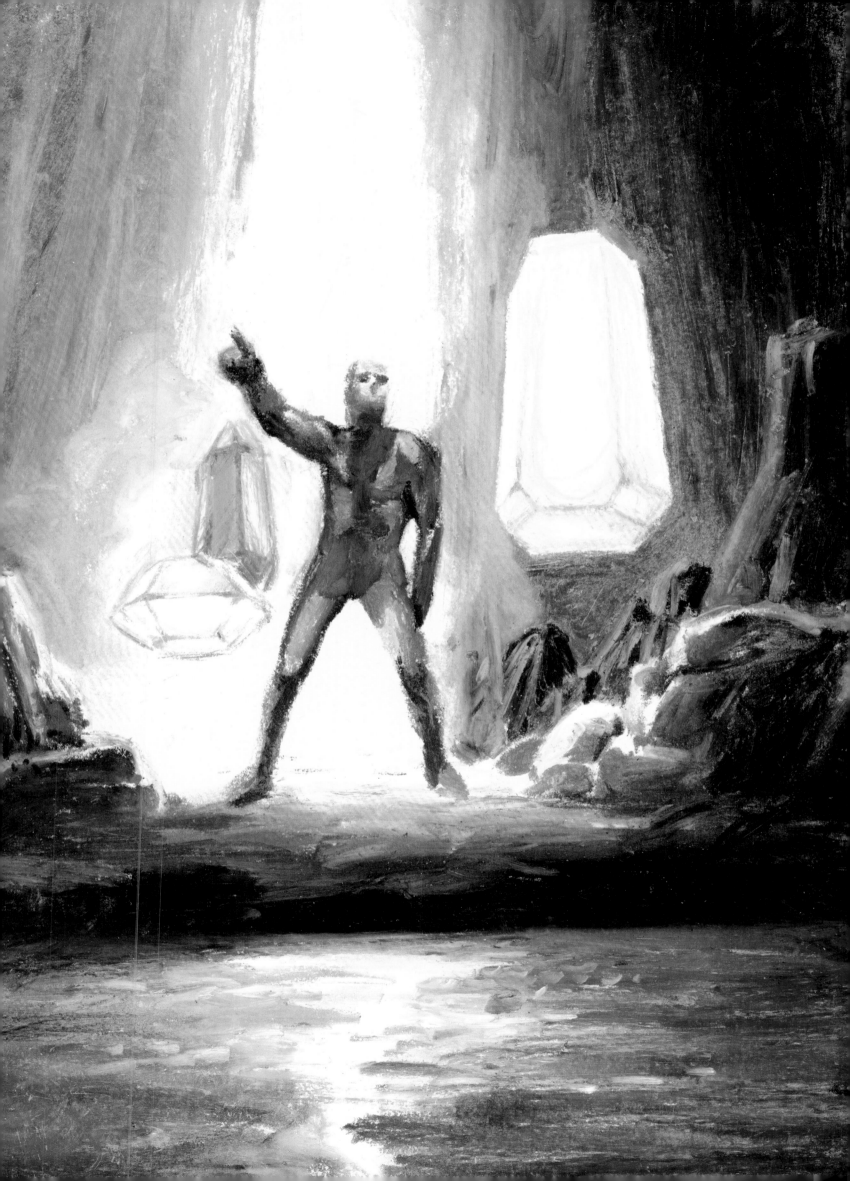

The image on the right-hand page is from *Xenogenesis*. It's a floating building from Sid's techno world that has decayed to the point where it can no longer levitate and has crashed to the ground. Just behind it is another floating building that is still functioning. These designs are influenced by just about everything, including *Star Wars*. There's a designer named Chris Foss who did a lot of science fiction book covers in the 1970s. He would draw these very strange, notional machines with big graphics on them, and that was a reference point for this floating building image. And again, *Ringworld* was a big influence because that novel had floating buildings too, so I give Larry Niven credit for that. The image at the bottom is a similar idea for a futuristic world, but that one wasn't created for *Xenogenesis*.

The image at top right depicts a version of a scene we developed for *Xenogenesis*. Jorden is exploring a planet that has these mesa-like rock formations when he decides to give up on his mission. He drops his outpack and is going to sit on the edge of a cliff to think. Then these tapeworm-like tentacles come out from under a rock and drag the outpack toward the rock. That's our first indication that there are life forms around that might be hostile.

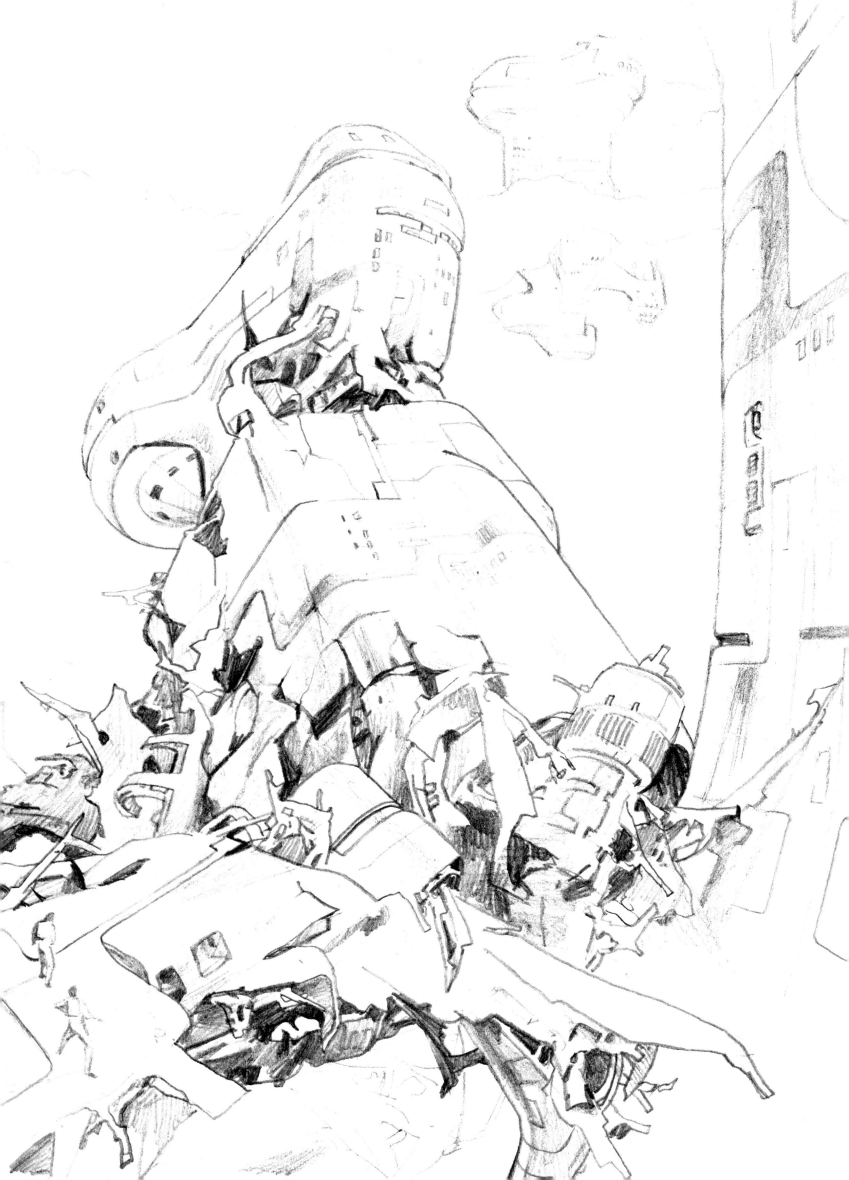

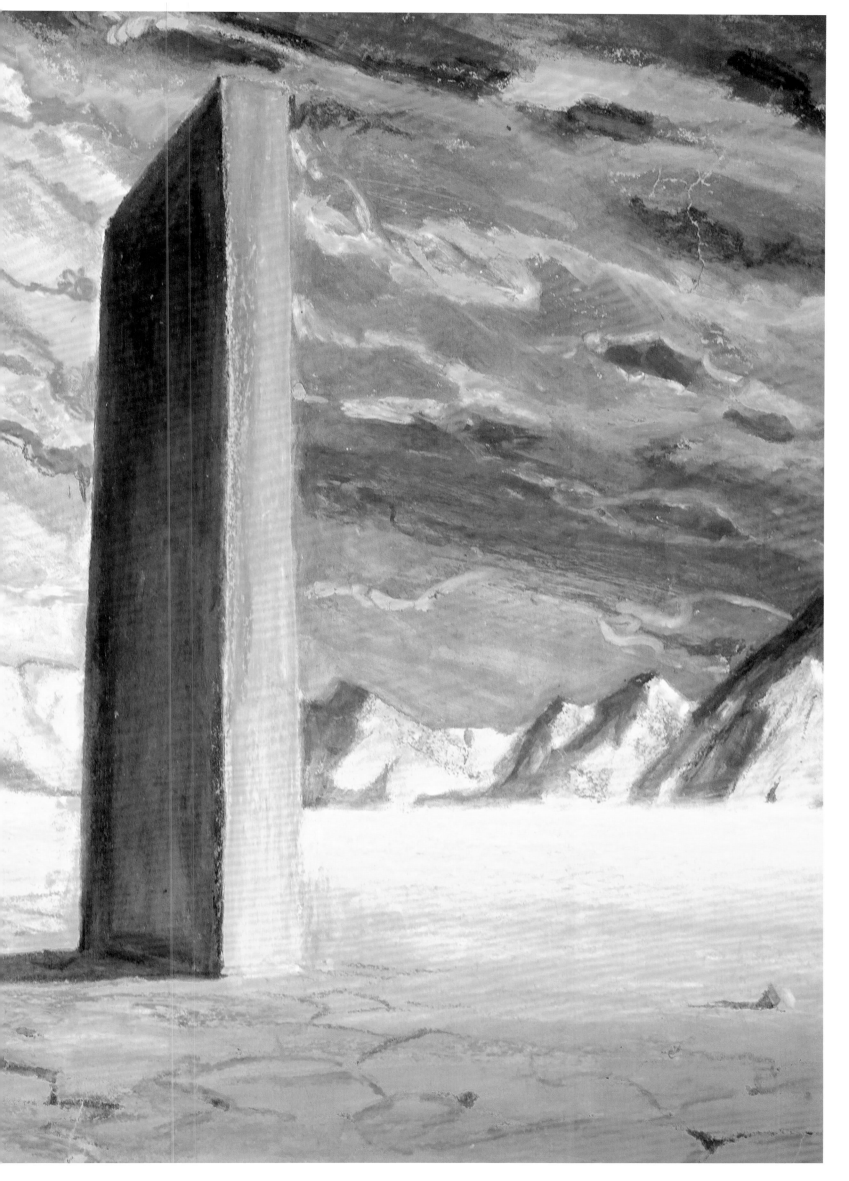

This image on the right-hand page was likely done in 1972 during my first year of college. Again, it has a transcendental theme with this guy who seems to be commanding some kind of starlike energy at his fingertip. I often go between these deeply dystopian, dark themes, and these kind of transcendent Arthur C. Clarke/Nietzschean themes of humans emerging from the muck and mire of their mistakes and becoming something great. Time will tell on that one . . .

This oil pastel drawing on pages 226–227 is obviously very *2001: A Space Odyssey*–inspired with the big monolith. The interesting thing to me about this image is the little skull in the foreground. It makes you think, "Where are we?," which gives it a narrative element. Maybe this guy didn't get what the monolith had to teach him and he didn't survive. Or maybe civilization has fallen? Again, the imagery invites you to piece together the story yourself.

The image below is my working drawing for a *Battle Beyond the Stars* matte painting. It's the village of the Akira people, the good guys in the movie who are threatened by the evil Malmori Empire. So I was actually a matte artist on that movie, too. I always feel like fortune favors the prepared mind. Doors open sometimes without warning—you go through them, or you don't. And the courage to go through them often comes from having thought about that moment of opportunity for ten years, about what you're going to do on the other side of the door. You develop your ideas and your skills to a point where when that door just kind of pops open right in front of you, it's like, "Fuck! I'm going." So when I jumped into *Battle Beyond the Stars*, I could draw, and that meant I could communicate with the art department, the builders, and the team as a whole. And then when they needed matte paintings, I could do them. So these kinds of opportunities are all about being ready.

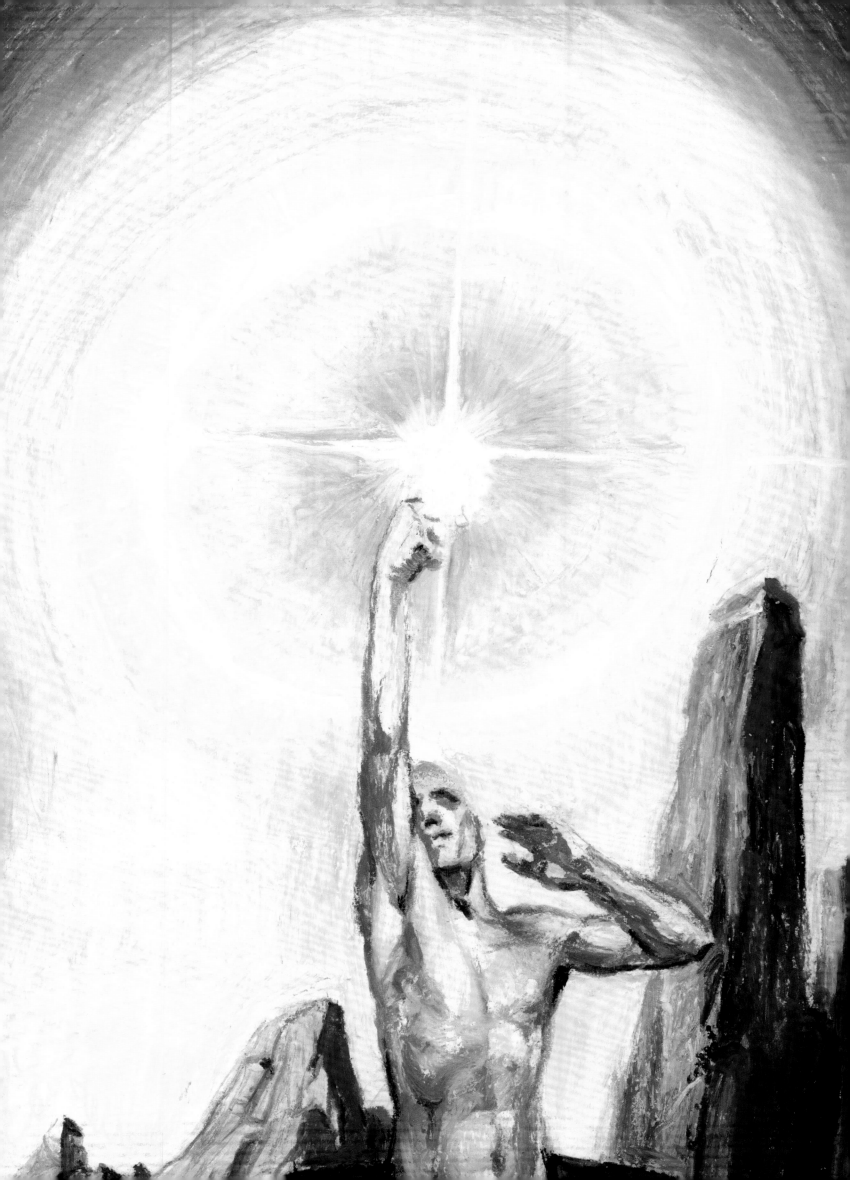

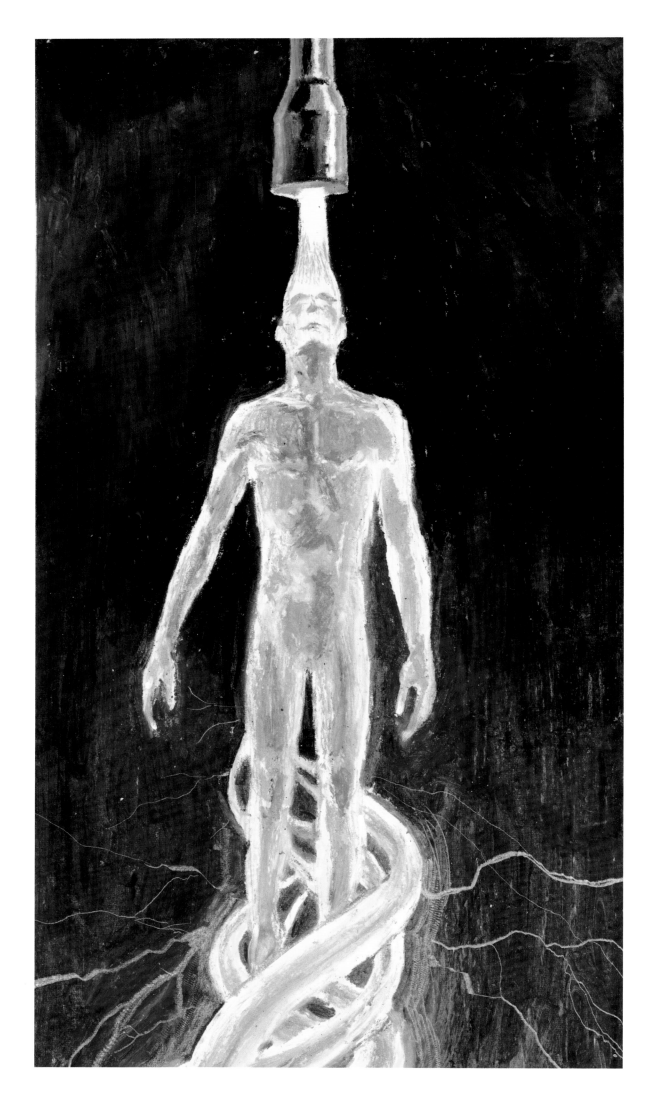

When I was drawing in school, I'd just sketch into a notebook because if I suddenly got out my oil pastels it would have been too obvious to the teachers that I wasn't doing what I was supposed to be doing.

I have no idea what the image on the left is! Appears to be a guy being extruded like glass. Interpret it as you will. But it's from around 1972/1973 when I was really into oil pastels. Typically, when I was sitting down to draw by myself I'd grab the oil pastels and do something in color. But when I was drawing in school I'd just sketch into a notebook because if I suddenly got out my oil pastels it would have been too obvious to the teachers that I wasn't doing what I was supposed to be doing.

This image looks like something I might have drawn in the school library—it's just a whimsical exercise in using driftwood and tree shapes to form human figures in some kind of druidic way. I was drawing a lot through all of the '70s. Once I got busy working for Corman and then segueing into *The Terminator*, I stopped drawing my own whimsical things and started drawing for a purpose. I'd draw either to eat, as with the movie posters, or to design my own films like *The Terminator* and *Aliens*. And so the whimsical stuff fell by the wayside.

I remember doing this one somewhere around the tenth grade when I was first experimenting with oil pastels. Obviously it was based on actual ruins, like those at Angkor Wat in Cambodia or other places such as Thailand and Indonesia. But I also gave it an otherworldly Conan-esque quality. There's a dinosaur and Komodo dragon–type creature on the left, so it has a *Lost World* feeling, too. It's very overgrown and collapsed and looks like the kind of place that Conan might go. So again, it's a single image that suggests a whole story to the viewer.

It's very overgrown and collapsed and looks like the kind of place that Conan might go. So again, it's a single image that suggests a whole story to the viewer.

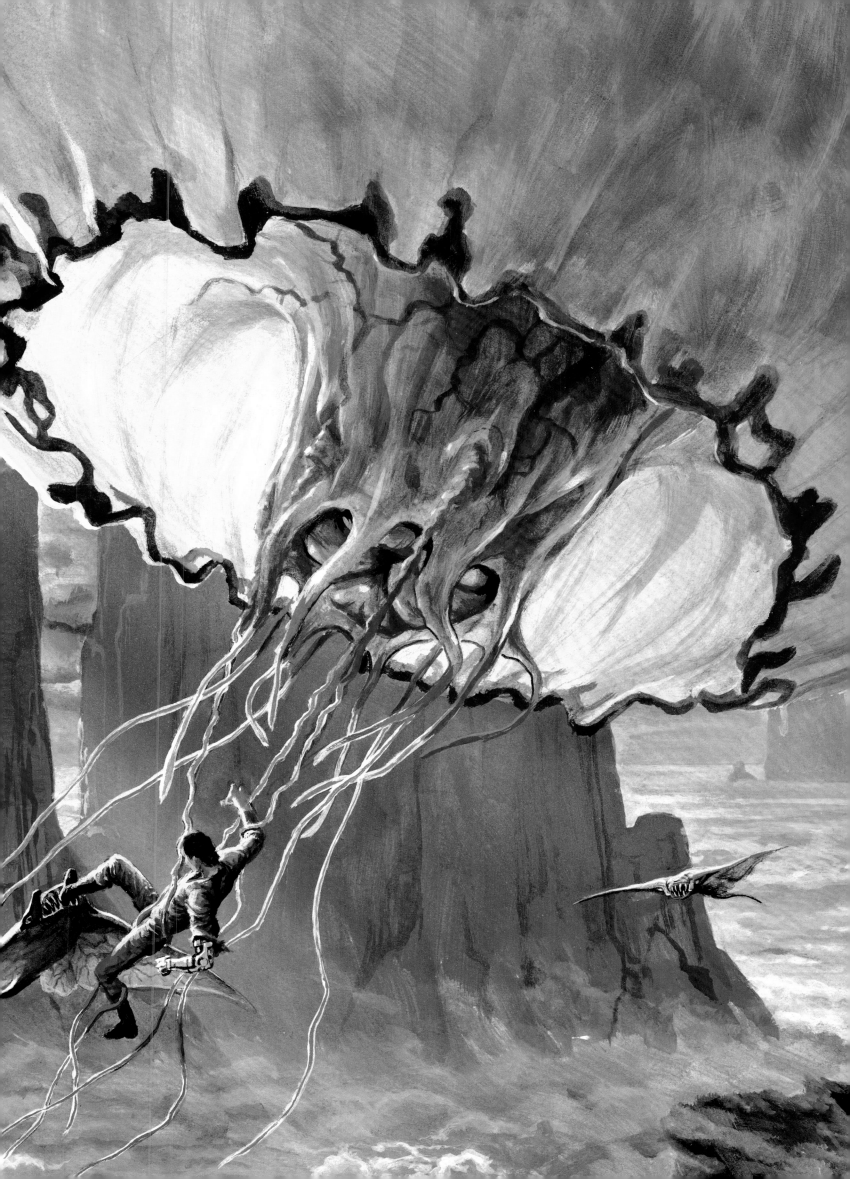

The mesa planet first appears barren and lifeless: It has toxic gases on the surface and the only things sticking up are volcanic core structures that have eroded into the tower-like mesas.

THE MESA PLANET

This is the mesa planet from *Xenogenesis*, which, in terms of the narrative, was the planet of despair. In the search to find a new home for humanity they go to a lot of promising planets that aren't quite right for one reason or another: They go to the luminescent planet, they go to the techno world where they meet Sid, and so on. But eventually, following a tragedy, Jorden loses heart. He just thinks their mission is over and they are never going to find a planet to colonize, and that's the moment when he throws away his outpack.

The mesa planet first appears barren and lifeless: It has toxic gases on the surface and the only things sticking up are volcanic core structures that have eroded into the tower-like mesas. But Jorden soon discovers that all the life on the planet can be found in the air. So you have this hydrogen gas–filled jellyfish creature, the Aerocoelenterate, flying around, and you have the Air Sharks. Jorden gets grabbed by the jellyfish and it's stinging him electrically. He's

fighting it off with his biomechanical arm, and at the same time he's getting attacked by the Air Sharks that are swooping in. He was in this deep moment of despair and about to give up, but when the Air Sharks try to take a chunk out of him, he's like, "Attack me? I'll fight!" The jellyfish pulls Jorden up to its mouth and he takes out his knife, hacks it open, lights its fucking gas on fire, and the thing blows up like the Hindenburg and crashes back down to the ground. Jorden gets covered in slime, but he manages to recover his gun, and when the next Air Shark takes a swipe at him, he blows its teeth out of its mouth. So he's like, "Fuck it, I do want to live after all. Okay, let's get on with the mission." So this scene was part of our cheesy approach to featuring all these cool worlds which we would drop our characters into. Each world had a narrative purpose, and in the case of the mesa planet, it functioned to bring our hero back from the brink and get his head back in the game.

THE ROAD TO PANDORA

The image below is a sketch for another of the potential homeworlds the protagonists visit in *Xenogenesis*. The planet surface is based on brain coral, but writ large. I would have drawn this in the late '70s when we were packaging up *Xenogenesis* for presentation to potential investors. During this period, I was regularly scuba diving off the shore in California. It wouldn't be until later, when I'd made a little money, that I'd be able to go to a real tropical reef and see actual brain coral, so I think this sketch is just me expressing something that I hadn't actually seen in real life yet.

The tree-like structure in the background is essentially a Christmas tree worm, a type of marine worm that lives on coral. It has this little kind of spiral fringe, and when it's threatened, it retracts this structure into a little tube and hides out there until the danger passes. Years later, I took the idea from this drawing and put it into *Avatar* to create the helicoradian—the large spiral plant-like animal that retracts into itself when Jake touches it. In the scene he touches a bunch of them and they all close up, eventually revealing a hammerhead titanothere lurking behind. So it goes from "This is amazing!" to "Oh shit!" I don't think we ever had a defined role for it in *Xenogenesis*, though.

I did the drawing on the right-hand page in eleventh grade. What you see here is a gigantic rainforest, ten times terrestrial scale, with giant creeper vines, hanging moss, big arched root systems that you could walk on, and bromeliad-type epiphytes—plants that grow on other plants. On the back of the piece I had written "Spring on planet Flora," but I look at it now and it's the frickin' rainforest from Pandora. When we started designing the Pandora rainforest for real, we used all these elements and made a big deal out of the planet's epiphyte ecosystem, but I don't recall ever taking this drawing in and saying to the concept artists, "Just do that." These elements were just somewhere embedded in my mind from back in the '70s. And after the movie came out and we faced a bunch of lawsuits, this was another image that saved my ass because it was clearly dated and proved there was provenance to my ideas.

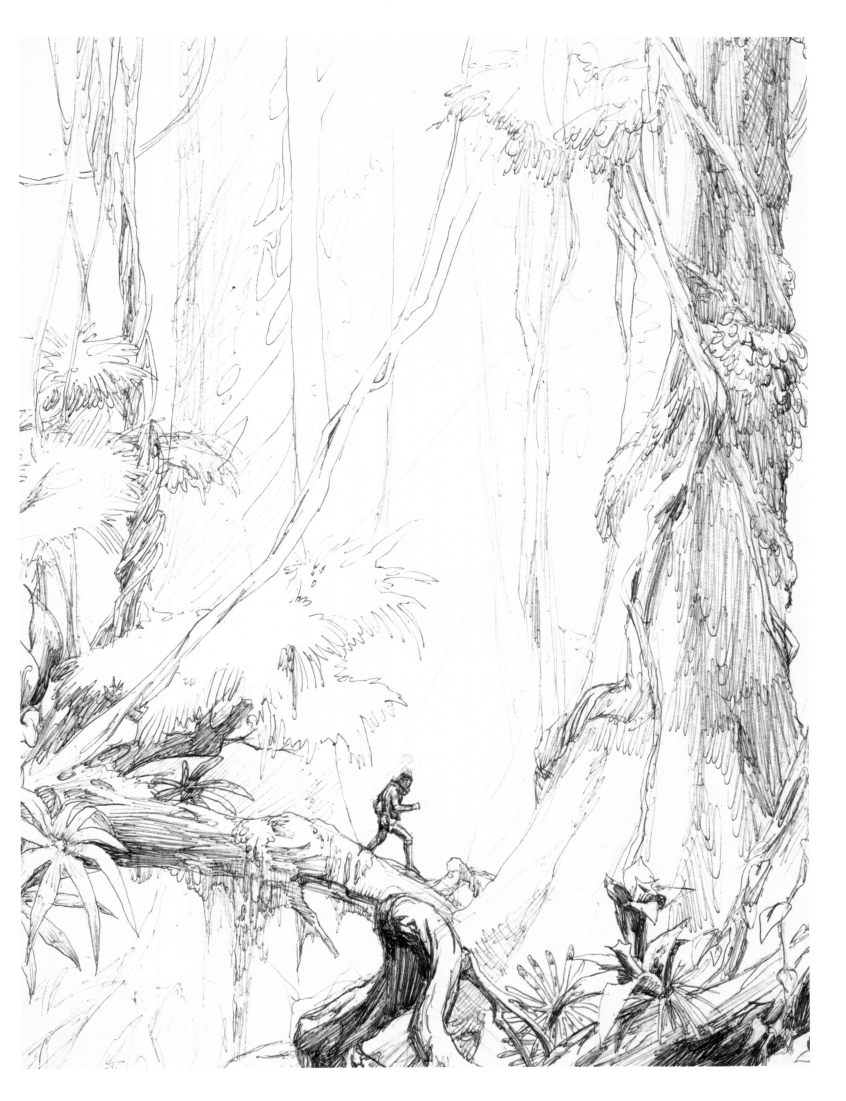

This is a really critical drawing in the chain of ideas that led to *Avatar*—it's the image I drew after the luminous forest dream I experienced when I was nineteen. You can see that there's a network of light, suggesting some type of nervous system effect in the forest. I was fascinated by the kind of fiber-optic lamps that were popular in the '70s—they were really quite beautiful. And to me, these trees were just big fiber-optic lamps. This idea essentially became the Tree of Souls in *Avatar*, the tree that connects the Na'vi to their deity, Eywa. The fan lizards can be seen in this drawing, too. The idea was that they unfurl like a Chinese fan, and the unfurling process would give them spin so they would fly like Frisbees in the planet's low gravity. At the bottom you can see the purple luminous moss that would also end up in *Avatar*—in the film, when Jake and Neytiri walk on the moss, it triggers biolume that ripples outward from their footsteps.

This drawing was created way before I started working on *Xenogenesis*. But when we were working on that project, I remembered the image and said to Randy, "What if we included a planet where everything glows?" So we worked up an idea that was something like the lotus-eaters from Homer's *The Odyssey*. The planet seemed like the most beatific paradise you could conceivably imagine. But that feeling of wonder was being chemically triggered by the plants, which were emitting pheromones that stimulated these feelings of elation. So the humans would get zoned out on how beautiful everything was, and they would just sit down and relax. But the flora on this planet was carnivorous and when people fell into this stupor, the plants would wrap them in their tendrils, weave them into silken cocoons, and start to dissolve them. And only by the furious power of his determination to complete his mission would Jorden be able to break this spell and escape—kind of like Ulysses and the lotus-eaters. The whole story of *Xenogenesis* was designed to be reminiscent of *The Odyssey*, with the hero going to different places, interacting with different cultures, and encountering different monsters. There's also some links to *Avatar* in the idea of Jorden getting wrapped up in this silken stuff: The soul transfer ceremonies featuring Sigourney Weaver's character, Grace, and Jake Sully at the end of the movie also involve the characters being wrapped in silken tendrils. So like I said, I have three or four good ideas and I just keep working 'em. You wait long enough that people forget and then you can sell it again.

The image on pages 242–243 is a piece of concept art for *Avatar* originally drawn by concept art director Dylan Cole (pictured on right in photo), which I then augmented. I was trying to show how the roots wrap up the walls around the Tree of Souls, and I drew in a pattern suggesting this idea. So my contribution was showing how the roots spread out and connected to a vine network that spread up the walls of the caldera and connected the tree to the world-forest.

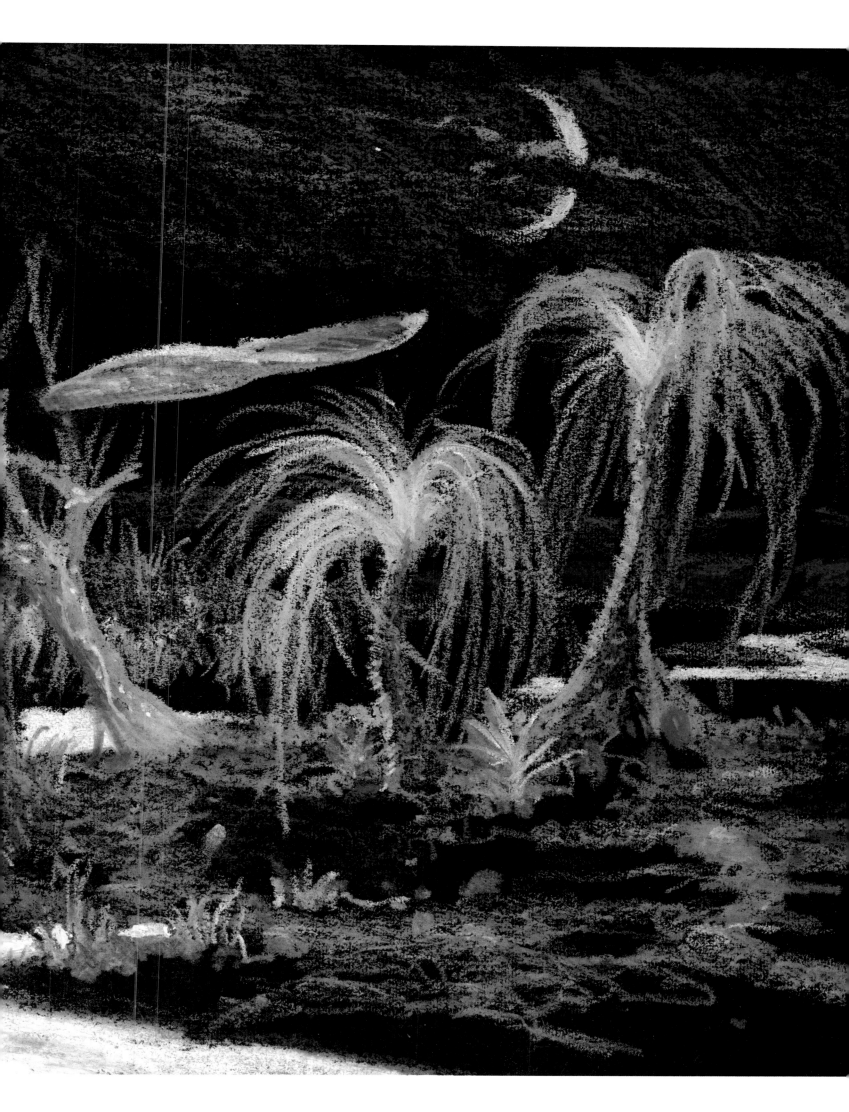

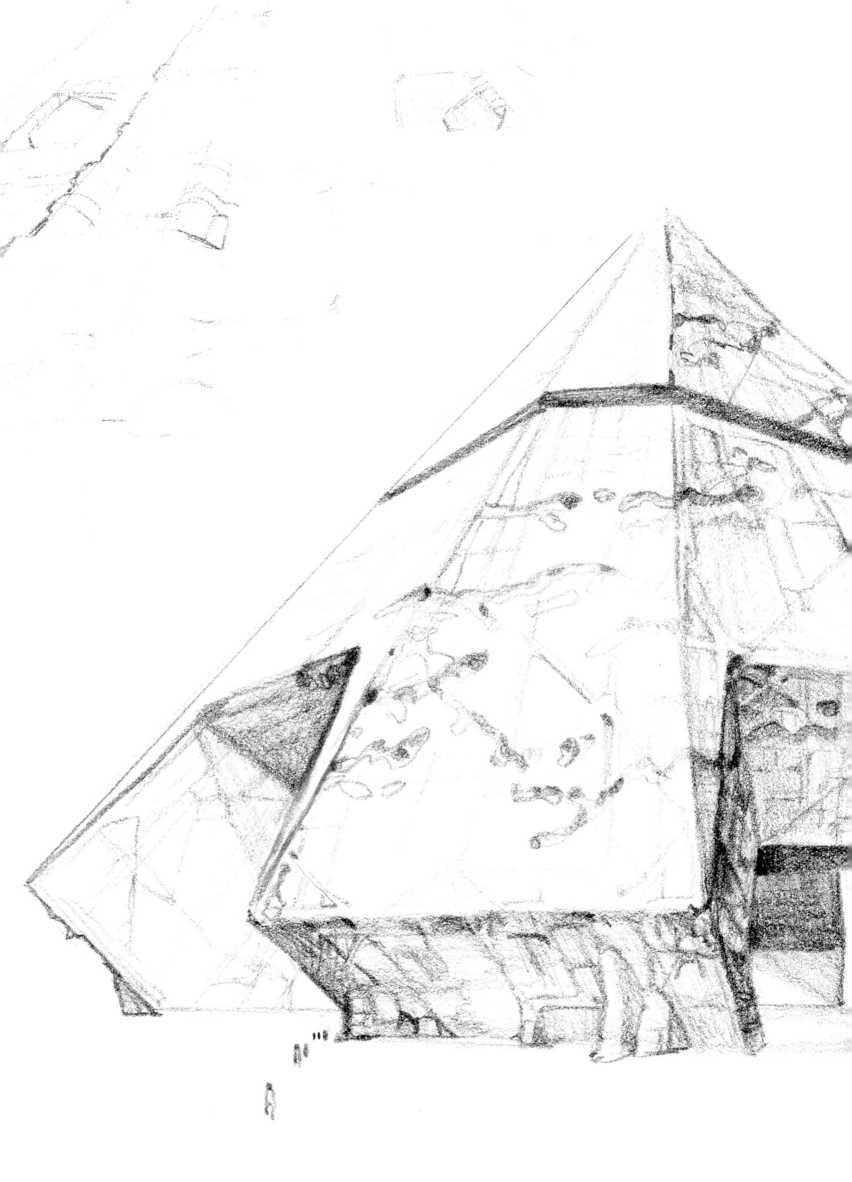

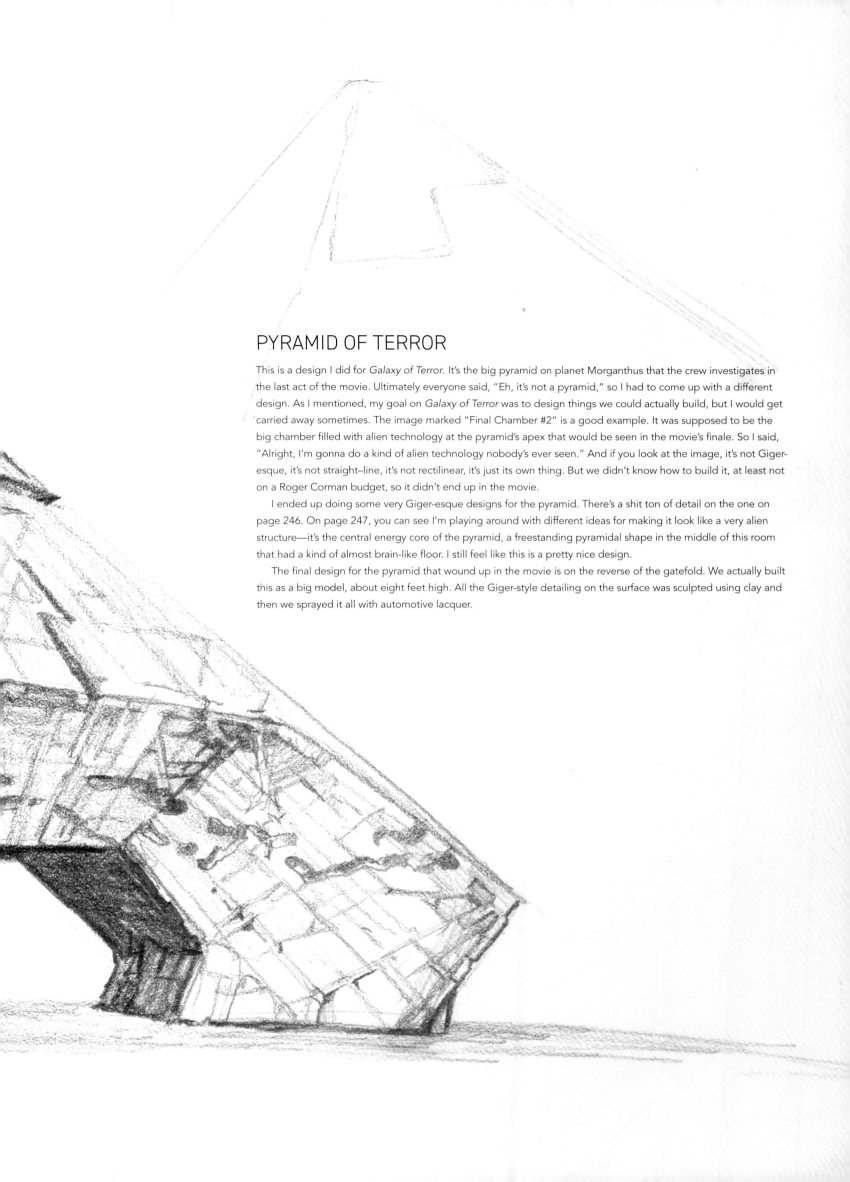

PYRAMID OF TERROR

This is a design I did for *Galaxy of Terror*. It's the big pyramid on planet Morganthus that the crew investigates in the last act of the movie. Ultimately everyone said, "Eh, it's not a pyramid," so I had to come up with a different design. As I mentioned, my goal on *Galaxy of Terror* was to design things we could actually build, but I would get carried away sometimes. The image marked "Final Chamber #2" is a good example. It was supposed to be the big chamber filled with alien technology at the pyramid's apex that would be seen in the movie's finale. So I said, "Alright, I'm gonna do a kind of alien technology nobody's ever seen." And if you look at the image, it's not Giger-esque, it's not straight–line, it's not rectilinear, it's just its own thing. But we didn't know how to build it, at least not on a Roger Corman budget, so it didn't end up in the movie.

I ended up doing some very Giger-esque designs for the pyramid. There's a shit ton of detail on the one on page 246. On page 247, you can see I'm playing around with different ideas for making it look like a very alien structure—it's the central energy core of the pyramid, a freestanding pyramidal shape in the middle of this room that had a kind of almost brain-like floor. I still feel like this is a pretty nice design.

The final design for the pyramid that wound up in the movie is on the reverse of the gatefold. We actually built this as a big model, about eight feet high. All the Giger-style detailing on the surface was sculpted using clay and then we sprayed it all with automotive lacquer.

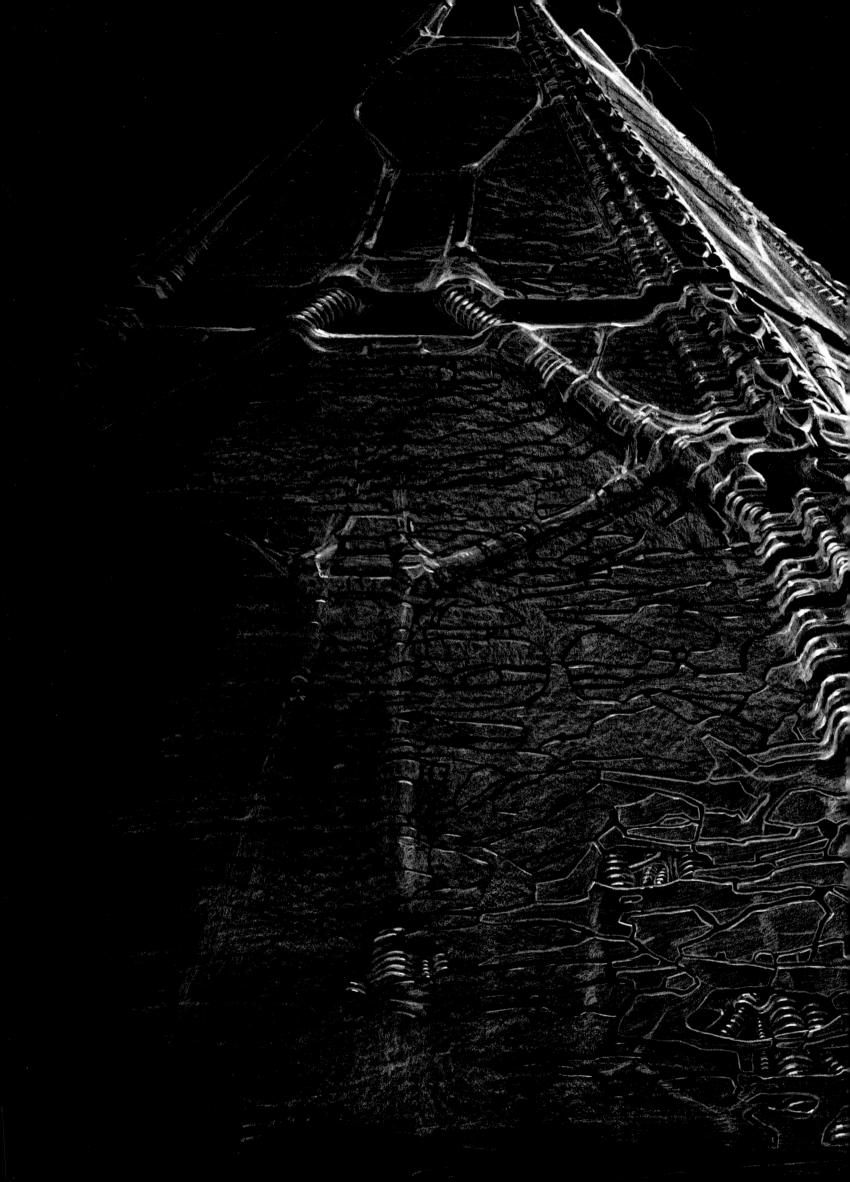

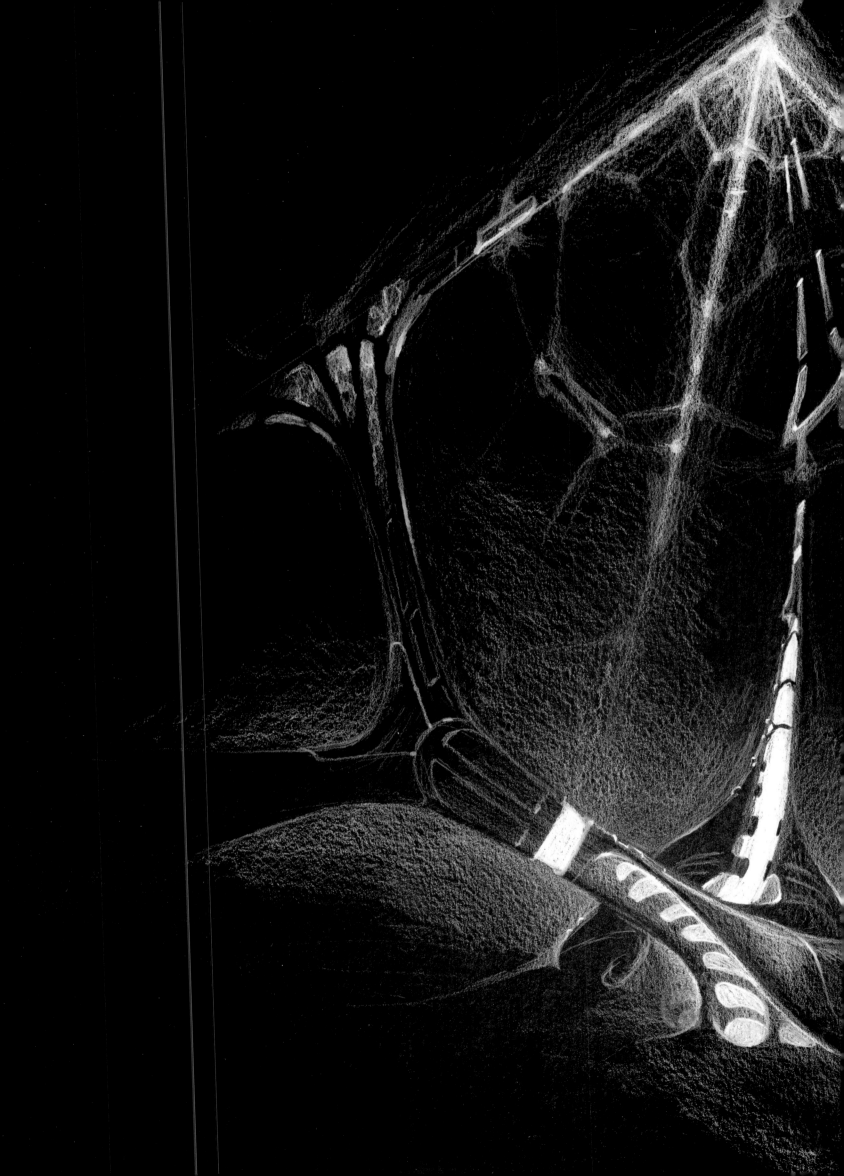

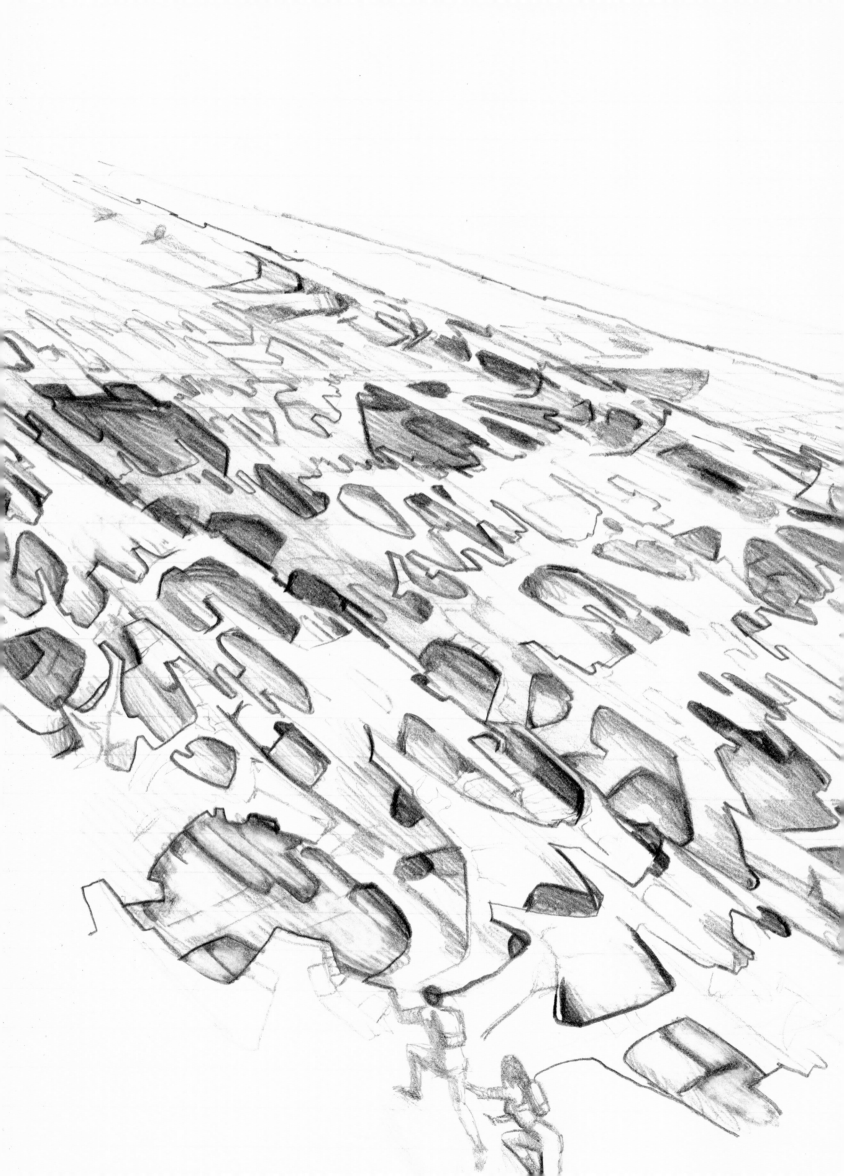

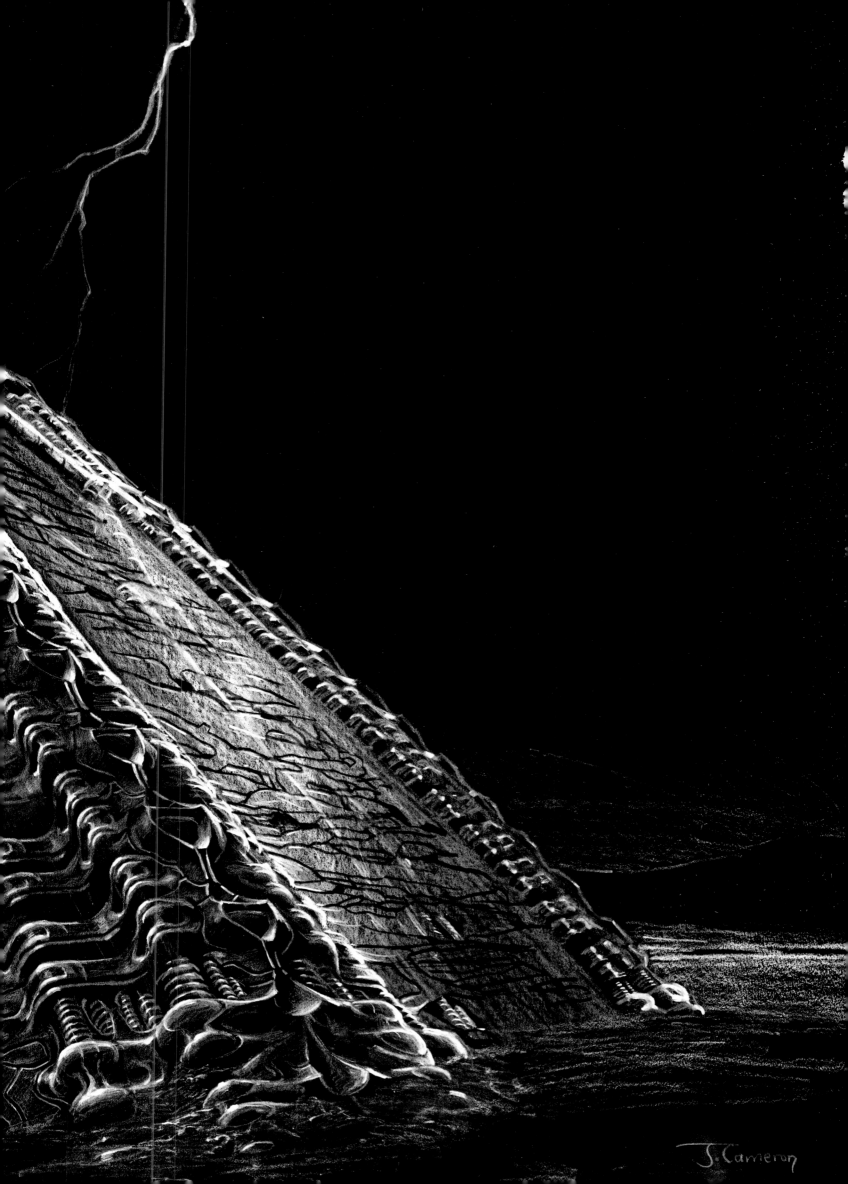

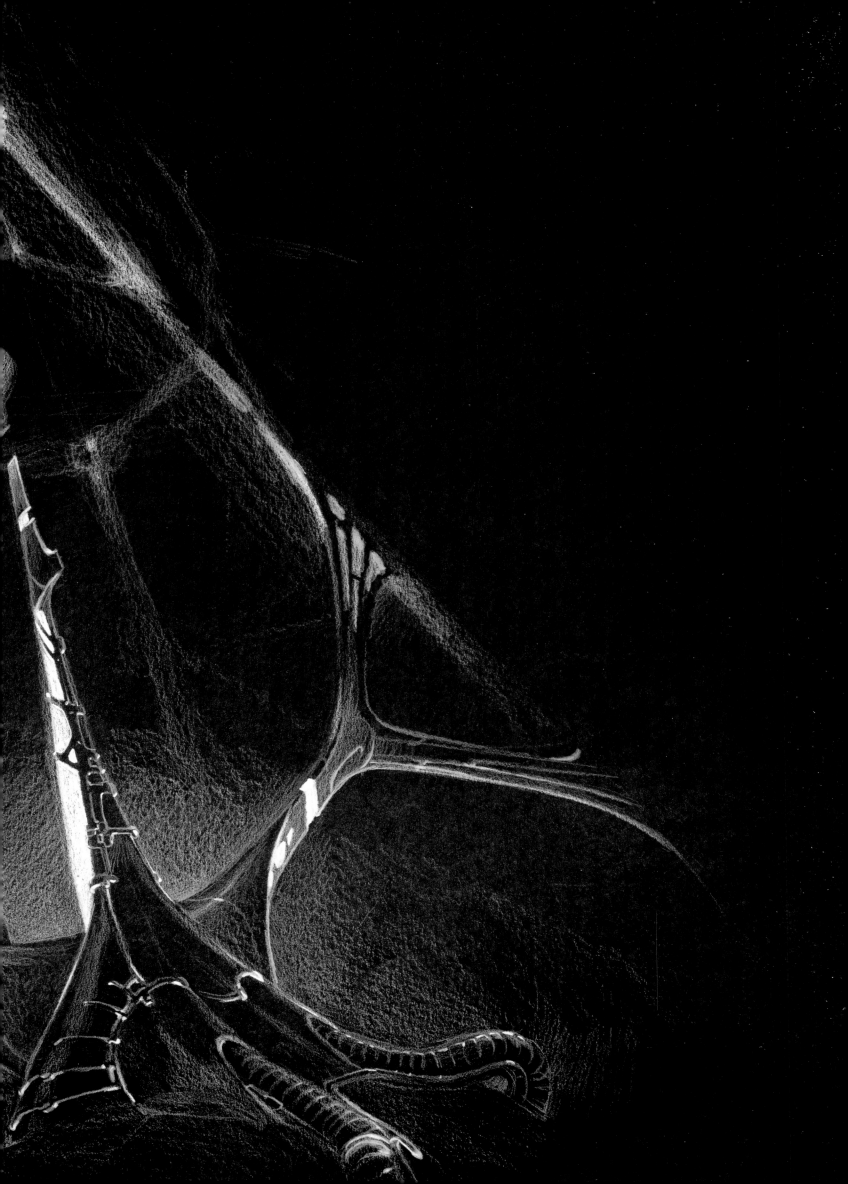

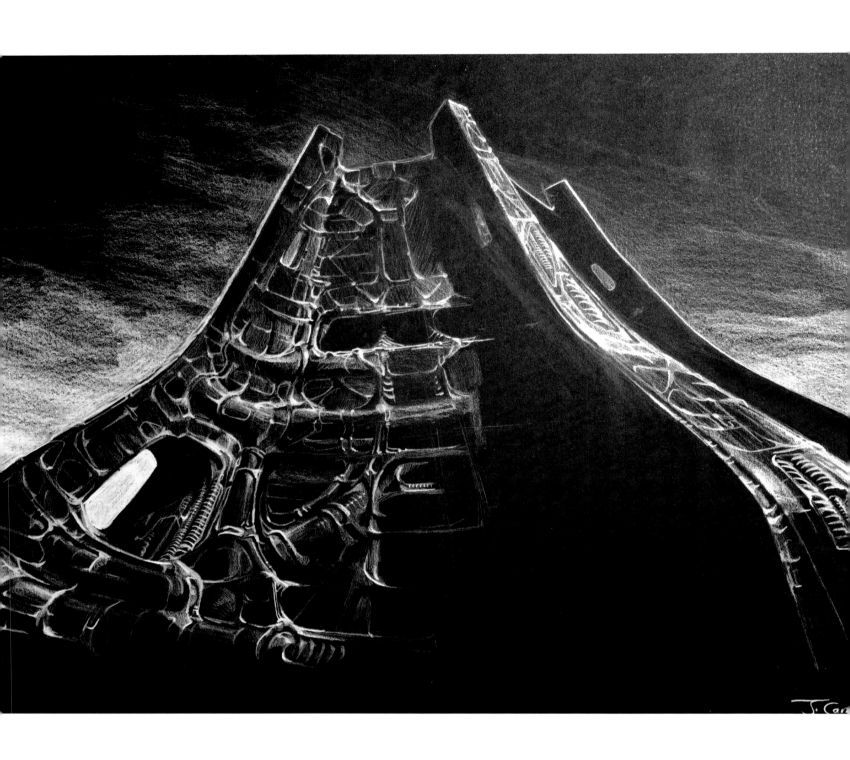

I also designed the pyramid's interior corridors and chambers. The room on pages 248–249 is one we did actually build using fiberglass and some other materials. The design was sort of based on a tokamak nuclear fusion experiment—I'd studied physics, so I understood the kind of toroidal shape of those reactors.

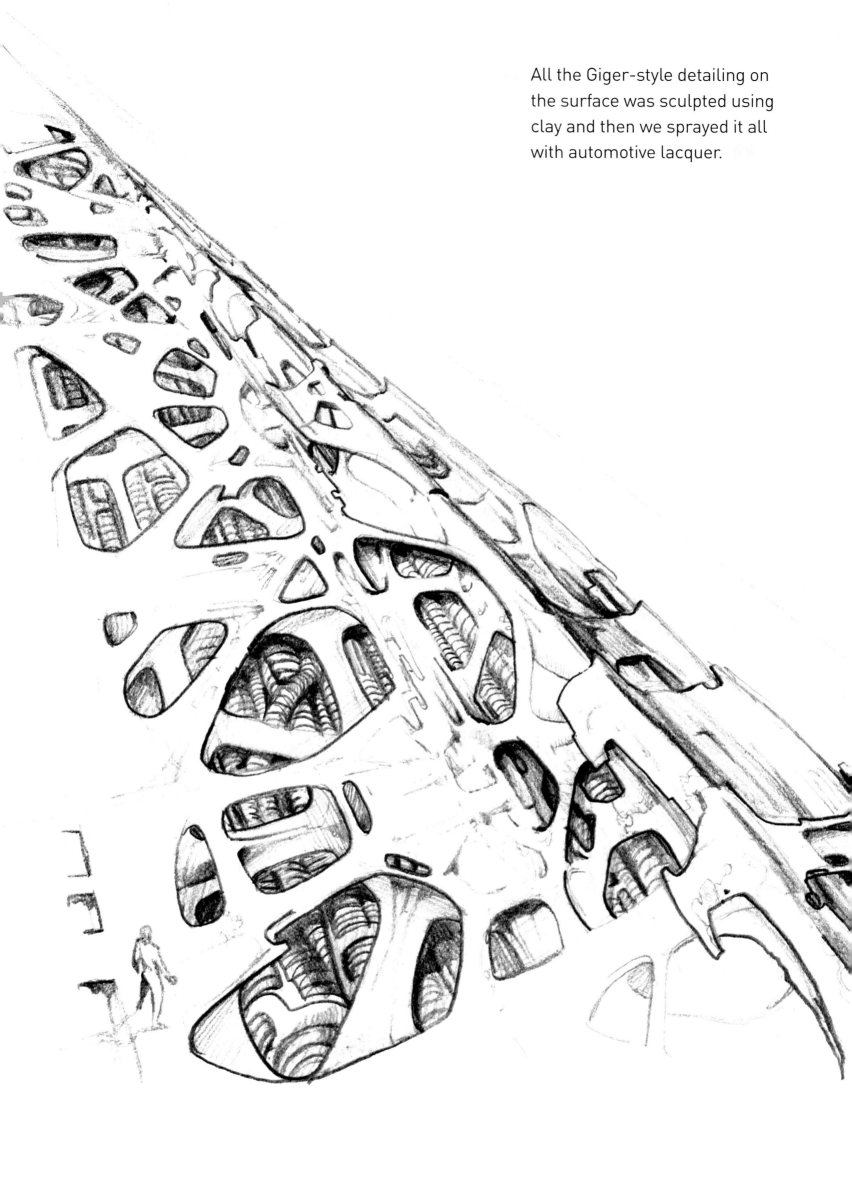

All the Giger-style detailing on the surface was sculpted using clay and then we sprayed it all with automotive lacquer.

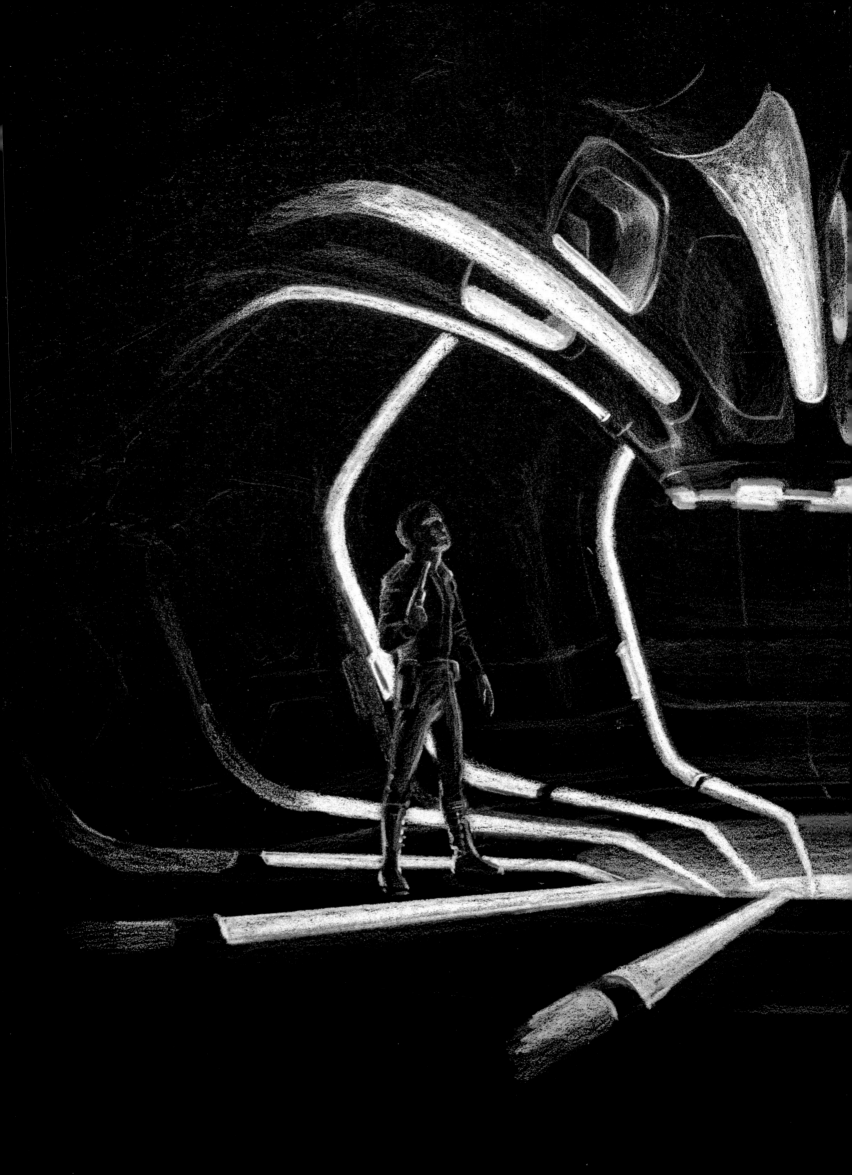

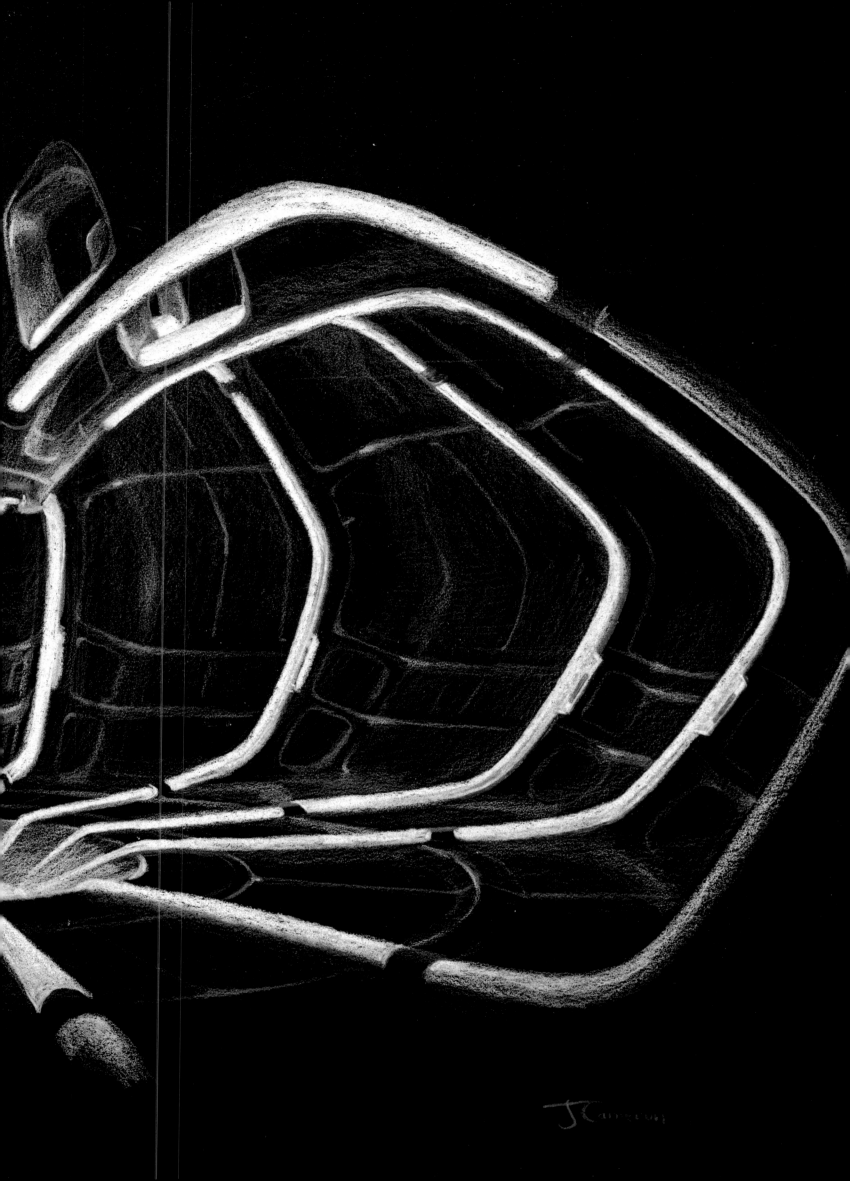

ACHERON

Below is my design for the surface of LV-426, aka Acheron, the planet from *Aliens*. I wanted something vaguely
H. R. Giger-esque and very alien in comparison to Earth rocks. I didn't want anything generic, so I needed to be
very specific for the sculptors. I'd take my concepts straight to the shop at Pinewood Studios and say, "Build these
rocks!" They'd say, "That's a two-dimensional drawing. I don't know how to build these rocks in three dimensions."
And I'd go, "That's your problem!" Ultimately, I had them sculpt my drawings using modeling clay so they would
understand how it would look in three dimensions and then they could go and build it. I remember reading that
Giger had done the same thing on *Alien*. I never met Giger in person, but I did read everything about the creation
of *Alien* that I could find. After *Aliens* we corresponded by letter. I told him I was a huge fan and gave him my
excuses for not involving him in *Aliens,* because I'd heard he was very disappointed at that decision. I felt bad
about it, but basically I wanted to design those critters myself. It would have been a case of too many cooks, so I
avoided it completely. A bit unfair, in retrospect. It would have been cool to work with him.

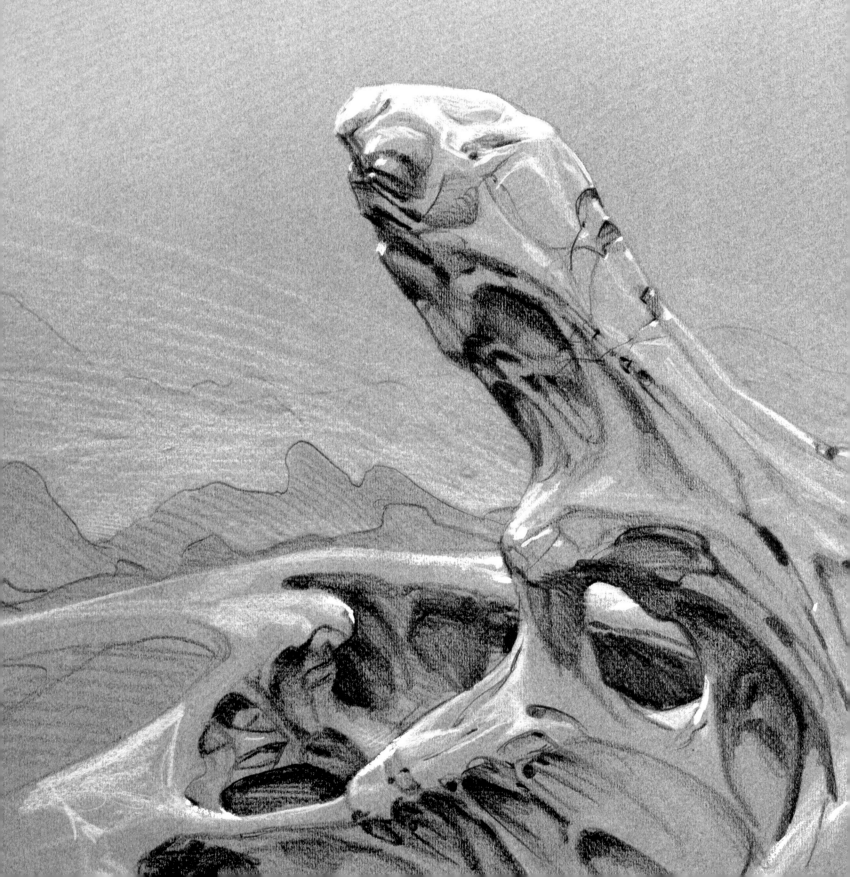

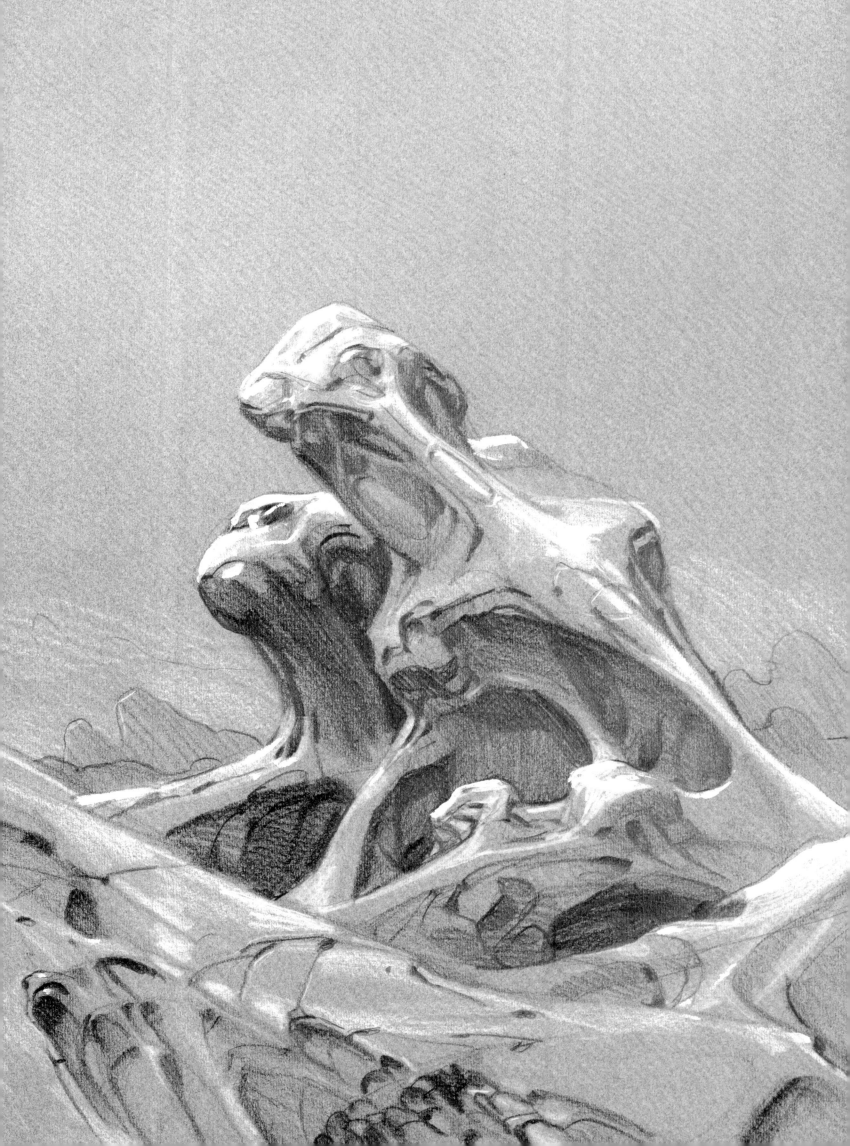

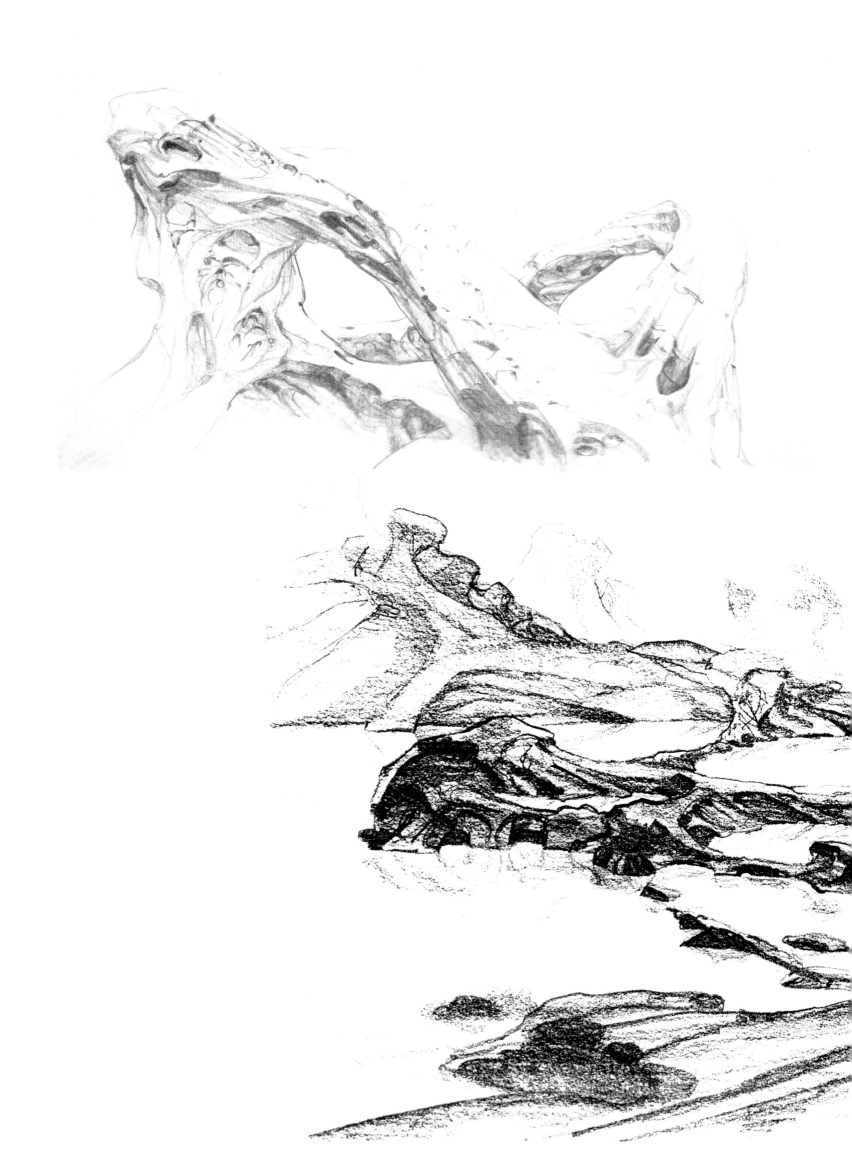

In the top left image I'm being very explicitly detailed about what defines an LV-426 rock versus something terrestrial. Again, I wanted to be inspired by Giger but I didn't want the designs to literally be Giger designs.

In the image at the bottom, I'm exploring what happens when you flood these alien rocks with water and puddles form. The rocks have weird bits of connective tissue, these igneous formations, so I wanted to see how rain would pool in those sections. I thought they would stick up out of the water kind of like tendons. Ultimately, there was never an exterior scene of a guy charging across the landscape in *Aliens*. At the time, I thought that it might happen when the Dropship crashes and the marines have to get out of its way, but it would have been way too complicated, so it's not something we ever filmed.

The rocks have weird bits of connective tissue, these igneous formations, so I wanted to see how rain would pool in those sections.

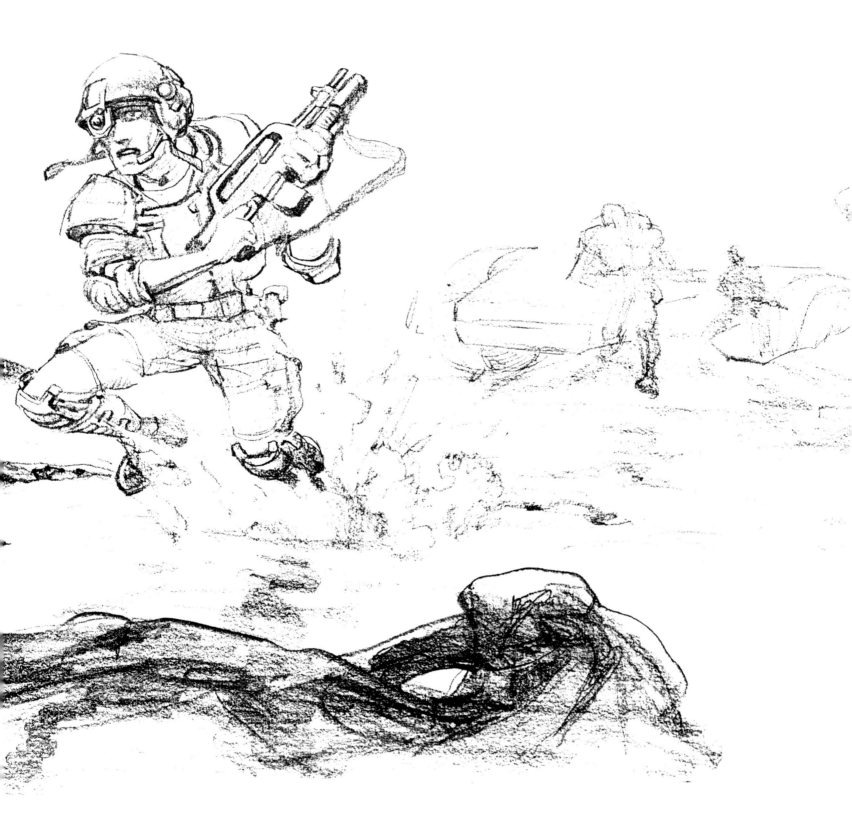

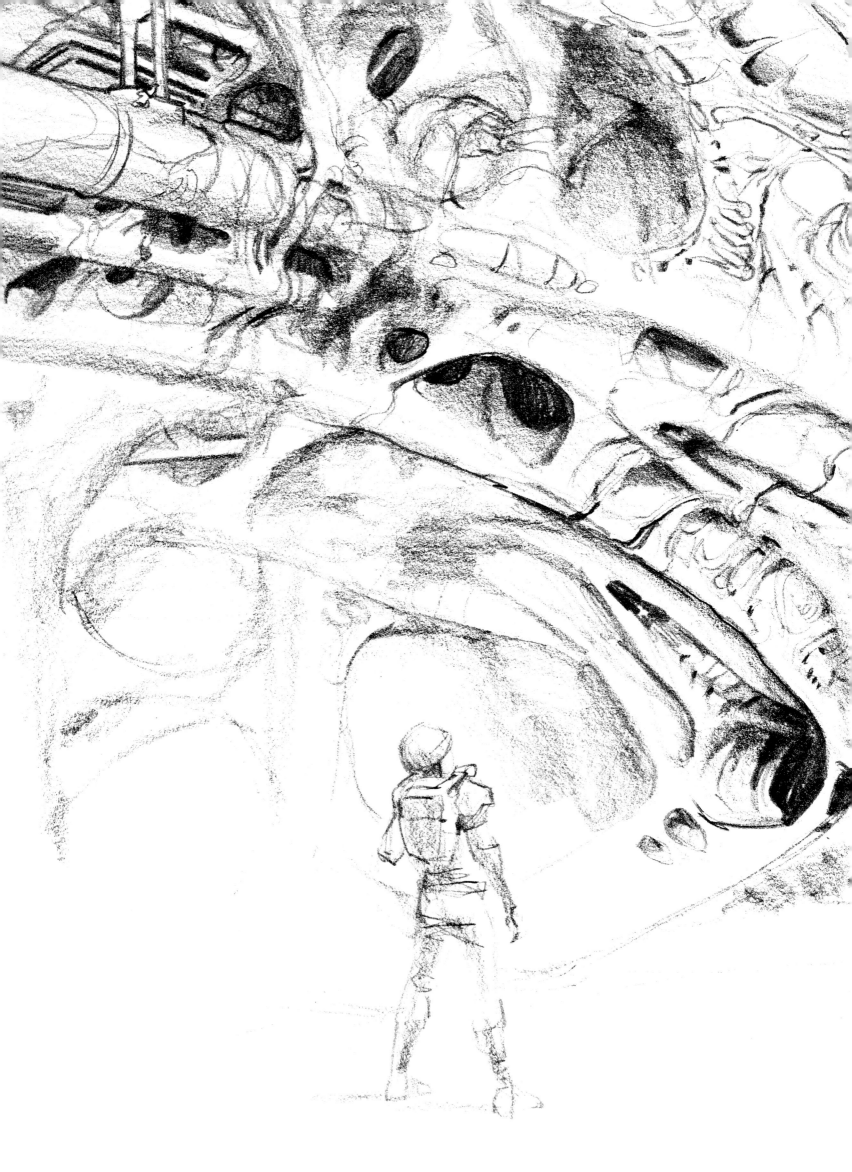

> I wanted it to look like a close-up of the human circulatory system or as if you were looking down the bronchi of the lungs—some kind of biological orifice that you really don't want to go into.

SECRETED FROM WHAT?

This is the alien structure created by the xenomorphs within the Atmosphere Processing Station. Again, it's very Giger-inspired, biomechanoid-type stuff. But it's kind of my own language—it's like a palimpsest where I'm using Giger for inspiration but I'm doing my own thing. You can see that it's made up of structural arches and then there's kind of a network that goes over it, a bit like the way that veins in the hand wrap over the tendons underneath them. Because this was all made by the aliens, it has to follow their logic and the way they might build things, but it also has to look structural. I wanted it to look like a close-up of the human circulatory system or as if you were looking down the bronchi of the lungs—some kind of biological orifice that you really don't want to go into. But then the commander orders you to walk in there, and it's like, "Aw shit. You're kidding me."

We needed to film the cast walking underneath this structure, so we constructed the bottom part of the set—the tunnel opening—full-size and then we built the alien structure as a miniature Plasticine model. When we shot the scene, we actually placed the model in front of the camera so it would be at the top of the shot, with the cast walking underneath. The Skotaks blended the two together so flawlessly that it just looked like one big set. I don't know how they hell they did it, but they were just amazing at these kinds of practical techniques.

When you go inside the structure you find the xenomorphs have constructed their nest from glued–together bits of junk and human bodies with their chests ripped open after being impregnated by aliens. I wanted it to look like the aliens had grabbed a bunch of machines, ripped them apart, and reconfigured them into these structures, but I don't think that really came across in the final film. We based it more on biological structures like bones—whether those were actually human bones or whether it was just the way the aliens excreted these rib-like structures.

The image on the right is the character from the film whom the marines find cocooned. She wakes up and an alien bursts out of her chest. The image is very close to the final scene in the film, particularly in the positioning of her arms.

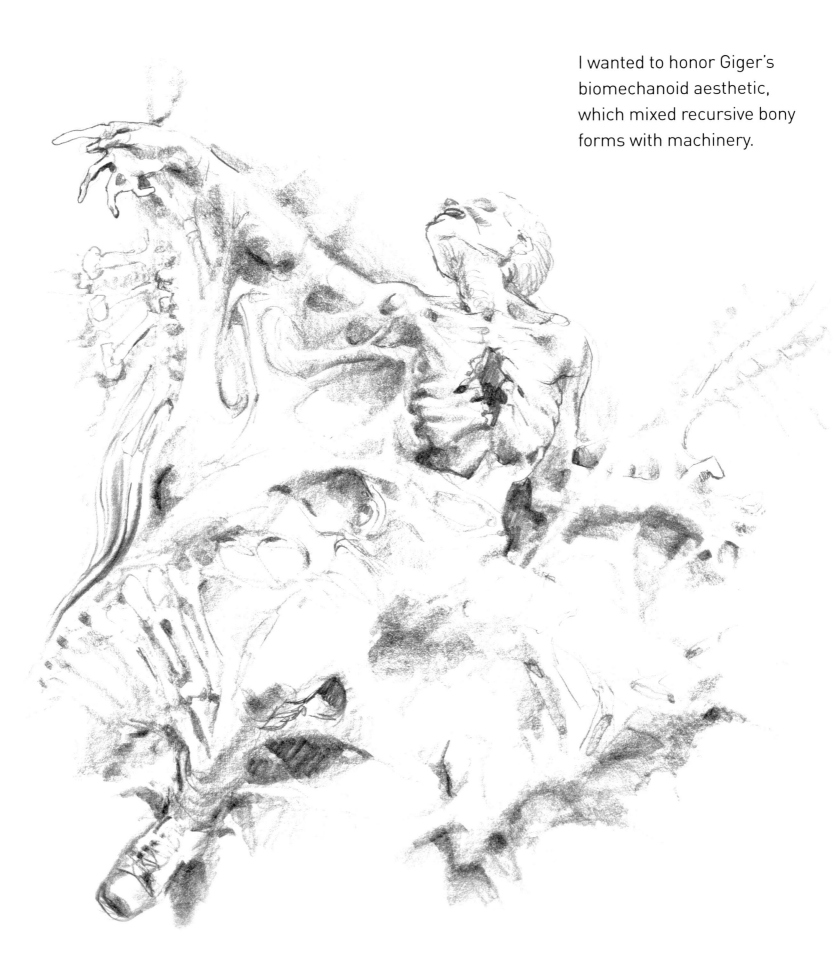

I wanted to honor Giger's biomechanoid aesthetic, which mixed recursive bony forms with machinery.

I had a very specific look in mind for the cocooned colonists. I wanted to honor Giger's biomechanoid aesthetic, which mixed recursive bony forms with machinery. In my mind the xenomorphs had built this big structure using human bones along with wiring and hardware ripped from the colony buildings, cementing it all together with some kind of excreted goo that hardened like resin. Where they excreted it from is never explained, but insects do this type of thing all the time. Then when they caught somebody they wanted to cocoon as a host for a facehugger, they just resined them into the structure. None of this is explained, but everyone seems to get it.

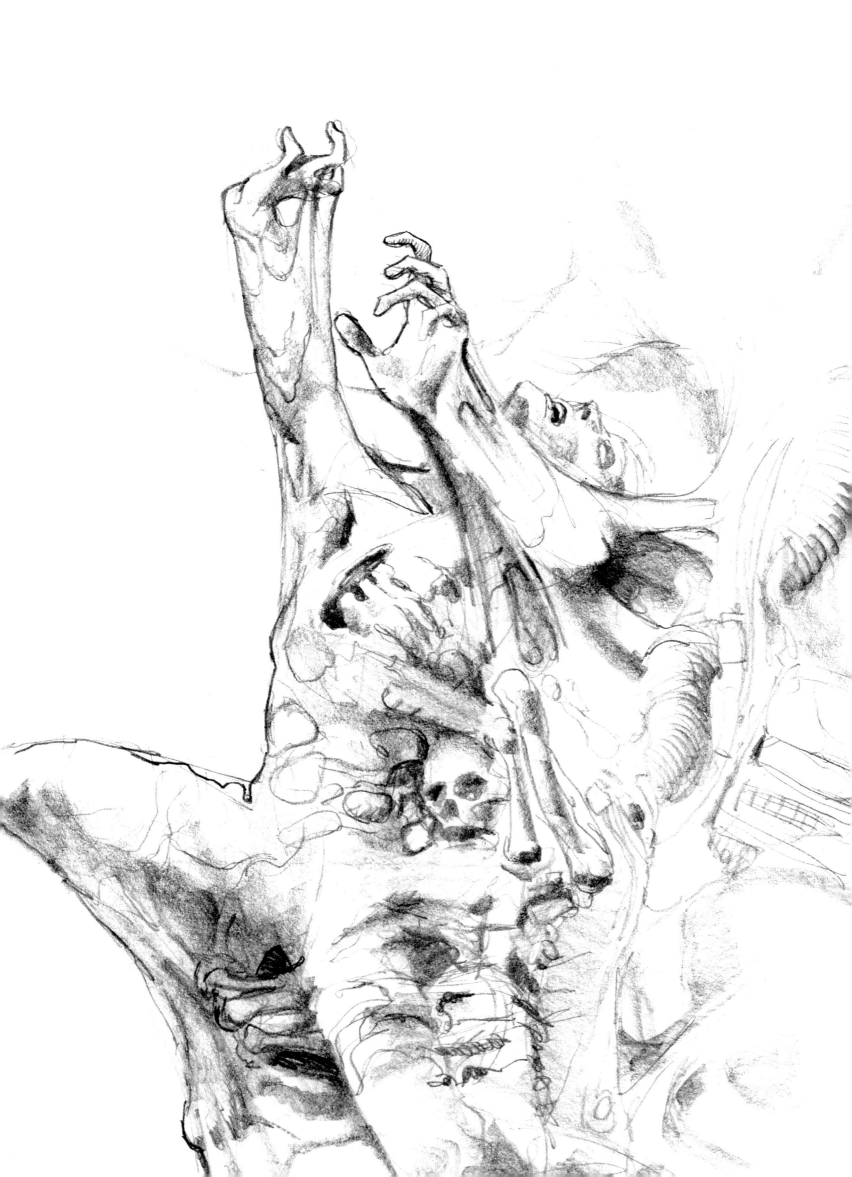

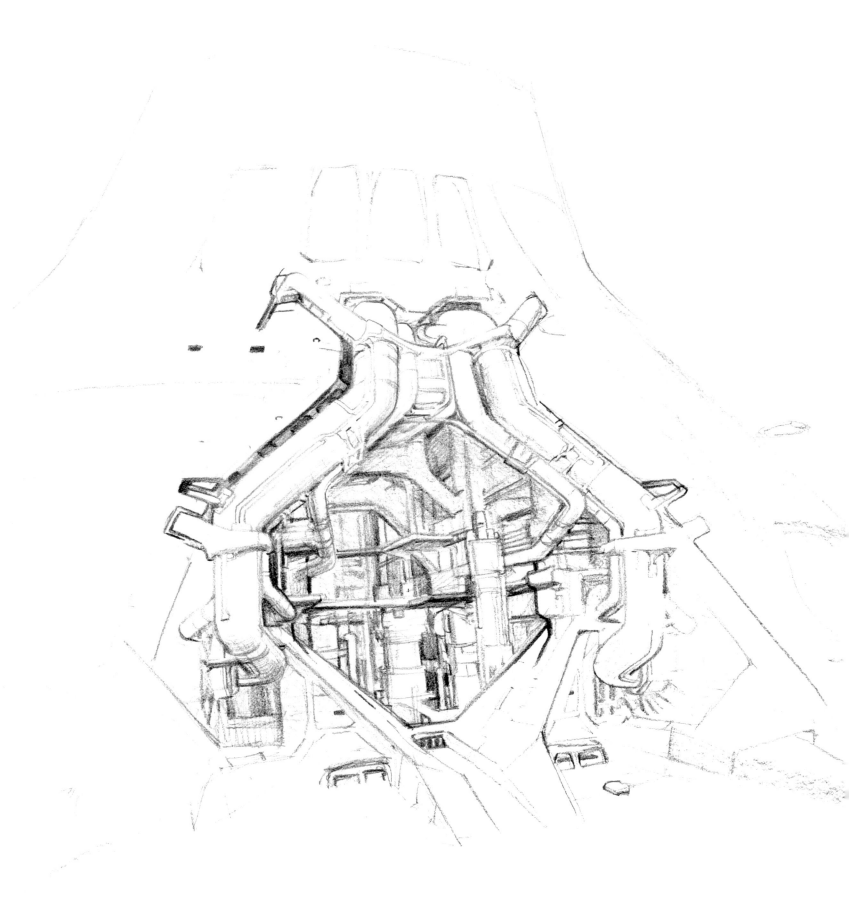

ATMOSPHERE PROCESSING STATION

This is my technical design for the exterior of the Atmosphere Processing Station. I would have given this to the Skotaks so that they could build the miniature model. Again, I'm trying to be very specific in this image so they would know exactly what to build. I wanted the entrance to be like these great gates of hell and very detailed inside. I also wanted it to be clear that there was only one way to enter it. Obviously, there's a Freudian aspect to the design because the gateway is based on female anatomy. That's a very Giger-esque idea, but this is more a kind of abstract, angular version of that concept. But again, I'm riffing on stuff that Ridley Scott and Giger initiated in *Alien*.

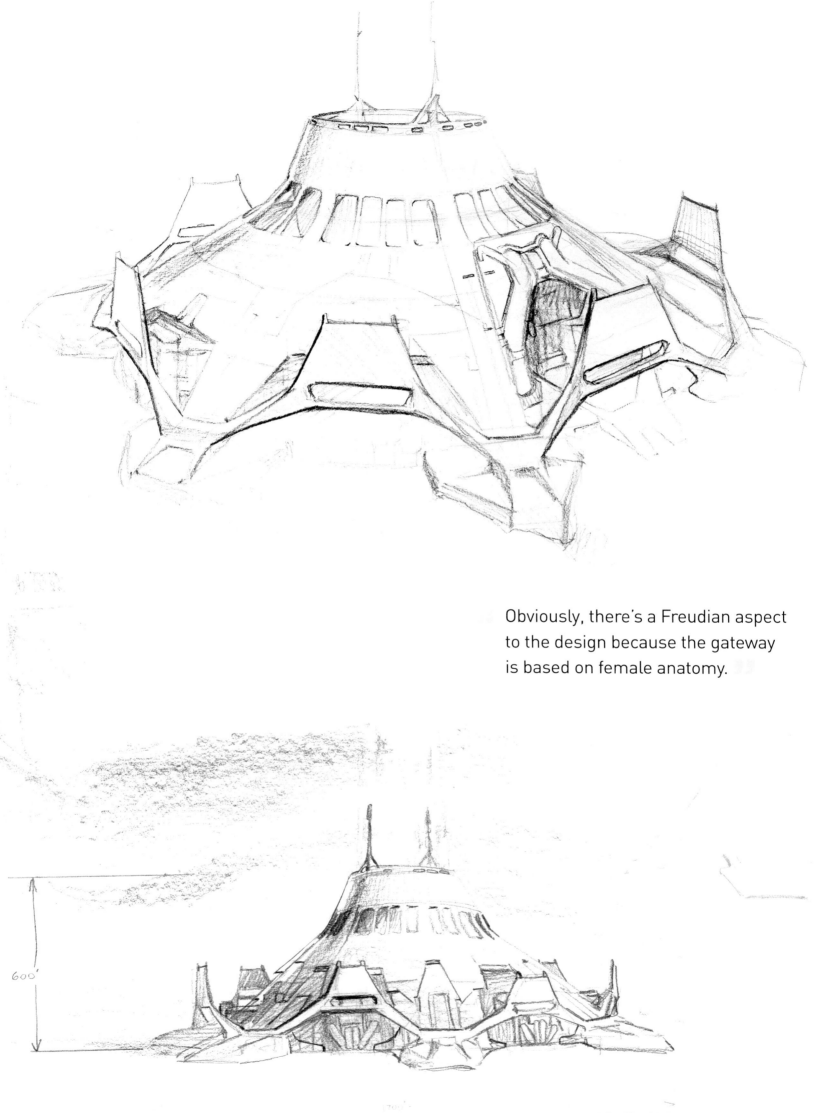

Obviously, there's a Freudian aspect
to the design because the gateway
is based on female anatomy.

600'

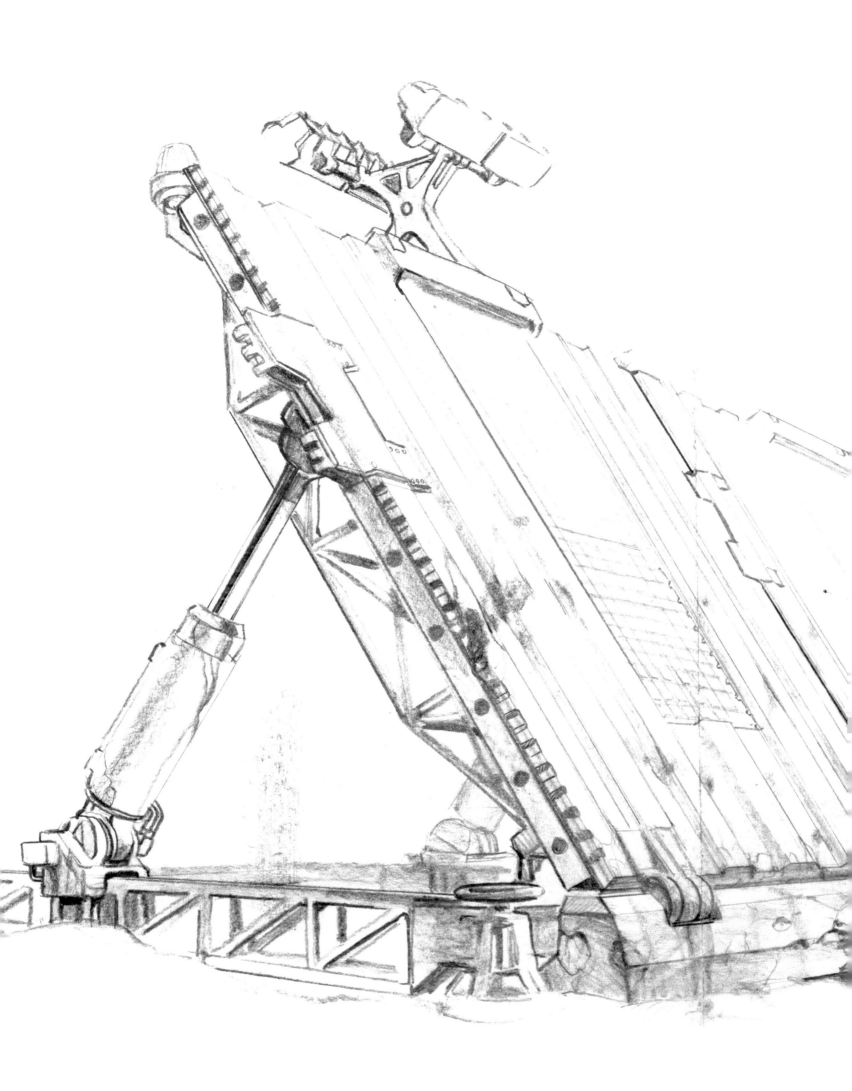

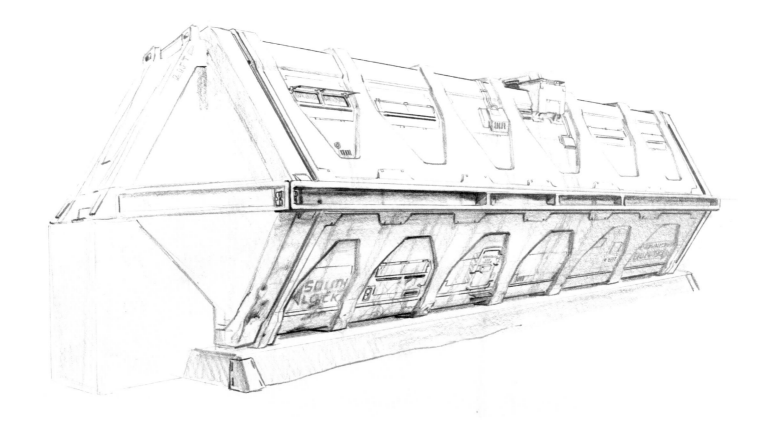

It's an extremely windy planet with hurricane force winds, so the colonists needed this big barrier to protect them.

The main tech and other elements that I designed for the colony on LV-426, Hadley's Hope, were more practical. The top right image is me just fooling around with the idea of a shipping container–type structure that was modular and could be bolted together with other containers. The image on the left-hand page is a blast wall—it's an extremely windy planet with hurricane force winds, so the colonists needed this big barrier to protect them. I'd give Ron Cobb some of these designs so he could develop them further. I figured if I gave him a sense of the level of detail I wanted for the colony, I could hand it off to him and he could lay out the entire colony, which he did. So it was a great collaboration.

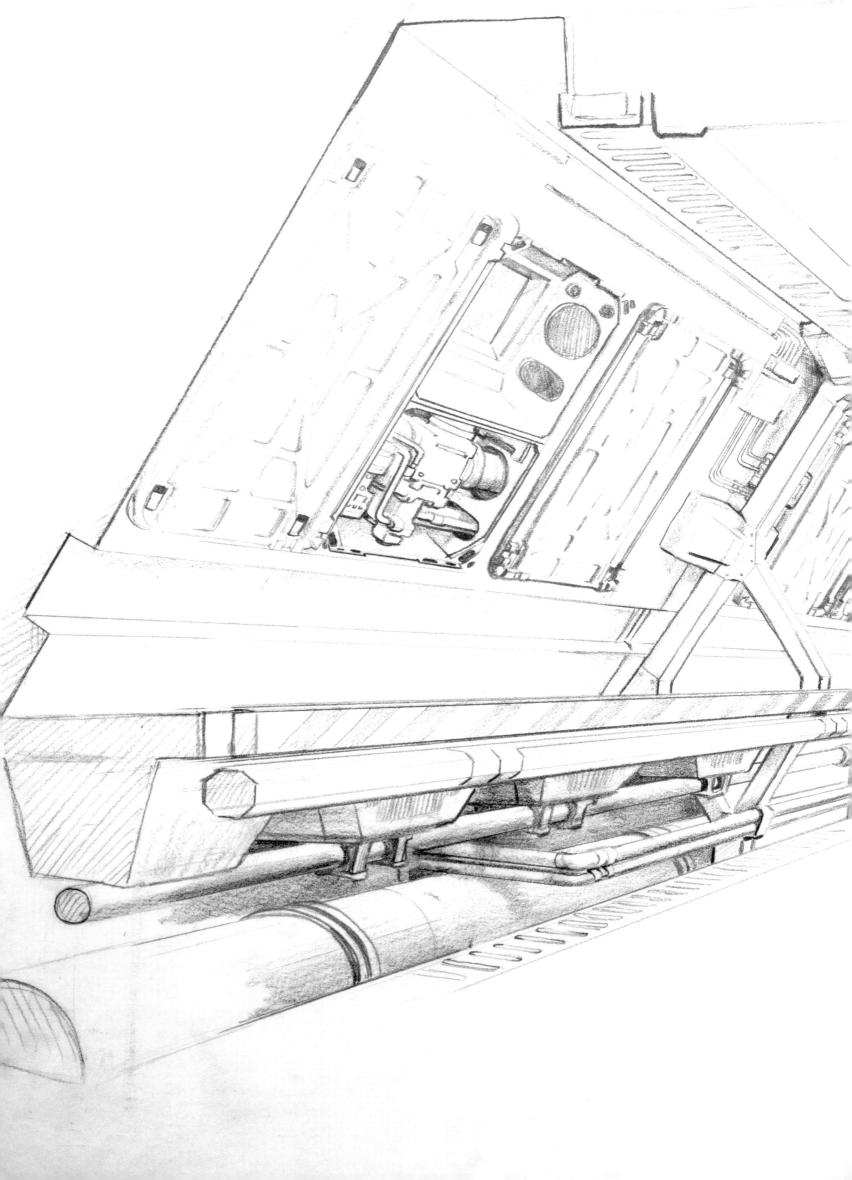

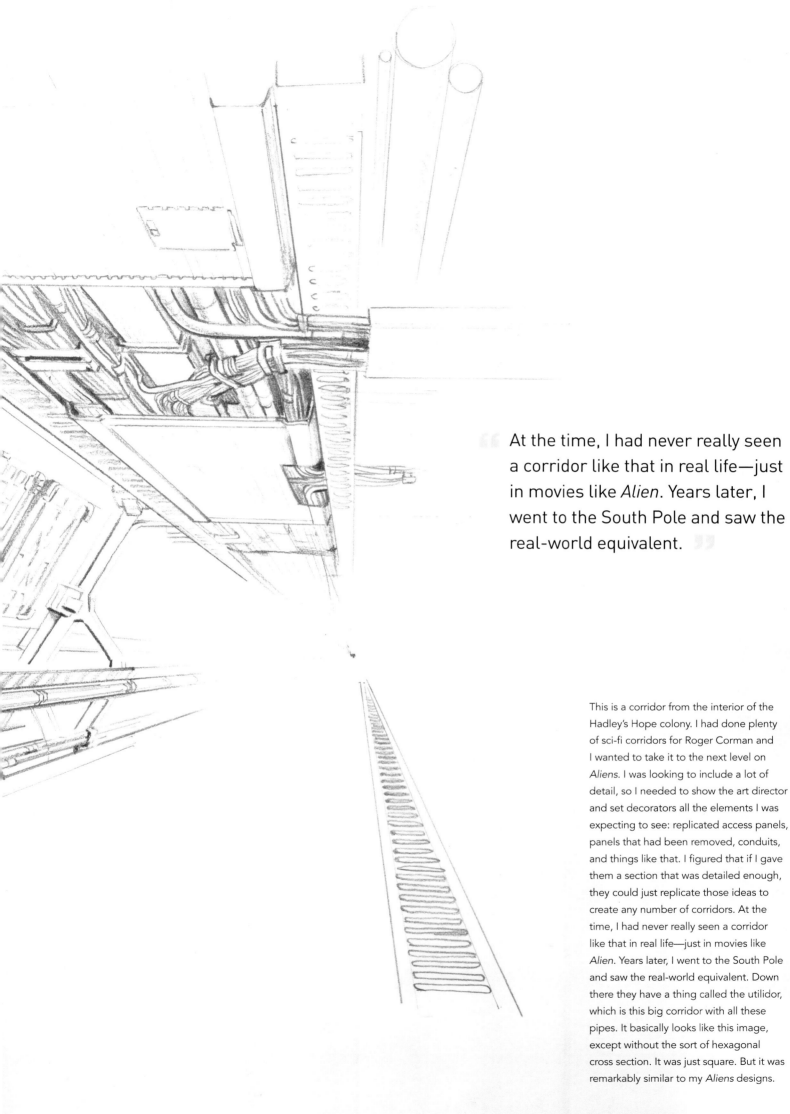

At the time, I had never really seen a corridor like that in real life—just in movies like *Alien*. Years later, I went to the South Pole and saw the real-world equivalent.

This is a corridor from the interior of the Hadley's Hope colony. I had done plenty of sci-fi corridors for Roger Corman and I wanted to take it to the next level on *Aliens*. I was looking to include a lot of detail, so I needed to show the art director and set decorators all the elements I was expecting to see: replicated access panels, panels that had been removed, conduits, and things like that. I figured that if I gave them a section that was detailed enough, they could just replicate those ideas to create any number of corridors. At the time, I had never really seen a corridor like that in real life—just in movies like *Alien*. Years later, I went to the South Pole and saw the real-world equivalent. Down there they have a thing called the utilidor, which is this big corridor with all these pipes. It basically looks like this image, except without the sort of hexagonal cross section. It was just square. But it was remarkably similar to my *Aliens* designs.

SUBAQUATIC WORLDS

These are design sketches I did for *Titanic* showing various rooms aboard the sunken ship. They were based on my actual observations during an expedition I undertook to the real-life wreck of the *Titanic* in 1995. We sent an ROV (remotely operated vehicle) inside and found a lot of extant woodwork. But our exploration was severely limited by the vehicle's tether, which was only eighty feet long. It allowed me to get into the D–deck reception space—far enough to see that there was oak wall paneling, wood coverings on the support columns, and so on—but it was very limiting.

So these illustrations are my attempts to extrapolate what I saw and apply it to other rooms on the ship that we weren't able to reach with the ROV. I knew what these rooms looked like before the ship sank, and so here I'm applying motifs I observed on the expedition to the original rooms, such as everything being overgrown with rusticles, some of the woodwork still being intact and other parts rotted away. And then these sketches were used to create the various sets that we were going need for the film. So these illustrations kind of represent our imaginary *Titanic* wreck, showing the places explorers had not been able to reach at the time.

I knew what these rooms looked like before the ship sank, and so here I'm applying motifs I observed on the expedition to the original rooms.

The illustration on pages 268–269 is a concept design for the sunken version of Rose's stateroom on the ship. It's a fictionalized version of a real room on *Titanic*. We took a floor plan of a different suite that was on C deck and applied the look of that room to a suite that was on B deck—I gave myself creative license to do that because nobody knew how that suite was actually decorated. My drawing basically explores what I thought might happen in that room after it's been at the bottom of the ocean for many decades—the wood is a little eaten away but fairly well survived and the gold inlay is still intact. At center left there's a sconce flipped upside down and it's hanging by its cables. But here's a really bizarre thing: On a later expedition to *Titanic* in 2005, we had built tetherless ROVs that we called bots. I managed to get one of the bots into the real room on C deck and guess what we found? The gold inlay was still there, just like in my drawing. Also, two sconces were ripped loose and flipped upside down and hanging by their cables, one on each side of the doorway. The only difference was that we discovered the sconces were made from gold-plated brass, and because brass corrodes green, there were green rusticles hanging from the sconces. But other than that, my image was really close. So whenever I look at this drawing now, I think, "How did we know?"

ONE-WAY TICKET

I drew these images for *The Abyss*. I didn't create much art at all for this movie as I had a team of world-class designers working under me, including Ron Cobb. These illustrations were akin to storyboards and had a very specific narrative purpose. In the last act of the movie, the protagonist, Bud, has to descend deep into the ocean to deactivate a nuclear weapon. During Bud's descent, I envisioned the frame to be mostly black, with Bud showing up as this tiny speck of illumination. So he's going down this rock face, and keeps going,

and eventually he becomes a little dot with the bubbles from his magnesium flare floating upward. I knew exactly what I wanted, so these images were designed to show the effects team what I wanted to see.

Then in the image on the right-hand page, Bud's tumbling down that rock wall—he's creating slides and you can see bits of debris going ahead of him. We really stuck closely to these drawings and the shots in the final movie are very close to these initial concepts.

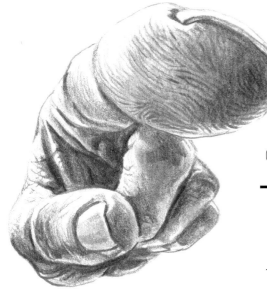

The Human Touch

The mere mention of James Cameron's films conjures mental images of alien planets, explosive action sequences, and unlikely heroes and heroines forced to battle for survival against impossible odds. But there is one central theme that binds his entire filmography together: the power of love, be it romantic or parental.

The crux of The Terminator *is a love affair that breaks through quantum barriers;* The Abyss *revolves around a tempestuous relationship between estranged couple Bud and Lindsey Brigman;* True Lies *is a blockbuster spy comedy, but under its high-concept veneer it's simply the story of a marriage that has lost its luster.* Titanic *and* Avatar *are both overt love stories, whereas* Aliens *and* Terminator 2 *both revolve around a mother figure's selfless quest to protect a child no matter the cost. Human connection may not be the first thing that comes to mind when we think of Cameron's output, but it's the beating heart at the center of all his stories.*

Cameron has always been a keen observer of human nature. Films like Aliens *and* The Terminator *might be sci-fi extravaganzas, but it's the relatable nature of the characters, often everyday working-class folks, that makes them so compelling. This talent for human observation is apparent in Cameron's early art, specifically in a series of expertly rendered life drawings. Perhaps unsurprisingly, his focus during his teenage years and early twenties was the female form, often transposing these feminine figures into sci-fi or fantasy scenarios. Female empowerment is, of course, a recurrent theme in Cameron's work.* The Terminator's *Sarah Connor, a young woman who must quickly learn to take responsibility for the fate of the entire human race, is the obvious example. But every one of Cameron's films features at least one strong female protagonist, not least of all Rose DeWitt Bukater (later Rose Dawson Calvert) from* Titanic. *Headstrong, daring, and curious, Rose is born at a time when these qualities are seen as abhorrent in a woman. Her liberation, ignited by her passionate relationship with carefree artist Jack Dawson, is* Titanic's *greatest special effect, delivered with an uncommon tenderness and sensitivity by a director best known at the time for action spectacles.*

The images in this chapter foreshadow this other side to Cameron, a keen observer of people with an eye for capturing their essence, their nuances, and their struggles.

As a young straight male whose teenage brain was suffering from toxic levels of testosterone, I loved drawing sexy women. But how much better if they were powerful as well as beautiful—warriors, or in this case a sorceress, conjuring a ball of energy to hurl at her opponent.

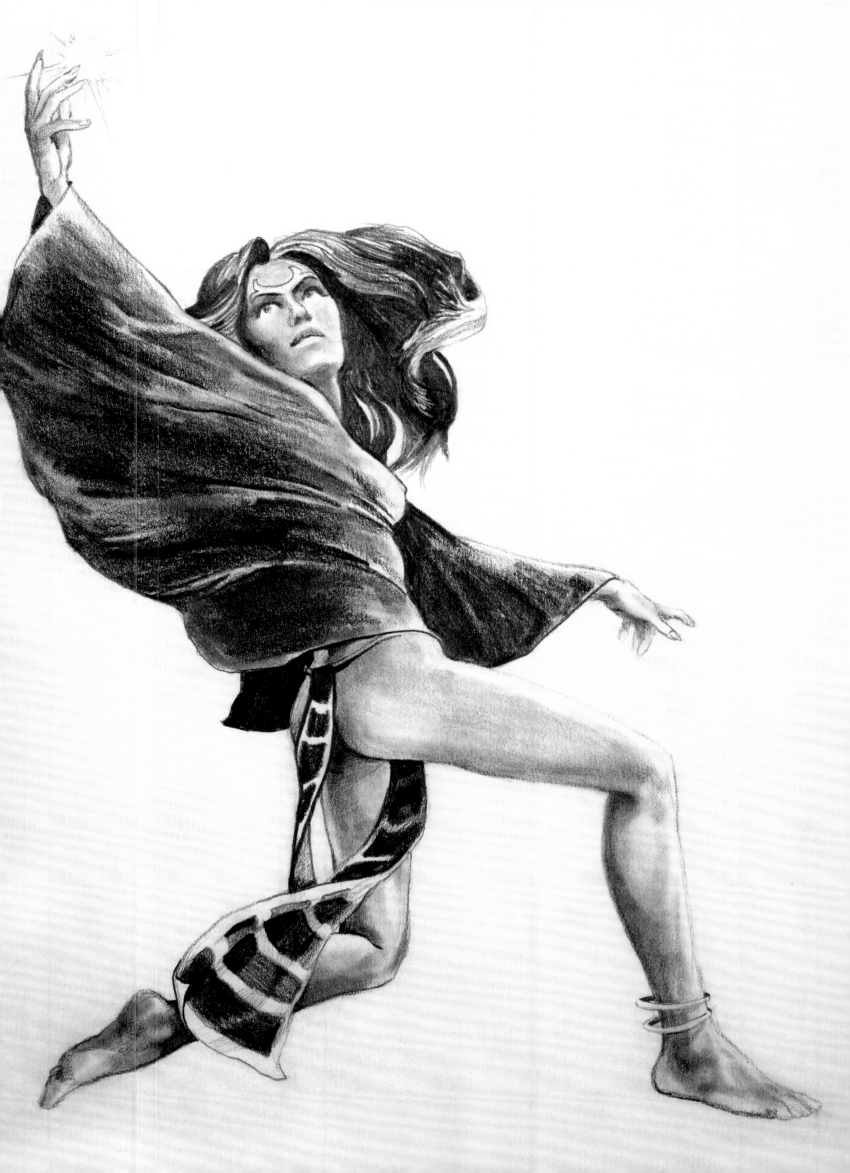

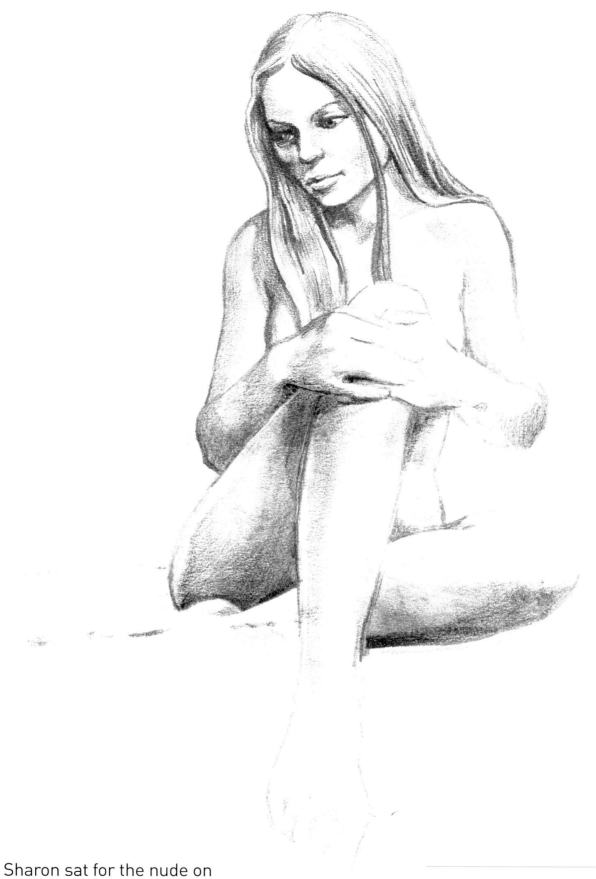

Sharon sat for the nude on the left but I changed the face to be someone else.

In the '70s I used to love the challenge of drawing from life. The girl on the right was a friend of my first wife, Sharon, and is drawn on the same damn Naugahyde couch I drew Sharon on in the image on page 47. I don't remember this person—I think she was one of the other waitresses where Sharon worked—but I do recall capturing her face well. Sharon sat for the nude on the left, but I changed the face to be someone else, I think because she didn't want any naked pictures of her around.

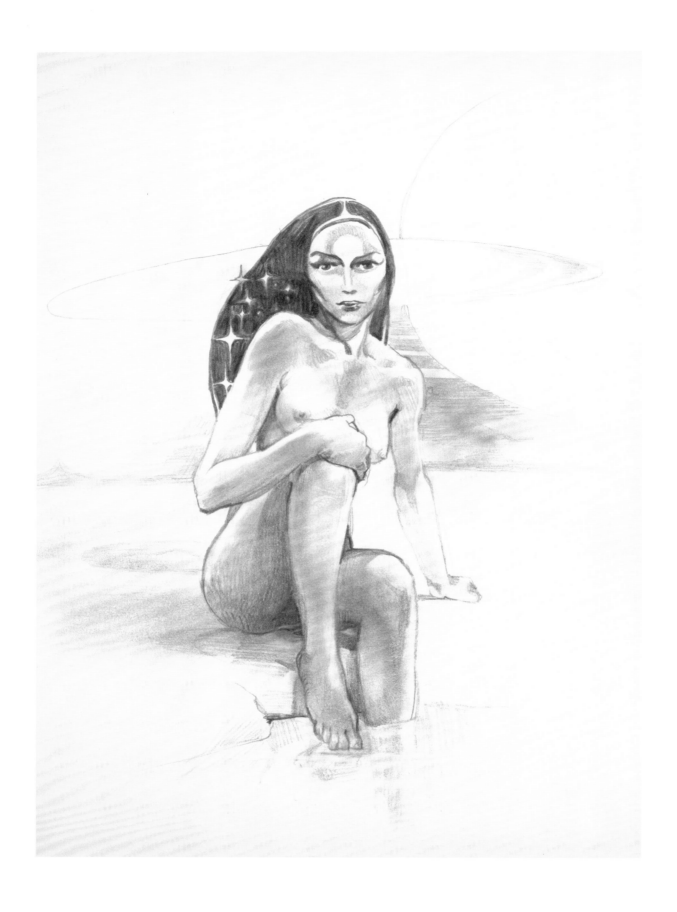

The image on the left-hand page is clearly some kind of science fiction character with flowers in her hair. All these illustrations predate *Heavy Metal* magazine, which first came out in 1977, but I would have fit right in with those guys. They were always like, "How can we combine high tech, horror, and sex?" And during this period that was pretty much my whole focus.

All these illustrations predate *Heavy Metal* magazine, which first came out in 1977, but I would have fit right in with those guys.

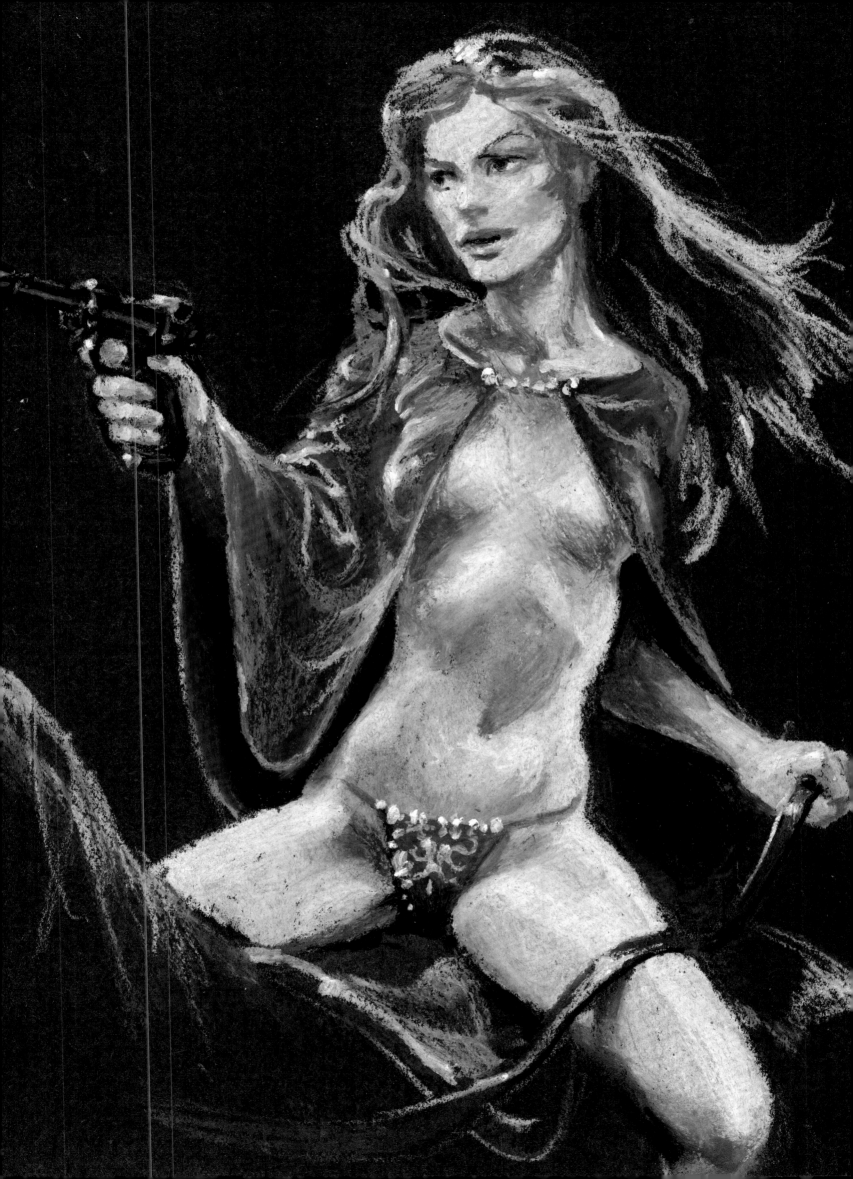

"I was very much influenced by the fantasy art of the time where the females are always artfully posed to be sensual and erotic, and the males are always engaged in some kind of highly aggressive behavior."

These are different figure studies from the early 1970s—just faces and characters, but to me they have a narrative element. On the right, I'm proposing a barbarian girl character of some kind, like Sheena, Queen of the Jungle from the Golden Age of Comics. Then on the left there's some kind of Egyptian queen, and another girl who was perhaps someone from my history class. I was very much influenced by the fantasy art of the time where the females are always artfully posed to be sensual and erotic, and the males are always engaged in some kind of highly aggressive behavior.

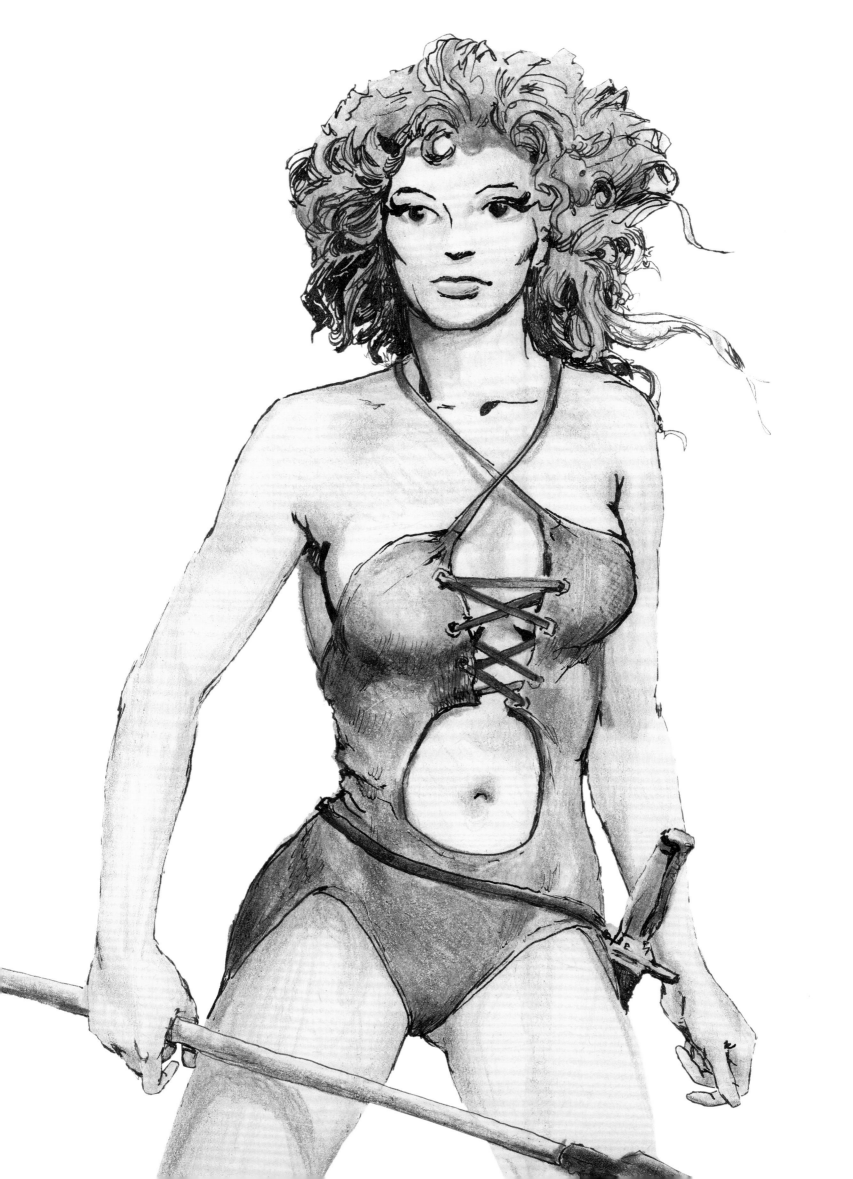

This was something I drew one day in tenth grade art class. I think I got another kid to sit still for me while I drew it, to get the structural details right. I never studied art formally in college, but I remember being an absolute sponge for art history in Mr. Ralph's class at Stamford high school, learning about the Greeks and the Renaissance painters, and the Surrealists and Impressionists. And I still remember it all. Mr. Ralph made art cool and exciting, and I was really into it. I think he was the only art teacher the school had, so I was in his class for, like, three years. Of course, I always got an A—I was such a teacher's pet. It's why the jocks in the class used to beat me up in the halls. Then I made a deal with the biggest guy in my class, Pasquale Salvatore, to do all his math and science homework if he beat up anybody that messed with me. Which he did, and I did. He got an A, and those jock assholes never bothered me again.

I was never athletic, but, after college, when I was driving a truck, I got into martial arts. Maybe because I was two years younger than my peers in high school, having jumped the second and fourth grades, so I was about a head shorter than the other guys and used to get thumped regularly. So in my twenties I studied kung fu and really liked the moves, especially the nasty ones. I used to imagine calling on those high school jock dipshits—just ringing their doorbell out of the blue and kicking their ass. Of course I think I wound up drawing fighters a lot more than actually training over the years. The move depicted in the image on the right-hand page is an actual takedown, an eye strike, and the kick the figure at the bottom is doing is a real kung fu kick. So these are literally based on what I was observing in kung fu class.

The move depicted on the right-hand page image is an actual takedown, an eye strike, and the kick the figure at the bottom is doing is a real kung fu kick.

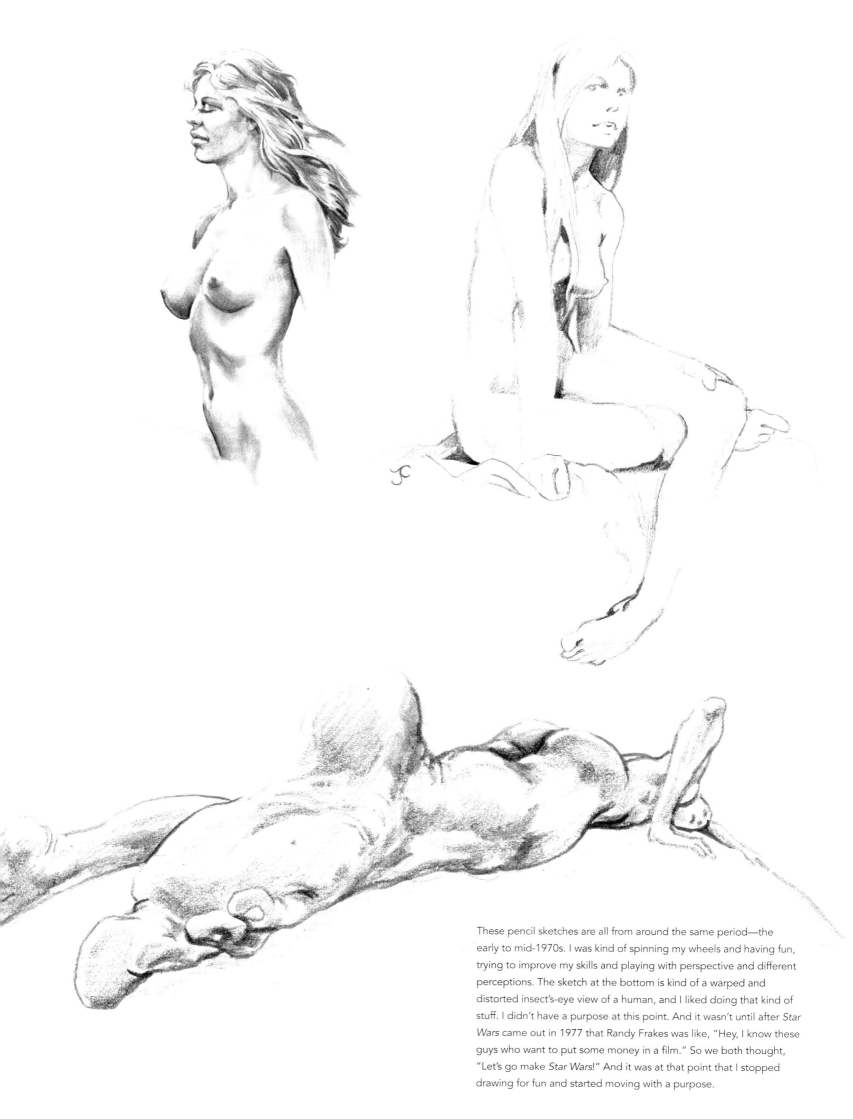

These pencil sketches are all from around the same period—the early to mid-1970s. I was kind of spinning my wheels and having fun, trying to improve my skills and playing with perspective and different perceptions. The sketch at the bottom is kind of a warped and distorted insect's-eye view of a human, and I liked doing that kind of stuff. I didn't have a purpose at this point. And it wasn't until after *Star Wars* came out in 1977 that Randy Frakes was like, "Hey, I know these guys who want to put some money in a film." So we both thought, "Let's go make *Star Wars*!" And it was at that point that I stopped drawing for fun and started moving with a purpose.

Life figure drawing is a great thing, and everybody who wants to be an artist should do it.

These are drawn from life. I joined a life sculpture class where a girl sits there for an hour and you're supposed to try to sculpt her in clay. But I was like "Ah, I don't sculpt. Can I draw her instead?" They said, "Yeah, you can draw but you've gotta sculpt eventually." So I drew for the first session, and after that I learned how to sculpt in clay. But life figure drawing is a great thing, and everybody who wants to be an artist should do it.

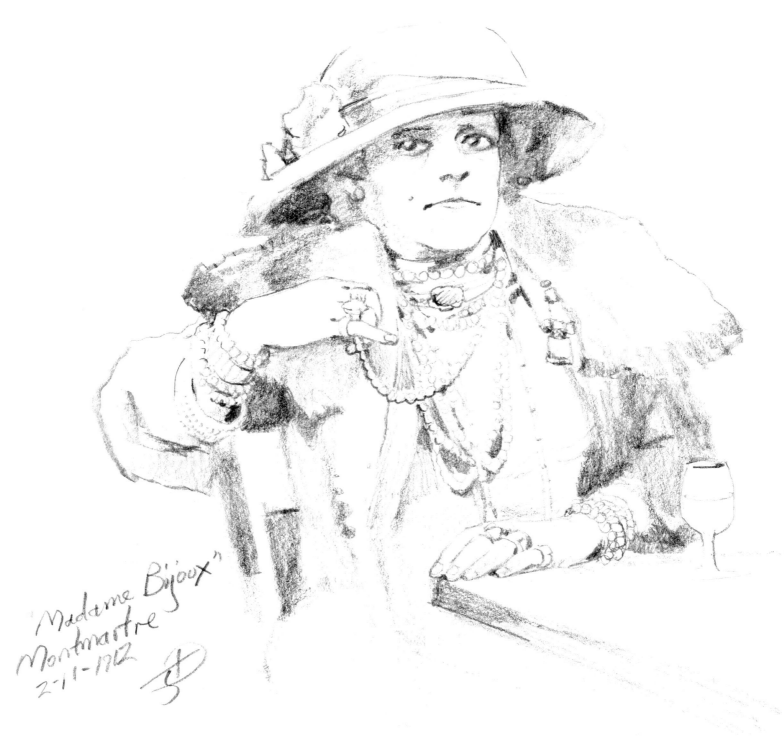

"Madame Bijoux"
Montmartre
2-11-1912

DRAW ME LIKE ONE OF YOUR FRENCH GIRLS

These are illustrations I drew for Jack's sketch portfolio in *Titanic*. All these sketches were done over a two-day period. Some were based on some degree of photographic reference, but in some cases I just winged it. We were already shooting and I was super under the gun, but I needed the damn portfolio. I already had the main drawing of Rose that Jack sketches in the film, but I didn't have all the other illustrations I needed for the scene where he shows his portfolio to Rose.

We were already shooting with the actors playing the little girl, Cora, and her father, so I got some stills of them and based the sketch at the top right of page 289 on those reference pictures. The two hands at the bottom left of the right-hand page were also based on still reference. But the image of the nursing woman in Edwardian garb is completely made up. I wanted Jack to draw stuff that wasn't obvious. I wanted him to be insightful and document things that were unusual or not seen as socially acceptable. Jack is fascinated by life. He's been to Paris, where he's seen a different way of living, and that's what he wanted to draw. So the point of the sketches was to make him seem interesting just from his drawings. And the idea of an Edwardian woman nursing her baby in public would have been a big deal back then and something pretty radical.

Above is Madame Bijoux, the Parisian lady that Jack tells Rose about—an elderly woman who would dress up in every piece of jewelry she owned each night and wait in a bar for her lost love to return. The sketch was actually inspired by some fairly famous photographs by the Hungarian-French photographer Brassaï from the early 1930s. They were taken in Montmartre, Paris, and show a woman wearing this long jewelry. I didn't copy those images exactly, I just did my own version, but they were certainly an influence.

When I was creating Jack's sketches, I wanted to get across the idea that he had been hanging out with dancers and prostitutes who would pose for him. He doesn't have any money. He's not an established artist with an atelier. He's hanging out in this kind of twilight world. I thought these experiences would make him an interesting, romantic character and both challenging and exciting for Rose, who comes from a very prim background.

The image at the top right of page 291 is based on a famous photograph of the actress Nastassja Kinski. I changed her face slightly, gave her some armpit hair, and also added the sprawled-out hair because she had quite short hair in the photo. But the pose of her hands, and the way she sort of dropped her left hand on her chest is from the photo. I wanted Jack to be fascinated by this character's hands more than her breasts. Jack is fascinated by people, so even though it's kind of an erotic image, it's not meant to be erotic. It's meant to be a portrait that looks into the person's soul to some extent. The other two images on these pages are completely made up, so I'd alternate between using reference and making them up from whole cloth.

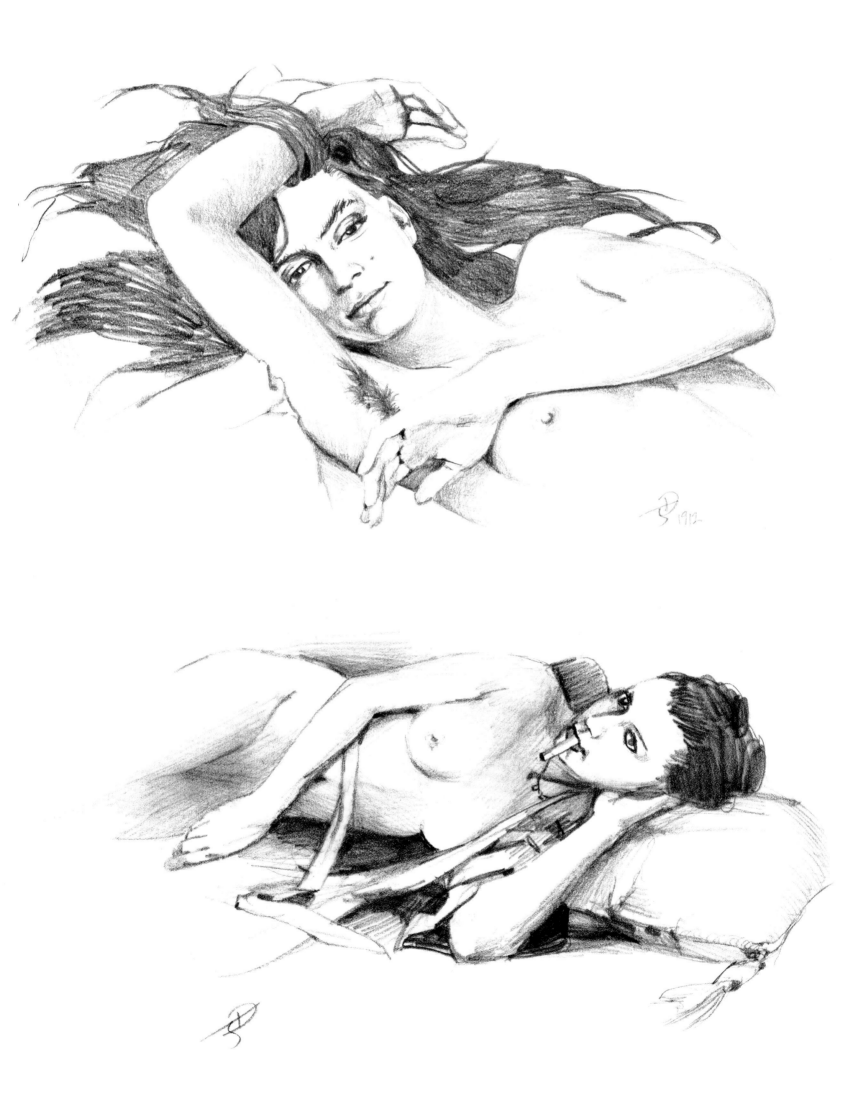

I didn't have time to find a hand model and take a bunch of pictures, so it was much quicker to adapt reference images.

The below image is based on a photograph of Georgia O'Keeffe's hands, which were really gorgeous. I redid the background and reposed the hands with this kind of gestural shape and these folds of fabric. I didn't have time to find a hand model and take a bunch of pictures, so it was much quicker to adapt reference images.

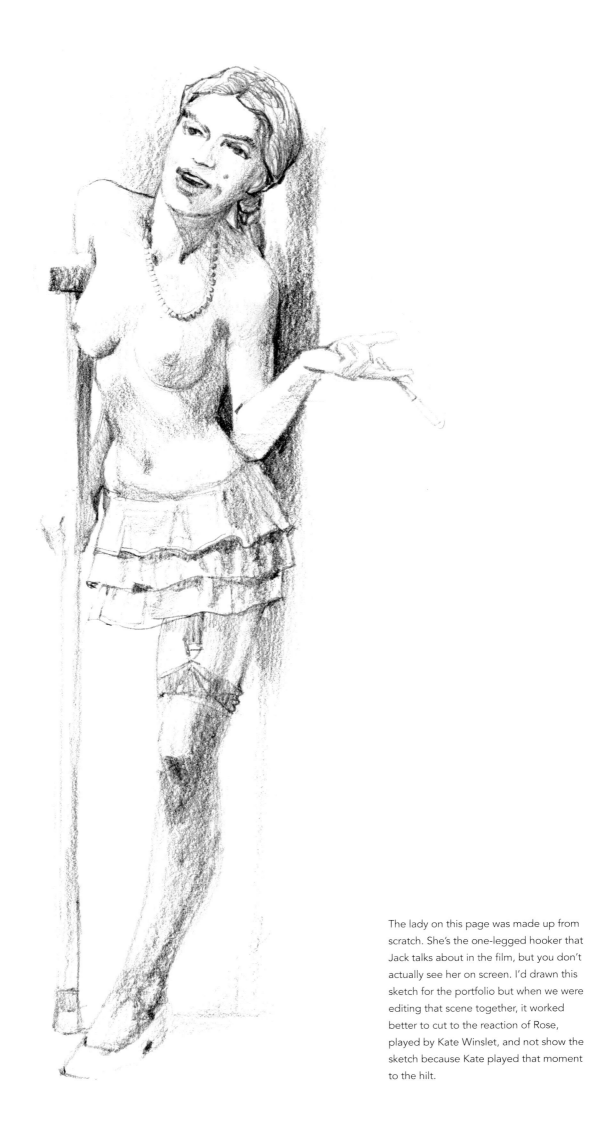

The lady on this page was made up from scratch. She's the one-legged hooker that Jack talks about in the film, but you don't actually see her on screen. I'd drawn this sketch for the portfolio but when we were editing that scene together, it worked better to cut to the reaction of Rose, played by Kate Winslet, and not show the sketch because Kate played that moment to the hilt.

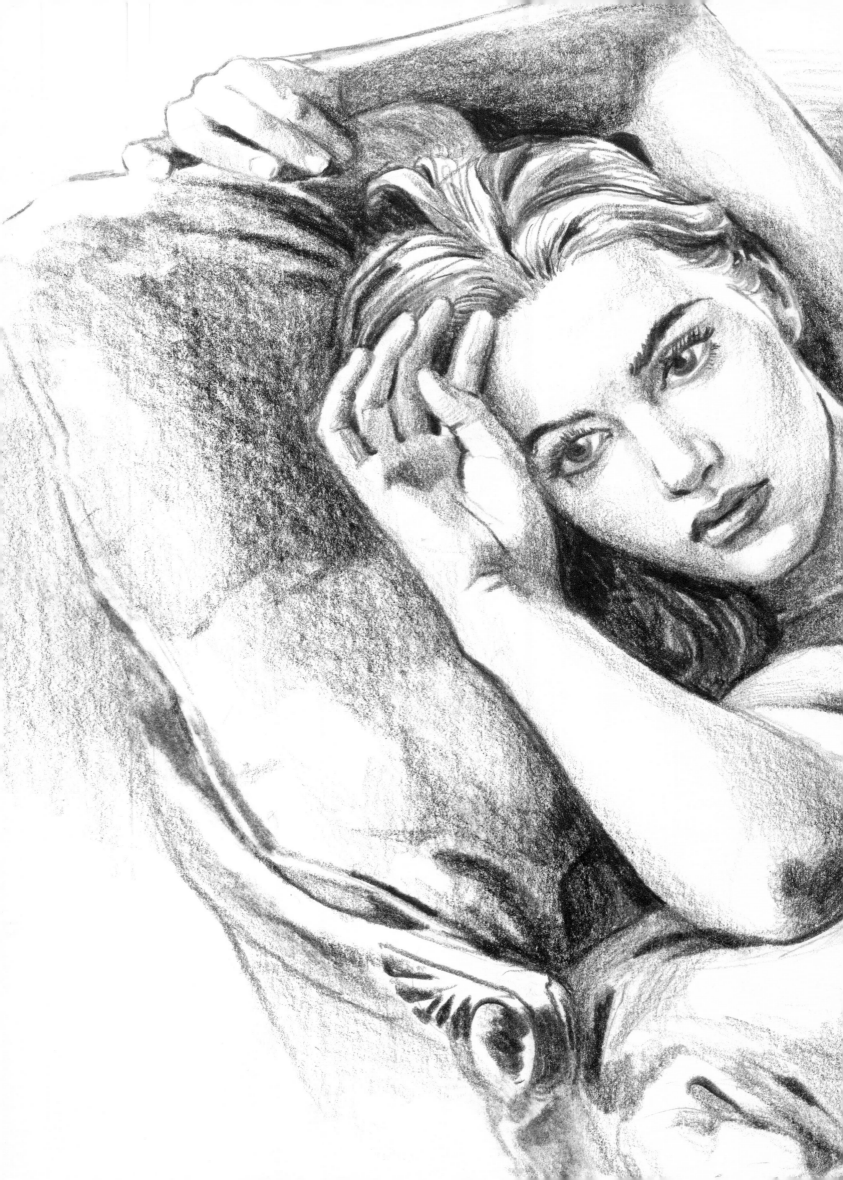

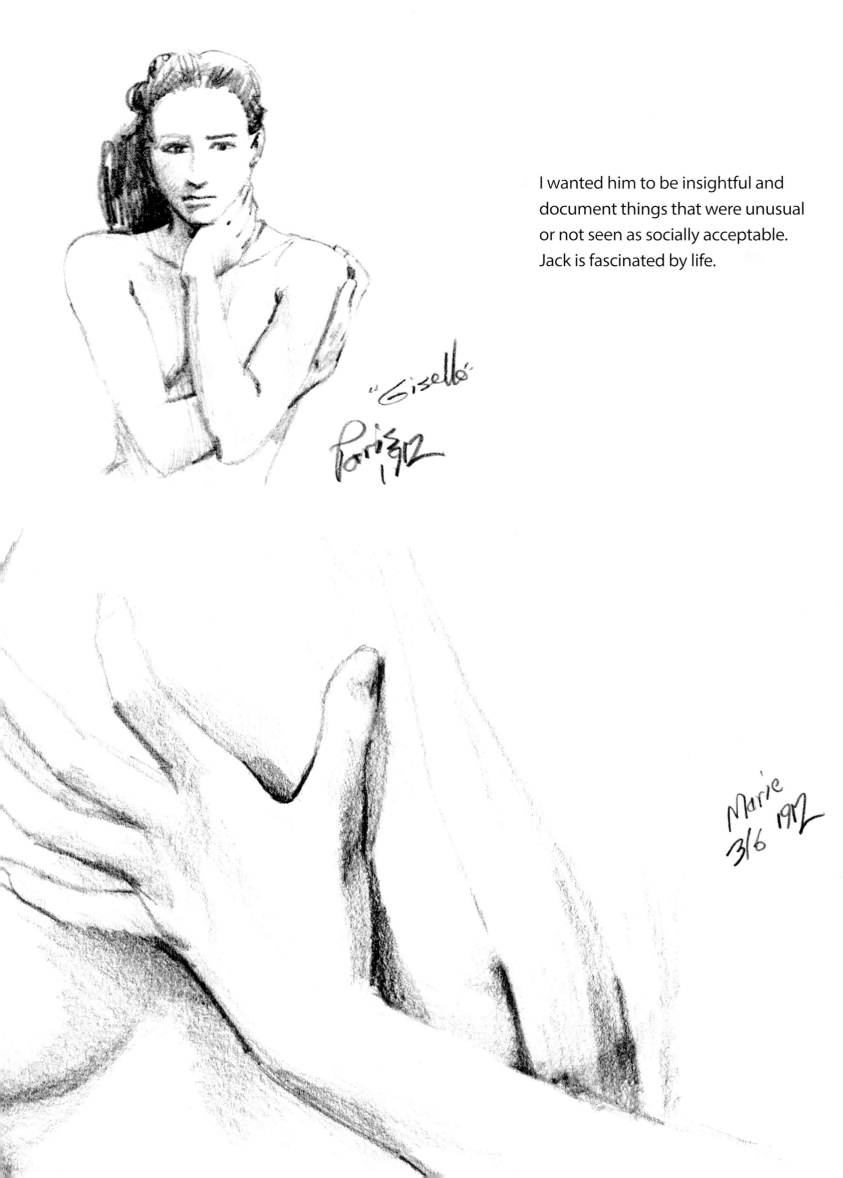

"Giselle"
Paris 1912

I wanted him to be insightful and document things that were unusual or not seen as socially acceptable. Jack is fascinated by life.

Marie
3/6 1912

I'm pretty happy with it,
but I feel like I never quite
nailed Kate's face. I got
close enough, though,
that you get it.

This image is the final Rose drawing that emerged from the earlier sketches. I'm pretty happy with it, but I feel like I never quite nailed Kate's face. I got close enough, though, that you get it.

There's a funny story about this sketch. You can tell whether an artist is left-handed or right-handed by the way they shade. I'm left-handed, and so there's a certain arc to the way I shade based on the rotation of my wrist. And if you look closely at the shading of this image you can see it arcs toward the left. But Leonardo DiCaprio was not an artist at all, plus he's right-handed. So we shot this whole scene and Leo was clearly drawing with his right hand. Next, we needed close-ups of the drawing actually being done. I had to be Jack's stand-in for those scenes, and it's my hand you see in the movie. But I had to use my left hand for the scene because I can't draw for shit with my right hand. So I had to do a mirror image of the drawing which we would then flop in the edit. I placed a flopped copy of the Rose drawing facedown on a light table, put a piece of paper on top of it, and traced over it using my left hand. We put the light out of phase with the camera, so that it shone when the shutter was closed and it went off when the shutter opened—that way, the audience wouldn't be able to see the flipped-over art I was tracing. It had to match perfectly, but the problem was that I couldn't shade those arcs with my left hand—which is why, in the film, you only see me doing the line work and the smudge work. None of the finished work is my hand because I couldn't do it. But I think we got the idea across.

When it came time to create the Rose sketch that drives the whole *Titanic* storyline, the art department took a stab at it, but it just felt generic. I figured it was time to put all that time I spent doing life drawing to work. I was too shy to ask Kate to sit naked for it—it was very early in preproduction and we barely knew each other—so we did a photo shoot, and she wore bra and panties. I joked with her that I was going to have to just make up her nipples, and if they weren't right, too bad. She said, "They're just normal fucking nipples," which is typical Kate. We played with a lot of poses, placing her hands near her face, so they would be strongly featured in the drawing. The photo below is the one I finally worked from, but you can see some of the other poses in the other sketches.

In the sketches, you also can see that I was struggling to capture the Kate-ness of it all. But when I hit on the version at the bottom of page 294, I realized that, like the Nastassja Kinski sketch, it was all about the hands—because the hands suggest something about Rose as a person, as opposed to objectifying her. She asked Jack to draw her naked because that was liberating for her. It was challenging—it's her way of ending her relationship with her fiancé, Cal, because she decides to put the sketch in his safe, where he'll find it. So it all made sense from a narrative perspective, but I wanted to make sure that it wasn't about her breasts—it was about Rose as a person. So, I was very, very particular about the hands, as Jack would have been as an artist.

No Fate

A true child of the '60s, the young James Cameron was all too aware that civilization was on the brink of disappearing in a nuclear flash. Growing up in the shadow of mankind's most terrible scientific achievement clearly had a resounding impact on the young artist, as his early work clearly demonstrates. Mushroom clouds, devastated cityscapes, skulls littering the ground—all these motifs would later become recurrent themes in Cameron's filmmaking.

Cameron's Terminator *films are a race to avert nuclear Armageddon, while* The Abyss *revolves around the disarming of a warhead—the extended special edition even introduces a plotline in which the underwater aliens plan to wipe out humanity to prevent us from destroying the world with nuclear weapons.* Aliens, True Lies, *and* Avatar *also prominently feature nuclear weapons, although* Aliens *is the only film in which a nuclear blast benefits humanity, apparently wiping out the xenomorph menace. In fact, for obvious reasons,* Titanic *is the only one of his films that doesn't feature nuclear weaponry, although it certainly explores mankind's propensity for self-destruction.*

The nightmarish imagery seen in some of Cameron's early pieces found its ultimate expression in a sequence from Terminator 2: Judgment Day. *Plagued by the knowledge that a future war with the machines still threatens to wipe out humanity, Sarah Connor dreams of a nuclear detonation that levels Los Angeles, disintegrating vehicles and burning the flesh clean off her bones. The sequence realizes the greatest fears of those born in Cameron's generation in agonizing detail and may well be the most horrific sequence he's ever filmed.*

But like Sarah Connor, Cameron is on a mission to change the future. Through his early art and, later, his films, he has repeatedly raised the red flag not only on the threat of nuclear obliteration but also on more insidious dangers, such as the slow but steady damage that humanity continues to wreak on the environment. A passionate environmental activist determined to effect change, Cameron wants to alter his fate, not accept it.

The art in this chapter can certainly be interpreted as pessimistic, and it's true that Cameron's worldview has not changed dramatically over the years. As he says himself, "I've sort of gone full circle. I went through a period of about ten or fifteen years where I actually believed that political systems could maybe yield some positive results. In any event, you had to play that game in order to get things to happen. But now I'm right back where I was when I was seventeen, where I think they're all a bunch of fucking assholes and it's a complete waste of time to engage with them—other than taking it to the streets and being ready to throw some tear gas back their way." Just like his characters, he may be facing incredible odds in the battle to save the world, but James Cameron is far from defeated.

The painting on page 297 has a funny story behind it. I enrolled in a painting class when I was at Fullerton Junior College in '72 because I figured it would be an easy credit. One day they gave us various objects to paint, including a stuffed bird and a skull. The bird wasn't sitting on the skull, but I combined the two and added in the cracked earth, fallen columns, and so on to create the image. They didn't give us much time, maybe a couple of hours, so we had to work quick. Then, in the last thirty minutes or so, the guy leading the class would critique everybody's paintings. So I finished this painting, and it was all wet—and if you've ever seen a wet oil painting you know that it's easy to smear it and screw it all up if you're not careful.

There were maybe ten or twelve students, and we all put our art up on easels at the front of the class. This guy walks up with a piece of chalk, and he starts drawing on the first painting and giving notes. And even from where I'm sitting, I can see the other student's painting is getting damaged, the oils are being dragged around and fucked up. I'm like, "What the fuck?" I mean, my jaw dropped. And then he went to the next one and I'm thinking, "Is he gonna draw on all of them?" My painting was at the end of the row, and it was like watching everybody in your village get shot one by one, knowing eventually they're gonna get to you. So he gets to the second-to-last painting and starts to draw on it. Then he turns to look at mine, his chalk starts coming down, and I'm like, "Stop right there!" And I got up, walked over, picked up my painting, and said, "You're not drawing on this. You got nothing to teach me. You don't know anything about art." And I took my painting, walked out, and quit the class. And that's why there are no chalk lines on this painting!

The image on the right-hand page was drawn for my unfinished novel *Necropolis*. You can see the city in the picture is in a state of collapse, and there's a pack of wild dogs and some kind of corpse in the foreground. The idea is it's the last city on Earth, and every other place has been completely destroyed. It survived because it had a nuclear defense system. Several other cities had defense systems too, but this was the only place where the technology actually worked. Because of this there's now only one city left on Earth, and then these characters come back on a starship a couple hundred years later, and they're like, "Well, I guess we've got *one* city . . ."

It's not meant to be a story moment, but to be symbolic of humans falling back to a primitive state.

This is another image with a post-apocalyptic theme, drawn when I was around seventeen or eighteen. It's not meant to be a story moment, but to be symbolic of humans falling back to a primitive state. So there's a caveman looming under the distant memory of a nuclear war—pretty simple symbology.

> *The Lucifer Ultimatum* was a thriller that revolved around a group of terrorists who develop a miniaturized fission bomb that can be carried in a suitcase.

THE LUCIFER ULTIMATUM

The Lucifer Ultimatum is a project I developed with Randy Frakes in the mid-'70s in parallel with *Xenogenesis*. Our original title for it was *Ground Zero*. We weren't having any luck selling *Xenogenesis*, so we began to think that we were starting off a bit too ambitious and needed to do something a little smaller. We had to establish a track record before we could get a big sci-fi film off the ground, so we thought, well, we've got to do something low-budget. *The Lucifer Ultimatum* was a thriller that revolved around a group of terrorists who develop a miniaturized fission bomb that can be carried in a suitcase. And if you're making a film about

a guy with a bomb in a briefcase, you can go pretty low-budget. The idea of terrorists being able to deploy a threat like this hadn't really caught on in the zeitgeist, but I was aware of it and thought it could become a major problem.

The images on these pages were meant to be one-sheet posters for our movie. When I started to think of myself as a potential filmmaker, I always came at it from the standpoint of "How do you sell it?" And to this day, I think that's a healthy way to approach a new project. My first questions are always: "What's the poster? What are we selling?"

... IT COULD HAPPEN ANYWHERE

This is actually from tenth grade art class. It was a linoleum block cut, which is a bit like the concept of a woodcut, where you carve an image into a hard material and then use it to print a picture. The idea was that you would do a progression where you would make a few cuts in the lino block and then print it with ink. Then you'd make a few more cuts and print it again. The idea behind my piece is that it shows the progression of the human race. The image in the first panel shows intelligence, the second human awareness, and the third mankind starting to think and build. In the fourth, fifth, and sixth we start to build cities. Then in the seventh, the cities go out of control, and it all blows up and turns into a pile of ash in the eighth panel. So it goes from the birth of human consciousness to the end of the world in eight easy panels!

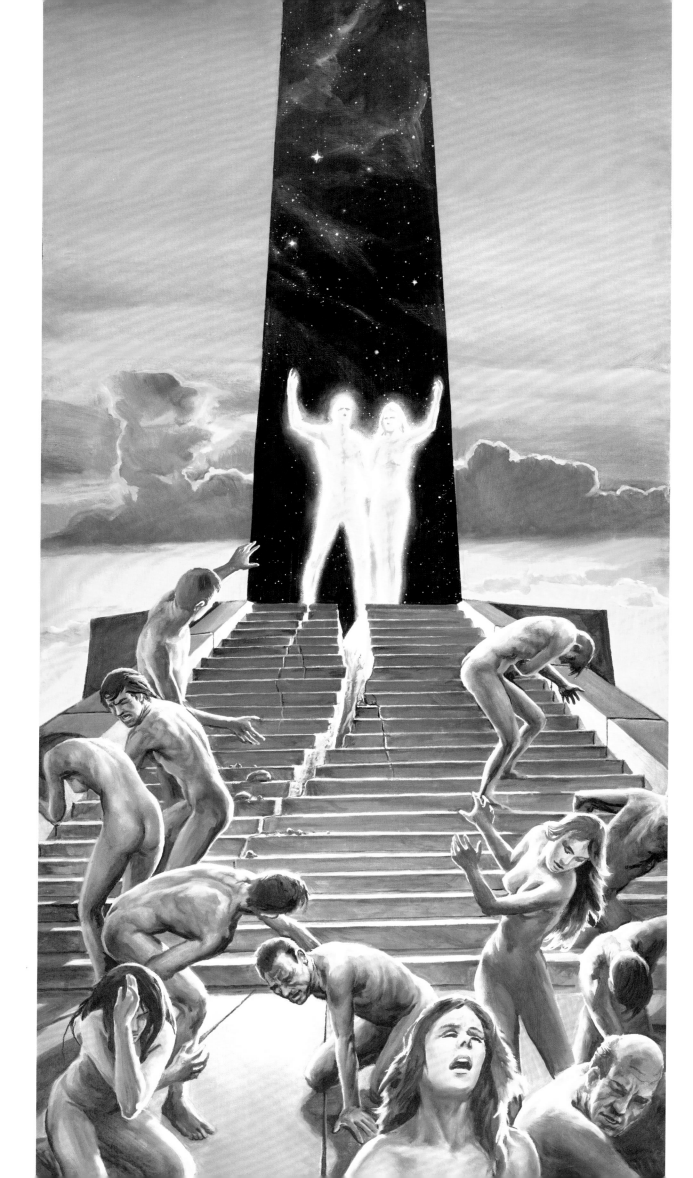

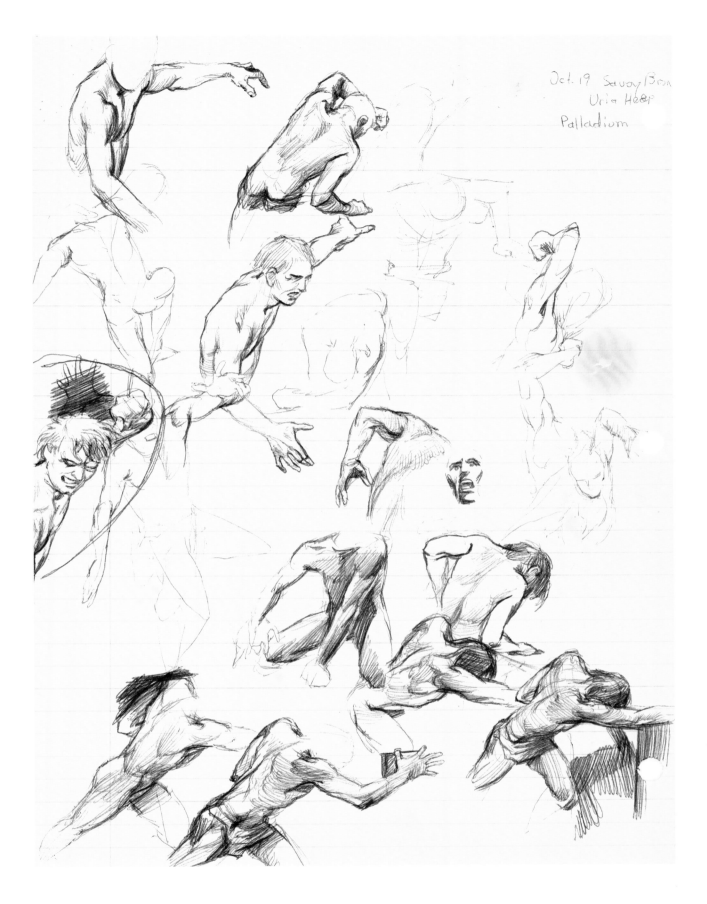

In the painting on the left-hand page, the couple in the center has returned through a dimensional portal from a different time or space and delivered a revelation that is too horrific for unevolved humans to take. Because I was studying art at the time, I consciously gave this a classic renaissance composition where everything points to the center of interest at the top of the triangular shape. It's very Rubenesque. I was just trying to have fun with human figures while also giving the piece some kind of broad symbolic significance. This was done when I was in college, back around 1973, and at the time I felt like, "Oh shit, my art should mean something *deeper*. I'm going for *meaning*, guys!"

When I look at the painting now, I feel it fails, even though the figures are well done—the studies for the people can be seen on the right-hand page. It doesn't seem luminous. It doesn't seem to be light-emitting. At the time, I didn't know how to suggest light at that strength. White paint is white paint, and you can't go any brighter than white paint. I later learned that what you can do is create the idea of halation—shafts of light and so on—with an airbrush. But I hadn't discovered the airbrush when I painted this.

APOCALYPTIC PASTS

I drew this one in 1970 when I was in the first half of twelfth grade. This was around the time of the Vietnam War, when people were out in the streets protesting the conflict. I'm very anti-war, but in Canada we didn't relate to Vietnam. We related more to World War I and World War II. We had Remembrance Day on November 11, the last day of World War I, and a lot of the imagery we saw around that date was related to WWI because the Commonwealth countries that fought in that war—including Canada, New Zealand, and Australia—really got their asses kicked. I was always struck by the horror of trench warfare and that really fed into this drawing. It's a nonspecific battle. The guy's lost his friend and they're still under fire. It's just an evocative image. And you can see at this point I'm starting to improve—getting a bit better at clothing, the musculature, and the hands.

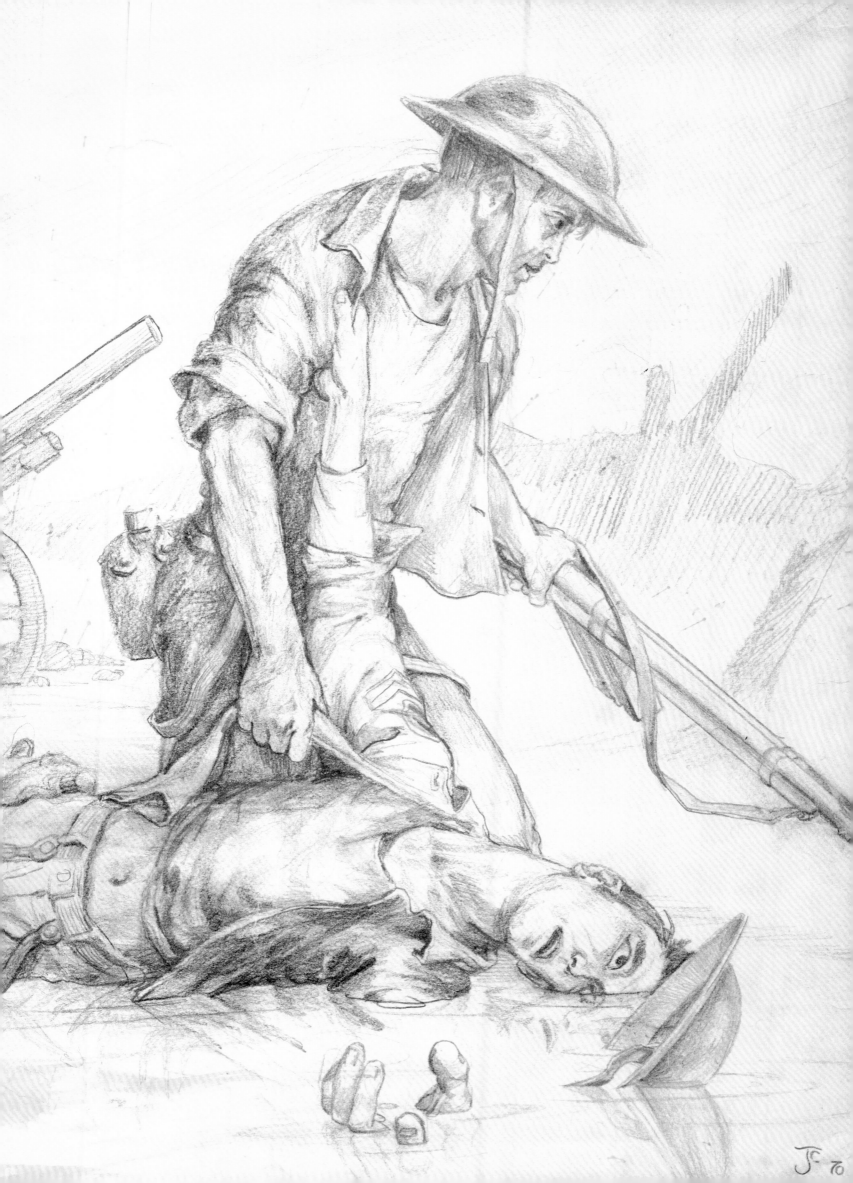

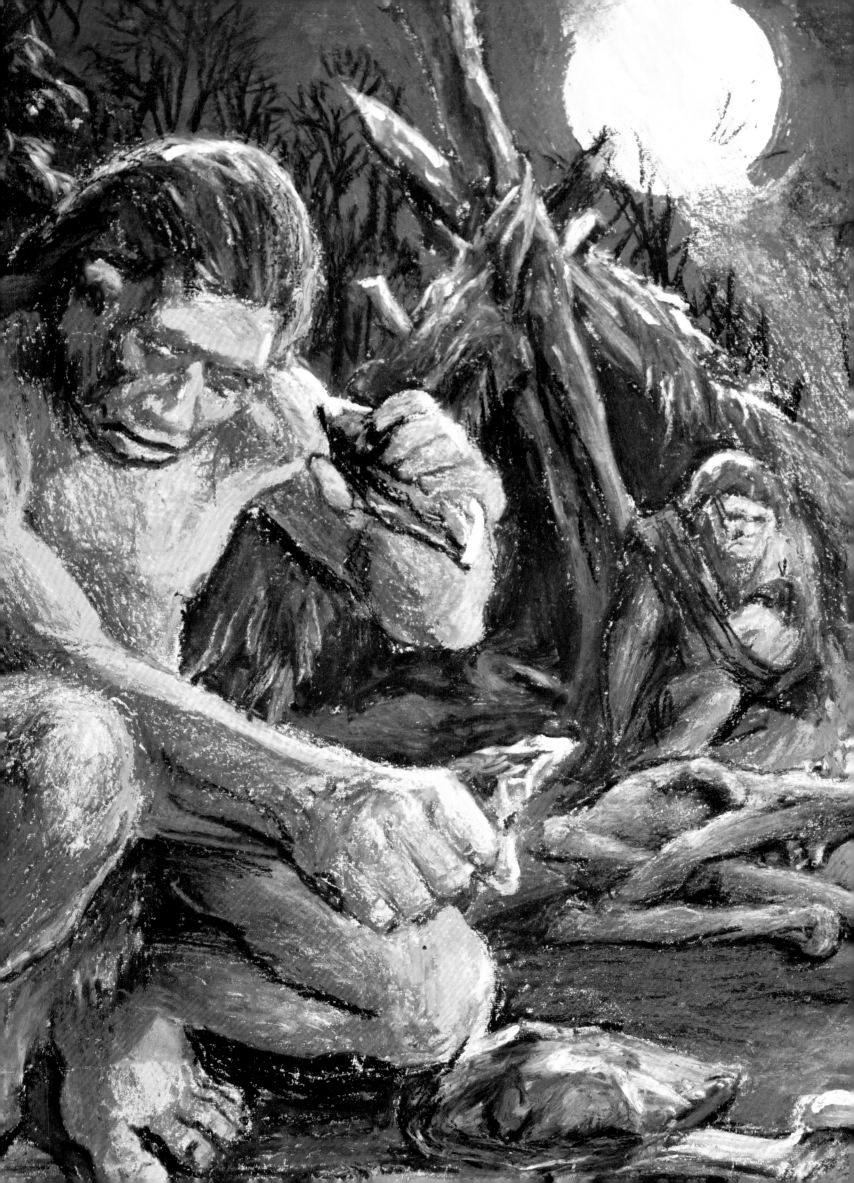

I've always been fascinated by early humans—Paleolithic through Neolithic. I did this one when I was twelve and in eighth grade, somewhere around 1967. Again, it's heavily influenced by Frank Frazetta's work. In '67 he did a cover for *Creepy* featuring a group of cavemen, and I was kind of inspired by that. The image on pages 310–311 is actually from a few years earlier, even though in some ways it's a better drawing. The guys in these paintings are clearly meant to be Neanderthals rather than anatomically modern humans. At the time I drew the image on these pages, I'd stumbled upon a news article that claimed someone had found a little shrine that Neanderthals had made by putting the femurs of a cave bear through a skull. I saw some reference for it and built the image around that. I think that idea has long since been debunked, though.

The image on pages 314–315 is from tenth grade. In our literature class, we read a short story called "Leiningen Versus the Ants" by Carl Stephenson. It's about this guy, Leiningen, who owns a plantation in the Brazilian rainforest. He hears that there's a massive swarm of soldier ants heading toward the plantation, but rather than run away, he decides to fight them off. I thought it was a really cool story, so in my art class I drew this scene from the book. It's Leiningen running through a field of a hundred million ants. He digs trenches around the field, fills them with petrol, and lights them on fire, but then the ants get to him and he has to run right through swarms of them, which is why he's all wrapped up to protect himself. I've not read it since school but it's a great story.

HIROSHIMA NATIONAL PARK:
PLAYGROUND OF THE FUTURE...

The images on these pages are thematic with apocalyptic overtones: "Hiroshima National Park" but it's just a bunch of burned-out ruins; flowers emerging from the ruins of a destroyed city with nature slowly coming back—so, similar themes about mankind's own technology causing its destruction. I remember that around the time I was drawing these kinds of images I wrote a play that we put on at school called *Extinction Syndrome*. It ended in a nuclear holocaust and all the dancers fell down under a strobe light. It was actually pretty good, I have to say. I mean, for a bunch of kids.

I drew these for an art class project somewhere around the eleventh grade—it's a reimagining of H. G. Wells' *War of the Worlds*. There was a comic book series at the time that adapted *War of the Worlds* and introduced a pretty cool design for the tripod machines, and I pretty much used that for my version. I was fairly literal in my adaptation; the meteor lands and the end cap of the alien craft unscrews just the way Wells describes it. Then you've got the heat ray and the alien itself, which I just made up. But I was putting my own swerve on the classic story, basically.

The war machines rose
out of the sand pit
weilding their
deady heat
rays...

...to begin their conquest of man

Then, strangely, one by one the great machines toppled, out of control...

To lie lifeless and still amid the rubble...

"The tiniest creatures which God, in his wisdom...

...placed upon the Earth."

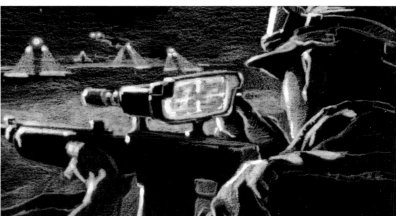

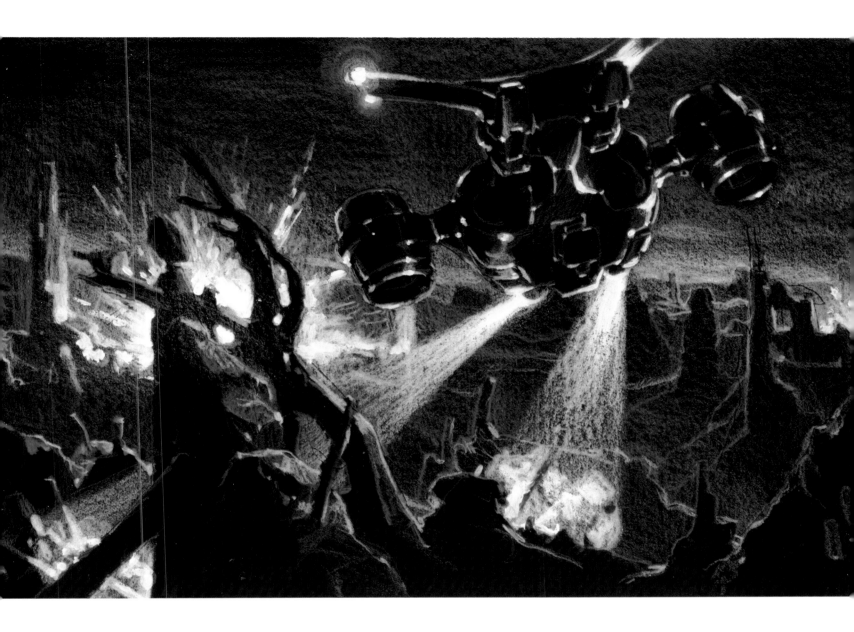

SCORCHED EARTH

The image above is concept art for a scene that didn't make it into the movie—it's the unassailable fortress where Skynet is based.

So jumping way forward to 1983, you can see how some of these apocalyptic themes manifested in my prep for *The Terminator*. The image above is concept art for a scene that didn't make it into the movie—it's the unassailable fortress where Skynet is based. But because we were on a tight budget and it didn't really need to be seen in the movie, it fell by the wayside and was never shot.

Opposite bottom and on pages 318–325 are my storyboards for the future war flashback scenes where Kyle Reese is battling Skynet's Hunter-Killers. I was using my Prisma-color-on-black technique with a little bit of highlight painting to try to get the dynamic range that I envisioned for the sequence. There was a sort of graphic quality that I wanted to suggest to the director of photography—the deep blue color, the green night vision glow when the characters raise their goggles, even the way that lights would shaft around the ruins as Reese hides from the Hunter-Killer. I could see it so vividly in my mind's eye that I figured I should just draw it all up.

It turned out to be a very valuable exercise because Gene Warren Jr. and his team at Fantasy II, who did the optical effects, could use the storyboards as a guide for elements like the halation of the energy weapons, the way the energy bolts would hit the ground, and so on. It quickly got them to a place where they understood the kind of atmosphere I was looking for and the way the lighting needed to be set up. And ultimately, I pretty much shot these storyboards frame-for-frame, even down to Reese jumping on the hood of the technical vehicle before it speeds away as the flying Hunter-Killer shoots at it.

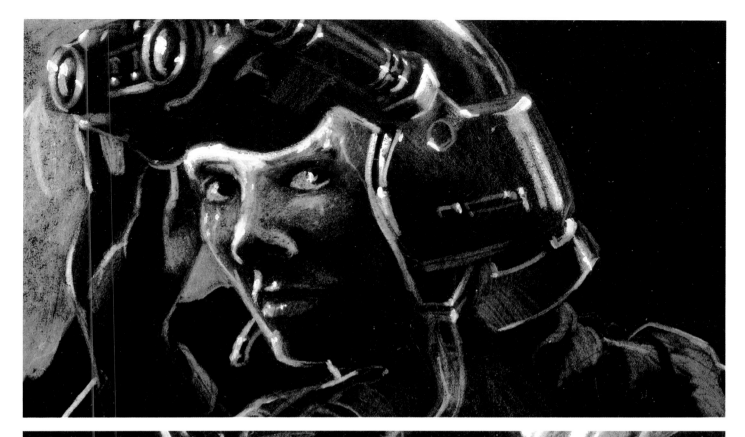

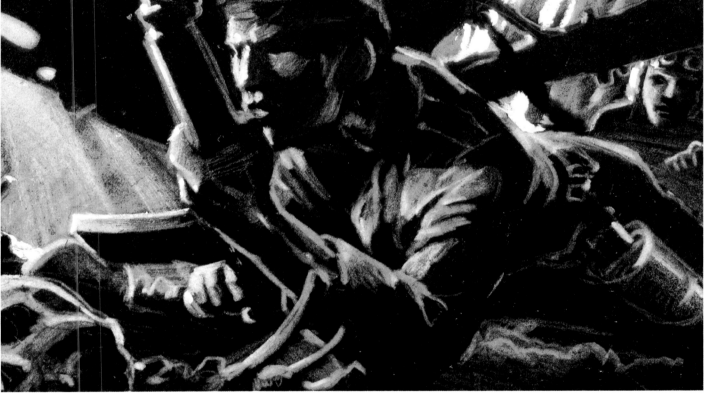

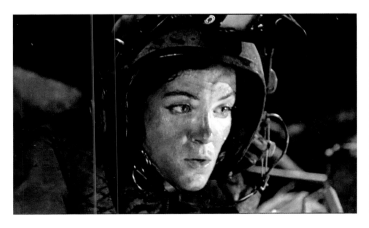

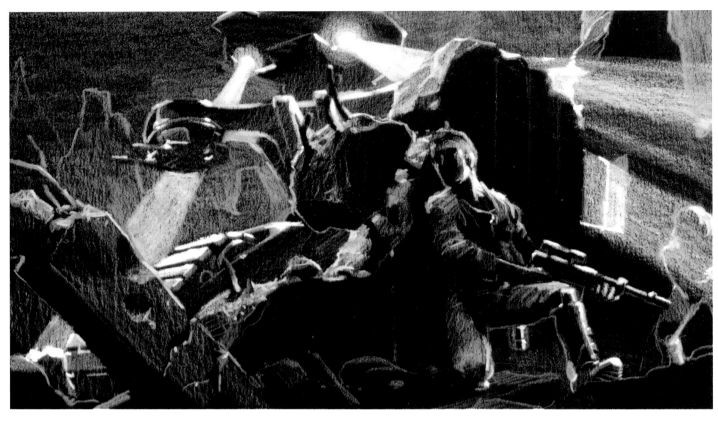

GUNNER SWIVELS GUN RAPIDLY AND
STARTS FIRING.

40

LOW ANGLE PAST BURNING
H-K F.G., PANNING R-L
W/ AERIAL H-K AS IT
COMES INTO VIEW FROM
BEHIND THE DISABLED H-K.

IT DESCENDS AS IT
ARCS TOWARD CAMERA

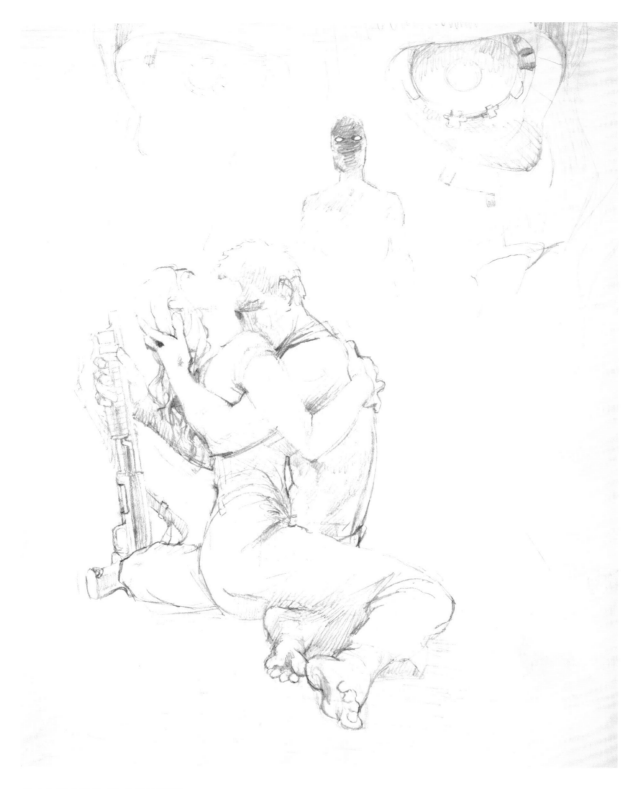

CANNES POSTER

This is a promotional image I created to help sell *The Terminator*—the initial study is on the left-hand page and the final is on the right. Because I had done that stupid *Last Plane Out* poster, I realized there was a thing called a film market where production companies try to get funding to make their movies. I heard Hemdale, the indie company producing *The Terminator*, was taking the movie to the Cannes Film Festival, so I did this for a sales brochure that they could hand out. At this point the script was written, so I knew there would be a scene where Kyle Reese and Sarah Connor embrace, thinking that they've killed the Terminator, not realizing that he's about to rise up out of the fire. I deliberately made the Terminator a kind of generic figure with red eyes—I didn't want to include the endoskeleton as I didn't want to give away what it looked like. Then in the background you can see this hint of a Darth Vader–like metal helmet. *The Empire Strikes Back* had come out in 1980 and there was a poster for that where Vader's helmet is kind of wreathed in fire, and I think it had some influence on that aspect of the image.

We didn't get greenlit off that brochure alone, but it helped the production gain momentum, and we soon got the commitment from Orion to make the film as a coproduction. Initially, nobody was ready to spend a dime until we had some casting in place, and then we cast Arnold, which made the production real. After that I was able to get started on all my designs and storyboards, and that's how it all began . . .

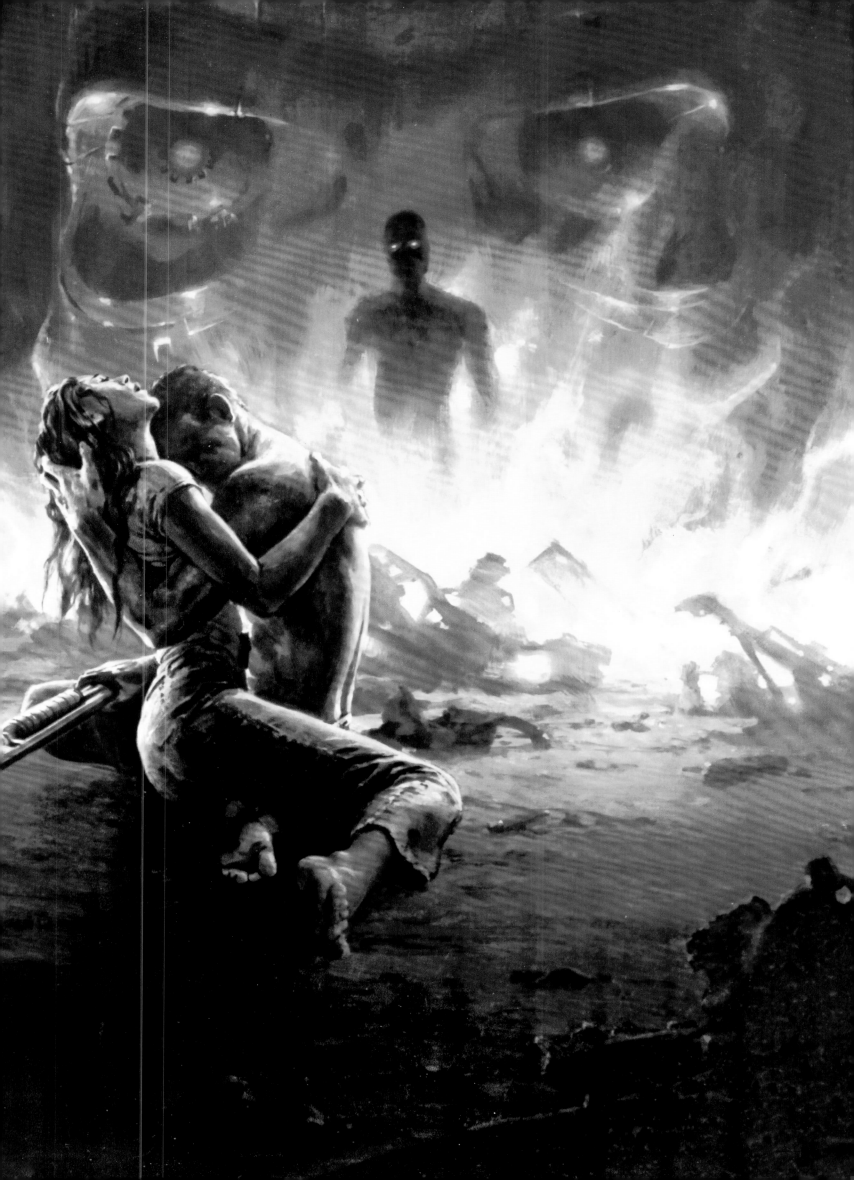

We didn't want to give away that the Terminator had a robotic endoskeleton in the artwork that was done for Cannes, but the endoskeleton had already been completely designed at that time. Stan Winston and I were already figuring out how we'd sculpt it and build puppets—how there would be a head-and-torso puppet worn on a backpack by one of his puppeteers, who'd operate the arms using Bunraku rods, and so on. It was a given from my first meeting with Stan that it was *not* going to be a guy in a suit. It made no sense. Even Arnold, as big as he is, doesn't have room inside him for a suit with a guy inside it. So it was going to be a puppet. Knowing that, I designed the waist to be skeletal, to tell the audience instantly there isn't a guy inside this thing. Then the outboard hydraulic rams filled out the shape and gave it the right width, but you could still see right through it. That was fundamental to the design.

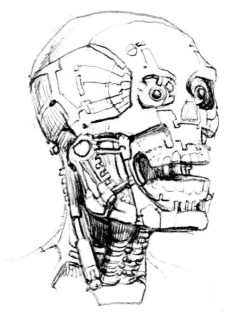

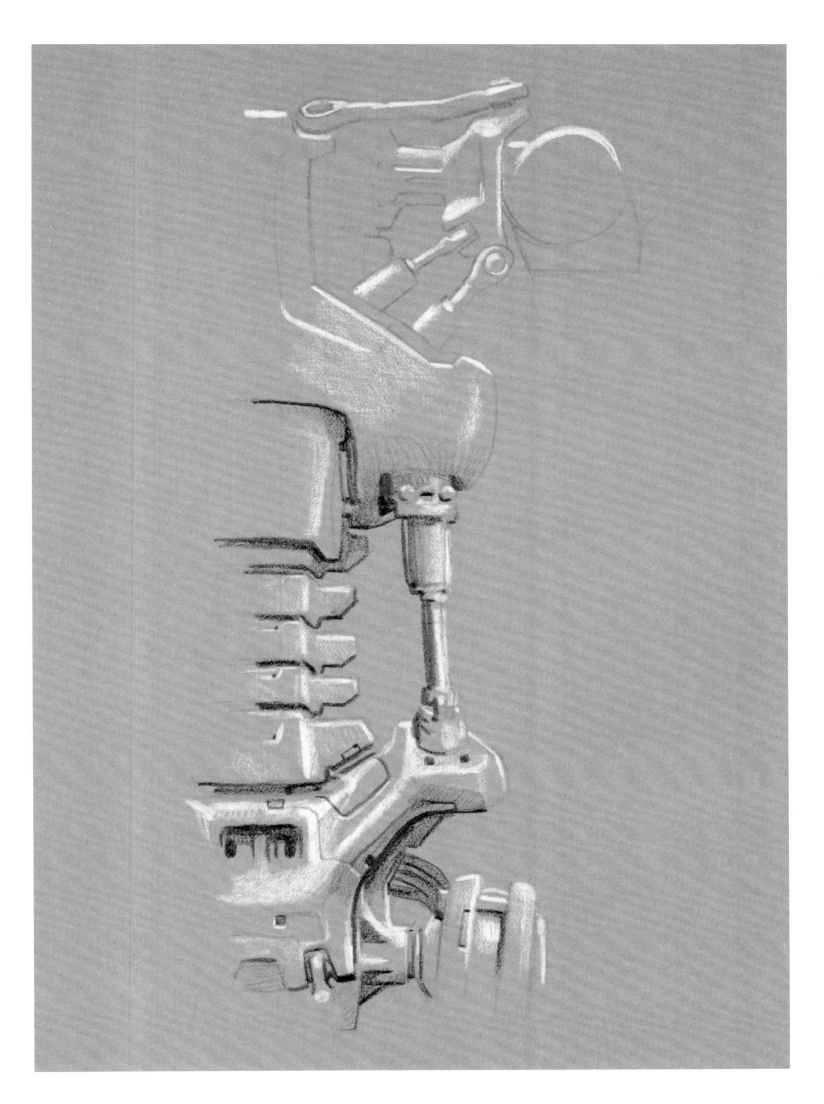

I did this rough sketch before we went out to shoot the plate, so Ken Marschall, the matte artist, would know what to add.

THERE'S A STORM COMING . . .

The last image of *The Terminator* is the storm coming, which is both literal in the scene and symbolic of the nuclear holocaust that Sarah knows is coming. I did this rough sketch before we went out to shoot the plate, so Ken Marschall, the matte artist, would know what to add. We were almost out of money in postproduction but had to get this shot. Gale Hurd and I went out to some random road near Lancaster, California, and and set up the camera, with just her personal assistant Polly helping us. Polly's hair was a pretty good match for Linda's, so she was our Linda double. Not a single car was going by for the couple of hours it took to set this up. We figured we didn't need a filming permit; we were in the middle of nowhere. We were about to shoot when this black speck appeared on the horizon, and as it got closer, we saw it was a cop—the only other car we saw out there all day. And he asked, "Where's your permit?" I looked him right in the eye, at the age of twenty-nine, and said, "Uh, we're just students from UCLA doing a term project." And he made us drag our tripod off the edge of the road, farther onto the shoulder, and told us to hurry up. Then he drove off. Ken did a beautiful job on the matte painting, which is actually surprisingly tiny. As a side note, Ken is the world's most authoritative painter of the RMS *Titanic* and was with me on the movie and several subsequent *Titanic* documentaries. We're still good friends to this day.

POSTSCRIPT: SPIDEY SENSE

And then there's Spider-Man, the greatest movie I never made. I couldn't finish this book without a bit of Spidey in it somewhere. Because my version of the project didn't get off the ground, very little concept art was created for it, although I did draw a couple of pieces myself. This is a sketch I did, in Prismacolor on black paper, to get myself in the mood for writing the script. I wanted to express the vertigo that the movie would induce, when going up high-rises with the fearless wall-crawler. I show him in an all-black suit here—anticipating that I would want the Venom alien symbiote version of Spider-Man to show up somewhere in the story, either in the first film or the sequel. I always think ahead. I was a big fan of Venom but wasn't too crazy about some of the other Spider villains—I never thought the Green Goblin or Kingpin were worthy of such a cool superhero. I eventually redrew it with the classic blue and red web suit (see pages 334–335). Spider-Man was an obsession of mine as a kid, but curiously I never drew him very much. But I definitely went to school on how Steve Ditko drew those crazy hands back in the mid-'60s. When I was in eighth grade, I wanted to be Spider-Man. I was trying to figure out how to make wrist shooters and I was doing pull-ups and stuff so that I could jump around on buildings. If parkour had been a thing back then I would have been doing it, I'm sure.

Somewhere around the early 1990s, I heard that a Spider-Man movie project was being developed by Cannon Films. Cannon was this super cheesy outfit that was slightly above Roger Corman in terms of the quality of their output. They were also infamous for never paying their bills, but they did have a pretty good run in the '70s and early '80s. Not long after, Cannon went tits up and their Spider-Man project was in the wind. I told Mario Kassar and Andy Vajna at the production company Carolco to go snap it up so I could make it. This was before I did *Terminator 2* with Carolco, but they already liked me at that point and were looking for more things we could do together. So they got the rights to Spider-Man and I went ahead and wrote a treatment.

When I was writing it, I talked to Stan Lee about my ideas. I said, "Hey Stan, I want to change Spidey's web-shooters. In the comics Peter Parker builds his web-shooters, but I want them to be biological. I want it to be a metaphor for puberty and coming into manhood, with all the confusion and anxiety that happens when your body changes. That's when you have to learn what's right and what's wrong and you have to do the right thing. That's what Spider-Man should be about. He's not a man—Spider-Man's a high school kid." So Stan said, "I like all these ideas. What do you want to do with the web-shooters?" I said, "Look, he makes this thing that freaking DARPA couldn't make. He's a smart kid but it doesn't really make sense. He gets bitten by a spider, it changes his entire body, changes his abilities and his senses. Why couldn't he have these little spinnerets in his wrists that only come out when he needs them? That would explain why he does that crazy posture with his hands: He's pushing the spinneret out." And he goes, "Oh, that's good. Do that." So I had creative sign-off from Stan Lee.

Then, not long after, Carolco went bankrupt and so I went and asked 20th Century Fox to buy the rights to Spider-Man. But Sony also had a stake in the property somehow, and Fox didn't have the stomach to get into a big fight with them even though it was very winnable. As a result, Fox left a multibillion-dollar franchise on the table. The truth is that nobody saw the value in Spider-Man at the time. Cannon bought it for a song, Carolco got it cheap from Cannon. Nobody thought it was worth anything. So in the end, my version ended up in limbo and I moved on to other things. And ultimately, in 2001, Sam Raimi became the first director to make a Spider-Man movie—but he did keep my biological spinneret idea.

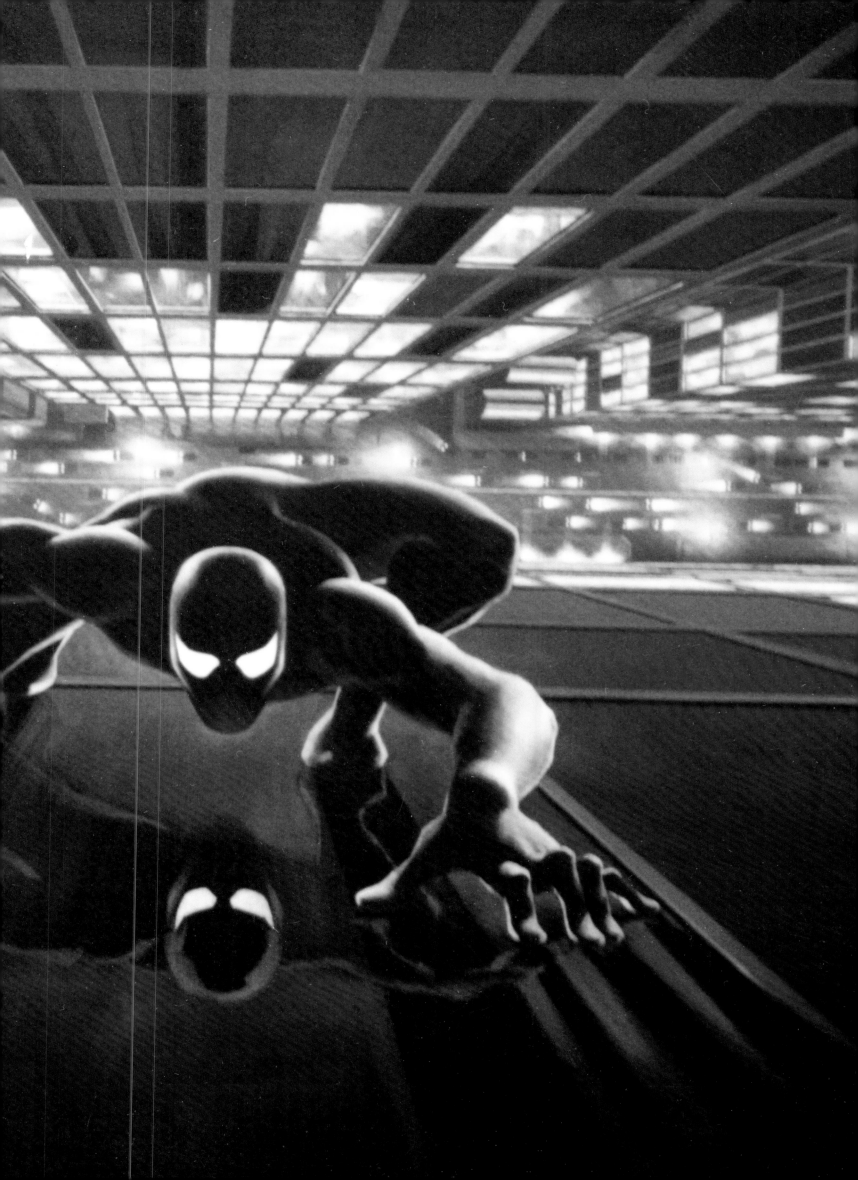

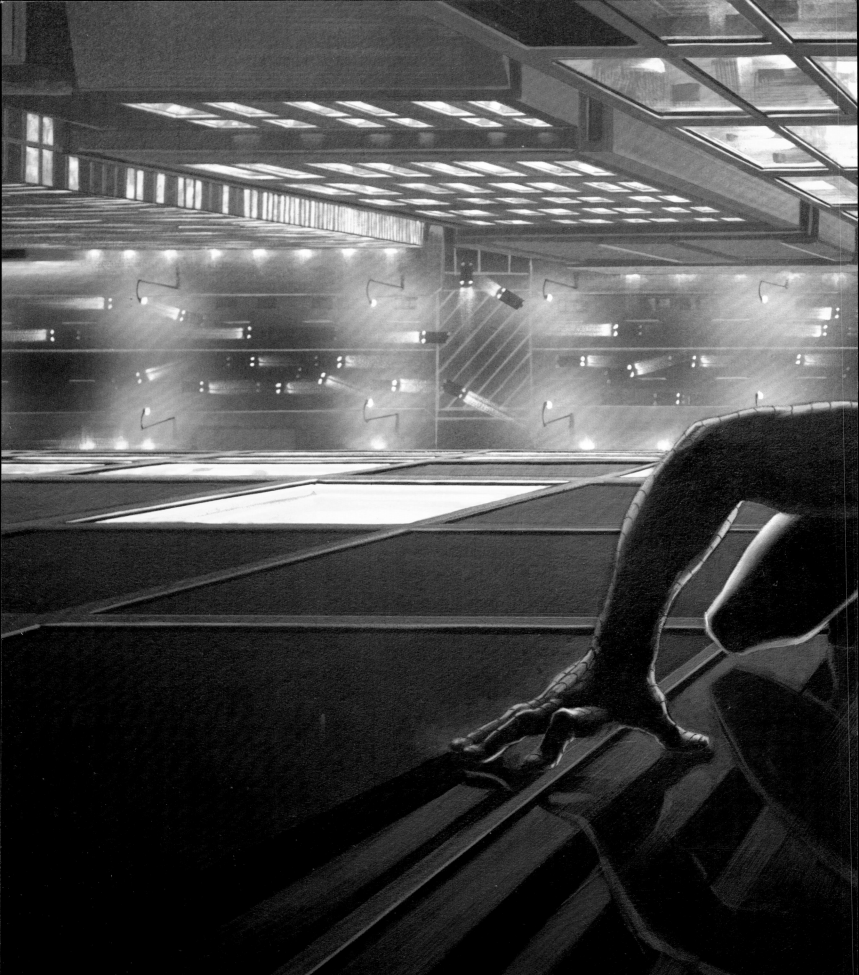

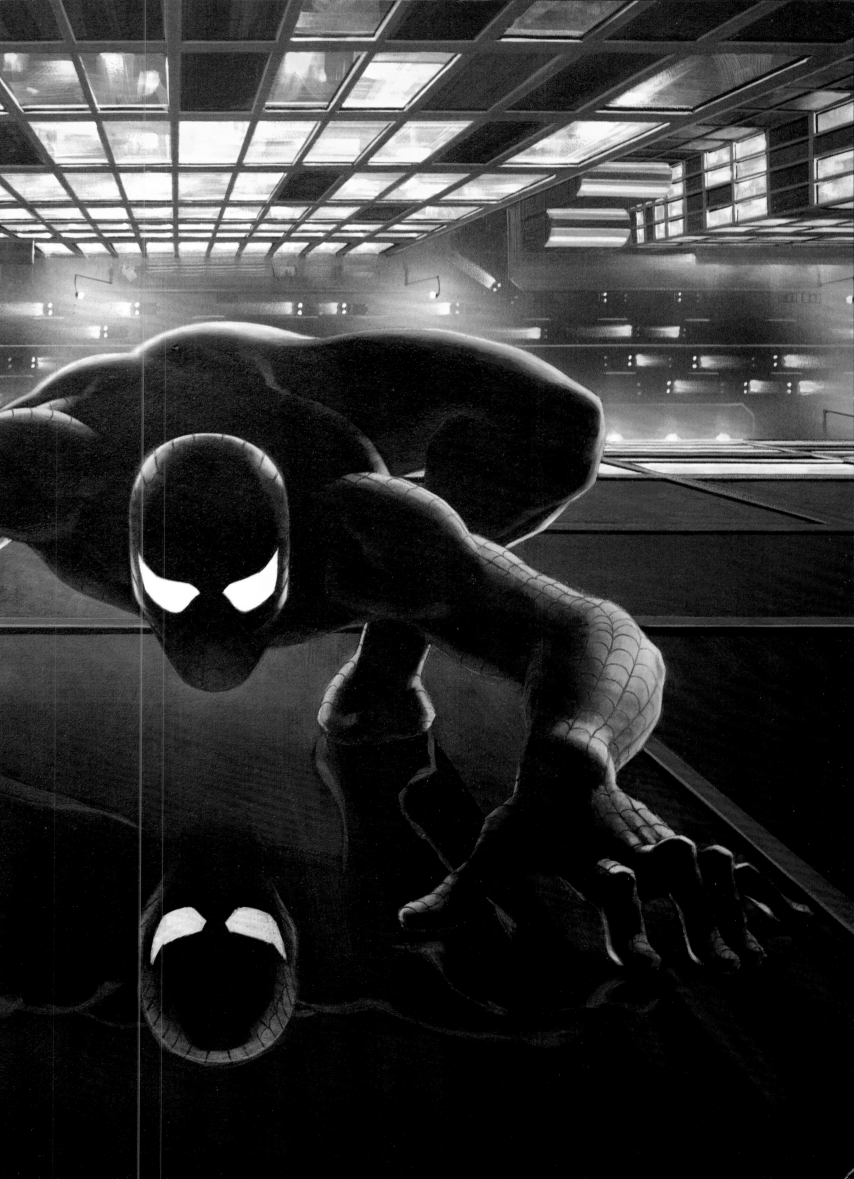

INSIGHT EDITIONS

PO Box 3088
San Rafael, CA 94912
www.insighteditions.com

 Find us on Facebook: www.facebook.com/InsightEditions

Follow us on Twitter: @insighteditions

Published by Insight Editions, San Rafael, California, in 2021.

Library of Congress Cataloging-in-Publication Data available.

ISBN: 978-1-68383-878-4

Publisher: Raoul Goff
VP of Licensing and Partnerships: Vanessa Lopez
VP of Creative: Chrissy Kwasnik
VP of Manufacturing: Alix Nicholaeff
Editorial Director: Vicki Jaeger
Executive Editor: Chris Prince
Editorial Assistant: Harrison Tunggal
Senior Production Editor: Elaine Ou
Senior Production Manager: Greg Steffen
Senior Production Manager, Subsidiary Rights: Lina s Palma

Design by Amazing15

Photographs on pages 8 and 9 courtesy of Dennis Skotak.
Photographs on page 209 courtesy of Robert Skotak.

Manufactured in Turkey by Insight Editions

10 9 8 7 6 5 4 3 2 1

ACKNOWLEDGMENTS

With heartfelt thanks to:

My spectacular wife, Suzy, my guiding star.

Maria Wilhelm, consigliere and the one who lives my adventure life for me while I'm stuck on my day job making movies.

The extraordinary Kim Butts.

Chris Prince, who's not afraid to go into my brain.

I'd like to thank Raoul Goff and Insight Editions for their partnership, creativity, and commitment to excellence.

Miss Calvert, Grade 8, who told me to make art, think differently, and follow my heart.

Mr. Mackenzie, Science, Grade 11 and 12, who let us start our own drama program and told me I could do anything in life I put my mind to.

Miss Anglin, History, Grade 10, who time traveled me to ancient Egypt, Greece, and Rome.

And Mr. Ralph, Art, Grade 10, 11, 12, who drummed the masters into us but let me paint whatever I wanted.

This book is dedicated to my mother, Shirley Cameron. She lived for art in a small town that couldn't spell the word. She encouraged my painting and drawing when all the other boys were kicking or batting balls around pointlessly.

—James Cameron

Insight Editions would like to thank James Cameron for his guidance, support and enthusiasm during the creation of *Tech Noir*. We would also like to extend our gratitude to Kim Butts and Maria Wilhelm for their partnership and collaboration. Additional thanks to Jon Landau, Terri DePaolo, Kassandra Arko, and Barney Doherty for their help in bringing this book to life. For their assistance, we would also like to thank Andy Bandit, Dylan Cole, Sven Larsen, Vitoria Lee, Ken Marschall, Angela Ontiveros, Dennis Skotak, Robert Skotak, Nicole Spiegel, and Nicole Su'e.

 REPLANTED PAPER

This is a bit of whimsy from my eldest daughter, Josa, a very talented artist. I think we're missing a bet not doing a mash-up of *Titanic* and *Aliens*—it could be a real hit.

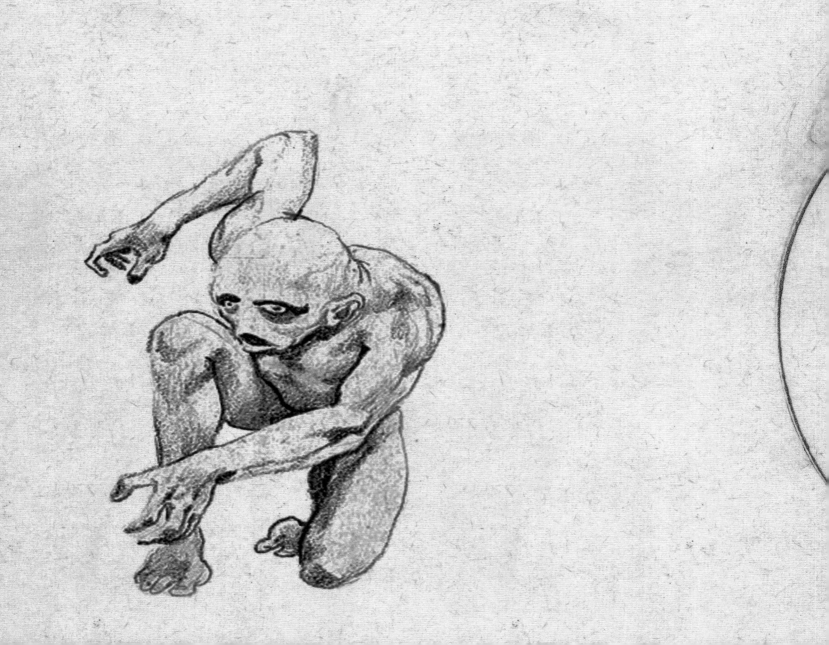